PRE-RAPHAELITE PAPERS

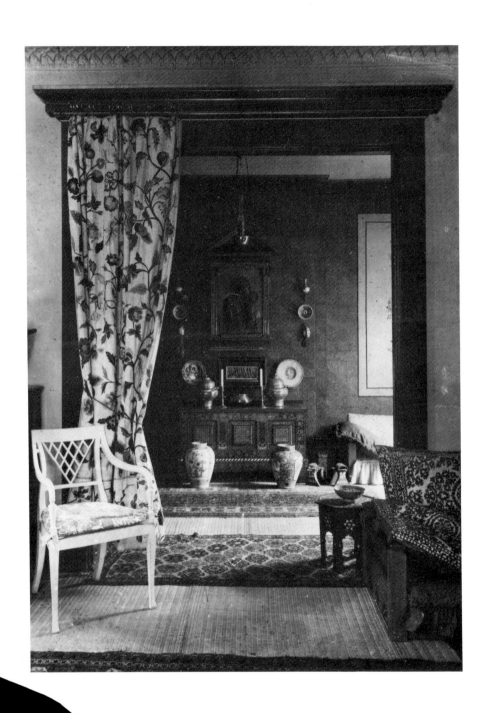

PRE-RAPHAELITE PAPERS

EDITED BY

LESLIE PARRIS

THE TATE GALLERY

frontispiece
Morning-room of W. Holman Hunt's house,
Draycott Lodge, Fulham, 1893
(see p.207)

ISBN 0 946590 02 8
Copyright © 1984 The Tate Gallery
Designed and published by the Tate Gallery Publications
Department, Millbank, London SW1P 4RG
Printed in Great Britain by Balding + Mansell
Limited, Wisbech, Cambs

Contents

Foreword

This volume of essays is published on the occasion of the major exhibition of Pre-Raphaelite art held at the Tate Gallery in the spring of 1984. The contributors include the principal authors of the catalogue of the exhibition and several members of its Committee of Honour. For the present book they were invited to write on whatever aspect of Pre-Raphaelitism currently interested them, the aim being to produce a collection that would reflect the wide range of modern studies in this field as well as the diversity of Pre-Raphaelite art itself.

As Quentin Bell reminds us in the opening essay, the Pre-Raphaelite movement did indeed contain some disparate elements. The original Brotherhood represented an odd mixture of talents and interests; what the second generation Pre-Raphaelites tried to do was radically different but no more clearly defined. Common interests can of course be discerned but, as the next two essays suggest, they are not necessarily those advertised at the time by the artists themselves. Alastair Grieve examines a peculiar and forceful style of drawing briefly shared by the early Pre-Raphaelites but used almost as a secret language for the expression of ideas which they judged unacceptable to the public. And Stephanie Grilli identifies an interest in phrenology shared by Millais and Hunt which went deeper than one might guess from the anecdotal account Hunt later published of Millais having his 'bumps' read; there was, she suggests, a scientific slant to the Pre-Raphaelites' concerns which is not conveyed by the name they chose for themselves. Two biographical pieces follow: Ronald Parkinson writes on James Collinson, an original member of the P.R.B., and Mary Lutyens on Walter Howell Deverell, who was proposed as Collinson's replacement when he resigned. For different reasons, their careers were cut short in the early 1850s and they have been neglected since. These accounts of them are the fullest yet available. In the last of the essays to focus on the early years of Pre-Raphaelitism, Benedict Read asks 'Was there Pre-Raphaelite Sculpture?', a question usually brushed aside despite Thomas Woolner's membership of the P.R.B. and the close association with it of other sculptors.

Three papers in the centre of this collection concern major works

painted by Hunt, Millais and Madox Brown in the years following the dissolution of the Pre-Raphaelite Brotherhood: Judith Bronkhurst publishes new material on Hunt's expedition to the Dead Sea in 1854 to paint 'The Scapegoat' (and gives us further instances of the artist's extreme sensitivity about his public image); Malcolm Warner discusses the meaning of 'Autumn Leaves', a key picture in Millais's development and, he argues, in nineteenth-century British art; and Mary Bennett documents the difficulties Brown encountered in selling his *magnum opus*, 'Work'. The three essays that follow shift our attention to the Rossetti camp. Julian Treuherz investigates the Pre-Raphaelites' knowledge of mediaeval illuminated manuscripts and especially their role in Rossetti's imaginative recreation of the mediaeval world in his watercolours of the later 1850s. The story of that celebrated joint venture in mediaevalism, the decoration of the Oxford Union by Rossetti, Morris, Burne-Jones and others, is told by Lady Mander. And John Christian shows how Ruskin, turning his back on the middle ages, tried to point Burne-Jones in new directions and to 'manage' him in a way that had proved impossible with Rossetti.

The volume closes with two autobiographical pieces: an irreverent account of Hunt's collecting activities by his grand-daughter Diana Holman-Hunt, who at the age of eight found herself pressed into guiding Sunday visitors round the Collection; and a personal view by Jeremy Maas of the Pre-Raphaelite revival of the last twenty or so years, in which he has played a leading role himself. With this last essay we return to the vacillations of taste which are the main theme of the opening one – to that spiralling wheel of taste which Quentin Bell so graphically describes and which will doubtless be given a further twist by the Tate Gallery exhibition.

Because *Pre-Raphaelite Papers* is intended to complement the exhibition catalogue, we have tried to avoid reproducing works which are already illustrated there. The abbreviation 'TG 1984, No.–' is used to refer readers to the relevant catalogue entry and illustration. A list of other abbreviations appears before the notes at the end of the book.

The Tate Gallery is very grateful to all those owners who have allowed their works to be reproduced in this volume and to the following for permission to quote manuscript material: J.P. Birch, Esq.; Bodleian Library, Oxford; The British Library; University of British Columbia Library; the heirs of Ford Madox Brown; The Huntington Library, San Marino, California; Lady Lever Art Gallery, Port Sunlight; The Pierpont Morgan Library, New York; The John Rylands University Library of Manchester; Tennyson Research Centre, Lincoln (by courtesy of Lord Tennyson and the Lincolnshire Library Service); Humanities Research

Center, The University of Texas at Austin. Extracts from *Letters of Dante Gabriel Rossetti* and *The P.R.B. Journal* are quoted by permission of Oxford University Press and from *The Diary of Ford Madox Brown* by permission of Yale University Press.

Leslie Parris

Deputy Keeper of the British Collection
Tate Gallery

The Pre-Raphaelites and their Critics

QUENTIN BELL

'Spit here'

These harsh words were pencilled in the margin of Dante Gabriel Rossetti's copy of Mrs Jameson's *Sacred and Legendary Art* whenever the name of Rubens appeared in the text. Burne-Jones, who came upon this annotated volume in Rossetti's studio, seems to have approved. He, too, hated Rubens. To us, I suppose, such a commentary seems fairly ridiculous and rather sad; as criticism it is neither helpful nor perceptive, indeed the injunction may appear so puerile (the Pre-Raphaelites were at times distinctly schoolboyish in their remarks) as to be unworthy of our attention. Nevertheless, even in so slight an essay as this, it is impossible not to notice that this kind of criticism is more frequent than one might wish. The question must be asked: how is it that abusive and dismissive remarks are so common in art criticism?

A part of our trouble arises from the fact that we enjoy abusing and we enjoy abuse. Rossetti may be rather too laconic for most tastes but an adorned and 'argued' version of Rossetti is nearly always welcome. The public enjoys the spectacle of a writer who loses his temper, and to the critic himself an explosion of rage, particularly if it gives an opportunity for wit, offers a much easier literary task than the sincere effort to understand and to sympathise with that which, at first sight, we are content to dismiss. Indeed, it may be said that if the art critic is to try and be both sympathetic and helpful he will no longer be readable. I don't think that that ought to prejudice us; but the reader may rest assured; he has nothing to fear.

The above words were written with some trepidation and not a little embarrassment; this writer has himself been an art critic and it may be that he has sometimes come uncomfortably close to the 'spit here' manner. My difficulties are increased by an awareness that my failings may be hereditary. In December 1925, Clive Bell wrote an article which was published in the *Nation and Athenaeum* under the title 'The Pre-Raphaelites'. The words 'spit here' are not used, that was not my father's style, but it was not far from his meaning. He declared that their 'output is worthless', their technical processes were 'tedious and insignificant' and 'not one of them is a painter'. There is not one word of qualification and no serious attempt is made to understand the artists' point of view. He, who

could on occasion illuminate, explain and analyse the paintings of painters with whom he was not in perfect sympathy, is here content to scold and to denounce.

Before starting to do likewise one should perhaps ask oneself whether one would expect a fairly young critic in the year 1925 to be entirely just to the Pre-Raphaelites any more than one would expect a young painter in the middle of the last century to be wholly just to Rubens, and if one decides, as I think one must, that such aesthetic equilibrum would be altogether exceptional, one might ask the further question: to what extent are critics the creatures of their age and with how much reason may we hope that critics will provide us with objective value judgements? In other words, we may, and I think should, condemn critical violence because violence leaves no room for the understanding which should inform criticism; but should we not, by the same token, seek to understand the violence of the critics themselves?

What was it then which made Rossetti lose his temper with Rubens and why was it that Clive Bell lost his temper with Rossetti?

It is a matter of historical fact that there are times when art engenders fanaticism and the aesthetic fanatic exhibits many of the virtues and the vices of the religious zealot. He is convinced of the absolute rightness of his views and neither understands nor seeks to understand those who differ from him. The beauty and sublimity of that which he admires is such that he can hardly tolerate discussion; anything which appears to be opposed to his conception of art is therefore intolerable. This, I think, was the situation of the young Pre-Raphaelites, but with this rather odd distinction, that they were much more clear and much better informed about what they did not like than about what they liked.

By a strange irony Sir Joshua Reynolds, President of the Royal Academy and no favourite of the Pre-Raphaelite brethren, must have been one of the first British painters to proclaim the excellence of artists before Raphael. His favourite 'Pre-Raphaelite' was Masaccio; but he was not alone in his taste for early painting; it was an attitude which grew steadily more popular in England and to an even greater extent on the Continent. Already by the beginning of the century, German painters in Rome had felt the new passion for old and 'christian' art and the young artists, if they were innovators, were so only in so far as they expressed that admiration in their own work. Here, this admiration could not but be vague in that there was so very little actual 'early' painting to be admired in this country, and the reader may observe with sympathy the efforts of F.G. Stephens, writing in *The Germ*, the Pre-Raphaelite organ, to praise the primitives without

having actually seen them. Ford Madox Brown was the only one of them who had been to Italy and knew what it was that they were to admire.

It was much easier to know what was to be condemned. The rot, it was felt, had set in with Raphael; his 'Transfiguration' marked the beginning of a process of corruption which had continued from the sixteenth to the nineteenth century and which was evident both in the teachings and the exhibitions of the Academy, teachings based upon a wearisome study of the antique, exhibitions containing work which had not even the qualities which might have been looked for amongst painters reared in an academic school but which combined a flashy and meretricious technique (what the Pre-Raphaelites called 'slosh') with very trivial subject matter. In this connection we should remember that the young men would have noticed not only the more distinguished 'academic' painting but a great mass of lesser work, the productions of epigoni and imitators, art of a kind which was very evident not only on the walls of the Academy but in Annuals, Keepsakes and other ephemera of the time. A glance through the *Art Journal* for those years will I think convince us that the young Holman Hunt was right in thinking that art stood in need of regeneration; in a society such as ours this must always be the case for so much of it is so feeble.

In the sad story of steady decline Rubens might well appear to be the chief captain of evil. If the quiet simplicity of art before Raphael is what we prize most in painting then Rubens may appear as a noisy vulgarian, pagan without the idealisations of paganism, fluent, nastily brilliant and unmistakably coarse. His very strength was a menace and, as readers of Ruskin will remember, that critic, while admitting his 'splendid power', cannot but condemn his 'baseness, brutality and stupidity'. For us it is the 'splendid power' which is most evident in his work, but the older view persisted into our own time. At a dinner party in Kensington, a party of cultivated 'art loving' people in the early 1900s, the conversation turned upon the relative merits of Rubens and Van Dyck. It was generally agreed that the pupil was a much greater man than his master; Rubens was wholly lacking in that delicacy of feeling, that exquisite refinement which distinguished the work of Van Dyck. Let me restore the family credit a little by saying that there were two dissentient voices: those of Clive and Vanessa Bell.

If indeed we can make any comparison between the situation in which Rossetti found himself and that which Clive Bell had to face, then I think it must be allowed that the condemnation of the Pre-Raphaelites was more natural and inevitable than the condemnation of Rubens. In 1925 the

fierce battle which in England began with the First Post-Impressionist Exhibition was a recent memory. In that affair tempers had risen high and beliefs were held with great fury. The Pre-Raphaelites, who by the end of the century had become established figures, were among the first to condemn the innovations of the French and it was Rossetti himself who at a very early date poured ridicule upon the work of 'an idiot called Manet'; all the other principal figures joined in denouncing the common enemy, and although they did not live long enough to become aware of Cézanne and the Post-Impressionists there could be little doubt of what their attitude would have been. If you found a deity in Cézanne it seemed impossible that you should find a place in your Pantheon for Ford Madox Brown. This is no longer an impossibility, but it is very understandable that in the year 1925 it should have seemed to be one.

Expressions of aesthetic intolerance are in fact the reverse side of genuine admirations and it is arguable that such resolute intolerance is a necessary part of the equipment of the art critic: if he must feel and display a religious zeal he must find a place not only for enthusiastic worship but for the faggot and the *index expurgatorius*. It is not to my mind a very convincing argument; extreme narrowness in a critic can never be a desirable quality and his words will not lack force because he is capable of wide sympathies. But such a constriction of the mind, even though it may be excusable in a critic, is surely fatal to the historian. This is a point that has to be made in considering the treatment accorded to the Pre-Raphaelites. Look through the general histories of art which have been published during the past fifty years or so and you will find, much too often, that the movement is alluded to with indecent haste, or a gross lack of information, and sometimes it is omitted altogether. It cannot be right that history should be at the mercy of aesthetic fashions.

Nor was the damage limited to those historians who simply could not be bothered to tell their readers about things of which they happened not to approve. It was a tendency which lead to the neglect of historical evidence.

Writing in 1942 Mr Geoffrey Grigson declared that 'here as everywhere in English Art there are conventional valuations to be rejected, pictures to be unearthed, letters and papers to be saved, books to be published, exhibitions to be arranged'. It took us twenty years to act upon this admirable advice and, even so, it came rather late. In fact the work of preservation should have been undertaken about 1925. By then all the major figures were gone; but there must have been a great many friends, relations, students and junior colleagues who could have been encouraged to reminisce and might have had a great deal to say. Diana Holman-Hunt,

who most fortunately, *has* committed her memories to paper, said: 'I had become used to hearing that unfashionable Pre-Raphaelism and crazy surrealism, were both withered branches on the tree of art. There was no future for literal painters, mere illustrators'. She fixes this period of total neglect a little later than the 1920s but the message is clear: there was no future for such artists, why then worry about their past? An opportunity was lost because, at the nadir of concern for the history of the movement, the scholars had lost interest.

Those of us who have lived long enough have therefore been able to see the reputation of the Pre-Raphaelites describe a semi-circle. In our youth we saw a movement which from small but noisy beginnings had soared to considerable eminence, dismissed and derided and then in our own time rise again with ever increasing public interest until now conventional valuations are indeed rejected, pictures unearthed, letters and papers saved and, as the reader can hardly have failed to note, exhibitions are arranged. The wheel has come half circle which is, as we should have known, the nature of wheels. There have been so many examples of this kind of mutation that one might suppose that the historians, at least, would have been cautious of acting upon the assumption that the Pre-Raphaelites would forever be forgotten. But, if the lesson has been learnt the learning of it must be something recent and perhaps its implications have yet to be assessed, for a belief in the complete finality of our judgements is by no means extinct even though the situation of one who proclaims the absolute immobility of his position and who at the same time is observed to be dangling in mid-air upon the ever-revolving platforms of a giant wheel, cannot but provoke a smile. Nor indeed can the dogmatic critic comfort himself with the reflection that if he keeps his station for long enough the wheel will return him to its former position. The wheel of taste is so constructed as to describe a spiral rather than a circular movement. We may now give Rubens his due but he is not exactly in the situation in which De Piles left him, and if we now look favourably on Burne-Jones it is not through Ruskin's spectacles, those indeed seem to be lost forever. Nor indeed should we take a purely mechanical view of the development of taste: circularity is but one tendency where aesthetic judgements are concerned. It would be more exact to speak of mutation, which is sometimes rapid and sometimes very gradual. It may even be that there are some who do not abide our question. What the fact of mutability and reaction *does* show is that it is never safe to 'write off' an artist or a school.

The fairly obvious point that I have been trying to make is descriptive rather than analytic. It would be satisfactory if one might proceed to a close

study of the motor forces which made and unmade the reputation of the Pre-Raphaelites. I do not know enough to do so; but certainly one element in the changing scene does appear to be social. From the very first these painters found their market amongst those whom contemporaries would have considered an ignorant and a philistine clientele, the 'self-made' men and manufacturers of the North. Ruskin was no doubt a powerful advocate but not, one would have imagined, with this class of person. The advantage, from the Pre-Raphaelites' point of view, of this kind of client, was that he would have been relatively uneducated. He would not have known enough to know that, for a cultivated public, Pre-Raphaelite painting was full of faults. He saw what he liked – a poetic feeling which took him far from the mills and the mines of the North together with a technique which was exemplary in its industry – and he purchased (we are of course speaking of a very small minority). Perhaps it was a similar lack of 'culture' which persuaded the new men in Chicago to buy Impressionists. Later no doubt Pre-Raphaelitism had become identified in the public mind with Aestheticism, the taste of an intellectual elite and therefore also of those who aspired to belong to that chosen group. As these constituted a much larger class, the movement then would have had its adherents and they would have been notable for their audacity.

> The Grosvenor's nuts - it is indeed!
> I goes for 'Olman 'Unt like pie.
> It's equal to a friendly lead
> To see B.Jones's judes go by.

W.E. Henley might laugh, just as a later generation was to laugh at those who 'affected a taste for cubism' but there is no advertisement so potent as derision. At a later date every room in which tea or education was dispensed was to have its Van Gogh or its Gauguin. So, by the end of the nineteenth century, 'The Scapegoat', 'Ecce Ancilla Domini' and other works more dubiously associated with the Pre-Raphaelites, travestied in even worse reproductions, were to find their place on the walls even of the humblest parlours. We all want to exhibit a cultivated taste, we all want to be enlisted in the cultural elite and of course in so doing we deprive the elite of its elitist character; that which had been distinguished becomes in the truest sense vulgar and the public is ready for something else; it is thus I would suggest that the wheel of fashion is made to revolve.

Here then is a simple, rough and ready account of what happened to the Pre-Raphaelites in public estimation. But it is neither an accurate nor a sufficient explanation. The critical examination and the public estimate of

the movement has suffered not only by reason of the normal vacillations of taste but because of a misunderstanding which arose in the first place because the original brethren had but the faintest idea of what they were trying to do and later because another generation attempted to do something equally ill-defined but radically different.

A purist might well complain that 'An English Autumn Afternoon' by Ford Madox Brown (TG 1984, No.51) hardly has a place in an exhibition which also contains 'Venus Discordia' by Burne-Jones (ibid., No.146). They are indeed very different pictures by very different painters; nevertheless, it is proper that they should hang together for both the painters are identified by the public as Pre-Raphaelites. The confusion must now be accepted, confusing though it is; but we should always bear in mind that what we now have to call the Pre-Raphaelite Movement contains some very disparate elements and this in its turn has had a profound effect upon critical assessments.

At this point it becomes necessary to say a little about the history of Pre-Raphaelitism, even though one must of necessity advert to some very familiar topics.

The first epoch of Pre-Raphaelitism, let us say 1848–60, is I think best described by the term 'hard edge'. It was, to be sure, the time of the Brotherhood, but membership of that body means remarkably little; some of the most typically Pre-Raphaelite painters of this period were not really Brethren, some of the Brethren were not really painters. It is not hard to recognise a Pre-Raphaelite painting of these early years, we know it by its technique. It will be very tightly and exactly drawn down to the very last detail, the use of the brush is as far as possible concealed, the colours are luminous, intense, and sometimes almost painfully vivid. The poses may sometimes be awkward but every detail is clearly taken from life and the faces are not those of professional models but of 'real' people who may often be decidedly plain. In subject matter there is less uniformity, the Pre-Raphaelite still-life is a rarity, landscape is usually populated, the nude is avoided. Millais, Holman Hunt and Rossetti are fond, in these years, of poetical and religious subjects. The many followers of the Pre-Raphaelites show a marked tendency to paint scenes of contemporary life. In one manner or another these are realist paintings and this realism finds its way even into the painting of sacred themes; but there is a Pre-Raphaelite drawing style which was I think confined to the Brethren and is more nervous and more romantic than the painting of this school.

This hard edge style was never abandoned by Holman Hunt but most of the brethren and followers had given it up by about 1860. In the work of

Dante Gabriel Rossetti it represents only a short initial phase; his whole inclination was towards a more romantic form of art and although he never abandoned the idea of producing a wholly realist painting of contemporary life he inclines throughout his career to a broader, although sometimes to an enormously detailed style.

When Morris and Burne-Jones came from Oxford looking for a leader, Rossetti was in command of the situation. Holman Hunt had gone to the Holy Land, Millais to the Academy. Rossetti, who was always persuasive and a natural leader, had the whole future of the Movement in his hands. Morris took and developed his interest in pattern and used it to make a very effective decorative style; Burne-Jones, a painter more interested in art than in nature, was also much preoccupied by questions of design. In his work we find numerous references to Mantegna and other painters of the Quattrocento and also to Michelangelo and the High Renaissance. Beauty is for him a matter of the first importance and he makes frequent use of the nude. In his paintings the element of realism is very slight, he is close to the voluptuous idealities of Rossetti's later years, and he is ready, at times, to use a very free and 'painterly' technique.

It will be seen that any criticism which attempts to embrace such very different schools (Morris and Burne-Jones may stand as the acknowledged leaders of their own brand of Pre-Raphaelism) must either be of a very general nature or very inexact. In fact their only real link is the fact that Rossetti was involved in both phases of the movement. I well remember the dismay of a German colleague who had asked for the loan of slides illustrating the Pre-Raphaelite School and who returned them in despair, complaining that these were realist paintings and nothing to do with Pre-Raphaelism as he understood the term. His situation was by no means unique. How often we meet criticism of the 'niggling' line, the harsh colours and ugly faces of those who forget Burne-Jones, Waterhouse and Meteyard, or on the other hand the mediaevalism and languid pallid romanticism which cannot be reconciled with the work of Martineau, Inchbold, Wallis or Brett.

Much the same difficulty must arise, I suppose, when we consider Pre-Raphaelite poetry, for whereas there does appear to be an affinity between Tennyson, Swinburne and the later Pre-Raphaelites, it is hard, surely, to find any contemporary poetry, even that which came from the pen of Pre-Raphaelite painters, which at all approaches the harsh, uncompromising and squalid realism of W.M. Rossetti's 'Mrs Holmes Grey', and yet we know that this blank verse narrative was intended to be the poetical equivalent of hard edge Pre-Raphaelite painting.

As a result of its increasingly heterogeneous nature Pre-Raphaelism becomes less and less susceptible to any kind of overall criticism. The further it travelled and the more that we know about the movement the less we are able to make any kind of valid generalisation. For this reason the criticism of the Pre-Raphaelites is more interesting and more rewarding when it deals with the hard edge painters. Here I think that our assessment of the critics suffers from a habit of thought which in its turn stems from the history of painting during the past 150 years, a history that is of the struggle between reactionaries and academicians who are always and in all circumstances wrong, and groups of young rebels or rebellious individuals who are, equally invariably, right. The picture which we paint for ourselves is of an ancient and hide-bound academic establishment assisted by naughty reactionaries such as Charles Dickens and the art critic of *The Times* attempting to crush a group of sincere and heroic reformers.

The picture is not entirely untrue; but here again I think that it may be worth while to try to understand rather than to condemn out of hand. The Academy of Eastlake, considered as a school for painters, was no doubt tied to ancient and tiresome teaching methods and to practices as old, indeed a good deal older, than the time of the Academy's foundation. Let us note in passing that Rossetti and Holman Hunt suffered from and disliked this teaching while Burne-Jones, who escaped it, seems voluntarily to have sought its equivalent. The college of academicians on the other hand was a very mixed body and to think of it as a monolithic group supporting academic principles as they were known to Sir Joshua Reynolds would, I am sure, be a mistake; certainly there were amongst the members some who very much disliked the young Pre-Raphaelites' work, but there were others who sympathised with the revolution, who made sure that, even in a time of public outcry, the Brethren should still be exhibited, who from a very early date supported the candidacy of Millais and who, later on, were to be amongst the fellow-travellers of the group. The hostile majority, even if it was a majority, did not fight Pre-Raphaelism on strictly doctrinal grounds. Nevertheless, if we consider the celebrated phillipic of *The Times* or that of Charles Dickens, both do refer implicitly to Raphael. Raphael and the High Renaissance had established in men's minds a picture of the Holy Family which was decorous, lovely and dignified. It must have seemed to people thus indoctrinated a matter not merely of reverence but of the highest spiritual moment that the principal figures of the Christian story should be represented as existing in an environment quite removed from the banalities of everyday life. Critics were deeply and very naturally shocked by what *The Times* called 'misery, dirt, even disease', or, as Dickens

puts it, by a madonna 'hideous in her ugliness'. Ruskin himself, who had to be dragged back by Dyce to the 'Carpenter's Shop' before he could see any good in it at all, said of the Pre-Raphaelites that 'they are as a body, characterised by a total absence of sensibility to the ordinary and popular forms of artistic gracefulness'. He goes on to say that they will learn better and of course he could see that they had extraordinary merits, but his reservations do remind us that the original critical battle was fought out between those who demanded beauty in a picture (admittedly a conventional idea of beauty) and those who insisted that the artist should tell the truth.

Ruskin's part in that critical war is in some ways obscure. The Pre-Raphaelites themselves do not seem to have been influenced by or indeed to have read the first volume of *Modern Painters*; it was the second volume which interested Holman Hunt. Presumably they became more aware of Ruskin as a critic after his celebrated intervention in 1851, but it was the critic himself who saw in them the exponents of that celebrated injunction to 'go to Nature in all singleness of heart . . . rejecting nothing, selecting nothing, and scorning nothing' and it was left to Ruskin to carry the war into the enemies' camp when in the third volume of *Modern Painters* he attacks Raphael, not without fury, and denounces him for telling elegant falsehoods, that is to say for bestowing a noble and pompous appearance upon what was in fact – Ruskin's fact – the most ordinary of transactions, the landing of the miraculous draught of fishes and the charge to Peter.

Ruskin's position was in a way false. He could see that this 'new and noble school' derived its strength from its unflinching honesty of purpose, in fact from its naturalism; but he himself was only half a naturalist. When we are told to examine a flower it is necessary that we should examine it with scientific accuracy, understanding perfectly the structure of calyx and stem, petal and corolla. One supposes that we should obey equally severe instructions when we attempt to depict a gasometer or an iron bridge. But Ruskin bids us do no such thing; rather we are to look the other way, dark and evil things are not to be depicted. And even among 'natural forms' Ruskin can find some which are 'vicious and vulgar'. The painting of ugliness is something that can be left to such wretches as the 'blackguard' Caravaggio and to Rubens. It is significant that Ruskin is moved to enthusiasm by Holman Hunt's 'The Awakening Conscience' but to even greater enthusiasm by 'The Light of the World' (TG 1984, Nos 58, 57) and that he failed utterly to see the merits of Ford Madox Brown. Rossetti was really his man and in later years his highest praise was bestowed upon Burne-Jones: with the wide-eyed nymphets of 'The Seven

Days of Creation' he was safe from all kinds of unpleasantness. It was in the highest degree unfortunate for everyone concerned that Whistler's 'Falling Rocket' hung in the next room in the Grosvenor Gallery. Not for the first time Ruskin showed that he too could spit; unfortunately his victim had also mastered this art.

By that time (1878) the Pre-Raphaelites had become entirely respectable. Millais was heading for the Presidency of the Academy and Holman Hunt was commanding record prices. Rossetti, solitary and unapproachable, except by the very rich, declined to exhibit, but after his death there was a commemorative exhibition which astonished the world; it was at last possible for the general public to see what he had been doing and although there may have been some who remembered the old hard edge days and were not a little astonished at the painter's later developments, the general sentiment was one of enthusiasm. The kind of 'pre-Raphaelism' by which it was now confronted was very much to its taste and the legend grew that Ruskin had inspired the movement and that Rossetti had been its leader. This was in fact a generally received opinion long before Rossetti's death and in 1868 we find Gabriel writing to Ernest Chesneau to say that this was in fact so far from the truth that, properly speaking, Rossetti himself could not be considered a Pre-Raphaelite. Presumably Millais and Holman Hunt did not know of this denial. To them it must have seemed that their old comrade was stealing all the credit for the establishment of the Brotherhood and was gaining tremendous posthumous fame while they themselves were increasingly relegated to obscurity. They began to look with jaundiced and peevish eyes at that unprincipled Italian so that, when Hunt began to write his memoirs and John Guille Millais wrote his father's biography, they were at pains to belittle Dante Gabriel's contribution. Old quarrels and shortcomings were remembered and perhaps magnified; it was, as Ford Madox Hueffer said in his life of Rossetti, an unworthy attitude.

In a sense the debate ends, in so far as it ends at all, with Rossetti in the ascendant. When we return to that nadir of the movement at which we started we still find that Rossetti gets most of the little praise that could now be bestowed. Biographies of Rossetti have been and indeed still are being published while we lack monographs on many of the most important figures. It is not unnatural: to later generations he was the most acceptable of the original triumvirate; the circumstances of his life seem to invite biography; both as a man and as an artist we are more in sympathy with him than with Millais or Holman Hunt.

Rossetti's followers were also nearer both in time and temper to the

present century than were the earlier fellow travellers. Morris is still admired not only as a designer but as a poet and a political thinker.

As a small child Duncan Grant used to pray each night that God would make him as good a painter as Burne-Jones and at the end of his life he declared that his opinions were unchanged. Burne-Jones might be sentimental but that did not matter, what did matter was his tremendous power as a designer; this was indeed the logical attitude for one who, despite many reservations, had accepted the view that the 'story' was not the most important thing about a picture. As Roger Fry said of the same artist in 1933, 'We can look at him now quite dispassionately and I've always maintained he had some qualities'. Fry was going to write about him, but alas, never did. If he had it would have given some relief to a period of condemnation, but one which we should remember produced Francis Bickley's admirable *Pre-Raphaelite Comedy* and Evelyn Waugh's study of Rossetti.

The enthusiasts of the past twenty years have given us many scholarly works, notably Professor Fredeman's *Bibliocritical Study* of the movement; but although some general histories have been written, no serious attempt has been made, so far as I know, to produce a general critical assessment. This seems to me absolutely right and proper. For reasons which I have advanced, such a blanket criticism is now impossible; the more we know the less we are able to form a judgement of this kind. No doubt particular judgements will continue to be made, even the most dispassionate researchers seem unable to resist the charms of those whom they research. It is right and proper that this should be so, but let us not fall into the opposite error. Above all let us not spit, for those who do must often discover that they are spitting into the wind.

Style and Content in
Pre-Raphaelite Drawings 1848–50

ALASTAIR GRIEVE

Drawing was important for the Pre-Raphaelites. Much of their time was spent on it and they used it for a variety of purposes – of course to make studies for paintings but also for lighthearted caricatures and for more serious subjects which were not intended for public consumption. Though a very few of their drawings were meant as engravings, the majority were private: they were not exhibited but were retained by the artists or presented to friends as tokens of esteem and testimonies of shared aspirations. While their paintings had to be made with an eye to the market, their drawings did not have to make concessions to public taste. So in their drawings we find references to controversial contemporary religious and social issues, to disturbing artistic prototypes, which are much less evident in their exhibited paintings. And there are large groups of subjects done in drawings which cannot be matched, even in bowdlerised form, in paintings, such as Rossetti's series of devilish, supernatural subjects from *Faust* and Poe, or Millais's series of Virtue and Vice subjects.

Drawing was of course important to them from well before the foundation of the Brotherhood in the autumn of 1848. Millais had been making prodigiously competent drawings since childhood and Rossetti, while at Sass's Drawing Academy and the R.A. Schools, seems to have spent his time not on the prescribed drawings from the antique but on imaginative compositions of an intensely Romantic nature drawn from sources such as Scott, Chamisso, Border Ballads, *Faust*, Poe and Dante. From at least the spring of 1848, possibly before, their production of carefully finished drawings was given impetus by a society called the Cyclographic to which all the painter members of the future P.R.B. belonged together with close associates such as Deverell and Hancock. Members of this society had to make drawings, sometimes on set subjects, which were circulated for written criticism by other members.[1]

Rossetti made at least three drawings for the Cyclographic Society in 1848 – in March or April 'La Belle Dame Sans Merci' (Surtees No. 32) from Keats, in July 'Gretchen and Mephistopheles in Church' from *Faust* (pl. 1)

and in August 'Genevieve' from Coleridge's 'Love' (pl.2). The first is already remarkable for the detail of the mediaeval dress and the bewitching intensity of the girl's expression. The second is larger and more elaborate. Its subject, first composed in 1846, also involves the supernatural and clearly fascinated Rossetti. It shows how 'Margaret having abandoned virtue and caused the deaths of her mother and brother, is tormented by the Evil Spirit at Mass, during the chaunt of the *Dies Irae*'.[2] This subject is diametrically opposed to that of Rossetti's contemporary painting 'The Girlhood of Mary Virgin' (TG 1984, No.15) where the Virgin, the epitomy of innocence, grows up under the watchful guidance of her mother and an Angel. Possibly Rossetti intended the comparison for the compositions of the two subjects match each other closely. Originally the painting had curved top corners like the drawing; the position of St Anne and the Virgin echoes that of Mephisto and Gretchen and the thorns and palm branch in the painting's foreground respond to the sword of wrath in the drawing. Both compositions are built up with block-like elements placed parallel to the surface plane, echoing the overall format and disguising spatial recession and the proportions of figures.

'Genevieve' (pl.2), the first of Rossetti's numerous scenes showing people entranced by music, is also composed of block-like shapes. But this is an outline drawing whereas 'Gretchen and Mephistopheles in Church' is elaborately hatched. Outline drawing was frequently used by members of the Cyclographic Society. Considered particularly suitable for illustrating plays and narrative poems, its sources go back to Flaxman, one of the Immortals chosen by Rossetti and Hunt at this time, and to popular German followers of Flaxman such as Retzsch, Führich and Rethel.[3] Retzsch in particular (see pl.4) has been seen to be influential but it is significant that their attitude to him was not uncritical. Hunt, for example, considered that Rossetti's 'Gretchen' gave him 'a far higher idea of Goethe, than I have before obtained either from a translation, or the artificial illustrations of Retzsch'.[4] For Hunt, *realism* was the aim.

But Hunt does use outline, albeit with more bite to it than Retzsch's, in several drawings of 1848 which were submitted to the Cyclographic Society: 'The Pilgrim's Return', 'And Still these Two Were Postured Motionless' from Keats's 'Hyperion', 'Peace' and 'War' from Leigh Hunt's *Captain Sword and Captain Pen*.[5] These last two illustrations to Leigh Hunt's poem have the vehemence and intensity we find in 'Rienzi', the painting he was working on in the summer and winter of 1848 (TG 1984, No.17). A further stage in his development of a true Pre-Raphaelite style can be seen in another outline drawing of 1848, 'One Step to the Death-bed',

illustrating lines from Shelley's 'Ginevra', which is initialled 'P.R.B.' and was presented by the artist to Rossetti (pl. 3). Here the figures are elongated, their poses mannered and we find prominence given to an awkward child. Brothers and sisters of this child appear in many mature Pre-Raphaelite works, by Millais and Rossetti as well as by Hunt, and help to evoke the naïve qualities of artistic infancy for which they strove.

In Millais's case we see this strained, awkward and naïve style developing through a series of outline designs for architectural lunettes which probably date between 1847 and the late summer of 1848.[6] The earlier designs are graceful, betraying the influence of Flaxman and Retzsch,[7] while in the later ones, which have compositions built up in rectangular blocks, limbs are twisted, expressions intense and the *gaucherie* of young children is emphasised.

It was only after he had finished the lunettes, late in the autumn of 1848, that Millais was able to start painting 'Isabella', his first Pre-Raphaelite picture, which was shown at the R.A. in the following year (TG 1984, No.18). He based this painting on a highly finished ink drawing, evidently made with a fine brush (pl.5). According to Hunt this was a design for an intended etching, one of a series planned by the Pre-Raphaelites at the time of the group's formation to 'show forth to the public their close connexion in purpose and in work'.[8] But Hunt's account is confused and Millais's drawing, which is not initialled 'P.R.B.', may date from earlier in the year and be connected with a Cyclographic Society project. An enthusiasm for Keats, whom the Pre-Raphaelites admired for his fondness for the life of the middle-ages, for early Italian art and for subjects concerning young love, was certainly already shared by them when Cyclographic members. Rossetti had proposed eight subjects from 'Isabella' to be drawn by members of the Society[9] and, as we have seen, in March/April contributed an illustration of 'La Belle Dame Sans Merci' which both Hunt and Millais had recommended should be painted. In May Hunt exhibited his painting 'The Flight of Madeline and Porphyro...' (TG 1984, No.9), from Keats's 'The Eve of St Agnes', which excited Rossetti's admiration and led to their close friendship. Hunt's 'Hyperion' illustration for the Cyclographic has already been mentioned and during 1848 he may also have started his own highly finished illustration to 'Isabella', 'Lorenzo at his Desk in the Warehouse' (TG 1984, No.163), but he was only able to complete this after 'Rienzi' went to exhibition in May of the following year.

Though Millais's 'Isabella' drawing (pl.5) can again be likened to Retzsch's outlines, it is a work of extraordinary, disconcerting, originality. We do not find in Retzsch the emphatic contours of deep shadow set

against large areas of pure white, the pronounced individuality and contrasts in facial expressions, the awkward, strained gestures, the rapt intensity of the lovers, the racing yet abruptly halted recession of space. These characteristics are already present to some extent in Hunt's painting 'The Flight of Madeline and Porphyro . . .', and the subject of class antagonism (Isabel's family is wealthy while Lorenzo is only a poor clerk) has a contemporary relevance which is also true of Hunt's 'Rienzi'. It is significant that Millais and Hunt went together to observe the Chartist gathering on Kennington Common in April 1848.

There are other drawings by Millais which, on stylistic grounds, must be of the same date as his 'Isabella' design. One is 'The Death of Romeo and Juliet', also dated 1848.[10] Like 'Isabella', its subject is about young love ending in disaster and death and this kind of subject, involving hidden physical and psychological violence, seems to have particularly attracted Millais for it recurs in 'The Woodman's Daughter', 'Ophelia' and 'A Huguenot' (TG 1984, Nos 32, 40–1). Again Retzsch, who illustrated the same scene,[11] may have provided a starting point for Millais but again Millais's design appears disturbingly original because of its awkward realism and the intensity and variety of individual expressions. In his attempt to provide a vivid insight into the middle-ages Millais was probably already looking at sources such as Lasinio's engravings of the Campo Santo frescoes and Camille Bonnard's *Costumes Historiques*.[12]

A similar naïve, 'mediaeval' style is found in another drawing of this date by Millais (pl.9) which is untitled but which this writer believes to show 'St Elizabeth Washing the Feet of Pilgrims'.[13] If this identification is correct, the subject links Millais's interest in the middle-ages with the social and religious problems of his own day and in this way points to his next exhibition picture, 'Christ in the House of His Parents'. The drawing was given by the artist to W.M. Rossetti but was an inappropriate gift to an atheist with republican sympathies for it seems to show the devout thirteenth-century Landgravine of Hungary washing the feet of pilgrims, spurred on by her spiritual director, the priest Conrad, while her husband, Duke Lewis, takes leave of her to embark on the Crusades.

The story of St Elizabeth drew the attention of several other Pre-Raphaelites and associates. Collinson's drawing of another incident in her life will be discussed. Rossetti also made drawings of another event. Christina Rossetti wrote a poem about her and Millais's close friend C.A. Collins exhibited a painting of her 'devout childhood' in 1852. St Elizabeth's life provided them with subjects because its significance had become a bone of contention between opposed religious groups of their

own day. In 1839 one of England's leading converts to Roman Catholicism, Ambrose Lisle Phillipps, had published his translation of the Count de Montalembert's *Chronicle of the Life of St. Elizabeth*.[14] This represented Elizabeth as a paragon of Christian virtue, a devoted wife and helper of the poor. Then, early in 1848, Charles Kingsley had published his version of her life written from what was to be termed a Christian Socialist point of view. Kingsley showed that Elizabeth had been subverted by the Church of Rome from her natural duties as a wife so that she could undergo the ghastly self-mortification which led to sainthood. He hoped his version would discourage 'those miserable dilettanti, who in books and sermons are whimpering meagre secondhand praises of celibacy . . . nibbling ignorantly at the very root of that household purity, which constitutes the distinctive superiority of Protestant over Popish nations'.[15]

It is difficult and really unnecessary to decide to which religious camp Millais belonged. For the most part he worshipped at a ritualistic, High Anglican church in Wells Street and many of his friends, particularly C.A. Collins and the circle around the Combes in Oxford, were sympathetic to Tractarian ideas. But he was certainly aware of the arguments of opposing movements and did not commit himself wholeheartedly to any one sector of the religious spectrum.

What was most important for him was that his subjects would evoke lively and predictable responses. He must have known that this drawing of 'St Elizabeth', as well as the one discussed below of 'The Disentombment of Queen Matilda' and, most of all, his painting of 'Christ in the House of His Parents', would deeply worry anybody not of High Church or Roman Catholic persuasion. Acts of penance, naked and distorted limbs, especially bare and dirty feet, and feudal trappings, were associated with controversial issues such as Tractarianism and Ritualism and the Young England movement. His style resembles that of the revived mediaeval art in Lord Vieuxbois's chapel in Kingsley's novel about these issues, *Yeast*, described sarcastically as not Catholic enough because 'the figures' wrists and ankles were not sufficiently dislocated and the patron saint did not look quite like a starved rabbit with its neck wrung'.[16] This was the language which Dickens was to use to castigate 'Christ in the House of His Parents' when Millais, uncharacteristically, stuck *his* neck out in public. Of course, 'St Elizabeth' and 'The Disentombment of Queen Matilda' were for private consumption.

'The Disentombment of Queen Matilda' (TG 1984, No. 165) provides us with Millais's most extreme use of 'Catholic' style and subject. He was working on this in May 1849, when Hunt and Rossetti were also pro-

ducing very important Pre-Raphaelite drawings, and it is initialled P.R.B. and dated with the year.[17] The subject is taken very directly from Agnes Strickland's *Lives of the Queens of England* and shows an episode in 1562 when the Calvinists pillaged the Abbey of Caen, opened the tomb of Matilda, the wife of William the Conqueror, and took a ring from her finger which they presented to the Abbess. Here the violence is overt, akin to that in his first exhibited picture, 'Pizarro Seizing the Inca of Peru' (TG 1984, No. 1), and Millais seems particularly concerned to show the effect of the brutality of the male looters on the non-resistant nuns. Odd as the subject appears, it had great contemporary relevance for it relates to controversies over the establishment of Sisterhoods and the anti-'Popish' riots connected with the revival of ritualism.

Millais's major efforts in 1849 were spent on 'Christ in the House of His Parents' (TG 1984, No. 26) which was shown in the following year without a title but with a Biblical quotation: 'And one shall say unto him, What are these wounds in thine hands? Then he shall answer, Those with which I was wounded in the house of my friends' (Zachariah 13.6). So its subject is again violent and it was presented to the public in the guise of a sermon. Indeed, it was inspired by a sermon which Millais had heard at Oxford, where he had spent the summer and autumn of the year and where he had friends closely associated with the Tractarians. Preliminary designs were probably made at Oxford. When D.G. Rossetti called on him on 1 November, soon after his return, he saw 'a design he has made of the Holy Family. Christ, having pricked his hand with a nail (in symbol of the nailing to the cross) is being anxiously examined by Joseph, who is pulling his hand backwards, while he, unheeding this, kisses the Virgin with his arm round her neck'.[18] By 7 December the subject had been redesigned and painting started at the end of this month.[19]

Several drawings survive which show much more exaggeratedly 'mediaeval' poses and more obviously ritualistic symbols than in the painting. For example, in the highly finished drawing in the Tate (pl.6), which may be the one seen by Rossetti, the apprentice's left arm is uncomfortably bent into a projecting right-angle while in the painting it is tucked in decorously, and the carpenter's triangle on the back screen, an obvious symbol of the Trinity, is central and upright whereas in the painting it is tilted and less prominent.

The subject of 'Christ in the House of His Parents' is presented in this drawing in a carefully thought out programme inspired by the ritualist and Tractarian ideas of the Anglican High Church. It symbolises some of the most controversial and deeply held beliefs of this movement in much

the same way as does the Tractarian Isaac Williams's extraordinary devotional poem *The Cathedral*.[20] The Tractarians believed that everything in the material world was an analogy to God's hidden power or, as Newman explained: 'that material phenomena are both the types and the instruments of real things unseen'.[21]

Millais confronts us with a view into the sanctuary of a church. We look in from the east end at the altar. Around this the principal figures are grouped symmetrically, as in an Early Italian *Sacra Conversazione* altarpiece, with the Infant Christ and the Virgin on the east side and in the centre. On the far right a woman faces us folding a cloth, a symbolic winding-sheet, and the apprentice on the left also faces, awkwardly, eastward. We are watching a Mass or Communion Celebration and the blood issuing from Christ's hand relates to the Tractarians' belief in His Real Presence at this Sacrament. The wall behind the group, bearing symbols of the Passion, is a rood-screen, which was of great importance to High Anglicans as it enforced their doctrine of Reserve in Communicating Religious Knowledge, the subject of Isaac Williams's *Tract No.80*. It was used in their churches to shield the sacred offices of the priests from the eyes of the laity in the main body of the church. In Millais's drawing the laity are a flock of sheep anxiously peering into the Sanctuary to see what is going on. Behind them, at the western end of the church, is a well, symbolising the Sacrament of Baptism.

Reference to this Sacrament was made more important in the composition after this drawing was finished, perhaps in the redesigning mentioned above, when Millais decided to remove the woman with the cloth and bring in the figure of the infant Baptist. This figure had certainly been included in the painting by 3 March 1850 when it was seen by W.M. Rossetti.[22] It is a conspicuous addition which may refer to one of the greatest crises in the High Anglican Church at the time – the Gorham Judgement. The Revd Gorham believed that Regeneration did not necessarily take place at Baptism and had quarrelled with his Bishop over the question. His appeal to the Ecclesiastical Court of Arches in 1848 had been unsuccessful so, in August 1849, Gorham appealed again to the Judiciary of the Privy Council. By the New Year of 1850 unofficial news that his appeal had been successful leaked out. The efficacy of the Sacrament of Baptism was one of the most strongly held beliefs of the High Anglicans and the judgement of the Privy Council not only questioned that belief but demonstrated that the State could interfere decisively in Church matters. As a result many leading Anglican Churchmen went over to Rome.

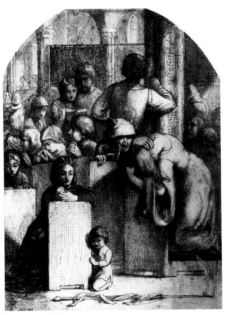

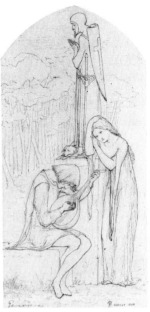

1 D.G. Rossetti, 'Gretchen and Mephistopheles
in Church', 1848; pen, 10¾ × 8¼ (27.3 × 21);
Private Collection

2 D.G. Rossetti, 'Genevieve',
1848; pen, 10¾ × 5½ (27.3 × 14);
Fitzwilliam Museum, Cambridge

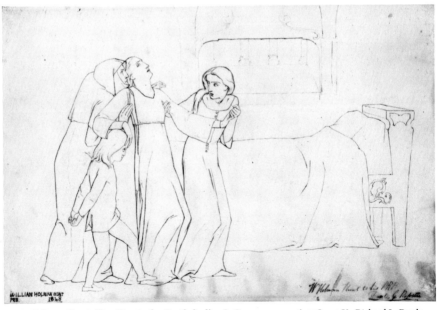

3 W. Holman Hunt, 'One Step to the Death-bed', 1848; pen, 7 × 11 (17.8 × 28); *Richard L. Purdy*

4 Engraving after Moritz Retzsch, *Macbeth*, Act III, Scene iv, 1833

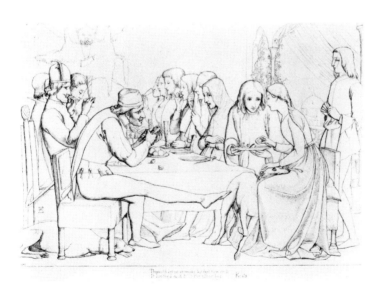

5 J.E. Millais, Study for 'Isabella', 1848; brush and ink,
$8 \times 11\frac{9}{16}$ (20.3 × 29.4); *Fitzwilliam Museum, Cambridge*

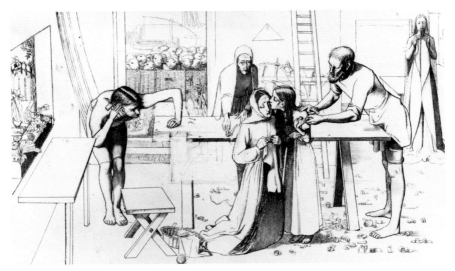

6 J.E. Millais, Study for 'Christ in the House of His Parents',
pen and wash, $7\frac{1}{2} \times 13\frac{1}{4}$ (19.1 × 33.7); *Tate Gallery*

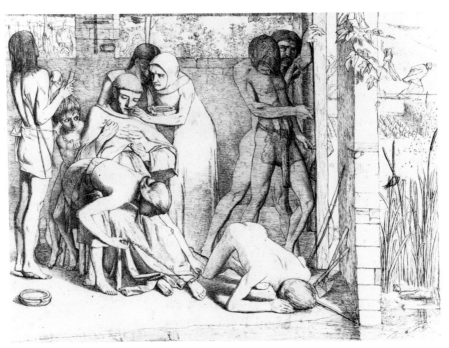

7 W. Holman Hunt, Study for 'A Converted British Family Sheltering a Christian Priest
from the Persecution of the Druids', 1849; pen, $9 \times 11\frac{3}{4}$ (22.8 × 29.8); *Johannesburg Art Gallery*

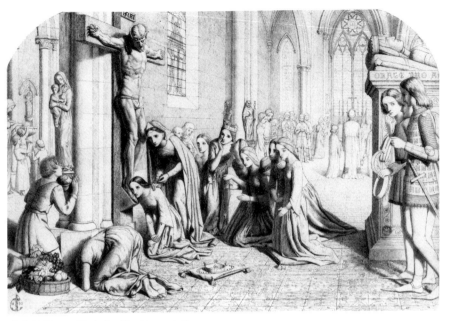

8 J. Collinson, Study for 'The Renunciation
of Queen Elizabeth of Hungary', 1850;
pen, 11⅞ × 17¾ (30.4 × 45.2); *Birmingham
Museum and Art Gallery*

9 J.E. Millais, 'St Elizabeth Washing
the Feet of Pilgrims', 1848; pen,
9¼ × 8 (23.5 × 20.3); *Private Collection*

10 Engraving after Eduard Hauser from
Count de Montalembert, *The Chronicle of the
Life of St. Elizabeth of Hungary*,
trans. A.L. Phillips, 1839

11 D.G. Rossetti, 'Dante Drawing an Angel on the First Anniversary of the Death of Beatrice', 1848–9; pen, $15\frac{3}{4} \times 12\frac{7}{8}$ (39.4 × 32.6); *Birmingham Museum and Art Gallery*

12 D.G. Rossetti, 'Ulalume', 1848–9; pen, $8\frac{1}{8} \times 7\frac{3}{4}$ (20.6 × 19.7); *Birmingham Museum and Art Gallery*

13 J.E. Millais, Study for
'The Woodman's Daughter',
1849; pencil, pen and wash,
$6\frac{15}{16} \times 4\frac{15}{16}$ (17.7 × 12.6);
*Yale Center for British Art
(Paul Mellon Fund)*

14 J.E. Millais, Study for
'Mariana', 1850; pen and
wash, $8\frac{7}{16} \times 5\frac{3}{8}$ (21.4 × 13.7);
Victoria and Albert Museum

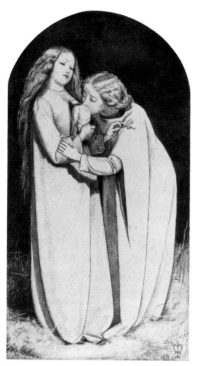

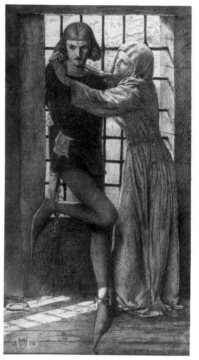

15 J.E. Millais, Study for 'The Return of the Dove to the Ark', 1851; pen and wash, $8\frac{7}{8} \times 4\frac{3}{4}$ (22.8 × 12.2); *National Gallery of Canada, Ottawa*

16 W. Holman Hunt, Study for 'Claudio and Isabella', 1850; pencil, pen and wash, $12\frac{1}{2} \times 7\frac{1}{8}$ (31.7 × 18.4); *Fitzwilliam Museum, Cambridge*

17 J.E. Millais, Study for 'The Eve of the Deluge', 1850–1; pen and wash, $9\frac{1}{4} \times 16\frac{1}{4}$ (23.5 × 41.2); *Trustees of the British Museum*

At the 1850 R.A. exhibition Holman Hunt's picture 'A Converted British Family Sheltering a Christian Missionary from the Persecution of the Druids' (TG 1984, No.25) was hung as a pendant to Millais's 'Christ in the House of His Parents'. Hunt had already completed the design for his picture by 23 May 1849 so it probably influenced Millais and at any rate the two works have a great deal in common and were possibly meant to be seen as a pair. Again Hunt's design (pl.7) is much more 'extreme' than his painting. For example the grotesque pose of the foreground boy thrusting his bottom into the air in the drawing is modified in the painting so that he lies decently on his side. The space is orientated in the opposite direction to that in 'Christ in the House of His Parents' and the Academy audience in 1850 must have tired their eyes in processing backwards and forwards through the two pictures.

In Hunt's composition we look over an isolating strip of water, symbolic of Baptism into the Church, to the enclosed Sanctuary of the hut. On the hut's back wall, the east end of the church, a cross is inscribed and a lamp flickers before it. In front of this, in place of an altar, the escaped missionary adopts the pose of Christ taken down from the Cross. The converted Britons around him hold symbols of His Passion, a thorn branch, a sponge, grapes. Hunt must have been aware that the Tractarians were particularly interested in the Early Church when he chose his subject and his calculation paid off as the picture was bought for a close associate of the Oxford divines, Thomas Combe, whose interest in the history of Christianity's origins earned him the nick-name of 'The Early Christian'. And, like Millais in his contemporary design of 'The Disentombment of Queen Matilda', Hunt was probably relating the persecution of the robed missionaries in his subject to that of the High Anglican ritualists in the Surplice Riots of his own day.

The religious controversies of the mid-century probably affected the minor Pre-Raphaelite James Collinson most deeply of all the Brothers, in his personal as well as his professional life. From about the mid-autumn of 1848 to about the late spring of 1850 he was engaged to Christina Rossetti. Like her he was intensely religious and he shared her High Anglican beliefs during the time of their engagement. But he was deeply attracted to Roman Catholicism and converted to Rome, possibly as a result of the Gorham Judgement. He broke off his engagement and, in a formal letter to D.G. Rossetti of 20 May 1850, resigned his membership of the Pre-Raphaelite Brotherhood.[23]

Collinson was able to switch his artistic style with less anguish, and while working on genre subjects in Wilkie's manner for the Academy was

happy to produce designs with religious subjects in the Early Christian or Catholic style. For the Cyclographic Society he drew 'The Novitiate to a Nunnery' (untraced) and for the second number of *The Germ*, which appeared on 31 January 1850, an etched illustration (pl. 32) to his own poem 'The Child Jesus, a Record Typical of the Five Sorrowful Mysteries'. He worked on this etching under the eye of Gabriel Rossetti and it has similarities to the earlier 'Girlhood of Mary Virgin' as well as to Millais's contemporary 'Christ in the House of His Parents' but, unlike these pictures, it is sanctimonious and is, perhaps, the closest any Pre-Raphaelite art comes to that of the Nazarenes, to Overbeck's work in particular. With its Latin inscription, emphasis on mystic numbers, ritual and analogy between events in Christ's Childhood and His Passion, it is difficult to know whether to categorise it as Tractarian or Roman Catholic.[24]

We have much the same difficulty over his subject 'The Renunciation of Queen Elizabeth of Hungary'. W.M. Rossetti mentions Collinson's intention to work at this subject already in December 1849.[25] The carefully finished design (pl. 8) is dated 1850 but the painting (pl. 28) was only shown in 1851. Again there is greater stress on 'mortified flesh' in the design than in the painting. For example the bare upturned feet of the prostrated female in the foreground of the drawing are covered up in the painting and the skimpy loin-cloth on the statue of the crucified Christ is also extended. In his design Collinson surely goes out of his way to emphasise the 'Popish' ritual and furnishings of the mediaeval church – Holy Water stoop, statues of the Virgin, Christ and the Saints, stained-glass, a tomb with a Latin inscription urging prayers for the dead, and a Mass in progress in the background. There is no doubt that Collinson's source was Montalembert's version of St Elizabeth's life and we are shown the episode where she shocks her future mother-in-law, the Duchess Sophia, by taking off her crown and prostrating herself before a crucifix during a Mass of the Teutonic knights.[26] Collinson also seems to have been influenced by the illustrations in Montalembert's book (see pl. 10) which were by Eduard Hauser who was a follower of Overbeck, a Roman Catholic convert and had been patronised by Pugin's supporter, the Earl of Shrewsbury.[27] But, though there is no doubt about Collinson's Roman Catholic sympathies, it is typical of his ambivalence at this time that he finished his painting of the subject from the furnishings in the model High Anglican church of St Barnabas, Pimlico.[28] This church, consecrated on 11 June 1850, became the object of violent anti-ritualist riots during the winter of that year, fanned by the Pope's establishment of the Roman Catholic hierarchy in September.

Collinson's intended brother-in-law, D.G. Rossetti, made no finished drawings of religious subjects. Although his paintings of this time, 'The Girlhood of Mary Virgin' and 'Ecce Ancilla Domini!', and his related devotional poem to the Virgin, 'Mater Pulchrae Delectionis', drew their inspiration from the High Anglican beliefs of his mother and his sisters, he seems to have found release in his drawings for the expression of passionate love and the weirdly supernatural which had been his primary interests since youth. In September 1848, the month after drawing 'Genevieve' (pl.2), he almost finished an elaborate design of 'Dante Drawing an Angel on the First Anniversary of the Death of Beatrice' (Surtees No.42A). This has the same extraordinary mediaeval detail, for example very long and sharply pointed footwear, and intense interchange of glance and engraved style that we find in Millais's contemporary drawings and it is significant that when it was redesigned and finally finished, in May of the following year, Rossetti presented it to Millais. There are influences from Retzsch's outlines in this second drawing (pl.11) and it is probable that Rossetti intended it as an engraving for his translation of the *Vita Nuova* completed during the autumn of 1848. It is of a subject about which he felt very deeply – a great poet surprised by friends while drawing, not from nature but from the real world of his imagination, an Angel conjured up by the event of the anniversary of the death of Beatrice.

There are other Dante drawings by Rossetti made at this time. The left compartment of a carefully finished diptych of 'The Salutation of Beatrice' (Fogg Museum of Art; Surtees No.116A) is dated 1849 and is similar in style to the drawing finished in May of this year discussed above. It shows Beatrice greeting Dante in Florence. Her death is symbolised by a naïve, childish *Amor* placed between this compartment and the one on the right side, dated 1850, where she is shown greeting him in Paradise. The figures in this right compartment are more rounded and weightier than those in the left and must have been influenced by free-standing Gothic sculpture. Studies of 'Paolo and Francesca Kissing' also date from 1849 and so, probably, do designs to Poe's poems 'The Raven' and 'Ulalume' (TG 1984, Nos 160–1).

These Poe illustrations deal with the same subject as the *Vita Nuova* illustrations, lovers separated by death with the male lover conjuring up the memory of his beloved on the anniversary of her death. The illustration to 'Ulalume' (pl.12) shows two variants of the male lover walking with his soul through the ghoul-haunted woodland of Weir on the anniversary night of Ulalume's death. The winged soul resembles the Angel drawn by Dante in the design given to Millais. It is difficult to imagine the drawings

by Rossetti of this period, such as 'Ulalume', executed as paintings. Pen and ink seems the medium best suited to express the intensity of their subjects.

Millais, following the harsh criticism of 'Christ in the House of His Parents' when shown in May 1850, seems to have determined not to produce another controversial picture and not to put all his eggs in one basket at the next Academy exhibition. In 1851 he showed three medium-small size paintings: 'The Woodman's Daughter', 'Mariana' and 'The Return of the Dove to the Ark' (TG 1984, Nos 32, 35, 34). Fine drawings survive for these pictures. That for 'The Woodman's Daughter' (pl. 13) is dated 1849 and is possibly the design seen by W.M. Rossetti on 7 December of that year when Patmore, whose poem of the same title it illustrates, was planning an edition of his works with illustrations by Millais.[29] The drawing shows the start of a childhood friendship between the rich squire's son and the woodman's daughter. The poem narrates how, years later, their friendship turns into an affair leading to the birth of a bastard who Maud, the woodman's daughter, drowns in a pool. She goes mad. So this apparently innocuous subject links with Millais's other subjects of disastrous love such as 'Isabella', 'Romeo and Juliet' and 'Ophelia'. The drawing has the same severe and naïve qualities as the last studies for 'Christ in the House of His Parents', with which it is contemporary.

The design for 'Mariana' (pl. 14), from Tennyson's poem, was evidently made sometime before the start of June 1850 when Millais went to Oxford for a prolonged visit and where he painted the backgrounds of both 'The Woodman's Daughter' and this picture.[30] It is extraordinarily different from the drawing for the former picture. Severity and naïvety have changed to languor and sensuality in keeping with the change in subject. There is a new suggestion of roundness and weight in the figure, a characteristic already noticed in the figures in Rossetti's 1850 'Salutation' drawing.

The design of 'The Return of the Dove to the Ark' (pl. 15) was the last to be drawn and was made in late January or early February 1851. This allowed little time for painting and helps to explain the dark, featureless background, which Millais originally planned to have filled with birds and beasts, and also the surprising absence of Noah. Shortage of time possibly also dictated the need for the enveloping, sheet-like, costumes on the girls. The plain, white material of these costumes falls in strikingly bold verticals, bolder in the drawing than the painting, between the areas of detailed work in the heads, hands and dove at the top and the straw at the foot of the picture. Their looseness and whiteness makes them resemble night-dresses and, without the title, we might mistake the subject for one of the

'Good Night, Pet' variety. Millais may well have been playing on this resemblance.

Taken together the three subjects of 'The Woodman's Daughter', 'The Return of the Dove to the Ark' and 'Mariana' show three stages of womanhood: childhood, pubescence and maturity. This may have been fortuitous here but later, in pictures such as 'Autumn Leaves', 'Spring' and 'The Vale of Rest' (TG 1984, Nos 74, 96, 100), Millais was to pose questions about the development of young women and their role in life. And already, in the period under discussion, there are several untitled drawings, carefully finished and obviously of importance to him, which show girls at leisure in flowering gardens with little other to do but wait.[31]

It is tempting to leave Millais there but one more major drawing must be mentioned, 'The Eve of the Deluge' (pl. 17). This is an ambitious work with the same long format as 'Isabella' and 'Christ in the House of His Parents'. Although unfinished it is complete enough in the outline of the composition and the detail of the heads and hands of the figures to suggest that it would have led to Millais's most remarkable painting had it been carried through. He was working on it during the winter of 1850-1 but abandoned it, he imagined only temporarily, in the New Year and instead worked on 'The Return of the Dove to the Ark' to which it is related in subject. It shows a marriage-feast on the eve of the Flood and was to have presented scenes of unheeding vanity and gluttony in the face of disaster.[32] Like his previous Academy work it was intended as a 'sermon' picture but now with the emphasis on the weakness of women, for most of the characters are female, and on their individual reactions to a major event within the family, a marriage. Millais has stressed the enclosed nature of the family, and the herd-like quality of the people within it, by grouping them facing inward around a semi-circular table which is contrasted with the rectangular window giving a view of the Flood at their backs. Tables had already been used, to great effect, in 'Isabella' and 'Christ in the House of His Parents' and now, in this third variation, he uses the semi-circle to unite the disparate characters in an arch sweeping majestically from bottom left, to top centre and down to the bottom right side. It would have made a masterful painting, but not a popular one.

Much less prolific than Millais, Hunt produced only a few finished drawings in 1849-50. In May 1849 he took up again his design to 'Isabella', 'Lorenzo at his Desk in the Warehouse' (TG 1984, No.163), illustrating the lines 'He knew whose gentle hand was at the latch / Before the door had given her to his eye'. As we have seen, this may have been started in 1848, with Millais's illustration to the same poem, but it was

only completed during the summer of 1850 and so spans the entire period under discussion. [33] Stylistically it relates best to drawings by Millais and Rossetti of 1848–9, to Millais's drawing of 'Lovers by a Rosebush' (TG 1984, No.158) and Rossetti's second version of 'Dante Drawing an Angel' (pl.11) for example, and together the drawings by the three artists made then provide the most definite manifestation of a shared Pre-Raphaelite style. In Hunt's drawing we find again the intense exchange of glance, the prominence given to extraordinary mediaeval detail such as pointed footwear and sleeves, which further exaggerates the awkwardness of limbs, and the treatment of space as integral to the narrative of the subject, as a vital stage-prop.

Dating from 1850, and designed by May of that year, is one of Hunt's most extraordinary designs: 'Claudio and Isabella' (pl.16) from *Measure for Measure* (Act III, Scene i). A comparison with the painting of the subject (TG 1984, No.45), which was only completed in 1853, emphasises the profound difference in their aims in the two media. Although Hunt retained the drawing almost all his life, he had the temerity to show it when it was made to a client for possible commission as a painting but was harshly rebuffed because of its 'hideous affectation'. [34] The rebuff is understandable for Claudio's limbs are painfully twisted and extended and Isabella's grip is fiercely tenacious, and in no way submissive. She is trying to persuade her brother, who has been imprisoned because of his affair with a girl, to die so that she may retain her virginity which is being sought by the prison governor. Claudio's agonising pose relates to his predicament and the rigid cell bars behind him to his sister's rectitude and the severity of the decision he has to make.

During the summer of 1850 Hunt drew two further finished designs: 'Valentine Rescuing Sylvia from Proteus' [35] and 'The Lady of Shalott' (TG 1984, No.168). The former is from *The Two Gentlemen of Verona* (Act V, Scene iv) and, like so many of Hunt's subjects of this time, shows a moment of moral decision and awakening. In its woodland setting and also in the doll-like character of the figures, the design was probably influenced by Millais's for 'The Woodman's Daughter'. It is complete except for the head of Sylvia which has been rubbed out but not redrawn. Possibly this was done at a later date to disguise the identity of the model. Hunt painted the design as his 1851 Academy exhibit and it seems that he, like Millais, was determined to avoid controversy at this exhibition.

'The Lady of Shalott', like Millais's 'Mariana' with which it is contemporary, is from a poem by Tennyson and shows a single female figure in a mediaeval setting. Hunt's figure is also more rounded and with a greater

suggestion of weight than is found in his earlier designs but the pose is still awkward. The pattern of mirrors has been compared with that in Van Eyck's 'Arnolfini Marriage', which was the first 'primitive' picture to enter the National Gallery (in 1842), and the figure's pose may also derive from this source. Again, Hunt has chosen to illustrate a dramatic moment of mental resolve and decision to change. The mirrors, like the one in 'The Awakening Conscience' (TG 1984, No. 58), show us what her future will be.

This essay does not pretend to have given a complete account of Pre-Raphaelite drawings during the period. Several finished drawings have not been discussed because of shortage of space, neither have any of the less finished studies for paintings, which are often extremely interesting in showing how ideas developed and content and style fused, nor have the many caricatures, drawn in quite a different style, which really deserve an essay to themselves. But it is hoped that enough works have been included to demonstrate the astonishing achievement of the Pre-Raphaelites in pen and ink during these two crowded years. Such impetus could not be maintained. There are surprisingly few finished drawings for the years 1851–2. After this, in 1853–4, Millais produced his savagely mordant Virtue and Vice series (see TG 1984, Nos 185–94) and Rossetti one or two drawings of distinction, such as 'Hesterna Rosa' (Surtees No. 57) and his design for 'Found' (TG 1984, No. 196). But the shared style of severe outline, mannered gestures, intense exchange of glance, controversial subjects in disguise, did not persist after 1850–1.

We can only speculate as to why it ceased. The extreme antagonism to elaborate ritual caused by the restoration of the Roman Catholic hierarchy in September 1850 possibly made the Pre-Raphaelites wary of becoming involved in further High Anglican subjects. Ruskin's support, starting in May of the following year, would have increased this wariness for he thought the Tractarians mistaken. Most importantly perhaps, the Brotherhood had ceased to be a secret society. Increasing celebrity, personal frictions within the group, drove them apart. The drawings discussed here could only have been made by a hermetic circle of young artists practising in private.

Pre-Raphaelitism and Phrenology

STEPHANIE GRILLI

If the Pre-Raphaelites have been dismissed as escapists, they have only themselves to blame. After all, unlike the Impressionists who were christened by a derisive critic, the members of the Pre-Raphaelite Brotherhood selected their own name with all the fussiness of a lepidopterist labelling a new butterfly species. Measuring word and letter combinations, the group sought a verbal equivalent suitable for their image of themselves; their corporate deliberation and typographical skills (P.R.B.) anticipate the work of modern public relations departments – the 'P.R.' in P.R.B. is most appropriate.[1] Marked by a typical mixture of waggishness and earnestness, the naming ritual itself encapsulates the youthful essence of the movement and, as such, passes into the legendary realm of seven artistic 'Peter Pans'. The group identity, as a result, never 'grows up' but remains fixed as a fraternal organisation devoted to the revival of archaic Italian painting or, even more whimsical, as a Victorian knighthood sworn to do battle against the onslaught of time. The term 'Pre-Raphaelite' refers to a major component of the Brotherhood's formal and theoretical foundation as is evidenced by their borrowing from Quattrocento compositions and their advocacy of this style in print. But can Pre-Raphaelitism, an artistic reform movement originating in the summer of 1848 and dissolving in January of 1854, be understood by the term 'Pre-Raphaelite' alone? Admittedly the 'ism' is coined from the word, but we cannot expect a single word to convey the range of cultural and intellectual impulses behind Pre-Raphaelitism.

Perhaps the Pre-Raphaelites would have fared better in the history of art if, like the Impressionists, the Fauves, or the Cubists, they would have been rudely described and so dubbed by a hostile reviewer. In the following essay I will present the Brotherhood as no more regressive than any of those groups just mentioned. The Pre-Raphaelites whole-heartedly embraced the progress they believed was taking place in Britain in the 1840s and 50s; and like many avant-garde movements, Pre-Raphaelitism combined a tendency towards the primitive with an inspiration from the scientific.

The progressive, scientific element of Pre-Raphaelitism is expressed in the title of the group's short-lived publishing venture, the small magazine

The Germ. In this instance the selected term, far more reductive than the romantic 'Pre-Raphaelite Brotherhood', efficiently suggests the group's desire for new beginnings and seminal ideas nurtured like an embryo or tended like a sprout. This biological and botanical reference was a note often struck by the more advanced and enlightened of the day; in fact, the expression is so ubiquitous that one is hard pressed to find a contemporary intellectual journal or pamphlet in which it does not appear. In February 1850 in the second volume of *The Germ*, one of the more active writers of the seven, F.G. Stephens, published the article 'The Purpose and Tendency of Early Italian Art'. Rather than a call to imitate an artistic style of 500 years previous, as one might assume, Stephens's essay is a celebration of what he sees as 'the recent progress . . . of art in England'. Stephens writes of his hopes for the future of art:

> The sciences have become almost exact within the present century . . . And how has this been done but by bringing greater knowledge to bear upon a wider range of experiment; by being precise in the search after the truth? If this adherence to fact, to experiment and not theory, – to begin at the beginning and not fly to the end, – has added so much to the knowledge of man in science; why may it not greatly assist the moral purposes of the Arts?[2]

It should be evident from this statement alone that the Pre-Raphaelites, with Stephens as the spokesman, believed that there should be no difference between the working methods of the artist and of the scientist, that both should persevere diligently and patiently in search of a Truth that was absolute – not unlike a lepidopterist labelling a new butterfly species. The perceived Pre-Raphaelite interest in Christian themes and typological symbolism does not preclude an accompanying fascination with science any more than Kandinsky's spiritual sensibility excluded his interest in atomic physics.[3] In fact, Stephens's statement seems to include the scientific method as part of a divine plan. In that Stephens's reference is included in a discussion of early Italian art, our understanding of the Brotherhood's interpretation of the term 'Pre-Raphaelite' is enhanced; in their admiration of the naive forms of the Quattrocento, the Brotherhood did not condemn this art as Academic canon would prescribe, but rather they saw Italian artists of the fifteenth century as prefiguring British empiricists of the nineteenth century – both pursuing direct observations and recording them in a 'trial and error' manner.

To be in touch with the times, unlike those grey-hairs of the Royal Academy, demanded a firm commitment to the physical sciences as a

means of beneficial change. The scientific revolutions of the nineteenth century had started with geological discoveries that established a time scale radically different from the Biblical model of creation.[4] Although shockwaves were still trembling, by mid-century the controversy was found elsewhere. Geologists had dug deep into the layers of the earth, and now psychologists were beginning to delve into the layers of the human psyche. With increasing optimism, British men of letters believed that human action could be charted just as precisely as all natural events. Due to advances in brain physiology, scientists concluded that the body was not the home of the soul but was the very essence of man itself, a thesis which shattered traditional notions of dualism.[5] In 1848, the founding year of the Brotherhood, the *Journal of Psychological Medicine and Mental Pathology* was first published. But the questions that psychology raised concerning matters of free will and determinism meant that interest was not confined to a handful of specialists. Of course this could be said of many scientific investigations of the nineteenth century. But the debate centering on man as the product of breeding vs. man as the interaction of chemistry and electricity was at the very core of the Victorian age of doubt.[6]

It was an issue not ignored by the Pre-Raphaelite Brotherhood. At a P.R.B. meeting on 22 November 1849, their friend and mentor Coventry Patmore declared that the only system of poetry 'now possible' was 'the psychological'.[7] Naturally the Brotherhood integrated poetry and painting so we may consider the implications of Patmore's statement for the visual arts. What exactly would a psychological system for painting be? How would an artist constructing such a system express himself? To begin, an artist might cringe at the very sight of so many 'waxwork effigies', a judgement made by Holman Hunt about the figures populating the canvases of the Academy walls.[8] Or such an artist might perceive a blandness and a lifelessness in the faces of contemporary paintings as Dante Gabriel Rossetti did in his story 'St Agnes of Intercession' – originally titled 'An Autopsychology': '... the wax doll is made to occupy a position in Art which it can never have contemplated in the days of its humble origin'.[9] As the study of man was refined, it was only fitting that some artists might remodel figure and head drawing in accordance with the re-definition of human consciousness. It is well known that the Pre-Raphaelite Brotherhood wanted to make their art 'true to Nature'. The Nature to which these artists referred not only included rocks, trees, birds, and bushes, but *human* nature. And in 1848, one scientific approach to understanding human nature was phrenology.[10]

Phrenology originated in the eighteenth century in Vienna. After

studying hundreds of brains over a period of years, a physician named Franz Josef Gall postulated that there were thirty-five different faculties located in specific parts of the brain. The endless ways that these various faculties could develop and combine accounted for the great variety of human character. Today we tend to think of phrenology as simply reading the bumps of someone's head. In actuality it was far more complex than this, taking into account the entire shape of the head, as well as qualities such as hair and skin colour. Through analysis, phrenology expanded on the notion of the immense variety of human heads found in nature and emphasised a world view based on aggregates rather than on homogeneity, on equilibrium rather than on proportion. Equally important, phrenology placed the brain and, therefore, the head in command of the rest of the body. As a result the head would loom large in comparison to the rest of the human form. Phrenology's underlying assumptions challenged the more uniform physiognomical ideals of the platonic tradition.

Today we associate phrenology mainly with those plaster heads found in antique shops. It has been assigned to the dustbin of discarded science. But in the nineteenth century, phrenology occupied a position of major importance in the British scientific and intellectual communities. Imported into England by Gall's disciple Johann Gaspar Spurzheim, phrenology was seized upon by physicians seeking ways to reform the backward medical profession. Spurzheim was less fatalistic in his reading of phrenological principles, and his optimistic outlook was adopted doubly by the man who would carry the torch.[11] After Spurzheim's death, phrenology's chief spokesman became the Scotsman George Combe. Offering a compromise of physical and moral enquiry, his *The Constitution of Man Considered in Relation to External Objects* was one of the most widely read books of the nineteenth century. Combe was able to span the gap between materialism and spiritualism by means of considering 'nature' as 'the work of this great Being, such as it is revealed to our mind by our senses and faculties'.[12] Rather than a cause for doubt, Combe's sweeping statements offered assurance to a great mass of people who made his publications almost as popular as the Bible. By 1838 the sale of all books on phrenology was greater than that of any other science except for those that were a part of professional education.[13]

In considering phrenology's obvious appeal to the public – even taking into account that many who bought the book might no more subscribe to it than those who purchase a diet book today might submit to a daily food regimen – we must recognise that most of Combe's readers could have been classified as middle class. As Roger Cooter has shown, phrenology's

incorporation of mental hierarchies and of self-help provided a perfect system for the rising middle class almost to the point of being an ideology.[14] In fact, many envisioned a direct social or political application of phrenology.[15] The system could bring about the advancement of society as a whole through enrichment of the individual who, armed with knowledge of his innate characteristics, could exert 'positive exercise' to improve himself. Women could aid society by selecting the partner with whom they would be most compatible. Rejoicing in seeming scientific objectivity, liberal reformers proposed phrenological readings as leading to rational employment and unemotional treatment of society's members: it could be a means of modernising penal systems and it was suggested as a means of selecting prisoners for New South Wales; it was believed to be an advancement in treatment of the insane or handicapped; and it was actively employed as an educational tool – Queen Victoria herself brought George Combe to Buckingham Palace to discuss the education of the royal children.[16] Interestingly, most of those active in their support of phrenology, medicine, or other institutions were from the lower middle classes or from the geographical fringes; Cooter has shown that such people were those who had the most to gain and the least to lose in holding such a 'wild card'.[17]

As pervasive as phrenological thought was, influencing medicine, religion, and politics, it should not be surprising to find advocates addressing aesthetic issues. In 1855, Combe published a book on the subject, *Phrenology Applied to Painting and Sculpture*.[18] But other writers had touched upon the matter even earlier than this date. In 1848, the same year in which the Pre-Raphaelite Brotherhood was formed, an anonymous author in the *Journal of Psychological Medicine and Mental Pathology* considered the impact of phrenology upon the fine arts. Plutarch, we are told, said that the great Greek leader Pericles had so long a head that he was ashamed of it. Because the head was out of proportion, Pericles considered it to be a deformity and covered it with a helmet for his famous sculpted portrait, a comment which reflects the Victorian tendency towards literal interpretations. The writer concludes that if Pericles had lived in the modern age of phrenology 'the intellectual vanity of the great Athenian might have been induced to hail his long head as a distinguished beauty'.[19] The classical ideal that dominated portraiture for centuries is clearly seen in Kresilas' bust of Pericles (pl. 18). Each feature of the Athenian ruler is generalised and blended into a harmonious whole. The face can be read as a sign of humanity rather than as a specific person. In contrast the 'modern' phrenological portrait would replace a uniform

and universal canon with an exposition of those irregularities that pro-
claim the exceptional or idiosyncratic man.

While a cause for amusement, the phrenologist's interpretation of form
is indicative of a shift in values from the ideal to the actual – a shift shaking
the foundation of the Royal Academy as well.[20] As long as the Academy
had existed, there had been grievances with its practices and rules, but in
the 1840s a strong move to reform came from within with members
seeking a stronger place for life study over the Antique. At the General
Assembly meeting prior to the Council meeting of 14 December 1848, the
'moderns' secured two premiums for painting from the live model and
reduced the medals for copied work to one; however, the 'reactionaries'
were able to influence the Council, and by the time of the Council minutes
of 13 July 1849, the limitation of medals for copying had been cancelled
as had the premium for painting from a draped model. The Keeper, George
Jones, a favourite among the students, wrote a letter to the Council
advocating more life study in order to 'prevent a similarity of countenance
too frequent in historical works'.[21] The Council responded with the decree:
'To give the proposition a trial – to commence as soon as the necessary
arrangements can be made.'[22] But it was a gesture at best. Instruction
continued as lectures on beauty rather than as practical demonstrations.

Given the haphazard education of the Royal Academy, any serious
student would have had to seek alternative or supplemental instruction.
Many disaffected artists banded together to provide a means of self-
education. Through a gradual shifting in membership in just such
societies, the Pre-Raphaelite Brotherhood came into existence. As they
had done in the Cyclographic Society, Hunt, Millais, and Rossetti now
passed their rendered scenes from Dante or from Keats around the table to
one another, receiving each other's suggestions for improvement in the
spirit of mutual admiration. Simply tolerating the lectures they received at
the Royal Academy, these young artists scorned the rote copying of an
'Apollo Belvedere' and instead delighted in the activity of mutual portrait-
taking or of doing portraits from memory. While engaged in heady
aesthetic conversation, the Pre-Raphaelites began to find their own
identity in the careful analysis of their own physiognomies.[23]

Guided by the principles of self-help and of self-knowledge, the Pre-
Raphaelites were attracted to the promises of phrenology. Much space in
the P.R.B. Journal is devoted to the character analyses by a 'head-reader',
as he would have been called, named Donovan.[24] A true showman,
'Donovan' is Charles Donovan who ran the London School of Phrenology,
where he gave free lectures every Monday evening and provided courses in

the art of 'examining the head'.[25] He was also available for consultations from 9 to 6 o'clock, or later by appointment. While more of a populariser than a true scientist – he granted himself an MA and a Ph.D – Donovan is crucial for the Pre-Raphaelite connection because of the location of his establishment: 1 Adelaide Street, almost around the corner from the Royal Academy. One can almost see the Pre-Raphaelites, young men ranging in age from nineteen to twenty-one, scampering down the steps of the building in Trafalgar Square to attend the dynamic performances of Donovan. Denied access to the Academy's Life Class, the Pre-Raphaelites learned from phrenology a method of portraying human nature through physiognomical peculiarities. As a result, their portraiture moved away from the synthetic and the ideal to the analytic and the actual.

An account of a typical P.R.B. meeting is provided by William Michael Rossetti in his Journal entry: 'Talked much of the worst pictures of the Academy, swimming, dreams, early recollections, and our personal characters.'[26] While their minds and their words were preoccupied with such subjects, their eyes and their hands were employed with drawing mutual portraits, such as the one by William Holman Hunt of Dante Gabriel Rossetti in the Fitzwilliam Museum, Cambridge (pl. 19). Although not dated, this casual drawing would seem to fit into the early years of the Brotherhood, due to Rossetti's beardless face and to the Romantic 'puckered-lips' attitude. Certainly not a major piece of work, this portrait reveals Hunt's first attempts at rendering *what is* rather than what *should be*. Taking his earliest lessons with the portraitist Henry Rogers, Hunt wrote later that this artist 'ingrained certain habits and traditional practices of which in after-years I had trouble to be rid'.[27] It is clearly evident that Hunt struggled with the line of Rossetti's jaw, as seen in the heavy-handed treatment, and he struggled more to move away from the classical tradition. In terms of modelling, of the shadows, of the placement and the proportion of the features, as well as of the general sculpted quality, this portrait of Rossetti begins as a textbook example of portraiture. In fact, in many ways it is remarkably similar to Kresilas' bust of Pericles. Accustomed to drawing the universal, Hunt had difficulty in achieving the downward slackness which identified the idiosyncratic Rossetti. Yet here is the very kind of portrait desired by the anonymous phrenologist writing in the *Journal of Psychological Medicine and Mental Pathology*.

The awkward contortion of Rossetti's features is a kind of 'deformation', that is, a distortion of an abstract model by means of the particular and the uncommon. Certainly this would have been Sir Joshua

18 After Kresilas, marble
bust of Pericles; *Trustees of
the British Museum*

19 W. Holman Hunt,
Portrait of D.G. Rossetti;
pen, $8\frac{7}{8} \times 7\frac{1}{8}$ (22.5 × 18.2);
Fitzwilliam Museum, Cambridge

20 J.E. Millais, detail from 'Isabella',
1848–9; *Walker Art Gallery, Liverpool*

21 J.E. Millais, detail from 'Christ in the
House of His Parents', 1849–50; *Tate Gallery*

22 J.G. Spurzheim, *Phrenology in
Connection with the Study of Physiognomy*,
1833, pl.23, fig.2: Richard Price

23 W. Holman Hunt, detail from 'Valentine Rescuing Sylvia from Proteus', 1850–1; *Birmingham Museum and Art Gallery*

24 J.G. Spurzheim, *Phrenology in Connection with the Study of Physiognomy*, 1833, pl.14, fig.1: Caracalla

25 W. Holman Hunt, detail from 'The Hireling Shepherd', 1851–2; *City of Manchester Art Galleries*

26 W. Holman Hunt, detail from 'The Awakening Conscience', 1853–4; *Tate Gallery*

Reynolds's view in consideration of the aesthetic he outlined in his *Discourses*.[28] If we follow the changes in Pre-Raphaelite portraits over the following years, we can see this process of deformation. In fact, by 1850 critics of Pre-Raphaelite pictures looked at the figures in these works as actually suffering from deformities.[29] Given the length of this essay, I can only consider artists' intentions rather than viewers' receptions, but I need mention that in the mixed reviews of Pre-Raphaelitism the type and the size of the heads were uniformly despised.[30]

At approximately the same time that Hunt's drawing of Rossetti was made, in October or November of 1848, John Everett Millais painted the portrait of his supporter Hugh Fenn (TG 1984, No.14), the father of a student-friend. In his memoirs Hunt assigned this portrait a prominent position, evaluating it as: 'so strong in form and finish, and so rich in well-justified colour, that it resembled a perfect Van Eyck or Holbein, and yet its excellence was in no ways mere truth at second hand'.[31] Rather than early Flemish painting the portrait of Hugh Fenn at first glance resembles much of the schematic portraiture of the 1840s: the deliberate way in which the modelling defines regular proportioned features – the way in which individual detail is sacrificed to general effect – falls in line with a portrait tradition that seems to have little to do with Pre-Raphaelitism. Upon closer examination, however, we do find that the portrait of Fenn has certain characteristics that diverge from this older tradition. Millais has painted each strand of hair on the finely formed head. He has included details like the pouches under the tear-moistened eyes, and the multiple lines and dimples around Fenn's nose and mouth. As a result we seem to get a greater sense of the character. We sense that this is a rather light-hearted, engaging fellow. An 'actual' man is emerging from the public persona usually found in such portraits.

If Millais's experiments were to go no further, we could dismiss the portrait of Fenn as simply a slightly more vivid portrayal of personality within an accepted format. But in the next few months of work, Millais began to accentuate the more individual effects found in the Fenn portrait. Some time after Millais painted the portrait of Hugh Fenn and before May of 1849, the artist decided to include this avuncular figure in 'Isabella' (TG 1984, No.18) as the man paring the apple. Fenn is the figure seated at the right side of the table, the third from the rear. There is no doubt now that this is a Pre-Raphaelite portrait. The artist is less dependent on formulas, such as the dramatic use of light and shadow, and instead is topographic in his straightforward mapping of facial features. The broad surface of the cheek is unmottled and flat – not at all the 'tweeked' effect one might

[54]

expect. Where once you could see every strand of hair on the head, you now can see each eyelash. Not only is the figure in the painting a portrait, but each feature within the face is portraitised. Later Ruskin would declare that 'Every Pre-Raphaelite figure, however studied in expression, is a true portrait of some living person'.[32] That living person, in this case Hugh Fenn, here sacrifices any claim to ideal beauty, or normativeness, to the new standard of observation and science.

Millais's increasing individuation in his treatment of the human form is in keeping with what may be called 'the philosophy of phrenology', which is also the title of a book published by Robert Hunter in 1845: 'In every department of nature, variety is the predominant characteristic. In the grass that covers the face of the globe, two blades cannot be found perfectly alike. Two objects in nature have never been found in the same state, and what reason have we to think that the *mind* is an exception to this law?'[33] Like the fifteenth-century Italian and Flemish paintings admired by the Brotherhood, Pre-Raphaelite compositions are packed with minute details often at the expense of a unified whole; but unlike the earlier model, the Pre-Raphaelite 'every blade of grass' realism assumes a hypnotic singularity that can only be found in a nineteenth-century context.[34] Both fifteenth-century painting and the styles to follow relied upon types, accepted visual characterisations, as a necessary device which would permit the reading of narrative painting. In his prize-winning painting of 1846, 'Pizarro Seizing the Inca' (TG 1984, No.1), Millais himself takes advantage of this practice, showing that types continued through Academic painting of the 1840s. On the far left, Millais included a figure of a priest holding a cross. He used his father as a model with no consideration that this esteemed man was, as a person, ill-suited to represent the forces of Roman Catholic superstition committing an act of infamy. But that fact is nullified because the artist has made his father's features barely distinguishable from those of the other figures in the painting, except for the slightly balding head. In other words, Millais's father portrays a 'stock character' in no sense possessing such an individual mind as described by Hunter.

When applied to the rendering of heads, the Pre-Raphaelite 'every blade of grass' realism could be used to counteract the neoclassical types that populated Academic paintings of the day. By singling out Millais's father in two more pictures, we can see the artist develop a more subtle way of presenting his text. By portraying the variety of physiognomical features of models appropriate for their role, the artist allows the viewer to read the character's mind and his motivation – just as the square-chinned actors of

the 1950s, the Rock Hudsons, were edged out by the method actors of the 1960s and 70s, the Dustin Hoffmans. Following this analogy, we must bear in mind that the Pre-Raphaelite characterisation remains just as much artificial construction as the performance of a method actor.

Returning to Millais and 'Isabella', we find Mr Millais Sr seated at the same side of the table as Hugh Fenn; the elder Millais is the figure wiping his mouth (pl.20). We can see the same change from the synthetic to the analytic, from the type to the actual, that characterised the development in the Fenn portraits. We can also see a much greater emphasis on the father's face as a face, and on his head, or to be more exact, cranium. 'Isabella' was accepted by the public as a fine example of the Early Christian style then in vogue; but in the following year, 1850, Millais pushed the phrenological portrait even further in the controversial 'Christ in the Carpenter's Shop' (TG 1984, No.26).[35]

Much of the criticism surrounding Millais's interpretation of the Holy Family centered on the figures, including the artist's father as Joseph, who were seen as deformed, indecorous, and even vile and base.[36] Although repelled by what he saw, one reviewer unwittingly perceived an important component of the Pre-Raphaelite aesthetics of ugliness: '. . . instead of giving us figures with those fine conventional heads and feet which we like to see in albums, the Pre-Raphaelites appeared to take delight in figures with heads phrenologically clumsy, faces strongly marked and irregular, and very pronounced ankles and knuckles'.[37] In 'Isabella' Millais had certainly portrayed his father more realistically than he had in 'Pizarro Seizing the Inca', but now the artist has made even fewer concessions to public taste. Each feature and form is graphically depicted, almost startlingly unadorned. Above all, primary among those features is the huge, finely shaped cranium, carefully rendered with rounded strokes that are visible upon close examination. Millais has truly painted what the Victorians called the 'dome of thought, the palace of the soul' (pl.21).[38]

It is often pointed out that Millais's quest for accuracy led him to use real carpenters for the bodies of the adult male figures. The fact that the artist felt it was necessary to place different heads on these bodies is usually passed over. Combining ideal body parts had long been an Academic practice, but rather than beauty Millais's intent was truth. As the surrogate father of Christ, Joseph should have the body of a carpenter, but his head would have to bespeak a very different sensibility. Appropriately, Millais selected the head of his own father, and he patterned him according to a textbook example of a finely formed cranium. I offer as a similar type an illustration from the 1833 edition of Spurzheim's treatise (pl.22).[39]

Phrenologists loved to rummage through historical portraits to find the corroboration for their science, never failing to see a correspondence between a famous person and a record of his/her life. In the head of the politician Richard Price, phrenologists found evidence of both a keen intellect and a religious devotion, a combination which marked Price as a highly advanced specimen of humanity and which made him a desirable model for Joseph. In fact, given that 'correct' drawing required a forehead to be equal to the height of the nose, one might wonder whether Millais may have painted his father's portrait to make it more flattering phreno-logically.[40] The sheer size of the cap of the head, the height to which it rises perpendicularly to the brow, and the regularity and the subtlety of the curve of the crown exceed normal expectations of human anatomy. But all of these features stress the most desirable cranial features – the shine no longer comes from a halo but from a smooth, tightly pulled temple.

The Pre-Raphaelite combination of models differed from Academic practice in that the result appeared to be a realistic portrait of a specific individual. Yet, this manipulation implies that there was a certain attitude which the Brotherhood never lost but redefined. As we shall see, this need for an ideal form – now a pseudo-scientific, additive one – meant that these artists were free to create types of their own. This is quite plain in a series of well-known works by Holman Hunt exhibited after 1850. By examining the work of this artist in a phrenological context, we can see that what is true for Millais is also true for other members of the Brotherhood. Most conveniently, Hunt provides us with an example of bad character to contrast with the good one offered by Millais. In representing the other extreme of male personality, the cad is a perfect foil to the chaste Joseph, and his physical realisation embodies the negative end of the phrenological spectrum. In essence, we are able to cull from the assortment of Pre-Raphaelite characterisations their version of 'Dr Jekyll and Mr Hyde'. With enough variation to suggest individuality, the 'Dr Jekylls' of Hunt's moral dramas are all 'cut of the same cloth' – each is grafted onto a different body and adjusted to suit the narrative text or the physical context.

In 1852, Hunt spoke of the perceived fallacy of Academic dogma: 'In painting landscape and portraits it was impossible for any with full degree of observant sense not to catch some aspect of Nature, but when imaginative work was demanded, no aid was sought from this eternal source of all inspiration.'[41] Undoubtedly this artist felt that he had managed to rectify this situation in his own recent work, such as his 'Valentine Rescuing Sylvia from Proteus' (TG 1984, No. 36). Hunt's heightened detail and his insistence on awkwardness give the Pre-Raphaelite painting more

immediacy and credibility than found in typical treatments of Shakespearean subjects of the day. Rather than simply a backdrop, the landscape in Hunt's painting is integrated spatially and tonally with the figures, who maintain their importance by means of their size and positioning in the foreground.[42] Although the tree forms echo the human, almost acting as silent witnesses, the branches have not been included, accentuating the close-up, voyeuristic position of the viewer. The curve of the picture crops the 'heads' of the trees off and, at the same time, follows the line created by the heads of the main figures. The phrenological accuracy of these heads, rather than the use of stock types, allows Hunt's painting to be understood – observation and science lend a hand to the imagination.

Hunt's 'Valentine Rescuing Sylvia' presents a scene from the final act of *The Two Gentlemen of Verona*. Proteus has attempted to sully the virtue of Sylvia, only to be apprehended by his best friend and Sylvia's beloved, Valentine. In the original drawing for this painting located in the British Museum, the head of Proteus was taken from a barrister named James Aspinal, and its weak rendering reflects Hunt's lack of commitment to this visualisation. In the final painting, Hunt changed Proteus's features by using what he called 'an idler' as the model (pl.23).[43] The character who betrayed his best friend and who attempted to violate Sylvia was, in terms of phrenological doctrine, more appropriately portrayed by a broad head and coarse red hair, clues to a brutish animal nature. That Hunt wanted the viewer to know that his characterisation was scientifically correct is indicated by the removal of Proteus's hat, which rests neatly on the ground. Just as Joseph had a suitable historical model, so too does Proteus, his being somewhat infamous. Among the villains in the phrenological textbooks, the Roman emperor Caracalla (pl.24) had a special position as one of the most despicable.[44] His particular kind of nastiness was specifically defined as complete and utter sensuality as was clearly evident in his low brow and broad head with its mass of snake-like ringlets. While Hunt's conception of Proteus certainly does not correspond directly to the head of Caracalla, it is evident that these heads are the same phrenological type, so that even if we did not know the plot of *The Two Gentlemen of Verona* or the title of Hunt's painting – assuming we were versed in phrenology – we might be able to know that the young fellow kneeling on the ground is 'up to no good'.

The following year, 1852, Hunt exhibited yet another subject in which a man's lust overpowers his sense of duty. Once again, 'The Hireling Shepherd' (TG 1984, No.39) would require a head which revealed the carnal sensibility of the main figure. The head of the swain is, in fact, quite

like the head that Hunt had used for Proteus the year before; now seen in reverse and inclined slightly, this head type (pl.25) consists of the same low forehead, broad skull, and coarse red hair which indicate a lascivious personality. The shepherd's head may be even more closely related to that of Caracalla, due largely to the muscularity of the country labourer. In addition, we can see that Hunt was very concerned with the way in which the model's earlobe connected to the head, giving the shepherd an animal-, or satyr-like quality. As a denizen of the fields, this robust figure sports a reddish complexion, also appropriate phrenologically as a sign of coarse animality. While a 'brother' to Proteus, the hireling shepherd was altered along lines that suited his occupation, underscored his kinship with his herds, and betrayed his rustic crudity. In contrast Proteus's features retain some sense of refinement, making his weakness less malignant and more easily overcome.

It is important to remember that the Pre-Raphaelites saw the scientific method as a means to 'assist the moral purposes of the Arts . . .'. Each of the visual texts that phrenology was intended to explicate centres on the tension between free will and determinism. No matter how strongly marked, any individual can exert positive force and can accentuate their positive faculties. In the British phrenological system, anatomy is not destiny, as one manual reminds the reader: '. . . the phrenologist does not assert that the peculiar form of the skull directs the actions of mankind affect and produce it [sic] . . . *Phrenology is but a visible evidence of the effects of the conscience . . .'.*[45] Nowhere is this more clearly spelled out than in Hunt's painting 'The Awakening Conscience' (TG 1984, No.58).

Two years after 'The Hireling Shepherd' was painted, Hunt needed to represent yet another randy, idle young man. The young bounder, who is attempting to impede the heroine's conversion, is a prefigurement of the 'picture of Dorian Gray' in the way in which his physical form is a 'visible evidence of the effects of the conscience'; except rather than a talismanic painting, the evidence is born by the man himself. So Mephistophelean is this figure that one might expect to see no reflection in the mirror behind him. He has the same low forehead, the same broad skull, the same coarse red hair, and the same animalistic appearance that Proteus and the hireling shepherd had (pl.26). Instead of the caprine appearance of the herdsman, this urban cad takes on a feline look; his whiskers, his flashing eyes rimmed by curling eyebrows, his gleaming, menacing teeth, and even his upward glance parallel the features of the prowling cat that has pounced directly below. Like this cat, this cultivated creature has a feral nature lurking below the surface of his seeming languor. Hunt has turned

the Caracalla type into a city slicker. Rather than coarse locks, this strayed cat wears his red hair in waves fiercely tamed with brilliantine. Given his overactive libido, his flesh has the same reddish cast as his country cousin as a result of his hot-blooded temperament. Both the slick hair and the complexion shine, but unlike Joseph's saintly glow this sheen is the equivalent of the polished veneer of the brash new furniture. The swell's sinister cast is intensified, because he, unlike Proteus and the hireling shepherd, has already seduced the innocent virgin and has committed his all too evident sin. Significantly, this model and the models for Proteus and the hireling shepherd are among the few who posed for the Pre-Raphaelites who remain anonymous. Obviously the Pre-Raphaelites did not wish to glorify such disreputable characters. As would the scientist, the Pre-Raphaelite artist felt that he must show the truth no matter how repugnant or distasteful.

Such repetition of phrenological types, paradoxically, amounts to a new repertoire of types. Or perhaps it is more accurate to say that the Pre-Raphaelites developed their own formal vocabulary to convey their meaning, and this Pre-Raphaelite formula, in part, came from a new sense of human consciousness.[46] Just as we look at the construction of an Impressionist painting, so too must we consider the form of a Pre-Raphaelite painting as an expression of the modern condition as we have come to define it: attention to detail created a world of multiple con-figurations and, thus, included a range of human possibilities; deformation of the ideal proportions stressed the head and, in turn, the brain, which meant that all these individuals were capable of thought and of choice; and at the same time, the accumulation of aggregates posited a world view in which there is a delicate balance of all these idiosyncracies and options. It just might be that the continuation of this individualised, dynamic world makes it difficult to recognise the schematisation of the Pre-Raphaelite vocabulary. Rather than look at these figures as artful constructions, we tend to place ourselves, the way we perceive our bodies, within the frame of a Pre-Raphaelite painting. The values that formed that idiom of reality still hold true, making us overlook Dante Gabriel Rossetti's boastful words concerning his colleague's 'Valentine Rescuing Sylvia': '. . . these figures are truly *creations*, for the very reason that they are appropriate individualities, and not self-seeking idealisms'.[47]

James Collinson

RONALD PARKINSON

It is hard not to feel sorry for James Collinson. With Collinson, art historians for once have agreed with both the judgement of their predecessors and the opinions of the artist's contemporaries and friends. Violet Hunt wrote that her mother was told by William Holman Hunt in 1903: 'Oh, Collinson was nothing! He had about as much in him as that old hen!'.[1] His reputation today rests on his membership of the Pre-Raphaelite Brotherhood, of whom only Rossetti wanted him; on his brief engagement to Christina Rossetti, who rejected him; and on one painting, 'The Empty Purse' (pl.33), in the national collection of British art at the Tate Gallery, which is only one of several versions of a picture that has become well-known through frequent photographic reproduction in books about the Pre-Raphaelites and their followers.

It is also difficult to add very much to Thomas Bodkin's article of 1940,[2] although a few more paintings have appeared in the saleroom, and even fewer biographical facts have been unearthed, mainly by a local historian, Sydney Race, writing in the *Nottingham Guardian*.[3] James Collinson was born on 9 May 1825, presumably in Mansfield, Nottinghamshire, where his father Robert had a business in Westgate as a bookseller, stationer, and sub-postmaster. A local search conducted by the *Nottingham Guardian* discovered no entry of baptism in local registers. His older brother Charles continued the family business after his father's death, while his mother and sister Mary lived at nearby Pleasley Hill. There does not seem to be any evidence that the artist Robert Collinson was related to this family. James left for London and entered the Royal Academy Schools, having a 'liberal allowance from home' according to Hunt (Doughty adds that Collinson was the only member of the P.R.B. who could afford to hire professional models).[4]

The painting of 'The Charity Boy's Début' marked Collinson's own début at the Royal Academy exhibition in 1847. Hunt reported the event: 'It was a surprise to all when, in the year 1848 [sic], he appeared in the Exhibition with the picture called "The Charity Boy's Début". To represent the bashfulness of a poor boy appearing before his family in the uniform of his parish was an honest idea, and although the invention did not go far

beyond the initial conception, the pencilling was phenomenally painstaking throughout.'[5] The picture was more admired by the few press critics who noticed it, but also particularly for its attention to detail. The *Athenaeum* advised that the painting 'by J. Collinson – a new name – gives good promise of a successful candidate for the honours of a reputation in the school of Wilkie. The subject is a charity boy preparing for his debut in a eleemosynary school, and undergoing the ablutions and dressing necessary to his entrée in public life. It augurs great future excellence'.[6] From the *Literary Gazette* we learn that the work 'though hung low is a genre piece, which ought not to escape attention; and we pay it the compliment of mentioning it after the foregoing'.[7] The 'foregoing' was Thomas Webster's 'A Village Choir', described as 'one of the memorable *chefs d'oeuvres* of the season', and now in the Victoria and Albert Museum. The review continued: 'The mother dressing the frightened boy in his new parish habiliments, the other *habitués*, the younger family, and the elder actors in the scene, are all drawn with characteristic fidelity; and the entire story told with a clearness and spirit it would require a long description to unfold.'[8] Although the *Athenaeum*, in Collinson's obituary notice, later remembered a 'humorous and homely study' in the manner of Joseph Clark,[9] we might most accurately imagine the appearance of this lost painting to resemble a cross between the domestic genre of Thomas Webster ('Goodnight! . . .', for example, exhibited at the R.A. in 1846 and now in the City Art Gallery, Bristol) and Collinson's own 'Italian Image Makers at a Roadside Alehouse' of 1849 (pl.27). The meticulous detail of 'The Charity Boy's Début' was referred to by Millais in a discussion sometime in 1848 recorded by Hunt: '"You'll see I intend to turn over a new leaf;" announced Millais, "I have finished these heads more than I ever did. Last year it was the rage to talk about 'Collinson's finish' in his 'Charity Boy': I'll show 'em that that wasn't finish at all".' Hunt continued the conversation. 'I added: "with form so lacking in nervousness as his, finish of detail is wasted labour"'.[10]

Presumably Collinson met Hunt, Millais and Rossetti before 1848, in the R.A. Schools (Hunt briefly refers to their student days together in the passage quoted below), but it seems to have been early in that year when he was introduced to Christina Rossetti and when W.M. Rossetti was convinced that Collinson had fallen in love with her.[11] Christina had noticed Collinson the year before at the church they both attended, Christ Church in Albany Street, and it must have been Collinson's relationship with Christina, together with Rossetti's keen admiration for his painting, that led to his enrolment in the P.R.B.

Hunt's account of the decision to admit Collinson to the Brotherhood is, to my mind, typical of the pomposity of his writing of the history of the P.R.B. more than fifty years after the events of 1848. 'I agreed [with Rossetti?] to submit to Millais the acceptance of James Collinson, who had already distinguished himself by paintings of the genre kind, and was now writing poetry in the highest Church spirit. He promised now to paint in the severe style, declaring himself a convert to our views.'[12] Hunt records Millais's response as 'Collinson'll certainly make a stalwart leader of a forlorn hope, won't he?'. To which Hunt remembers replying: 'Now comes the forlorn-hoper; it appears that the Rossettis are much attached to him, and Gabriel, having taken possession of him, declares he can attain to a higher standard of work than he has accomplished, and Collinson himself has been pressing me to get him accepted. I like the meek little chap. All I can say is that there was a good idea in his "Charity Boy", and that the manipulation was conscientious, so that with higher inspiration he might do something good.'[13] Presumably the 'higher inspiration' was to come from the Brotherhood, and it is worth remembering here that in September 1848, at about the time of which Hunt is writing, Collinson was twenty-three years old, while Hunt was twenty-one and Rossetti was twenty.

There was no mention by the P.R.B. of Collinson's only 1848 exhibit – 'The Rivals' – shown at the Royal Academy. The *Art Union* described it as 'two boys, one of whom offers an apple to a little girl, which the other objects to her receiving. A small picture, very faithful in its rendering of childish character'.[14] Perhaps Hunt was right to believe that Collinson was in need of higher inspiration.

It seems to have been in September 1848 – the most likely date of the formation of the P.R.B. – that Collinson first proposed marriage to Christina; she found his recent conversion to Roman Catholicism unacceptable, and refused. He returned, presumably in consequence, to the Church of England, and became engaged to Christina, although there does not seem to have been an official recognition of any kind of the event. Indeed, no-one appears to have even mentioned it. It is impossible to reconstruct even the dimmest picture of their romance. Her biographers record her visit to his family at Pleasley Hill in August 1849, and her letters show that she did not like them.[15] The engagement ended in the Spring of 1850, and soon after Collinson returned to Roman Catholicism and resigned from the P.R.B. To these barest of biographical bones, the only additions are the few reminiscences of Hunt and W.M. Rossetti, and Collinson's extant paintings of 1849 and 1850.

There is, perhaps most significantly, the portrait by Collinson of

Christina (pl.29). The likeness has much of the intensity of Rossetti's depiction of his sister as the Virgin in 'Ecce Ancilla Domini!' (TG 1984, No.22). The physical vulnerability, the narrow shoulders, and wide-eyed stare, reinforce the notion that it was as much the appearance of Christina Rossetti that determined the emaciated and angular style of the Brothers as any return via Lasinio's engravings to the Pre-Raphael frescoes in the Campo Santo at Pisa. It is likely that Christina was the only young woman that the Brothers actually knew in 1848. As a model, Elizabeth Siddal was to add only her more compelling physical presence and availability, extraordinary hair, and less complex personality. With our knowledge of Collinson's love for Christina at the time he painted her portrait, we can see his attraction to her expressed in the image.[16]

Hunt seems to have resented the acceptance of Collinson into the P.R.B., no doubt because he disapproved of Collinson's lack of energy and devotion to the cause; again, his feelings were magnified by the passage of time. His later account of Collinson's acceptance is certainly begrudging. 'It transpired that he had roused himself up of late and entered the Roman Church; and had summoned effort to paint this picture [presumably 'The Charity Boy's Début']. All the students blamed themselves for having ignored Collinson, but Rossetti went further, and declared that "Collinson was a born stunner", and at once struck up an intimate friendship with him. It will be seen that Rossetti had decided that Collinson only wanted our enthusiasm to make him a great force in the battle. Accordingly we gave him permission to put the secret initials on his works, to attend our monthly meetings, and to receive us in his turn.'[17]

Millais's opinion of Collinson as expressed in his sarcastic description of a 'stalwart leader of a forlorn hope' – surely meant to be as critical of the P.R.B. as of Collinson – was shared by other Brothers. W.M. Rossetti described him as 'a small thick-necked man, chiefly a domestic painter, who began with careful and rather timid practice; in demeanour, modest and retiring'.[18] Hunt, despite professing a liking for 'the meek little chap', clearly despised him. His longest description of Collinson concerns his sleepiness, for which Collinson seems to have been notorious: 'James Collinson had been an amiable fellow-student, painstaking in all his drawings, and accurate in a sense, but in his own person tame and sleepy; and so became all the figures he drew. "The Apollo Belvedere", "The Laöcoon", "The Wrestlers", "The Dancing Fawn", and the drunken gentleman of that race, all seemed to belong to one somnolent family. No one, a year later, could have trusted his memory to say whether our quiet friend had or had not been in the schools, so successfully had he avoided

27 J. Collinson, 'Italian Image Makers at a Roadside Alehouse', 1849;
oil, 31 × 43 (78.7 × 109.2); *Private Collection*

28 J. Collinson, 'The Renunciation of Queen Elizabeth of Hungary', 1851;
oil, 47⅜ × 71½ (120.3 × 181.6); *Johannesburg Art Gallery*

29 J. Collinson, Portrait of
Christina Rossetti; oil,
$7\frac{1}{4} \times 6\frac{1}{8}$ (18.5×15.5);
Private Collection

30 J. Collinson, 'Mother and Child
Seated on a Stile, Culver Cliff, Isle
of Wight, in the Distance'; oil,
$20\frac{3}{4} \times 16\frac{5}{8}$ (52.5×42); *Yale Center
for British Art (Paul Mellon Collection)*

31 J. Collinson, 'Answering the Emigrant's Letter', 1850;
oil, $27\frac{5}{8} \times 35\frac{7}{8}$ (70.1 × 91.2); *City of Manchester Art Galleries*

32 J. Collinson, 'The Child Jesus', 1850;
etching, $4\frac{15}{16} \times 8$ (12.5 × 20.4); *Tate Gallery*

[67]

33 J. Collinson, 'The Empty Purse',
c.1857; oil, 24 × 19⅜ (61 × 49.2);
Tate Gallery

34 J. Collinson, 'To Let', c.1857;
oil, 23 × 18 (58.4 × 45.7) *FORBES*
Magazine Collection, New York

disturbing any one in any way.' At the P.R.B. evenings, 'he invariably fell asleep at the beginning, and had to be waked up at the conclusion of the noisy evening to receive our salutations. In figure he was far from being like the fat boy in *Pickwick*, for he was both light and small. He could but rarely see the fun of anything, although he sometimes laughed in a lachrymose manner, and I fear our attempts to enliven him were but futile'.[19]

Hunt continues with an unamusing anecdote about a midnight excursion through North London during which Collinson fell asleep. This aspect of Collinson's personality seems to have resulted in him being nicknamed 'the dormouse', and it is tempting to link him with the later creation of the more famous sleepy dormouse by Lewis Carroll.[20]

1849 and 1850 cannot be described as years of frenzied artistic activity for any of the Brothers – as much time must have been spent talking as painting – but Collinson's reputation for work during this period rests on only four known paintings and his illustration for *The Germ*. The most important, and most P.R.B. in style, is the St Elizabeth of Hungary picture exhibited at the Portland Gallery in 1851 (pl.28); the others are 'Italian Image Makers at a Roadside Alehouse' of 1849, the painting of a mother and child probably from the same year, and 'Answering the Emigrant's Letter' exhibited at the R.A. in 1850.

We must assume 'Italian Image Makers . . .' (pl.27) – exhibited at the R.A. in 1849 with the inscription 'P.R.B.' and in the company of Hunt's 'Rienzi' and Millais's 'Isabella' – to be evidence of the 'something good' that Hunt hoped would result from the higher inspiration of the Brotherhood. I judge the painting only from a monochrome photograph, but it seems to retain too much of the Wilkie and Webster tradition to hang comfortably alongside 'Rienzi' and 'Isabella' (TG 1984, Nos 17–18). While it happily lacks both the touring company melodrama of Hunt's painting and Millais's awkward and pedantic assembly of observed components, it sadly lacks the earnestness and bravado of the former and the compelling strangeness of the latter. Without wanting to sound here like Hunt, I find Collinson to have tried to hard to match his Pre-Raphaelite Brothers, with too little success; there are the same profile portraits, the variety of poses and responses, the carefully observed details and the overall frieze-like composition. Perhaps the subject Collinson chose to paint is at the root of the failure. If, as one of the many willing victims to Victorian audiences' desire for novelty, he is trying to accommodate several genres in one picture, the result is at the same time bewildering and dull. It is, for example, very difficult at first to read what is happening in the painting.

The central episode – the small child in raptures at what we presume is a first realisation of the image of the Virgin and Child – is orchestrated by a randomly placed group of players with their own stories to relate. Like so many Victorian artists, Collinson misunderstands the artistic device of dramatic contrast; the boy standing on the same chair as the adoring child to play with the statuette of a nodding chinaman, for example, is a clumsy development of Wilkie's famous 'The Blind Fiddler' (Tate Gallery), where the youth with a pair of bellows mimics the violinist on the other side of the room.

The 'Mother and Child' painting, showing Culver Cliff in the distance (pl. 30), must result from his painting trips to the Isle of Wight: he was there, for example, in August 1848.[21] The lay-figures and the studio are forgotten – the painting presents a powerfully simple image set in a carefully observed landscape. To judge from its style and because of the visits to the Isle of Wight, the picture should date from 1849 or 1850; a label on the back of the painting bears Collinson's address in 1851 and 1852. It is not identifiable with any exhibited titles except the 'Mother and Child' shown at the R.A. in 1865.

On 30 May 1849, the P.R.B. Journal records Collinson 'doing "a smoky picturesque little interior" at a high point of finish', and that 'he has thought of a capital Wilkie subject, sure to sell; and that on his return to London [he was visiting his family in Nottinghamshire], he is determined to "really do something"; furthermore, that he has a portrait in hand'.[22] In September he was working on designs for the background of a 'sacred picture', perhaps the 'Christian Art design of Zachariah reading the Scriptures to the Holy Family'.[23] The smoky interior must have been 'Answering the Emigrant's Letter', while the Wilkie subject may have been the 'Pensioner', mentioned again in the Journal as in progress in December 1849.[24]

'Answering the Emigrant's Letter' (pl. 31), like 'The Italian Image Makers', is a genre scene painted in considerable detail, and is more successful in its treatment of the topical and popular subject of emigration. This painting has been confused by some writers in the past with a similar subject, 'The Emigration Scheme' exhibited at the Liverpool Academy in 1852.[25] Although in March 1850 Collinson 'may at last find himself unable to finish his picture of the Emigrant's Letter for the Academy, and seems almost inclined to set about some very small work',[26] the painting was shown at the R.A. that year, although hung 'at a height where all its merits are lost'.[27]

The entries in the Journal for 6 and 22 March 1850 outline Collinson's

plans for work in that year and beyond:

> After this year he has made up his mind to cut the Wilkie style of Art
> for the Early Christian, and what he has in his head for the subject of
> his next picture is his old design (in the days of the venerable
> Cyclographic) – *The Novitiate*, into which he would probably introduce
> another figure – that of the Lady Abbess.[28]

> He has again changed his mind as to subjects for his next year's works;
> and is now resolved to carry out the old sketch of his of 'The New
> Curate' (entitling it 'The Controversy'[29]), and to paint Tennyson's
> Dora in the reaping, – the first for the Academy, and the second for the
> Institution. He speaks resolvedly of setting to work immediately after
> his present picture ['Answering the Emigrant's Letter'] is sent in; first
> making a finished design for 'The Controversy', next finishing up the
> *Pensioner*, and finally working at his new subjects.[30]

On 7 April 1850, 'The idea of painting for next year the subject of Saint
Elizabeth before the Altar is again strong upon him'.[31]

But Collinson resigned from the Brotherhood, in a letter dated Whit
Monday (20 May) 1850.[32] Bodkin thought that 'Collinson's timid spirit
expresses itself rather incoherently';[33] certainly his reasons for resigning
may be interpreted in different ways. It may well have been his belief in the
Roman Church, or perhaps the criticism given to Millais's 'Christ in the
House of His Parents' (although Dickens's attack did not appear until
about three weeks later), or the crude financial arrangements that led to
the demise of *The Germ*. Collinson's postscript, 'Please do not attempt to
change my mind', proved unnecessary, and in any case it might be argued
that the Brotherhood did not exist any longer in its original form. It is
interesting that his 'replacement' as a Brother, Walter Deverell, does not
appear to have been formally admitted to the P.R.B., and his membership is
only vaguely referred to in the Journal.[34]

Collinson's last 'official' contribution to the Brotherhood's campaign
was his illustration (pl. 32) to his own poem 'The Child Jesus. A record
typical of the five Sorrowful Mysteries', published in the second issue of *The
Germ*. The poem narrates events from Christ's childhood, making parallels
with five stages of the Passion. The poem was completed by 10 January
1850,[35] and W.M. Rossetti records that it was much admired in Oxford
and elsewhere.[36] The etching deals with the subject 'where Christ is
crowned by his companions, among whom he will introduce John the

Baptist',[37] described in the third section of the poem:

> . . . the children knelt,
> And cast their simple offerings at his feet:
> And, almost wondering why they loved him so,
> Kissed him with reverence . . .

Hunt recorded in his memoirs that he helped Collinson with etching technique,[38] and the fourth impression was judged satisfactory on 28 January and published in *The Germ* on 31 January 1850.[39] Landow considers the poem to be 'the first Pre-Raphaelite work to employ elaborate prefigurative symbolism' if – as seems true – the first draft was completed by the Autumn of 1848.[40] Landow also claims that the last section of the poem anticipates work by Browning and Tennyson, and draws attention to Collinson's use of 'word-painting', relating the poem to Millais's 'Christ in the House of His Parents' and Hunt's 'A Converted British Family . . .', both exhibited in 1850 (TG 1984, Nos 26, 25).[41] The etching is less successful than the poem, and this is not due solely to the clumsy use of the etching technique. The delineation of the background, which resembles the Isle of Wight on the left and – strangely – an illustration by David Hockney on the right, is accompanied by the crudely handled anatomy of all the figures in the foreground.

There may well be drawings, if not paintings, yet to come to light from 1849 and 1850 which demonstrate Collinson's full espousal of P.R.B. principles. At present, we have to accept his painting of St Elizabeth of Hungary (pl.28), exhibited at the Portland Gallery in 1851, as his testament to true and pure P.R.B. theory. If only the drawings by Millais and Rossetti, which, like Collinson's composition drawing for this painting (pl.8, TG 1984, No.169), illustrate Charles Kingsley's play *The Saint's Tragedy*, were to be shown as executed or conceived at about the same time, another concerted P.R.B. illustrative scheme like that for Keats's 'Isabella' could be reconstructed.[42]

Towards the end of 1852 or early in 1853, Collinson went to Stonyhurst (selling all his artist's equipment beforehand, according to Hunt[43]) and stayed there for nearly two years. Stonyhurst was the great house of the Jesuits in Lancashire, and Collinson was placed in nearby Hodder House to train for the priesthood; he is recorded as beginning his novitiate on 15 January 1853, but did not complete the two-year term, leaving some time before September 1854.[44] W.M. Rossetti thought he was a 'working brother' rather than a novitiate, which may well be true,[45] and W.B. Scott was very dismissive about the whole episode: 'They did not want him as a

priest; they were already getting tired of that species of convert; so he left, turned to painting again, and disappeared.'[46]

Whatever happened at Stonyhurst to change Collinson's mind about the religious life, Rossetti wrote to William Allingham on 11 May 1855: 'What do you think? Collinson is back in London and has two pictures in the R.A. The Jesuits have found him fittest for painting, and have restored him to an eager world.'[47] There is something very unsympathetic in all the recorded statements about Collinson's religious convictions; perhaps it was Collinson's conversion of words into action that annoyed the others. There was also the matter of the broken engagement to Christina, which may have been more than just embarrassing. Certainly the Brothers were not keen to resume friendship, although there are letters between Collinson and Stephens that show they remained acquainted. Collinson's later years are ignored by the Pre-Raphaelites. W.M. Rossetti recorded that Collinson had 'I think, only one child, a son, who may be now living';[48] Hunt's last words on Collinson have not only a hint of malice but also that chilling lack of personal interest that comes after friendship has deteriorated even beyond distant acquaintance:

He was an amiable fellow and in a year or so he was convinced that after all his true vocation was art, and he retired from conventual life, he then gained a footing in the Society of British Artists [he was Secretary from 1861 to 1870], and there exhibited paintings of an ecclesiastical type said to be much above the common level. A good decade later I met him one night in the street, and during a friendly talk I gathered that he no longer was a convert to any special church, but since then I have been assured that he died a good Catholic. Certainly he had more reason to feel the pure and sweet peace of an innocent life than many more daring men may enjoy at the end of their days. If I have dwelt too exclusively upon his weaknesses I must plead that it was necessary to explain how the nominal extension of our number to seven had now become a means of weakness, of confusion, and of serious mischief to our cause. Collinson had been by no means our least effective probationary member, but his qualities were not those either of a van-guard soldier or of a reformer.[49]

We hear nothing more of Collinson from his friends, and have only the paintings that survive, knowledge of his marriage to the sister-in-law of the painter J.R. Herbert, and his moves (as recorded in exhibition catalogues) from Chelsea to Epsom and to Upper Holloway.

In 1855 he exhibited two paintings at the R.A., 'Temptation' and 'The

Writing-lesson', both of which have appeared in recent years in the saleroom.[50] The *Art Journal* described the former as showing a new Eton schoolboy with a coin being offered something in exchange, 'every object in it is most carefully made out'.[51] The Phillips sale catalogue identifies the 'something' as a fleam – a pocket-knife with a blood-letting instrument attached – and an old label on the back of the painting adds 'Bleeding the Freshman' to the original title, providing one of those double meanings beloved of Victorian artists and their audiences. The picture itself is undemanding genre, as is the rather more charming 'The Writing-lesson', which Ruskin admired as a 'very careful and beautiful study . . . a good piece of work throughout'.[52] The following year Collinson showed at the British Institution and then in 1857 at both the b.i. and the Royal Academy. The two R.A. exhibits were what became his best known pictures, 'For Sale' and its companion 'To Let'.

There are five known versions of 'For Sale', known also as 'At the Bazaar' and 'The Empty Purse', which is an indication of its popularity. Such has been Collinson's obscurity that the Tate Gallery version (pl. 33) has been identified in the past as the work of both the more famous Charles Collins and W.P. Frith. None has a provenance before 1910, all are almost identical (the only difference is that the words 'Follow Me' are missing from the print of 'The Way to Calvary' in two of the versions), and four are approximately the same size (the fifth is quarter size).[53] There are also three versions of the companion, 'To Let', also titled 'The Landlady' (pl. 34).[54] Of the versions that I have seen, there is no discernible difference in quality, but (to judge from a photograph) the small replica is an inferior piece of work and may well be a copy by another artist. What seem to be the original pair exhibited at the R.A. (if we accept that it *was* the original pair that was exhibited at the R.A.) are the paintings in the Graves Art Gallery; although they are known by different titles from those in the Academy catalogue, they are signed, and dated 1856 and 1857 respectively.

Again, both pictures are simple genre subjects, paintings of attractive women engaged in familiar activities. It is hard to believe that there is a sub-text, or that Collinson intended any double meaning in the titles. *The Times* critic, at the 1937 Leicester Galleries exhibition where one of the pairs was shown, thought the titles mildly salacious; this seems to say more about 1937 than 1857. An engraving after 'To Let' has the title 'A Fine Prospect, Sir!', but there are no other examples of such *double-entendres* in Collinson's work, and it seems unlike the little we know of his character. According to Anne d'Harnoncourt, Collinson was 'apparently distressed when the public interpreted the title of "For Sale" . . . as a

description of the girl'.[55] Although the objects for sale at the bazaar seem to me mainly remarkable as ordinary and innocuous, some of the details may have a significance; Rosemary Treble has drawn attention to the fashion doll and the religious print.[56]

The two paintings were either ignored or coolly received by the critics. The *Literary Gazette* called them 'two specimens of vulgarity in the shape of a showy landlady and a lively saleswoman', which 'are attractive at a distance from their smart drawing and bright colour: but are hung too high to allow of any certain estimate being formed of their merits'.[57] Bodkin suggested that Collinson was inspired by Frith's popular painting 'Sherry, Sir?', which was available as a print published in 1853 and also had a pendant in 'Did You Ring, Sir?'.[58] Collinson published a print of 'Good for a Cold' in 1858, closer to Frith's painting, as an alternative companion to the print of 'To Let', and this subject may have been that of the picture 'Solace for an Invalid' shown at the British Institution in 1861.

To say that Collinson never again achieved the success of 'For Sale' and 'To Let' is not to say very much, even if we believe in the first place that those paintings were as successful as their subsequent history suggests. The *Athenaeum* obituary writer was hard put to comment on Collinson's later career – and we are talking about a period of more than twenty years – and few even of his exhibited pictures are now known. To judge from the titles, which are often so bland that any comment is impossible ('The Letter', R.A. 1864), he mostly stayed with tried and tested anecdote. Tried and tested by himself, but also by others: 'Off to the Derby' in 1860 (Frith?), 'The Blind Basket-maker' of 1862 (Wilkie?), and 'Cat's Cradle' of 1869 (Joseph Clark?). He retained his interest in conventual subjects ('A Sister of Nazareth' in 1867, 'Sisters of Charity Teaching Blind Girls to Sing' in 1869), and one's curiosity is aroused by 'Papa's Leggings' of 1866. There is also evidence of painting trips to France, in titles such as 'Fisherwoman, Boulogne' of 1866.

Collinson is listed for the last time as a member of the Society of British Artists, and seems to have exhibited in London for the last time, in 1870, at the age of forty-five. Among his last recorded works are a view of St Malo in 1877 and 'A Fishwife' in 1880.

Collinson died in 1881, according to W.M. Rossetti in the Spring,[59] but more precisely on 24 January of pneumonia at 16 Paulet Road in Camberwell, South London.[60] Christina Rossetti recorded James's death in her diary. She published a sonnet by him in 1885, noting that a 'friend' had given it to her many years before.[61]

Walter Howell Deverell (1827–1854)

MARY LUTYENS

Walter Howell Deverell came nearer than any other artist on the fringe of the Pre-Raphaelite movement to becoming a member of the Brotherhood. He died at twenty-six after exhibiting only nine pictures, only one of which was sold in his lifetime. His work has been underrated, and what is known of his life and art deserves to be told.

The Deverell family claimed to be descended from Jean d'Evrolle who came to England with the Conqueror. Other blood they were proud of was that of the Wykehams, through Alice, sister of William of Wykeham, and of the Spencers, John Spencer of Defford, an ancestor of the Earls Spencer, having married a Deverell heiress in the fourteenth century. The family prospered greatly as Wiltshire landowners until they took the losing side in Monmouth's rebellion in 1685 and lost all their possessions.

Walter Howell Deverell's grandfather, the Revd Robert Deverell, was curate at Castle Bytham, eight miles from Stamford, Lincolnshire, from 1802 to 1826, and for many of those years chaplain to Lady Willoughby de Eresby at Castle Grimsthorpe in the same county. In 1824 one of the Revd Robert's sons, Walter Ruding Deverell, on the eve of his departure for America, married Margaretta Phillips, of a well-to-do Pembrokeshire family. Her father was Stephen Howell Phillips, hence the artist's second name. The Revd Robert was unable to give his son any financial assistance on his marriage. A pair of miniatures at the time of the wedding show Walter Ruding to have been fair and very good looking, and Margaretta, a year older than her husband, dark and rather plain.[1]

Walter Ruding Deverell's eldest son, Walter Howell, was born on 1 October 1827 at Charlottesville, Virginia, where Walter Ruding had some kind of teaching job. Charlottesville was at that time a village of a few hundred inhabitants, dominated by the newly founded University of Virginia, and no parish records were kept until 1836. Walter Howell's birth was recorded in the family Bible which has been preserved, but the pages to do with the family were torn out by a later Miss Deverell who did not want anyone to know her age.[2]

Walter Ruding returned to England in 1829 and nothing is known of him until June 1836 when he became secretary of the Statistical Society

and lived at 25 James Street (which changed its name to Buckingham Gate in 1900)

Walter Ruding's and Margaretta's family eventually consisted of five boys – Walter, Spencer, Chantry, Wykeham and Ruding – and three girls – Jemima, Margaretta and Maria.[3] Walter Ruding, who was an erudite man, largely taught his sons himself, though at some time during his boyhood Walter was in Scotland with a private tutor who, he wrote, 'initiated me into the mysteries of Greek participles and Latin verbs' (see note 5). Walter became a proficient Latin scholar, his commonplace book being thick with Latin quotations. At the age of fourteen his journal shows him to have been keenly interested in politics, the theatre, racing, natural scenery, poetry and the arts. At fifteen he was writing poems and stories, some of which he managed to get published. Another lasting love was for amateur theatricals. He was producing and acting in performances of Shakespeare from an early age.[4]

In April 1840 Walter Ruding Deverell resigned the secretaryship of the Statistical Society when he was appointed Governor of the general prison in Perth at £400 a year, an office he held for only two years.[5] He then became secretary-assistant to William Dyce, the Director of the Government School of Design, opened in 1837 and accommodated at Somerset House in the three rooms at the top, previously occupied by the Royal Academy. Since the Director received only £400 a year, Mr Deverell's salary must have been less than he had received in Perth. True, an official residence at Somerset House went with the appointment, but then he had also had an official house in Perth.

When Walter was sixteen his father placed him against his will in the office of a solicitor friend in Westminster. By that age, however, the boy was so determined to become an artist that his father gave in, and the following year he was allowed to attend art classes at Sass's Drawing Academy in Bloomsbury,[6] a preparatory school for the Royal Academy. There he met Dante Gabriel Rossetti and fell under his spell. Although seven months younger, Rossetti from that time onwards became his mentor and closest friend. They had poetry and love of the theatre in common as well as art.

In December 1846 Walter was admitted to the Antique School of the Royal Academy, then at the National Gallery, to which Rossetti had preceded him in July. There was a very stiff entrance examination to this free Academy School, and then a boring probationary period of drawing from casts before advancing to the Life School. Millais, eighteen months younger than Deverell, had been at the R.A. since he was eleven (the

youngest student ever to be admitted), and Holman Hunt, six months older, was also there. In due course Deverell became a favourite with them all. 'If there was one man who, more than others, could be called the "pet" of the whole circle, it was Deverell', wrote William Michael Rossetti, who also called him 'very handsome and winning'.[7] Arthur Hughes described him as 'a manly young fellow, with a feminine beauty added to his manliness, exquisite manners and a most affectionate disposition'.[8] William Bell Scott recalled him as 'a youth, like the rest of them, of great but impatient ability, and so lovely yet manly a character of face, with its firmly formed nose, dark eyes and eyebrows, and young silky moustache, that it is said that ladies had gone hurriedly round side streets to catch another sight of him'. Bell Scott also referred to him after his death as 'as beautiful as "the morning-bright Apollo, young Apollo"'[9] (Walter had inherited his father's looks and his mother's colouring). Holman Hunt wrote of him: 'His spirits were, in fact, often boisterous... He would drop in upon me any evening by chance, chattering and laughing like a young child, but as he drifted through his gay prattle he would light upon a sad passage, and then his note would show the deep vein of pity, and even wrath, in his nature.'[10]

Hunt made a drawing of him in 1853, said by William Michael Rossetti to be an excellent likeness (see note 50). He was also the model for Claudio in Hunt's 'Claudio and Isabella' (TG 1984, No.45). He painted himself as Duke Orsino in 'Twelfth Night' (ibid., No.23); and in Millais's 'Isabella' he is the young man seated at the left, on the far side of the man holding up a glass of wine (ibid., No.18). Rossetti made three drawings of him enclosed in letters (see notes 37 and 38) and two small sketches.[11] There is also an early self-portrait at the Fitzwilliam Museum.[12] But the likeness that shows him most faithfully as described by Bell Scott is as the page in the left foreground of Ford Madox Brown's 'Chaucer at the Court of Edward III' (see TG 1984, No.7; Madox Brown's diary for 25 June 1849 has the entry: 'painted . . . the head of page from young Deverell (7 hours)').[13] Deverell was, however, very careless in his dress, often going out without bothering to button his shirt collar and sometimes literally out at elbow. He had better things to spend his small allowance on than clothes.

As well as visiting the studios of his new friends, Deverell would invite them home one evening a week when Mrs Deverell would banish the rest of the family from the sitting-room to give him privacy; and at the beginning of 1848 he revived with Rossetti the Cyclographic Society, joined by Millais, Hunt and others, to which the members contributed drawings that were passed round for criticism at a meeting every Saturday.

Grief had come to the family in April 1846 when Jemima died of consumption, aged fourteen.[14] A year later Deverell had his first picture exhibited at the Royal Academy – 'Reposing after the Ball' (a boy resting after a ball game) – and in 1848 another picture – 'Margaret in Prison visited by Faust'. Neither of them has been traced. By this time he had left the Academy School where he had evidently been thought highly of, for J.R. Herbert, one of his teachers there, was writing to his father in April 1848: 'You ought to be proud of your boy. I have no doubt as to his future success.'[15] Deverell continued to work at home as well as going to Life classes at a drawing school in Maddox Street which Rossetti and other friends were now attending at a fee of half a guinea a month.

In a page from his journal, dated by Deverell simply June but in fact 1848, he recorded:

I continue at Maddox St. (the early one) where I contrive to be punctual – going to bed very early in order to be up by five. . . I should not omit to say that I have idled one week away at my Uncle Mr Hogarth's house . . . playing with the children and above all watching the garden. I have quite a passion for watching in an open country, the glorious brilliance of the sky, the mighty convolutions and forms of the gray clouds, and all the freshness of summer foliage, the graceful maze of the boughs, the vivid gleams of sunshine through them, and the form and color of all wild weeds and vegetation. I do often wonder, doubt and yet hope, if this love of nature will ever come to anything? . . . Pity it is that in youth when the fancy is most fertile and the heart most bountiful and pure that we cannot make an outward and visible sign of it for want of knowledge in Art.[17]

At the same time as the Pre-Raphaelite Brotherhood was founded, September 1848, Deverell was appointed an assistant master at the Government School of Design at Somerset House where his father was still secretary. The hours were from midday until three for the Morning School and from six to nine for the Evening School. The fees for students were four shillings a week in the mornings, attended by about seventy boys, and two shillings a week in the evenings, attended by about 200, with three headmasters and five assistant masters. The emphasis of the teaching was on ornamental design for industry. A headmaster received only £150 a year, so Deverell's salary must have been small. He taught at both sessions in the class of Form under Henry Townsend and his assistant, Richard Burchett, who later became a headmaster of the School and remained a

friend of Deverell's for life. A museum had now been assembled at Somerset House for the benefit of the students which was to form the nucleus of the South Kensington Museum.[18]

Herbert prophesied to Townsend that Deverell would make an admirable master, and at the same time J.C. Horsley, one of the other headmasters, was writing to Mr Deverell praising Walter, but adding, 'I think so well of his abilities that I should be very sorry if his engagement at the School were to prevent the steady pursuit of his own studies'.[19] Walter managed to work hard at his own painting as well as being a most conscientious teacher.

Having exhibited nothing in the spring of 1849 (the year Rossetti exhibited 'The Girlhood of Mary Virgin' at the Free Exhibition, and Hunt 'Rienzi', and Millais 'Isabella' at the R.A., all three pictures bearing for the first time the initials P.R.B.), Deverell was working in the autumn and winter of 1849 on the scene from *Twelfth Night* when Duke Orsino asks the jester to 'sing that old and antique song we heard last night' (see note 23). The Duke was said to be a good self-portrait of Deverell, though without his moustache; Rossetti was the model for the jester and Elizabeth Siddal for Viola. The story of how Deverell discovered Elizabeth Siddal when he went with his mother to buy a bonnet (she would never buy a bonnet without his advice) is well known. Her hair was just the colour he was seeking for Viola, a coppery gold. His mother arranged for the girl to sit for him and she went to Somerset House where she was chaperoned by Mrs Deverell. The day after this first sitting, according to Holman Hunt, Deverell went to his, Hunt's, studio where Rossetti was with him, and 'dancing to and fro about the room . . . whispered "You fellows can't tell what a stupendously beautiful creature I have found . . . to-day I have been trying to paint her . . . To-morrow she's coming again; you two should come down and see her"'.[20] Hunt could not go; Rossetti did, and so entered upon the great romance of his life. The only uncertain thing about this story is the date of the meeting. On 14 December 1849 William Rossetti recorded in the P.R.B. Journal: 'Gabriel . . . painted at the hair in Deverell's picture part of the morning.'[21] Since Elizabeth Siddal's hair was her greatest attraction, it seems reasonable to assume that it was Viola's hair in 'Twelfth Night' that Rossetti had been painting and that he had therefore met the girl before the middle of December 1849.

Deverell also made an etching of Elizabeth Siddal as Viola for the fourth and last number of *The Germ*, the Pre-Raphaelite journal – the scene where Viola first visits the veiled Olivia. William Rossetti justly calls it 'defective in technique. . . This face does not give much idea of hers, and yet it is not

unlike her in a way'.[22] The etching has a certain awkward charm.

Deverell was one of the eight proprietors of *The Germ* which first appeared in January 1850. In the second, February, issue he contributed a poem, 'The Light Beyond', consisting of three sonnets. The first lines give the tone:

> Though we may brood with keenest subtlety
> Sending our reason forth like Noah's Dove,
> To know why we are here to die, hate, love . . .

and ending with a 'reconciling vision of God's plan'.

The last number contained a much longer poem by Deverell, entitled 'A Modern Idyll', about his little girl cousin playing in a garden, probably one of the children he had played with while watching the garden of his Uncle Hogarth's house.

In April 1850 Deverell exhibited 'Twelfth Night' (TG 1984, No.23)[23] at the National Institution of Fine Arts (as the Free Exhibition had become) at the Portland Gallery in Langham Place. William Rossetti gave it a very long, anonymous review in the *Critic* on 1 July, praising it on the whole but pointing out some of its weaknesses:

> . . . For the Duke something of a more noble refinement, and certainly of nobler action, might have been selected. . . The head of *Viola* is beautifully intended, but not physically beautiful enough, owing, as we fancy, to inadequate execution . . . we think the impolicy as well as immodesty of her short dress must have been overlooked by the painter . . . Mr Deverell has here, for the first time in a form at all conspicuous, entered on art boldly and with credit to himself; his faults are those of youth, and his beauties will doubtless mature into the resources of a true artist.

It is a remarkable work for a man of twenty-two. There is an attractive informality about the Duke; one can believe that he loves music and that Viola loves him.

When in May 1850 James Collinson resigned from the P.R.B., Deverell was nominated by Rossetti to take his place. William Rossetti was writing in the P.R.B. Journal in October:

> Deverell has worthily filled up the place left vacant by Collinson. His work at the National Institution this year was a strong ground of claim; and this has been confirmed by what he has since done and is doing. He hopes to exhibit two pictures next year: Rosalind witnessing

the encounter of Jaques and Orlando in the forest, – which is pretty nearly finished; and the ordering of Hamlet's departure for England [see p.83] . . . Other recent designs of his are the converse of Laertes and Ophelia, Claude du Val dancing with a lady of quality after attacking her carriage (in the possession of Stephens), James 2 in his flight overhauled, and his person rifled by Fishermen [pl. 36],[24] (given to Gabriel), and the flight of an Egyptian ibis.[25]

Deverell must certainly have considered himself a member of the Brotherhood when he received the following letter from Frederic Stephens, written on 23 December 1850: 'I am writing to the P.R.B. to come here [59 Walcott Place] to hold the anniversary meeting on the 2nd January. You must come and we will elect you into your proper chair in form.'[26] This meeting does not seem to have taken place, and on 13 January 1851

. . . a meeting of the P.R.B. (not including Deverell) was held, and a resolution passed thus: 'Considering the unforeseen vacancy as above stated, Resolved that the question of the election of a successor be postponed until the opening of the year's art exhibitions' – i.e. until May. And before May 1851 the Pre-Raphaelite Brotherhood, tho' never expressly dissolved or discontinued, had ceased to have any corporate solidarity, and so the question of Deverell's election was not further raised.[27]

Before this, an even greater sorrow than Jemima's death had struck the Deverell family: on 21 October 1850 Mrs Deverell had died at Somerset House. She had had hepatitis for three weeks and bronchitis for one week. Mr Deverell comes suddenly into focus with a long poem he wrote 'For the gravestone of my beloved wife' – all the more touching for being such bad verse:

. . . Here mother and daughter lovingly side by side repose.
Death withered first the offspring bud, then snapped the parent rose.
My child, Jemima, dearest, since thou here last slept
How lorn has been thy mother, how often has she wept!
And now thyself art gone! Margaretta! my angel wife!
O that my tears and prayers could bring thee back to life! . . .[28]

By December 1850 Rossetti and Deverell had decided to share rooms on the top floor of 17 Red Lion Square (the same rooms that Burne-Jones and William Morris were to occupy in 1856). The rent was £1 a week. Deverell was to live there and Rossetti to use it as his studio. William Rossetti

recorded this in the P.R.B. Journal on 7 December, adding that the landlord had stipulated 'that the models are to be kept under some gentlemanly restraint, "as some artists sacrifice the dignity of art to the baseness of passion"'. William went on: 'Little seems to have been done to his [Deverell's] pictures: to the *Hamlet* scarcely anything; to the *As You Like It*, some repainting on Orlando's figure and progress in the head of Rosalind.'[29] Deverell must have been relieved to get away from the house of mourning where he would have found it difficult to paint.

In April 1851 he exhibited 'The Banishment of Hamlet' at the National Institution. It was a smaller picture than 'Twelfth Night', though the actual size is unknown, for it was later destroyed in a gas explosion. William Rossetti reviewed it anonymously for the *Spectator* of 19 April, having become art critic for that paper late in 1850:

> ... The florid-complexioned military-looking Claudius is by far the best conception of the character we have in painting; while his sudden nervous action, and ill-disguised embarrassment as he quails beneath the serenity of Hamlet are of fine subtlety. Not less distinct is the embodiment of Hamlet himself. There is a certain brooding indolence in his whole figure... The figures descending the 'stairs of the lobby' with the dead Polonius, the whispering faces of Rosencrantz and Guildenstern ... and the glimpse in another room of the Queen, and of poor Ophelia among her women, not to be comforted, and pressing her head as though to keep out madness – all these are points of thought and feeling which rank Mr Deverell high in our new generation of art ...

In late May Rossetti left Red Lion Square to share a studio with Madox Brown,[30] and Deverell, unable to afford the rooms on his own, returned to Somerset House. It was on the 13 and 30 May this year, 1851, that Ruskin's letters defending Millais's and Hunt's pictures at the R.A. appeared in *The Times*, turning the tide in favour of Pre-Raphaelitism.

By 1852 the museum of the School of Design, enlarged and enriched by purchases from the Great Exhibition, needed more space for its collection and the Prince Consort offered it rooms in Marlborough House. The museum moved there in April and Mr Deverell lost his home. He rented a house with a large garden at Kew near the Green, called Heathfield House, belonging to the Englehardt family and dating from 1760. The name has now been changed to Adam House, 352 Kew Road. The top floor and basement have apparently not been changed since the eighteenth century, and one of the ground floor rooms has retained its original cornice and decorated plaster ceiling with a painted figure in the centre. The simple

narrow staircase is also original. It is an elegant, unpretentious house on
three floors with no large rooms.

The School of Design itself did not move until 1853 when the Treasury
requisitioned the rooms at Somerset House; it was then accommodated in
wooden huts in the courtyard of Marlborough House. For over a year,
therefore, Deverell had to travel six days a week from Kew to Somerset
House and back, and afterwards to Marlborough House, sometimes in
draughty railway carriages and sometimes, at night, having to walk all
the way, journeys which he believed damaged his health. The stable at
Heathfield House (now a double garage belonging to Adam House but
divided from it by a neighbour's garden) was fitted up for him as a studio.
Perhaps because of the move he exhibited nothing in 1852.

It was probably during that summer of 1852 that he wrote this poem,
'The Garden':

> Except the voice of birds, there is no sound.
> The fruit-trees rustle not: the sultry whirr
> Of insects, it is true, is all around,
> Swimmingly about me with a swoony stir.
> The sparrows peck the peaches. Branches green,
> In most admired confusion interlaced,
> Look down upon the walks – a shady screen
> Of languid coolness; emerald and bright,
> With golden patches of the sun's warm eye.
> Flecked only by the faintest cirrhi white,
> A blank pale blueness reigns throughout the sky.
> It might be thus that Isaac Newton paced,
> And saw the apple drop upon the mould.
> The apple more than Adam's sure was graced –
> Telling the laws of nature's Goddess old,
> A revelation vast and manifold.[31]

Deverell worked very hard during the rest of 1852 and had several pictures
ready for the 1853 spring exhibitions. 'The garden of the house at Kew was
a great delight to me –', he wrote in his journal in 1853, 'with its vistas of
shrubs flowers & trees from which I painted carefully a background to the
picture of 2 Miss Bird [note 42] and also the conservatory in *The Pet*
[TG 1984, No. 54] now on view . . . in Liverpool – but I fear from its coldness
this studio was very destructive to my health.'[32]

The garden is very much smaller now; trees have been cut down to make
room for other buildings and the house has been built out at the back;

35 W.H. Deverell, 'As You Like It', 1850–3; oil, 32½ × 19¾ (82.5 × 50.2); *Birmingham Museum and Art Gallery*

36 W.H. Deverell, 'James II Overtaken in Flight and Robbed by Fishermen', 1850; pen and wash, 11⅝ × 15³⁄₁₆ (29.5 × 38.6); *Birmingham Museum and Art Gallery*

37 W.H. Deverell, 'The Grey Parrot', 1853;
oil, $21\frac{1}{16} \times 13\frac{7}{8}$ (53.5×35.2);
National Gallery of Victoria, Melbourne

38 W.H. Deverell, fragment of 'Miss Margaretta and Miss Jessie Bird', 1852–3; oil, 17 × 14 (43.2 × 35.5); *Mrs Pamela Greenman*

below left
39 W.H. Deverell, 'Eustatia', 1853; oil, 22 × 14 (55.9 × 35.5); *Tate Gallery*

below right
40 W.H. Deverell, Portrait of Spencer Deverell, *c.*1846; oil, 21½ × 15½ (54.6 × 39.4); *Mrs Diana Plowden-Wardlaw*

nevertheless it is possible to see the spot from which Deverell painted 'The Pet', the wall on the left having remained as it was.

The painting of the mock marriage of Orlando and Rosalind from *As You Like It* (pl. 35) was also finished at Kew (this is a different picture from the meeting of Orlando and Jaques). Deverell's elder sister Margaretta accompanied him to Combe Wood for the background 'where she was expected to pose as Rosalind regardless of weather. A special dress was made for her for this picture – a grey tunic. Sometimes Walter continued to paint under an umbrella in spite of his sister's remonstrance'.[33] Rosalind is indeed wearing a grey tunic in the picture and also grey breeches; she is standing on a carpet of autumn leaves not yet covered by the new bracken in the left foreground. Deverell's brother Spencer was the model for the fine head of Orlando;[34] the awkward pose of the figure is due to the long bow under his left arm.

But Deverell's earlier pictures were still unsold, greatly to the annoyance of his father who believed he could get him many commissions if he would give up narrative painting and take to portraiture.[35] Another attraction of Kew for Deverell was the acquaintance of Mr N. Angel, the actor-manager of the Richmond Theatre, who occasionally gave him small parts to play for practice and pleasure'. Mr Deverell is unlikely to have approved of this activity either, for Walter himself owned that acting was not a suitable profession for a gentleman.[36]

Rossetti had warmly praised Deverell's 'Twelfth Night' to his own patron, Francis McCracken, the Belfast shipping agent and art collector; in consequence Deverell received a letter from McCracken in March 1853 asking him to send him the 'Twelfth Night' at his expense and any other pictures he could. McCracken had a bad habit of part-paying young artists with other pictures he no longer cared for, and three such pictures he now offered to Deverell in part exchange. Deverell sent McCracken's letter to Rossetti who replied:

> Victoria! Said I not that I knew the beast? The letter of his which you sent me yesterday is a triumph of our diplomacy, and today I have just received another letter from him in which he says that I '*must* get you to send over the pictures, whether or not you consent to exchange'.[37]

Deverell did not send the 'Twelfth Night' since he had a chance of exhibiting it in Dublin; he sent instead 'The Banishment of Hamlet' which called forth letters from Rossetti of 23 and 31 May, saying in the first, 'MacCrack seems in a terrible state to see your picture ['Twelfth Night']. I fear he will fall ill if it does not reach him soon'. In the second letter Rossetti

wrote how extremely sorry he was to hear that Deverell had been so ill: 'Has Burchett got the school people to give you a holiday? You are shockingly in need of a change of air.' This is the first mention of Deverell's illness – Bright's Disease, a disease of the kidneys.[38] Mr Deverell was also ill by this time and had had to retire from work.

In March 1853 Deverell recorded in his journal:

Sent off to the Suffolk St [the annual exhibition of the Society of British Artists] two pictures – 'The Grey Parrot' [pl. 37] and 'Eustatia' [pl. 39]. They are both an advance as far as strength of effect is concerned – but the color to my eye seems to be heavy and dull. On these I have tried the effect of glasses over them which in my opinion not only serves in the most wonderful way to preserve oil pictures as I have found by personal experience but also takes off all the little blemishes of the surface and gives atmospheric quality to the colour. Having de-spatched these two I commenced finishing on the picture from 'As You Like It', re-designed and painted an entirely new figure of Rosalind, this making the 4th figure having previously erased three, and also improved the face of Orlando [possibly by adding a moustache]. Altogether I am more pleased with this picture than anything I have yet done. To the picture of *Irish Vagrants* [TG 1984, No. 53][39] did very little this month. If any of the pictures are rejected I should prefer it to be this – Rossetti seemed of opinion that I should not exhibit it this year. As the subject was so good & important I had better paint it on a larger scale – I must confess however that I myself do not regard it so unfavourably, tho' I hardly know what to think of it till some little time has elapsed – when I shall be able to regard it with less partiality – The stern head of the Irish woman seems to offend greatly the few casual visitors I have had [people did not drop in on him at Kew as they had done at Somerset House] tho' it is certainly one of the most just & natural expressions I have ever done . . . The duties of the Westminster [Marlborough House] School slightly increased owing to lessons in practical Geometry which Mr Burchett has delivered, many of the students being unable to follow him it is necessary to explain and work the figures out for them on the evenings following.

In April the journal continued:

About this time the Suffolk Street Society opened – but not having much curiosity about the matter remained in ignorance as to whether my pictures were received – until by chance I dropped on a No. of the Spectator a week old in which I found a very kind and indulgent notice

of myself – It then became known as to the fate of the pictures sent to the Academy Exhibition. I had sent five – two only of which were received and these badly hung – The portrait of the Misses Bird [pl. 38] was in the East room at the further end. It was hung rather too high to be seen well – The Marriage of Orlando and Rosalind ['As You Like It'] was disgracefully hung – the most insulting position in the Octagon Room – So all my hopes and labours of the preceding year were overthrown at one fell swoop![40]

And the hopes of a lifetime, for within ten months he was dead. It is strange that he should have felt no curiosity about the fate of his pictures at the Suffolk Street Gallery. The 'kind and indulgent notice' was, of course, by William Rossetti: 'The two best and most pleasing single pictures – *The Grey Parrot* and *Eustatia* by Mr Deverell – are shabbily banished to the Watercolour Room. Of the first a small study appeared in the British Institution [untraced].'

'The Grey Parrot' is a delightful picture. A young woman is seated, showing her right profile, near a window half veiled with a white curtain. There is an open book on her lap and she is caressing with her left hand the head of a parrot perched on her right hand. Her dress is a deep grey, trimmed with white, and the parrot is greenish grey with a bright red tail.

'Eustatia' is also the portrait of a young woman, standing, almost in full face, dressed in deepest black, except for a blue collar, and holding a white lace-edged handkerchief. The picture shows how right Mr Deverell was in thinking that Walter would be successful as a portrait painter.

On the old mount of another study for 'The Grey Parrot'[41] is written 'Eustatia Davy (Mrs Lawrence)'. Not only do the women in 'The Grey Parrot' and 'Eustatia' look very much alike (although their hair is a different colour), but the model for 'The Pet' seems also to have been Eustatia Davy. All three young women wear their hair in plaits round their heads and have exceptionally full under-chins.

William Rossetti's review went on to say that the picture of 'Orlando and Rosalind' at the Academy was so badly hung that it was impossible to see it. Of the other Academy picture he wrote: 'Mr Deverell almost makes a subject out of his portraits of *Miss Margaretta and Miss Jessie Bird*,[42] which evince the sense of graceful propriety to be perceived in his pictures of incident. Everything here is very nicely characterized, though not highly wrought.'

There is no record of which three pictures of Deverell's were rejected by the Academy. One of them may have been 'The Pet'. 'The Irish Vagrants'

may have been another. It is at present unfinished, but there is evidence from x-ray photographs that Deverell painted out part of the background, so it is quite possible that after its rejection by the R.A. he began some repainting which was never finished. This is perhaps his most interesting and original picture. There were still many beggars in England at that time driven from their country by the potato famine, and in the expression of the man's face, even more than in the 'stern' expression of the woman's profile, Deverell has managed to convey despair.

Deverell was given a fortnight's holiday at the end of May. He went to Windsor because Mr Angel had taken the Royal Theatre there for Ascot week and Deverell had agreed to act for him during that week which in 1853 ran from Tuesday 7 June. He went down the week before – 'I was out all day by the river side and the fresh air, weather and idleness recruited me wonderfully'. He stayed first at Copeland's Coffee House in the High Street, but finding it too expensive moved to The Jolly Miller – 'a little dingy public at the village of Clewer some two miles from Windsor' (Clewer is still a charming village on the river). He devoted the Ascot week entirely to acting, and since no play was repeated more than twice, he was continually busy learning and rehearsing his parts. He returned to Kew very anxious to know how his father was progressing and found him much weaker.[43]

Mr Deverell died at Heathfield House on 25 June, aged fifty-two. His occupation is given as 'gentleman' on his death certificate, and the cause of death as 'Stricture of the Urethra 4 months Catarrhus Viscia'. The most common cause of stricture of the Urethra is gonorrhoea. But whatever the cause in Mr Deverell's case, the only treatment for stricture would then have been regular rodding. Mr Deverell may well have died of an infection from an unsterilised instrument used in his treatment. Rossetti was later to write about his death that it was on the whole a relief, for 'old D. was the perpetual torment of everyone around him'.[44] And Millais afterwards wrote, 'The father was a very learned man but a determined atheist, and died without altering his opinions. His behaviour was frightfully cruel to his now dying son. He would never permit his children to attend church, turning religion into ridicule on all occasions'.[45]

This account of Mr Deverell's atheism is puzzling. The poem he wrote on his wife's death was not the work of an atheist. It ended:

> To be forever with thee in those bright realms above
> And know, with all our sins forgiven, that 'God is love' . . .
> Prostrate, we adore, and say, 'Thy will be done'.

[91]

Perhaps it was the Church rather than God he did not believe in. The Church had denied his father preferment for at least twenty-four years.

The responsibility for the support of the family now fell on Deverell. By this time there were only two boys and two girls living at home. Margaretta was grown up, but Wykeham was only sixteen, Ruding fourteen and Maria twelve. Nothing is known of Chantry except that he went to Australia and became something of a black sheep. He may have gone in 1852 when so many young men went out there in the gold rush, and it is possible that Spencer (pl.40), about whom nothing at all is known after he posed for the head of Orlando, may have gone with him.[46]

Heathfield House had to be given up and the family moved to 3 Margaretta Terrace, leading from Oakley Street off the King's Road. Built in 1851 the house had two good-sized rooms on the ground and first floors connected by double doors, and two bedrooms of the same size on the second, top floor, as well as a third, small bedroom. There was no basement, so the kitchen must then have been built out into the yard at the back. The original pretty cornices and fireplaces are still in situ. It was definitely a gentleman's and not an artisan's house.

Deverell noted in his journal that he took with him carefully from Kew the pictures he was 'occupied with' – 'The Pet', 'As You Like It', 'The Irish Vagrants', 'The Young Couple' and a miniature sketch of 'Young Children Watching a Funeral' (probably noticed at his father's funeral), then on view at Birmingham. He began to work on two large canvases which were merely in outline at the time of his death – a self-portrait and 'The Doctor's Last Visit'.[47] Rossetti maintained that there was nothing morbid in this last subject, painted at such a time; it was an idea that Deverell had had in mind when they were sharing a studio.[48]

By October Deverell was very ill and had had to give up work at the School, though he continued to paint at home. Holman Hunt wrote to tell this news to Millais who was at Glenfinlas with the Ruskins. Millais replied on 20 October that he would do anything to help. He showed Hunt's letter to Ruskin who wrote to his father on the same day: 'The enclosed letter is from Hunt – the P.R.B. . . . it refers to one of the Pre-Raphaelites, Deverell – who has been unsuccessful and appears to be a person to whom a little kindness, in the way of a shape of rice or a little sweet sherry or anything which would signify some care of him, would be a true service.'[49]

At Hunt's suggestion, Hunt and Millais bought between them for £80 Deverell's picture 'The Pet', then on show at Liverpool. Millais would have bought it anonymously if Hunt had not preferred to take 'the comforting news' to Deverell himself. While he was there he made a drawing of his

head, pronounced by William Rossetti to be the best likeness of him.[50] He looks more than twenty-six, but then he was ill and anxious. Even if Hunt had not told him who had bought the picture he would have known, for the secretary of the Liverpool gallery wrote on 31 October congratulating him on having his 'work purchased by two of the most distinguished artists of the present time', and naming them.[51] Deverell must surely have realised that the picture had been bought as an act of charity. All the same, the £80 would have been a godsend to him; it was what Wykeham was soon to be earning for a whole year in some unspecified job.

Rossetti had heard by this time that Deverell's doctor had said that he could not live six months, but when calling on him he had found him in his usual good spirits. He did not seem to suffer much in the evenings, though his feet and ankles were swollen and he was 'always in trouble with diarrhoea'; the morning was his worst time. He was eating nothing but bread and milk. Madox Brown's friend, Dr Marshall, went to see him at his request and took an equally grave view of his case. William Allingham, the poet, who had been on a visit to London from Coleraine where he worked in the Customs Office, had been with Rossetti to visit him; Allingham had recently seen Deverell's 'Twelfth Night', on exhibition at the Royal Hibernian Academy in Dublin, and had heard it was sold. Rossetti hoped this was true, but could not get Deverell to take the trouble to write and find out.[52] Deverell had shown the same strange indifference, it may be remembered, to the fate of his pictures at the Suffolk Street Gallery in April.

The picture had not been sold. When Allingham returned to Ireland he did his best to persuade Francis McCracken to buy it through a friend of his, the treasurer of the Hibernian Academy, who was also a friend of McCracken's. Now, however, McCracken had lost interest and did not even want to see it. Allingham wrote to Deverell telling him of his efforts and then asking him if he would make a drawing for a wood-engraving for the title page of a little book of his poems, *Day and Night Songs*, which Routledge were soon to publish. He then described in detail the design he had in mind.[53] Deverell made this drawing, carefully following Allingham's description (pl.41), and it appeared anonymously in the first (1854) edition of *Day and Night Songs* – now a very rare book, for Deverell's wood-engraving did not appear in later editions.

On 12 November Deverell himself wrote to the artist Andrew McCullum, saying that McCullum's letter and invitation to stay had been like 'a sweet burst of music' to him, but that for some months past he had been 'seriously ill' and obliged to keep to his bed, forbidden by his doctor 'to go outside the door'.

My ailment [he went on] appears to be some complicated, chronic disarrangement of the bowels and kidneys, brought on it is supposed by my railway trips of a night from Kew to Westminster & back. You must know that as my School did not close till after nine I rarely reached home at Kew until eleven at night and I was exposed to every kind of bad weather which it appears has had a nearly fatal effect upon me . . . Of course in my present health I cannot follow art in the vigorous & persevering manner it ought to be followed but I try and keep up to it for a short time each day in as *game* a style as I can. I have during the past month been steadily at work upon two modern subject pictures . . . have retouched the Twelfth Night which has won me many kind opinions & letters from people in Dublin where it was sent; but although many have haggled about it, have not succeeded in selling it yet, however I have lately sold a small picture at Liverpool for £80 – . . . I began this note thanking you for your kindness & while I write old Mr Ruskin, the father of the Graduate, has been sent here by the latter to enquire after my health although I have never seen him & am not acquainted with him – He merely having seen one or two of my pictures. The good old gent introduced himself & has sent me presents of wine & game, new laid eggs ec ec [none of which Deverell could eat] . . .

At the top of this letter Deverell had unaccountably written 'P.R.B. at Somerset House from 1848'.[54]

Of all his friends, Millais and Stephens were the most attentive to Deverell during his last months. Millais often sat by his bedside reading the Bible to him, though he resisted Millais's persuasions to see a clergyman. Millais would stay with him so late that he would sometimes have to walk back to Gower Street in the snow at midnight.[55]

On 30 December Millais wrote to Mrs Thomas Combe, wife of the Superintendent of the Clarendon Press at Oxford, to ask if she could recommend a nurse for Deverell, whom he, Millais, would willingly pay for. As well as being so ill, Deverell had

a poor little sister who soon after the father's death was struck with paralysis in the right arm, the use of which she has lost for life . . . My poor friend is so uncaring of himself and his eldest sister is so unfit to nurse him . . . Last night I was with him, and was grieved to see the apathy of the servant[56] and his sister, who had been out that night at a dance, and was now gone to bed! There was no fire in his room, and the invalid was hanging partly out of bed, with his hands as cold as

ice. I am going there again to night to amuse him. It is almost cruel to tell him of his danger, as he is so alive to the distress that will come upon his family in the event of his dying. [57]

Deverell continued to paint, almost up to the end when he could hardly stand from weakness. One of the last times Rossetti saw him 'he rose up in bed as I was leaving and kissed me, and I thought then that he began to believe that his end was near'. [58] He died on Thursday, 2 February at four o'clock in the afternoon, three months after his twenty-sixth birthday. Millais wrote on the same day to Mrs Combe, 'I have just come from inquiring after Deverell, who died whilst I was in the house. I sent (for I could not see him) a message urging him to see a clergyman, but when the cousin who had been with him got to the door of his room she found it locked, and ascertained from the nurse within that all was over'. [59]

The cause of Deverell's death on his certificate was 'Albuminaria some years Ulceration of the bowels six months Dysentry six months'. Albuminaria is Bright's Disease which he could have got from a streptococcal sore throat or scarlet fever. His journeys from Kew could not have caused the disease but might have aggravated the symptoms.

Rossetti, whose grief was very deep, told Madox Brown that Deverell had 'retained his senses to the last, and died without pain. He had been told in the morning that he could not live through the day and he appeared to receive the announcement without either emotion or surprise, saying he supposed he was man enough to die'. [60] He was buried in the graveyard of Brompton Parish Church on 7 February.

After Deverell's death Richard Burchett would have taken the younger girl into his own home if Wykeham had not wanted to keep the family of four together. Wykeham got a post at £80 a year; Ruskin found Ruding a job with his publisher, Smith, Elder, while the girls each had about £40 a year of their own. John Miller, a Liverpool merchant and art collector, bought the 'The Mock Marriage of Rosalind and Orlando' for 50 gns some six weeks after Deverell's death. When Wykeham and the others moved to lodgings, Mr Burchett gave house room to Deverell's pictures from Margaretta Terrace (it was while they were with him that 'The Banishment of Hamlet' was destroyed in a gas explosion). The rest remained with him until 1866 when Rossetti took them into his own house in Cheyne Walk in the unrealised hope of selling them for the family.

To sum up: of Deverell's paintings, 'The Pet' (the only one sold in his lifetime), the two 'As You Like It' pictures, 'The Grey Parrot', 'The Irish Vagrants', 'Eustatia', the early self-portrait and the portrait of Wykeham

as a child have found their way into public galleries. 'Twelfth Night' is in the Forbes Magazine Collection, and the portrait of Spencer and part of 'The Two Miss Birds' belong to Wykeham's granddaughters. It is possible that other pictures mentioned in this essay may still come to light. It is worth looking out for them.

41 W.H. Deverell, wood-engraving on title-page of William Allingham, *Day and Night Songs*, 1854

Was there Pre-Raphaelite Sculpture?

BENEDICT READ

In the entry in the P.R.B. Journal for Friday, 16 to Friday, 23 May 1851, William Michael Rossetti wrote: 'We saw Tupper's bas-relief, which the Academy rejected. It is illustrative of the "Merchant's Second Tale", by, or ascribed to, Chaucer, and represents the chessplaying between the Merchant and the old man he meets in the strange city. It is at the extremest edge of P.R.Bism, most conscientiously copied from Nature, and with good character. The P.R.B. principle of uncompromising truth to what is before you is carried out to the full, but with some want of consideration of the requirements peculiar to the particular form of art adopted. According to all R.A. ideas it is a perfect sculpturesque heresy, whose rejection – especially seeing that it is the *introductory* sample of P.R.B. system in sculpture – cannot be much wondered at, though certainly most unjustifiable.'[1] In spite of some qualification on the writer's part about half way through, the passage could be said to indicate not only that there was a sculptural context within Pre-Raphaelitism, but also that there were quite specific Pre-Raphaelite values that could be applied to sculpture.

On the other hand, John Lucas Tupper is not the first name that springs to mind as a Pre-Raphaelite sculptor, or as a Pre-Raphaelite at all. The same could be said of the sculptors John Hancock and Bernhard Smith, although the first of these features in the second entry in the P.R.B. Journal (Wednesday, 16 May 1849), 'requesting to be informed whether he might put P.R.B. to his works',[2] while the latter signed a plaster medallion portrait of Miss or Mrs M.E. Gray of 1849 'Bernhard Smith PRB'. It is true that the sculptor Alexander Munro sometimes features in the literature of Pre-Raphaelitism, particularly for his work 'Paolo and Francesca' (TG 1984, No.44) which, thanks to some connection with Rossetti's handling of the same subject, has been claimed as the only true example of Pre-Raphaelite sculpture. But little reference is made to the rest of his oeuvre or career, apart from his being a possible source for the public revelation of the meaning of the initials P.R.B. As for Thomas Woolner, his main claim to fame has been until very recently that the occasion of his departure as emigrant to Australia in 1852 served as inspiration for Madox Brown's 'The Last of England'. Grudgingly admitted as a Pre-Raphaelite Brother,

reference to his work pending the duration of the Brotherhood is most commonly to his poetry, sometimes called 'sculpturesque'. This it certainly is, according to the definition given by Coventry Patmore, who first called it such; but most other users of this term make of it a gesture towards Woolner's main profession, and then pass on without further examination of it, and The Last of England becomes in effect The Last of Woolner.

Such references in the secondary sources for Pre-Raphaelitism may eventually sound like a defiance of history; there are, nevertheless, particular circumstances surrounding sculpture in general in the period in question that make it difficult to place in any context, let alone that of the Pre-Raphaelite movement. Study of Victorian sculpture has until recently been virtually non-existent, so that even a general framework of reference has been lacking. Recent study, such as it has been, serves only to indicate that the 'condition of sculpture', so to speak, is so different from the situation with regard to painting – conceptually and practically – that any attempt to connect their ideologies will be liable to difficulty. To take some simple illustrations of this: there is no equivalent in British painting in the first half of the nineteenth century to the singular predominance of the neo-classical ideal in sculpture of the period, nor was there a similar historically-conceived conceptual structure for the development of sculpture that could come up with an obvious equivalent to pre-Raphaelism in painting. Even the basic structure for the practice of sculpture was too dissimilar for easy parallels to be made; a sculptor was much more dependent on patronage to realise his works in a final state of marble or bronze, with the result that a much greater conformism to market demand prevailed. It was one of the most consistent complaints of sculptural apologists that artists were bound to portraiture (particularly busts) and funerary commemoration because these were the only means of livelihood, while the Ideal Works (from literature, mythology and so on) in which the sculptor was most able to express the heights of his art must remain, if formalised at all, often only provisionally so, in plaster that was all too perishable.

These features of the particular 'condition' of sculpture bear directly on the question whether there was Pre-Raphaelite sculpture. Study of the subject is still so rudimentary that, although enough of the oeuvre of Woolner or Munro is in evidence for some sort of assessment to be possible (and this is why both will feature so strongly in what follows), even the dedicated enthusiast cannot yet reconstruct the oeuvres of Tupper, Hancock or Smith. Smith, it is true, almost certainly gave up sculpture in his early thirties after emigrating to Australia with Woolner; while the

latter was not to be deterred, Smith instead followed a career as a minor public official, becoming a police magistrate. Tupper, though, was active as a portrait sculptor until the late 1860s, while Hancock's professional career extended over more than twenty years, with production of a full range of typical Ideal subjects from the Bible, Milton, Spenser, as well as Dante (for which, see later) and Shakespeare – so far, at any rate, as one can tell from the lists of his Royal Academy exhibits. But virtually all trace of the bulk of their works has disappeared and the few that do survive, by presence or illustration, while sometimes tantalisingly suggestive, are too random to constitute a definite picture.

The problem of absenteeism in sculpture, the basic non-survival of work that is almost total for Smith, Hancock and Tupper, applies in the particular circumstances of the period 1847 to 1851 even to Woolner. For while 'Puck' (TG 1984, No.2) and the early Tennyson medallion (ibid., No. 30) may have survived, it is clear that Woolner was at work on higher things. Holman Hunt describes visiting Woolner's studio in 1847 and seeing there a colossal figure standing in the middle: 'It was an illustration to the text "Lo, one generation passeth away, and another cometh;" the past generation was represented by a figure prostrate on the base, while the advancing epoch was striding over him somewhat disdainfully.'[3] It was partly on the evidence of work like this that Woolner became a member of the Brotherhood; other works, like Tupper's Chaucer subject referred to earlier, feature in the P.R.B. Journal, but, like Tupper's, do not survive; such works, conceived at the height of the Pre-Raphaelite movement, by their absence must make answering the question 'Was there Pre-Raphaelite Sculpture?' that much more difficult.

It will be apparent from the miscellaneous pieces of evidence so far cited that at the very least a certain sculptural context for Pre-Raphaelitism existed. This is confirmed in theory in the articles in *The Germ* on 'The Subject in Art' where sculpture almost invariably follows painting as 'Art' is defined. One has a slight feeling that it is almost inserted *de rigueur*, as there are no specific discussions of sculpture in the articles. On the other hand, they were actually written by J.L. Tupper, who was a sculptor, so the references may be spontaneous. Elsewhere in the periodical sculpture is less systematically mentioned in Orchard's 'Dialogue on Art', featuring specifically only in a discussion on nudity. On the other hand, the first number opens with poems by Woolner; the first discussion about *The Germ* took place in Woolner's studio (14 August 1849); Woolner was instrumental with Dante Gabriel Rossetti in appointing William Michael Rossetti as editor; Woolner, Hancock and Tupper were all present when

the title *The Germ* was settled on, and it was Woolner who initially proposed (successfully) that contributors should be anonymous. So sculptors (if not sculpture itself) were quite effectively involved in the publication.

In the P.R.B. Journal there is no question of the non-association of sculpture with the Brotherhood. As already mentioned, Hancock appears almost immediately, asking whether he might put 'P.R.B.' to his works, and features intermittently thereafter; Tupper's frequent mentions climax in the designation of his Chaucer relief as Pre-Raphaelite sculpture. Smith occurs less frequently, Munro (for some reason) scarcely at all. But this is well made up for by Woolner who gets 110 mentions, third among the Brotherhood only to the two Rossetti brothers and actually exceeding Hunt (89) and Millais (71);[4] such statistical seniority is not surprising granted Woolner's membership of the Brotherhood. Moreover the references are by no means confined simply to his presence or literary activity; at least thirteen works of sculpture are mentioned between May 1849 and January 1853. This must finally and ultimately confirm the presence of sculpture within the Pre-Raphaelite movement.

What such evidence does not tell us, of course, is in what way this sculpture beyond its simple presence should be defined as Pre-Raphaelite. The case of Munro illustrates this most pointedly, for how can a man who features so little in this way have a work treated as the only true Pre-Raphaelite sculpture? One can perhaps call Munro's 'Paolo and Francesca' (TG 1984, No.44) Pre-Raphaelite by association and inference. It is clearly linked in its Dante subject matter with Dante Gabriel Rossetti, though one should remember that Hancock too did Dante subjects in sculpture: his 'Beatrice' was shown at the Great Exhibition in 1851, a 'Dante's Beatrice' (which may be the same work) was shown at the Royal Academy in 1854, No.1416; while 'Beatrice', a bust in marble, was shown at the Royal Academy of 1862, No.1054. Munro's connection with Rossettian ideals, with what one might call the Rossetti branch of Pre-Raphaelitism, continues in the tympanum relief on the Oxford Union building of 'King Arthur and the Knights of the Round Table' (pl.79), which he executed *c.*1857–8 from a design by Rossetti as part of the Oxford Union decorative scheme. At the same time, Munro could be linked with the more sentimental scenes of couples being produced by two further particular Pre-Raphaelite friends of his, Millais and Arthur Hughes in the 1850s. Munro's 'Lovers Walk' (at the left of pl.42, now lost) was shown at the Royal Academy in 1855 (No.1452) accompanied by a quotation from William Allingham, a thoroughly acceptable Pre-Raphaelite poet-

associate; 'Another Reading' (at the right of pl.42) maintains a similar mood and style.

But perhaps Munro's major contribution to Pre-Raphaelite sculpture could be said to be his six statues of famous scientists at the University Museum, Oxford. In all its ramifications including in particular the projected but not executed decoration by Rossetti and associates, this building can be seen as embodying a wider Pre-Raphaelitism, both decorative and naturalistic – the latter characteristic in particular of the vegetal capitals carved by the O'Shea brothers, which are clearly identifiable with real-life natural examples. It is even possible to see in some of Munro's statues (e.g. 'Galileo') a certain stiffness in the handling of drapery, perhaps simulating a Gothic style to go with the neo-Gothic building. Here also we find a rare surviving Tupper work, the statue of 'Linnaeus' (pl.43). The botanist's furry coat is represented with a truth to nature that is truly Pre-Raphaelite – it is possible that the original model for the coat was a goatskin jacket belonging to Dante Gabriel Rossetti,[5] and one can hardly get more Pre-Raphaelite than that.

Also at the Museum is Woolner's 'Francis Bacon', and in fact Woolner contributed sculpture to a number of neo-Gothic architectural settings with Pre-Raphaelite connections. That at Llandaff Cathedral was a restoration job under John Pollard Seddon, brother of the painter Thomas Seddon, an associate of the Pre-Raphaelites. Originally at Llandaff there was a painted reredos by Dante Gabriel Rossetti, 'The Seed of David', sculpture from a design by Rossetti ('The Pelican Feeding Her Young'), stained glass by Burne-Jones and Madox Brown, and four relief panels by Woolner on the pulpit. These represented Moses, King David, St John the Baptist and St Paul. Now, although Woolner sometimes wrote rather disparagingly of these architectural sculpture works of his, they can be granted certain Pre-Raphaelite qualities. William Michael Rossetti (the Pre-Raphaelite Brother), in his 1861 paper on 'British Sculpture, Its Condition and Prospects', claimed that the divorce of sculpture from architecture was foremost among the causes of the poor state of sculpture, thus inferring clear merit to architectural sculpture. Moreover, Woolner's works in this area, such as the 'Bacon' or 'St Paul', do embody a truthfulness of portrayal of character that is quite distinctive – J.P. Seddon considered 'St Paul' to be a most admirable attempt to realise the character of the Apostle as he described himself in 2 Corinthians 10.10: 'for his letters, say they, are weighty and powerful, but his bodily presence is weak and contemptible'.[6]

This quality of truthfulness in Woolner's work was one of the main

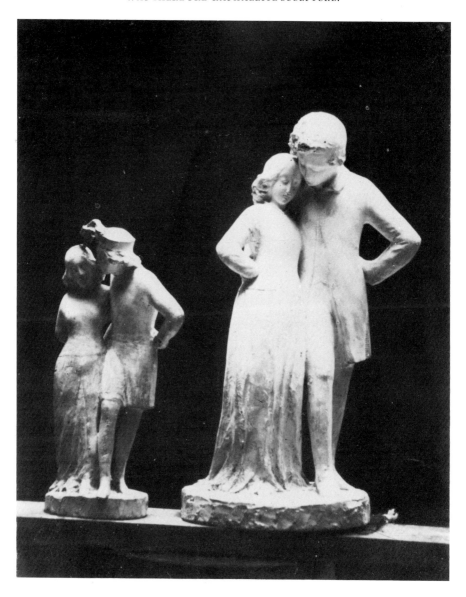

42 Nineteenth-century photograph showing
Munro's 'Lovers Walk' (left) and 'Another Reading' (right)

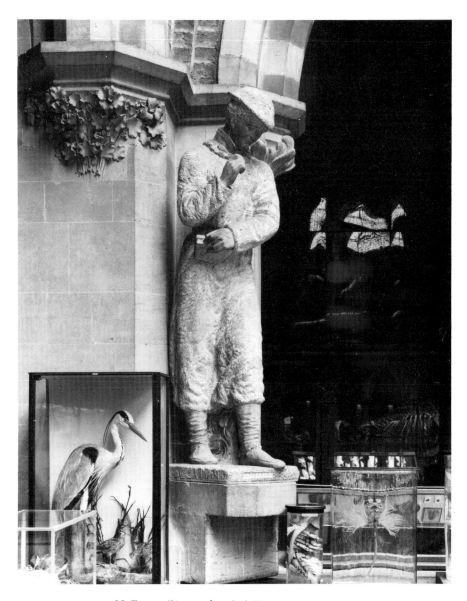

43 J.L. Tupper, 'Linnaeus', *c*.1856; *University Museum, Oxford*

44 T. Woolner, 'Mother and Child', 1856–67;
National Trust, Wallington, Northumberland

45 T. Woolner, Wordsworth Monument, 1851; Grasmere Church

46 T. Woolner, Statue of William Whewell, 1873 (detail);
Master and Fellows of Trinity College, Cambridge

reasons why he had gained admittance as a full member of the Pre-Raphaelite Brotherhood. Holman Hunt records: 'Rossetti, whose enthusiasm for our principles grew with greater familiarity, talked much of Woolner as one to whom he had explained the resolution of Millais and myself to turn more devotedly to Nature as the one means of purifying modern art, and said that Woolner had declared the system to be the only one that could reform sculpture, and that therefore he wished to be enrolled with us . . . The many indications of Woolner's energy and his burning ambition to do work of excelling truthfulness and strong poetic spirit expressed in his energetic talk were enough to persuade me that Rossetti's suggestion that he should be made one of our number was a reasonable one; in due course, therefore, Millais having known him at the Academy, he was approved as a member.'[7] Hunt's prescription for Pre-Raphaelitism in sculpture is confirmed by William Michael Rossetti who wrote that Tupper was as zealous as the P.R.B. were regarding 'the need for serious inventive thought in works of art, and for care and detailed study of nature in their carrying out'.[8]

It is possible to identify these Pre-Raphaelite qualities in Woolner's work specifically of 1851–2 and, granted the twin polarities of poetry and nature, it is no surprise to find them embodied in his two monuments to Wordsworth, the poet of nature and one of the Pre-Raphaelite Immortals. Woolner's first 'Wordsworth' is the local monument at Grasmere in the Lake District, set up in August 1851 (pl.45); it consists of the poet's head carved in profile, with sculptured flowers on either side. That the head was not a simple, generally modelled image was apparent to the contemporary viewer: 'The likeness to the man has received decisive praise from persons whose verdict is final; the intellectual likeness to the poet will be more widely appreciated and recognized with as cordial an admiration. The meditative lines of the face, the thoughtful forehead and eye, the compressed sensitive mouth are rendered with refined intelligence.'[9] In other words, this is a truthful representation not just of the details of the physiognomy and the total image (i.e. Nature), but he has got the intellectual character in, via these delineaments, as well (Woolner almost certainly obtained the likeness of Wordsworth from the bust by Chantrey).[10] On either side of the head there is a crocus, a celandine, a snowdrop and a violet treated, as the same critic wrote, 'with a rare union of natural beauty and sculpturesque method'. This inclusion of such natural species, instantly recognisable because so accurately represented, besides being appropriate for Wordsworth as poet, can be taken as a Pre-Raphaelite demonstration, since it was at just this time that Hunt and

Millais were working together near Ewell on the relentless naturalistic detailing of 'The Hireling Shepherd' and 'Ophelia' (TG 1984, Nos 39–40).

While he was working on the Grasmere 'Wordsworth', Woolner was evolving a more elaborate work for the competition for a national Wordsworth memorial, to be set up in Westminster Abbey. Unsuccessful in this, Woolner showed his design at the Royal Academy in 1852, and wrote the following description:

> In the present design, the aim kept in view has been to embody the 'Individual Mind' of Wordsworth. In the centre is the Poet himself: on the pedestal which supports him is an illustration in *rilievo* from 'Peter Bell' – as being the poem wherein he has most distinctly enunciated his doctrine *that common things can be made equally suggestive and instructive with the most exalted subjects*; whence arose his direct influence on modern literature. The Groups are symbols of the two great principles he strove to inculcate.
>
> 1. Control of Passion (being the basis of Law.) This is represented by a father admonishing his sullen boy.
>
> 2. Nature contemplated to the glory of God. (Being the basis of Religion) Here a Mother, while discovering to her daughter the works of creation, becomes lost in her own sense of their mystery.[11]

The seriousness of this work's symbolism recalls other projects by Woolner of this period – that seen by Hunt in Woolner's studio in 1847, described earlier, and another described by William Michael Rossetti in the P.R.B. Journal for Tuesday, 5 November 1850: 'he [Woolner] has decided to make a design of the oppression of weakness by despotic physical power, and its salvation by moral and intellectual strength, – a subject the conception of which he has long been maturing. It appears that this kind of treatment in sculpture – emblematic of something beyond the external evident intention – is in the taste of Mr. Sartoris. The figures in Woolner's group would be a woman, the type of dependence, a strong man, un-elevated in intellect, and therefore using physical means, as oppressor, and another man, strong but less brawny, as the deliverer, whose glance conquers not less than his brave hand'.[12] That this use of moralising symbolism – 'emblematic of something beyond the external evident intention' – reinforcing a declaration of faith in a poet of nature, was a specifically Pre-Raphaelite concept, even in sculpture, is surely demonstrated by Woolner signing his manuscript description of the Westminster Wordsworth project 'Thomas Woolner PRB'.

These suggested Pre-Raphaelite qualities of Woolner's Wordsworths,

once identified and accepted as such, can be found subsequently through-
out his work. Truthfulness both of physiognomy and of character became
the hallmark of Woolner's portraiture, as the Tennyson bust (TG 1984,
No.89) shows; Gladstone gave Woolner many sittings for a bust of 1883,
and when the model was finished we are told Gladstone literally danced
round it in delight and satisfaction. It was just as he desired to go down in
posterity, he said[13] (the bust was destroyed in the Second World War).
Even the literal, truthful representation of natural specimens continued, so
that the Morning Glory surrounding the medallion portrait of the botanist
Daniel Hanbury of 1876 at La Mortola, near Mentone, is instantly
recognisable as such to an experienced gardener.

The combination of High Seriousness and Naturalism typified by the
Westminster Wordsworth was maintained by Woolner in the major Ideal
works of the rest of his career. The poetry, elevation and truth central to the
Fairbairn Group (TG 1984, No.117) is as sustained in the Trevelyan Group
at Wallington, also known as 'Mother and Child' and 'The Lord's Prayer'
(pl.44). Setting out to demonstrate the triumph of Christian religion over
savagery, the work is a modern-life subject, representing a religious idea,
with the modelling of features, figures and drapery aiming to be natural
and truthful – Woolner went to immense trouble to get real models and
materials that were just right. It is perhaps not fanciful to see parallels for
such concern in works by Hunt such as 'The Light of the World' or 'The
Awakening Conscience' (TG 1984, Nos 57–8). Even at the very end of his
life, with 'The Housemaid' of 1892, Woolner was prepared to represent a
subject with uncompromising truth to what was before him. The work is a
life-size figure of a servant girl wringing out the cloth with which she
washes the doorstep, a sight which, we are told, in those days could be seen
any morning early in the London streets. The sculptor had noticed the
graceful action involved; in addition, he used to say the servant girls in
their plain print frocks and caps were the best dressed women in London on
weekdays (and the worst dressed on Sundays).[14]

Woolner's truth to nature, the accuracy of his observation and the
representation of this in three-dimensional form throughout the range of
his work obviously give him a primacy in consideration of Pre-Raphaelite
sculpture, not surprising as he was the only sculptor strictly eligible to add
P.R.B. to his name (William Michael Rossetti dismissed his brother's gift of
these initials to Smith in 1849 as 'one of the rather arbitrary acts in which
my brother indulged himself now and again'[15]). But it is possible to posit a
Pre-Raphaelite dimension to the concern and practice of all the sculptors in
and around the circle with portraiture. That portraiture was the principal

means of livelihood for any sculptor at the time must be granted; nevertheless it was possible to make a Pre-Raphaelite virtue of this necessity, bringing either the decorative, poetic ideal or a determined truth to nature to this field. The works of Tupper, Hancock and Smith in this area tend towards the absentee (as previously defined) and one must deal in the main just with lists. Of Hancock's thirty-four R.A. works, only five are portraits and only from 1858 onwards; two of these took medallion form (Gunnis however records a portrait medallion of Dante Gabriel Rossetti of 1846). All Tupper's eleven R.A. exhibits were portraits, seven in medallion form, including one of Holman Hunt. Fourteen of Bernhard Smith's seventeen (or so) R.A. exhibits were portraits; two are specified as medallions, two others not so designated we know to be so.

It would appear that sculpted medallion portraits were thus something of a Pre-Raphaelite concern, especially as they were not otherwise much used by sculptors. It is in this light that we should correctly view Smith's medallion of Miss or Mrs Gray which he signed 'PRB', and indeed Woolner's extant examples (see TG 1984, Nos 30, 76–7), in which he pursued his truth to nature with some relentlessness. Munro made of the portrait medallion type something more his own (see ibid., No. 118): less truth to nature than character expressed in a decorative, almost architectural ideal, with a smoothness of modelling going counter to particular physiognomic detail, which he possibly derived from his work under Pugin at the Houses of Parliament. His portraits of Sir Walter and Pauline Trevelyan at Wallington demonstrate two variations of this type, Sir Walter seen in profile in shallow relief, Pauline fuller-faced and in deeper relief. The smooth modelling in both Munro carried over into his portrait busts, such as those of Henry Wentworth Acland or Sir William Armstrong. This may not achieve truth to nature in all its bumps and wrinkles, but it certainly conveys a poetry and truth of character that could be allowed as Pre-Raphaelite ideals.

For bumps and wrinkles, we must go to Woolner. Whether in the form of the portrait bust or the full-length portrait statue, he aimed to portray the whole person that he saw before him. The physiognomy and bulk of his 'William Whewell' of 1873 at Trinity College, Cambridge (pl.46) amount to a superb statement about a man described as being 'of splendid physical development. A Cambridge legend told of a prize-fighter who had exclaimed, "What a man was lost when they made you a parson!". His face showed power rather than delicacy, and a massive brow gave special dignity to his appearance'.[16] This simply reiterates the effectiveness seen in the 'Tennyson' bust of 1856 (TG 1984, No.85) and seen in so many other

of Woolner's portraits – Rajah Brooke of Sarawak, Lord Lawrence of the Punjab, or Thomas Combe (ibid., No. 125). These images of truth and character should finally convince us that not only was there a sculptural context to Pre-Raphaelitism and a specific decorative brand of sculpture that may be called Pre-Raphaelite, but that in the work of the one Pre-Raphaelite Brother who was a sculptor, Thomas Woolner, certain fundamental aims and principles of the Brotherhood were embodied and sustained to no less an extent than in the work of any of the other Brothers.

'An interesting series of adventures to look back upon': William Holman Hunt's visit to the Dead Sea in November 1854

JUDITH BRONKHURST

'An interesting series of adventures to look back upon' was the phrase Hunt used, in a letter of 2 December 1854 to Thomas Combe, to describe the seventeen-day expedition he had just made to the southern end of the Dead Sea.[1] It was an opinion which the artist upheld thirty-three years later, when he came to write up his experiences for publication.

Hunt's articles 'The Pre-Raphaelite Brotherhood: A Fight for Art' had appeared in the *Contemporary Review* of April–June 1886.[2] These were motivated by a desire to counteract the widespread belief that Dante Gabriel Rossetti had been the moving force behind the Brotherhood,[3] and Hunt felt that his first attempt at autobiography had an effect not only on his reputation but also on the sales of his pictures. He wrote to Harry Quilter, the editor of the articles and of the *Contemporary Review*, on 4 April 1886: 'I think the paper is attracting much attention. and I doubt not that the little pictures sold at Christie's on Thursday got part of their enhanced value from the Contemporary – and the other part from the Bond St exhibition –'.[4] These included the small version of 'The Scapegoat' (pl.47; TG 1984, No.84), which was purchased by Agnew's from William Graham's executors' sale for £525.[5] The large version (pl.48) was at that time on view in Hunt's retrospective at the Fine Art Society, and when the artist came to revise and expand the 1886 articles he decided to add, as he informed Millais on 7 March 1887, 'a good deal of my experience in painting "The Scapegoat"'.[6] Correspondence with George Lillie Craik, a director of Macmillan & Co., reveals that Hunt intended to publish the revised text in the form of a full-length book, with illustrations, but nothing came of the idea at this time.[7] Instead an essay, entitled 'Painting "The Scapegoat"', appeared in the July and August 1887 issues of the *Contemporary Review*, by which date the picture was in the collection of Cuthbert Quilter, the editor's brother.[8]

The 1887 account was largely based on a journal Hunt had kept on his second trip to the southern end of the Dead Sea. The artist had first visited

the area on 24–26 October 1854, accompanied by the Reverend William Beamont and Beamont's son.[9] They returned to Jerusalem on 30 October, from where Hunt wrote to Combe: 'my journey delighted me very much. the Dead Sea is I think the most extraordinary place in the world. at the northern end it is nothing in comparison to the Usdoom end. I hope to describe a few feet of it in a picture which will describe better than this missive could do. I go away again after tomorrow to encamp in the Wady Zoara by an old fortress – I remain a week a fortnight or three weeks in proportion to my progress and my power of enduring the place'.[10] Hunt had heard rumours that the area was haunted, and there would be no other English travellers on the second expedition. Keeping a detailed account of his adventures was a means of coping with the loneliness he experienced, as his letter of 2 December 1854 to Combe indicates: 'you can imagine that 17 days without a single word of English – and no companion of any kind in the most desolate place in the world . . . was not a cheerful time. I kept a kind of journal but as I will send you this whenever I am despatching any parcel to England – I need not spend much more space on the subject here'.[11] Hunt went on to describe at length his return journey to Jerusalem via Hebron on 28–29 November, and this may well form the concluding part of the journal, which otherwise appears to be incomplete. The account, begun on the night of 13 November, is closely written on quartos of thin blue paper, four of which are in the John Rylands Library of the University of Manchester (pl.49).[12] A fifth quarto is bound in with Hunt's letters to Combe in the Bodleian Library.[13] The journal is over 16,000 words long, and must have taken Hunt some time to write up each evening. It is possible that the extant manuscript is a fair copy of the original, made on Hunt's return to Jerusalem, for some words are represented by blank spaces as if the artist was unable to decipher his own handwriting. There is a gap on the verso of the first folio which is annotated in another hand 'Part of story missing': this relates to the early part of 14 November, when Hunt arrived in Hebron and executed a sketch (pl.50) which gives no hint of the disturbed state of the town. However, according to the Prussian doctor with whom Hunt stayed that night, 'fifty had fallen last week alone'.[14]

The published account of 1887 and the chapter in Hunt's memoirs of 1905, which is more accurate in some respects than the first version, emphasise the artist's fearlessness in the face of the very real dangers he was to encounter on his expedition to the Dead Sea in November 1854. Hunt's adherence to the ethic of the stiff upper lip led him to scold Millais furiously for suggesting that he had been afraid of the Arabs on his first

visit to the area,[15] and his real feelings were only revealed in his letter of 2 December to Thomas Combe: 'Before leaving here I had all manner of arguments and weaknesses to overcome. or rather to fly in the face of – in making my preparations and setting off. no ⟨one⟩ frank had ever been in the place for more than a few hours hitherto, it was notorious – for the wildness of the few inhabitants. then the many deaths by fever that had occurred to people who had spent any time in the atmosphere of the pestilential lake and many other facts were represented to me to dissuade me until finding my judgement yeilding I remembered that I had already determined ⟨the⟩ my course and that it could not be changed'.[16] The artist's anxieties manifested themselves in the form of disturbed dreams both before and during the expedition, as his journal reveals.[17] The area round the Dead Sea was extremely dangerous,[18] and Hunt's difficulties were compounded by his rudimentary grasp of Arabic. The language barrier is played down in the published accounts, in which, for example, Hunt states that he discussed the curse over the Dead Sea plain with Sheik Abou Daouk.[19] In fact, he regarded the man with such contempt that he would not have attempted to explain his reasons for making the trip: he was only concerned to negotiate a safe passage to Usdum.

Hunt's first brush with danger had occurred on the night of 13 November, and is somewhat exaggerated not only in the published accounts but also in the letter to Combe of 2 December 1854, which mentions that 'in going to Hebron I was attacked with stones by fellaheen'.[20] According to the journal, while riding south from the Pools of Solomon a stone struck Hunt on the leg; fearing an attack he pulled out his pistol and shouted 'in my best and loudest Arabic first that I was an Englishman and secondly that I would shoot the first man I saw – I had almost prepared myself for some awful return to my threat and I waited silent. when as suddenly and like an evil dream all the noises ceased'.[21] Upon reflection, Hunt came to the conclusion that this had been a false alarm, caused by 'a vivid imagination and fear on the part of my Servant', Nicola Beyrouti, and the dislodging of stones by the horses' hooves. This is an indication of the state of nervousness of the entire party, and is only one instance of Hunt's use of the journal as the repository of his fears and uncertainties.

Once Hunt arrived at Usdum, on 17 November, the dangers were real enough, for the place was not as deserted as the 1887 account suggests.[22] Soleiman, Sheik Abou Daouk's son,[23] was able to distinguish between hostile and friendly Arabs, as Hunt noted in the journal: 'on the way we met two or three dark arabs coming up from the Sea – whom Soleeman

saluted with a kiss in the most sacred manner I greeted them with "marhabalak," (welcome!) which seemed premature when Soleeman told me on passing them that they were robbers and would cut my throat were it not for his countenance'.[24] In fact, when Hunt did need Soleiman's help it was not forthcoming: the servant was lying down when three Arabs, two of whom were armed with spears,[25] approached Hunt, who, with admirable sang-froid, 'sat still working keeping a good hold of my gun, which I use as a mohl stick ⟨and⟩ not noticing them until they said something in salutation'. Although he could not speak their dialect, he realised that one of them demanded water, and he called Soleiman to fetch it: 'while this was going on I expected to have to defend myself from the three – I would not move however but affected the utmost coolness – praying that my hand might not shake as I touched the picture'. The Arabs passed on, but Soleiman's 'account of the morals of these people have determined me in my course in case of an attack and I assured him that I would shoot them all if they attacked me for not having money with me I wish I could feel certain as to where is the line of private forgiveness and return of good for evil and that resistance which is akin to public justice: for I only make this resolution in a sort of uncertainty as to the proper line to pursue –'.[26] The verbal declaration certainly won Soleiman's respect, but Hunt had to face worse dangers at Hebron on his return journey: he was actually shot at when his party became caught between two warring Arab factions.[27] Four days later, on 2 December 1854, Hunt admitted to Combe: 'I can't think myself a coward but in my last excursion I have once or twice thought myself beyond the reach of any further want – than my merciful Saviour –'.[28]

There is no doubt that Hunt's faith sustained him during the expedition. On his arrival at the southern end of the Dead Sea on 17 November he noted in his journal:

never was so extraordinary a scene of beautifully arranged horrible wilderness. . . . I can understand the use of Art in thinking how interesting a picture of such a scene would be, and in thinking that I was doing right morally ⟨to⟩ in undertaking a work of similar value in conveying important knowledge I commended myself. to God's merciful protection from all the dangers by which I had ventured to challenge in this pursuit – I believe if I had not had ⟨this⟩ the comfortable assurance of his presence and defence of me – that I should have been overcome and creid like a child at the misery of my solitary position – as I reached this place and alighted for the shade.[29]

He rationalised the necessity of working on the sabbath (19 November) with the phrase 'I regard my occupation as somewhat akin to that of the priests', and wrote in his journal: 'if a man wishes to understand how truly ⟨every⟩ "we have left undone those things which we ought to have done, and we have done those things which we ought not to have done. and there is no health in us" I think he need only shut himself apart for a week. and think of God's goodness in contrast to his past life –'.[30]

Hunt's manuscript account of his adventures reveals his awareness of the religious associations of the landscape of the Holy Land. This aspect was rather played down in the 1887 articles – by that date the Christian symbolism of 'The Scapegoat' no longer seemed relevant to many of his contemporaries, and the picture was considered one of the artist's greatest triumphs on aesthetic grounds.[31] There are several passages in the journal, however, which describe the terrain with a painter's eye and go on to explore its transcendent qualities. The first occurs on Hunt's journey from Hebron on 15 November: 'the late rains had enriched the earth with young grass, and had caused delicate lilies of a tender violet tint to spring up ⟨?li⟩ and blossom in the ⟨tr⟩ crevices of the sandstone rock, I had heard of these as the probable "lilies of the fields" but had not felt satisfied with the description, ⟨but⟩ the modest gracefulness of the plant was beyond question as a robe more glorious than a King's anxiously gained riches however. and I believe it was not honoured by our Saviour's comparison . . .'.[32]

Hunt was interested in the geological nature of the Dead Sea, as this had a bearing on the identification of Usdum with Sodom. On his October visit to the area, he had been disappointed at not finding the ruins which Félicien de Saulcy's *Narrative of a Journey round the Dead Sea and in the Bible Lands in 1850 and 1851* had led him to expect,[33] and he obviously had this work in mind when he noted in his journal of 16 November: 'I believe that travellers weaken the testimony of the Bible to casual students in overloading a sceptical mind with evidence neither necessary nor to the point in many cases –'.[34] The following day he reached the Dead Sea plain, and lyrically described the view:

the Mountains of Moab were floating in the mysterious sun
shadow the sea was a delicate pearly green but the whole was not so
beautiful, altho a stranger picture than it formed when ⟨we⟩ I was
here before late in the day, at the brink it was wonderfully added to
with the lower stage a region of wild bareness which extended to the
Wady Zoara tahter and beyond in grotesque masses and plains to the
precipice which went down to the Sea[35]

47 W. Holman Hunt, 'The Scapegoat', 1854–5, 1858;
oil, 13¼ × 18¹⁄₁₆ (33.7 × 45.9); *City of Manchester Art Galleries*

48 W. Holman Hunt, 'The Scapegoat', 1854–5;
oil, 33¾ × 54½ (85.7 × 138.5); *Lady Lever Art Gallery, Port Sunlight*

(6)

was a delicate pearly green but the whole was not so beautiful, altho a stranger picture than it formed when I was here before late in the day, at the brink it was wonderfully added to with the lower stage a region of wild barreness which extended to the Wady Toara tables and beyond in grotesque masses and plains to the precipice which went down to the Sea I could here see my intended home for the next twelve days or more it is at the foot of my curious pile of diluvium which had been left standing almost the original elevation by the divided winter stream which has descended violently for ages in these precipices the whole has perpendicular sides from the nature of the composite which descends spontaneously in lines as the lower part is removed and this has a fantastic resemblance to a building in the pillars thus formed about its sides, perhaps it was this that first suggested the excellence of its position for a castle or it may simply have been the natural strength of the place. and the danger of an incursion from the arabs on the other side of the Sea into the southern country in this place whoever may have built it. there it still remains in part perched on the summit of this pile with a court yard on the level fifty yards below where the entrance gate and part of the wall still remains. I am writing now on the spot and I have had opportunity of examining the whole but I can not assign any date to it. from the fact of its having a pointed arch I should attribute it to the Christian of the Crusade but in Sebbeh where there can scarcely have been any thing added since the Jews I observed a pointed arch of the same style in all respects and even with certain rude character scrawled on both portals alike. but I am anticipating somewhat for I cannot pass a wonderful view which I had from the heights through the next Wady to the right over the region to the South of the Dead Sea - never was so extraordinary a scene of beautifully arranged horrible wilderness. I could not help expressing my wonder at this to the Arab who seemed puzzled as he looked first at the place and then at me. I can understand the use of Art in thinking how interesting a picture of such a scene would be; and in thinking that I was doing right morally to in undertaking a work of similar value in conveying important knowledge I commended myself to God's merciful protection from all the dangers by which I had ventured to challenge in this pursuit. I believe if I had not the comfort able assurance of his presence and defence of me. that I should have been overcome and cried like a child at the misery of my solitary position. as I reached this place and alighted for the shade. When the tent came up and I had had a cup of coffee I set off on foot with Soleeman to the scene of my labours, to speak of all the wonderful scenes then I thought to the bottom of the Wady and across the plain to the Sea by Usdom was two miles at least and the road was disagreeable - on the way we met two or three dark arabs coming up from the Sea - whom Soleeman saluted with a kiss in the most sacred manner. I greeted them with "marhababalak" (welcome) which seemed premature when Soleeman told me on passing them that they were robbers and would cut my throat were it not for his countenance, and he took greater pains than was necessary to assure me that he knew all the robbers. I kept my gun in hand as we walked past Usdom and along the Sea coast to find a suitable spot for my labours. I had passed all the ground before in going and returning to the cave of Usdom and in investigating the margin of the Sea I had walked over a yielding surface. without consideration until on the moment of standing still I began to sink in the horrible salt mire and had no

49 A page from Hunt's account of his journey to the Dead Sea: English MS 1210, f. 4v., 17 November 1854; *John Rylands University Library of Manchester*

50 W. Holman Hunt, 'Hebron', 14 November 1854;
pencil and bodycolour, $5\frac{1}{2} \times 8\frac{3}{4}$ (14 × 22.2); *R.D. Franklin, Esq.*

opposite
53 W. Holman Hunt,
Study for 'The Scapegoat', 1854;
pencil, $5 \times 5\frac{1}{2}$ (12.8 × 14);
Mrs Elisabeth Burt

51 W. Holman Hunt, Study for 'The Scapegoat', 1854;
pencil, $5\frac{1}{2} \times 8\frac{3}{4}$ (14 × 22.2); *Mrs Elisabeth Burt*

52 W. Holman Hunt, Study for 'The Scapegoat', 1854 (verso of pl. 51); pencil, 4 × 5⅜ (10 × 13.6); *Mrs Elisabeth Burt*

53

Although he was not convinced of the validity of de Saulcy's researches, Hunt felt that the desolation of Usdum made it a more likely candidate for the biblical site than anywhere else on the Dead Sea. He noted in his journal of 19 November:

> we see foot prints of beasts but I think none of them inhabit the place. the Vulture never comes there to make his feast altho' he might gorge him self to the full on the camels corrupting in the Sun, and only fed upon by the savage hornet, who roam about like the efreets of the dead, sometimes a crow circles over there but never to light nearer than on the mountain height – the mountains lie afar. beautiful as precious stones but anear they are dry and scorched, the rose color is the burnt ashes of the grate. the golden plain is the salt and naked sand. the Sea is heaven's own blue. like a diamond more lovely in a kings diadem than in the mines of the Indes but as it gushes up through the broken ice like salt on the beach, it is black, full of asphalte scum – and in the hand slimy, and smarting as a sting – No one can stand and say it is not accursed of God. if in all there are sensible figures of men's secret deeds and thoughts then is this the horrible figure of Sin – a varnished deceit – earth joys at hand but Hell gaping behind. a stealthy, terrible enemy for ever. [36]

The whole expedition was motivated by Hunt's desire to paint the background of 'The Scapegoat' at the site of God's destruction of the Cities of the Plain (Genesis 19), but descriptions of the artist's progress on the picture take up a relatively small part of the journal. On Friday 17 November Hunt chose his locale – 'a track of level beech from which the sea has receded at this season but leaving a deposit of salt thickly encrusted ⟨together⟩ with salt like white ice with shallow water beneath' – and spent two hours adapting his design (possibly the beginnings of the small oil version, pl.47) 'to the place itself'. [37] He may at this time have made a preparatory drawing, inscribed 'Dead Sea from Western Shore looking towards Moab 1854', and annotated with colour notes to remind himself of the appearance of the mountains of Edom in the evening light (Coll. R.D. Franklin Esq., exh. Liverpool 1969, No.165 verso). Hunt put in a full day's work on the following day, despite his servants' continuous 'exhortations to be quick to escape the robbers'. [38] On the Sunday an attack of diarrhoea nearly persuaded the artist 'to retrace my steps and seek a change of air on the hills for the day but I remembered that want of courage failed as much in such pursuits as mine as in war –'. [39] Despite feeling unwell, he managed

to work until late in the evening, ignoring the dangers of returning to the camp after dark. The way in which the canvas was transported from Usdum to Wady Zuara – a good two miles – was not altogether satisfactory, and on Monday 20 November Hunt 'looked at my yesterdays work – which I was grieved to find had become covered with dust and chipps from the inside of the box in riding on the ass'.[40]

From now onwards Hunt carefully noted his progress: on 20 November he worked 'at the shadow on the lower part of the near Mountain for which I had a good opportunity in the many cloud⟨s⟩ shadows – I was sorry at being obliged to leave off before the sun had gone down –'.[41] The following day he 'worked all day at the sea to the left, and the upper part of the beach adjoining, in which I progressed well, but not so satisfactorily as I might have done in remaining another half hour when the effect came right –'.[42] 'The distant mountains' were painted on the Wednesday, and on Thursday, 23 November Hunt recorded in his journal: 'I have worked very hard to-day at the distant foreground on the right hand side of the picture but have not progressed. altho' I have been helped with a cloudy day'.[43] By this time the artist was running short of funds, and was aware that the food for the horses would not last for more than a couple of days.[44] Hunt was unable to vent his feelings of frustration on the servants, but revealed them at length on paper:

I am tired out and brought to submit to a great disappointment – the loss of my object for in two days I can scarcely do enough of the intricate foreground, ⟨even⟩ to enable me to finish at home; and so I fear all my past work is lost. this which I undertook so sanguinely and have encountered so many difficulties to succeed in, that I might have a picture of some value in the next exhibition! it is like all endeavours of late I must not wait for more than another example of perverse fortune to conclude that all works undertaken here partake of the curse over the country. I have seen so many things to lead me to think so. I had thought that some valuable illustrations of scripture might be found here for the painter, but the time has not come yet for ⟨?such⟩ his labours Heaven help me to escape from despair of the worth of my vocation I would not for any – worlds content myself to be a sort of caper-cutter upon canvass. an acrobat who turns and grimaces in the high road to the thousands passing ⟨busily⟩ by busy to evil or to good.[45]

Hunt's disappointment was all the harder to bear in the light of his letter of

about mid-September 1854 to Thomas Seddon, which condemns his friend's decision to leave the country before completing 'The Valley of Jehoshaphat' (TG 1984, No.83).[46] Hunt obviously had this in mind when he wrote to Seddon, by this time in Dinan, on 16 December 1854: 'my bold attempt was, as other efforts I have made, only a complete failure –...Dont let my letter to you at Siloam affect your judgement of your picture...I am humbled you see in having to do my Dead Sea work almost entirely without Nature. I painted the Mountains the Sea and some of the foreground. but the other, the sky &c I have to do from the top of Sims house. or otherwise I must just throw the picture away. according to my first impulse'.[47]

When Hunt negotiated with Abou Daouk on 15 November 1854, he informed the Sheik of his desire 'to go to the Wady Zuara for 15 days',[48] and the realisation that his time was to be curtailed by a third was indeed a bitter blow. On 25 and 26 November, however, the artist did manage to get his picture into some sort of shape, as his journal reveals:

> Saturday. I went down early this morning and I laboured ceaselessly ⟨the⟩ till sunset not having a soul passing to trouble me ⟨the⟩ except my guard Soleiman – I did not complete much but I worked at parts which may be filled in from memory – in ten or fifteen minutes of sunset I managed to do a large piece of the lower foreground on the left, and this encourages me for tomorrow, for I feel that I have succeeded in the color and tone excellently. I spent an hour in shading and lightly modelling the Mountains which are not finished . . .
> Sunday – After breakfast and an hour spent in reading the church service I descend to my work – the drift of reeds &c I worked hard hoping to get an hour on the other part but when it was sufficiently completed to leave I ⟨find⟩ found it was too near sunset to move to my usual place and therefore I continued at the salt adjoining a violent wind had arisen which made it necessary for Soleiman to hold my box. I left reluctantly altho' what is done already inclines me to continue it at home in hopes of making a picture of some interest in its components – it would not all be painted so scrupulously from nature as I should like but at least I have made every exertion to obtain the proper opportunity and some truth in its features must be the result – I hope.[49]

Hunt's ideal of painting from nature was to be elucidated in a letter of 12 August 1855 to William Michael Rossetti, which states that 'The

Scapegoat' formed part of an artistic campaign devoted 'to the task of spreading knowledge':

> I have a notion that painters should go out. two by two, like mer-
> chants of nature. and bring home precious merchandize ⟨from⟩ in
> faithful pictures of scenes interesting from historical consideration. or
> from the strangeness of the subject itself. only call to mind the
> principal names in your memory. and consider how absolutely
> nothing Art has done even where quite easy to illustrate the idea
> connected therewith to give you a truer notion of the thing. in
> Landscape this is an idea which Lear has had some time – it naturally
> suggest itself to a painter in travelling unless he be entirely thoughtless
> – and he has done some good things in the work but it must be done
> by every painter and this most religiously. in fact with something like
> the spirit of the Apostles fearing nothing. going amongst robbers. and
> in deserts with impunity as men without any thing to lose, and every
> thing must be painted even the pebbles of the foreground from the
> place itself, unless on trial this prove impossible. In figure pictures the
> work is just as practicable and would be easier and easier every year if
> once commenced . . . I think this must be the next stage of PRB
> indoctrination and it has been this conviction which brought me out
> here, and which keeps me away in patience until the experiment has
> been fairly tried.[50]

Hunt had to date, however, always painted figures and landscape at different times, and although he went to the trouble of transporting a rare white goat from Jerusalem to the southern shores of the Dead Sea – a distance of some sixty miles – there is no indication in his letters or journal that he anticipated completing this part of 'The Scapegoat' at Usdum.

The article in the *Contemporary Review* of 1887 suggests that the goat was sketched in on the canvas of the large version on the first day of painting.[51] The journal records that on the afternoon of 17 November 1854 Hunt 'set off on foot with Soleeman to the scene of my labours . . . I had further to go than I thought to the bottom of the Wady and across the plain to the Sea by Usdoom was two miles at least and the road was disagreable –'.[52] Hunt would surely have mentioned the practical difficulties of taking the goat with him had he done so, and although the three slight pencil drawings of the animal (pls 51–3) appear to have been executed at Usdum, it is possible that they were in fact made at the encampment. The goat is not mentioned at all in the journal until Monday, 27 November, on Hunt's return journey from the Dead Sea: 'I was con-

cerned at finding my white goat fall ill . . . I bought it in the Spring and have it kept ever since for my model for this picture, and brought it with ⟨he⟩ me here that I might study his peculiarities on the spot and under the circumstances – as far as might be – which I have chosen for the subject –'.[53] His distress at the animal's subsequent death was sincere enough, and totally self-centred: his 'serious regret' was not for the poor goat, as the 1887 account suggests, but for the poor artist who would have the greatest difficulty in finding a substitute.[54]

At the age of sixty Holman Hunt looked back on the adventures he had experienced many years before, and wrote to Mary Millais on 22 June 1887: 'I should think no picture was ever painted under such romantic circumstances, and so it seemed only right to tell the story'.[55] He had in fact been entertaining his close friends with the tale for many years: for instance, in early 1879 Hunt stayed with the Craiks at Shortlands, Bromley, while recuperating from a serious attack of typhoid, and on 13 January Dinah Mulock Craik noted in her diary: 'H. Hunt much better – made the children shout with laughter over adventures with Arabs while painting the Scapegoat by the Dead Sea –'.[56] The expedition never lost its magic for the artist, and in old age he posed for a photograph which shows him reliving the experience of working at Usdum: he wears a *keffiyeh* to protect his head and his *aba* (cloak) is hung up behind the easel; the rifle is skilfully tucked under his left arm and does not get in the way of his brushes and palette.[57] Mrs Craik's diary, like the photograph, suggests that Hunt had not lost his ability to see the ridiculous side of things, which is characteristic of the 1854 journal: for example, on reaching the encampment of Abou Daouk on 15 November, the artist presented the sheik with the gift of a coat from the British Consul at Jerusalem: 'I think ⟨it⟩ I performed my part with a sedateness and an air of importance which would have won ⟨lasting⟩ repeated burst of laughter from my poor dead friend – Walter Deverell'.[58]

This sort of anecdote does not appear in the published accounts, which advance a far more serious image of Hunt as a determined and fearless explorer. In fact he had at one point considered calling off the whole expedition: the journal of 16 November 1854 reveals that the artist was so disgusted by the cruelty of some children in Abou Daouk's tribe that 'it almost became a matter of indifference to me ⟨,⟩ whether, with such difficulties to contend with, I succeeded in the object I have in mind or ⟨whether I⟩ returned minus some napoleons and three or four days vainly spent'.[59] By 1887 Hunt presumably felt that an admission of this kind would have involved a certain loss of face. Just as, before his 1886 one-

man show, he had felt it necessary to retouch many of his pictures, so he revised his manuscript account. The published versions screen out the young man's uncertainties and in so doing present a far less attractive and complex character than that suggested in the 1854 journal, in which Hunt's apprehensiveness and awareness that confrontation would involve him, as a Christian, in a moral dilemma, highlight rather than detract from the courage he exhibited during the expedition to paint 'The Scapegoat'.

John Everett Millais's 'Autumn Leaves': 'a picture full of beauty and without subject'

MALCOLM WARNER

On 5 May 1856, the day that year's Royal Academy exhibition opened to the public, Millais showed 'Autumn Leaves' (pl.54) for the first time to the collector for whom it was painted. This was James Eden of Lytham, Lancashire, proprietor of a bleaching works in Bolton. At the time, Eden seemed satisfied with his prospective new acquisition but a few days later he wrote saying he had changed his mind and no longer wanted it. Millais replied assuring him that he would have released him from the commitment he had made (presumably in writing) if only he had expressed a dislike of the picture immediately, but that now he would not.[1] So Eden had to pay the agreed sum of £700.[2] He forced himself to sit facing 'Autumn Leaves' at dinner for a few months but it failed to grow on him and he bartered it for three pictures more to his taste with the Liverpool collector, John Miller.[3] What Eden had thought his Millais was going to be like, what he had seen or been told about it, we can only guess. But the problem was almost certainly, judging from the rest of his collection, that he had expected a mere *genre* painting, a simple, inconsequential, homely episode.[4] He had probably imagined that Millais's picture of children building a bonfire would have the sweetness and charm of 'The Pet of the Common' (pl.55), painted for him by J.C. Horsley, or Thomas Webster's 'Spring' (pl.56). The Webster was Eden's by 1866, when it was engraved in the *Art Journal*. We do not know when he acquired the work but it was shown at the Royal Academy in 1855 and may already have been in his collection when he undertook to buy 'Autumn Leaves'. As a picture of children, with a seasonal title, it makes an obvious comparison with the Millais, and similarities such as the stances of the little girls holding flowers at the right of each composition suggest Millais may even have had it vaguely in mind when designing 'Autumn Leaves'. But in mood and meaning, the two works could hardly be more different.

'Autumn Leaves' is about mortality. The setting is a Scottish autumn, seen in the garden of Annat Lodge, Perth, where the artist and his wife Effie came to live after their marriage in 1855, near Effie's family home,

Bowerswell. The passage Effie devotes in her journal to describing how the work was produced (see TG 1984, No.74) identifies the models as her younger sisters, Alice and Sophie Gray, and two local girls, Matilda Proudfoot and Isabella Nicol, discovered by her in a search through Perth for pretty children. The images of decay and death that surround the girls are intended to remind us that youth and beauty such as theirs, and life itself, are transient. The season represents the end of summer, the sunset the end of the day, the burning leaves the end to which all living things must come. Both Matilda and Isabella were from lowly backgrounds and Matilda is wearing the uniform of the local School of Industry, which was for the children of the extremely poor. The evident contrast in social rank between them and the artist's well-dressed, middle-class sisters-in-law underlines the fact that time and death show no respect for that kind of distinction.

Most of Millais's audience failed to read any such universal meaning in 'Autumn Leaves' and regarded it either as pure *genre*, albeit inexplicably solemn, or just as a landscape with figures. It seems likely that James Eden was looking at the work as a *genre* picture. The landscape view was taken by Ruskin, who lavishly praised the twilight effect but made no comment on its possible significance.[5] When 'Autumn Leaves' was interpreted on a higher plane, as a kind of allegory, as it was by F.G. Stephens in an article on the Pre-Raphaelites in the American magazine *The Crayon*, Millais was delighted. He even wrote to thank him:

> I have read your review of my works in *The Crayon* with great pleasure, not because you praise them so much but because you entirely understand what I have intended. In the case of 'Autumn Leaves' I was nearly putting in the catalogue an extract from the Psalms, of the very same character as you have quoted in your Criticism, but was prevented so doing from a fear that it would be considered an affectation and obscure. I have always felt insulted when people have regarded the picture as a simple little domestic episode, chosen for effect, and colour, as I intended the picture to awaken by its solemnity the deepest religious reflection. I chose the subject of burning leaves as most calculated to produce this feeling, and the picture was thought of, and begun with that object *solely* in view . . . I cannot say that I was disappointed that the public did not interpret my meaning in the 'Autumn Leaves' as I scarcely expected so much, and I was not sanguine of my friends either, as I know I am not the sort of man who is accused of very deep Religious Sentiment, or

reflection. However as you certainly have read my thoughts in the matter I do not hesitate to acknowledge so much.[6]

This is what Stephens had said:

> Of all the pictures Millais has painted, unquestionably the most impressive was that which we shall notice as the last he has yet produced, – 'The Burning of Autumn Leaves'. By the margin of a valley-wood stand four fate-like children, who are burning fallen leaves with fire; they have gathered a fresh heap, from which the smoke creeps upward, while one continues to add more and more. The sun has sunk and dark night cometh, the whole valley is full of a luminous mist, out of which stark, denuded poplars rise at intervals, standing sharp against the sky, which has been golden, but now fadeth to a dun brassiness, while in the zenith is the black-purple of night: 'For the night cometh in which no man can work'. The children's faces are turned from the glowing west, and are in the shadow; – there is a strange impassivity upon them, as if they knew not what they did, senseless instruments of fate, not foolish, but awfully still and composed; – they gather the leaves and cast them upon the pile, half unconscious of the awful threat:
>
> 'For wickedness burneth as the fire: it shall devour the briers and thorns, and shall kindle in the thickets of the forest; and they shall mount up like the lifting up of smoke.'
>
> 'Through the wrath of the Lord of hosts is the land darkened, and the people shall be as the fuel of the fire: no man shall spare his brother.'
>
> Nothing more awful than this picture can be conceived, or out of fewer materials have we ever seen so much expressed. You might take it either way; – as a beautiful study of a peculiar effect of nature, such as is rarely painted, and a triumph that way; or might conceive it as we have attempted to describe.[7]

The quotations Millais commends Stephens for, surprisingly apocalyptic in tone, are from the Gospel of St John (9.4) and Isaiah (9.18–19). Which extract from the Psalms he contemplated attaching to 'Autumn Leaves' himself, we can only guess, although 'My days are consumed like smoke' (102.3) would seem a good candidate. There is a sacramental quality about the girls' gestures in 'Autumn Leaves' and the church spire in the left background, St John's Kirk, Perth, adds to the religious atmosphere Millais was avowedly trying to create. On a symbolic level, the most clearly

religious element is the apple held by Isabella Nicol like the attribute of a saint in an altarpiece. This carries the usual association with the Fall of Man and in this context with the Fall as the origin of mortality.

The main precedent in art for the symbolism of mortality is the *vanitas*, a predominantly Dutch type of painting in which objects are used to illustrate the idea that 'all is vanity', 'omnia vanitas est', from Ecclesiastes 1.2. This usually consists of a still-life with the commonest *memento mori*, a skull, perhaps accompanied by picked fruit or cut flowers to suggest the inevitability of decay, an hour-glass to suggest the passage of time, and so on. Dead leaves seem never to have been used but rising smoke is common, whether issuing from a pipe or a snuffed candle. Children are occasionally introduced, as in 'Autumn Leaves', to indicate that death awaits even the young – and they are often shown blowing bubbles, another symbol of the ephemeral nature of human life which Millais takes up much later in his career in the famous 'Bubbles' (A. and F. Pears Ltd). He would certainly have seen *vanitas* pictures and they may well have played some part in the genesis of 'Autumn Leaves'. There are also, of course, precedents for the representation of the seasons. In the visual arts, however, autumn invariably appears as the season of abundance, a southern European conception derived from its association with the vintage. Ripa's *Iconologia* shows a group of women with head-dresses decorated with jewels, vine-leaves and fruits, and Poussin's 'Autumn' (Louvre) shows the Israelite spies bringing a gigantic bunch of grapes back from the Promised Land. In presenting an alternative, northern view of autumn as the season of decay and death, 'Autumn Leaves' is iconographically unique.

Its sources lay not in art but poetry. With the notable exception of Keats, for whom autumn is the 'Season of mists and mellow fruitfulness, Close bosom-friend of the maturing sun', the association of autumn with nostalgia and a sense of transience is a commonplace of English verse. The *locus classicus* for the idea is James Thomson's *The Seasons* (1730), in which the autumnal winds induce feelings of 'Philosophic Melancholy'. In 1848, the year of the formation of the P.R.B., Millais's Pre-Raphaelite Brother D.G. Rossetti wrote an autumnal poem called 'The Fall of the Leaf':

> Know'st thou not at the fall of the leaf
> How the heart feels a languid grief . . .
> And how death seems a comely thing
> In Autumn at the fall of the leaf.[8]

The tone is melancholy enough, and with the idea of 'The Fall' faintly biblical, but more personal and agonised than either Thomson's poem or

Millais's painting. Rossetti's heady association of dead leaves and death-longing is echoed in Millais's 'Mariana' of 1850–1 (TG 1984, No.35), in which fading sycamore leaves are strewn over the dejected heroine's embroidery. The Tennyson poem from which 'Mariana' is taken makes no mention of the season, although, as we shall see, the autumnal imagery Millais introduces in his painting is completely Tennysonian in spirit.

Closer to 'Autumn Leaves' than the Rossetti poem, both in date and in its softer tone, is the 'Autumnal Sonnet' by another friend of Millais's, William Allingham:

> Now Autumn's fire burns slowly along the woods,
> And day by day the dead leaves fall and melt . . .
> and now the power is felt
> Of melancholy, tenderer in its moods
> Than any joy indulgent summer dealt . . .

This was in the edition of his *Day and Night Songs* published in 1855, the year 'Autumn Leaves' was begun, with illustrations by Millais and other Pre-Raphaelite artists. The 'Autumnal Sonnet' was not illustrated but Millais would undoubtedly have read it. Allingham's fondness for seasonal imagery is evident in the anthology he edited in 1862 under the title *Nightingale Valley*, which includes Shelley's 'Autumn: A Dirge', a poem 'from the German' called 'The Last Day of Autumn', Tennyson's 'A spirit haunts the year's last hours' and the autumnal song 'Tears, idle tears' from Tennyson's *The Princess*. In connection with Allingham, we should also note that Rossetti's illustration to the *Day and Night Songs* (pl.57) may have had some influence upon the roughly symmetrical and frontal arrangement of the figures in 'Autumn Leaves'.

Both Rossetti's 'The Fall of the Leaf' and Allingham's 'Autumnal Sonnet' owe much to Tennyson, whose work contains a wealth of autumnal imagery and is probably the single most important source for 'Autumn Leaves'. Holman Hunt quotes Millais as having declared his feeling for the kind of scene it depicts as early as 1851:

> Is there any sensation more delicious than that awakened by the odour of burning leaves? To me nothing brings back sweeter memories of the days that are gone; it is the incense offered by departing summer to the sky, and it brings one a happy conviction that Time puts a peaceful seal on all that has gone.[9]

'The days that are gone' recalls 'the days that are no more' in the song from
The Princess we have already mentioned:

> Tears, idle tears, I know not what they mean,
> Tears from the depth of some divine despair
> Rise in the heart, and gather to the eyes,
> In looking on the happy Autumn-fields,
> And thinking of the days that are no more.

Millais was reading songs in *The Princess* in October that year (1851).[10]
'Tears, idle tears' seems to have stuck in his mind and he alludes to it in a
letter to Hunt of February 1856, when work on 'Autumn Leaves' was
probably still in progress. Hunt had just returned from the Holy Land and
Millais writes to him of the changes 'amongst your friends, and the old
circle' that have come about since his departure: 'There is something
unspeakably sad about all these alterations, although they are not
attended with any real cause for sorrow. It is just *"The days that are no
more"*.'[11] This may permit us to read 'Autumn Leaves' as being at least
partly personal in meaning, expressing the artist's feelings about the
passing of the P.R.B. and his separation from former companions in
London. Whether or not that was his intention, it certainly shows that
'Tears, idle tears' was in his thoughts around the time of painting 'Autumn
Leaves'. Hunt, incidentally, had included a setting of the same song in 'The
Awakening Conscience' (TG 1984, No.58) to reinforce the idea of his
heroine's having irrevocably lost her innocence.

Millais visited Tennyson at Farringford in November 1854, a year before
painting 'Autumn Leaves', and the poet's wife Emily noted in her journal
that he had been 'beguiled into sweeping up leaves and burning them'
during his stay.[12] Perhaps he remembered the experience the following
autumn and conceived 'Autumn Leaves' as a result. Tennyson would have
been in his mind since he was engaged before and during the execution of
the picture in designing illustrations for the Moxon Tennyson (published
1857), though not for any autumnal poems. One of his illustrations for
'The Talking Oak' shows Alice Gray wearing the same dress as in 'Autumn
Leaves'.

Like the poems we have cited, and unlike the pictures with which Millais
had made his name earlier in the 1850s, 'Autumn Leaves' is non-
narrative. It is metaphorical, self-contained and strangely static, with no
implication of events or action leading up to the moment depicted or
continuing afterwards. The work has a theme and creates a mood, but tells
no story. As Effie says in her journal, undoubtedly echoing the artist's own

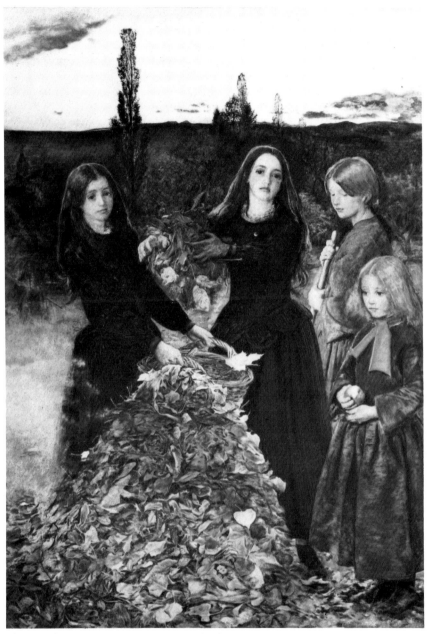

54 J.E. Millais, 'Autumn Leaves', 1855–6;
oil, 41 × 29 (104.1 × 73.6); *City of Manchester Art Galleries*

55 Engraving by H. Lemon after J.C. Horsley's
'The Pet of the Common', 1854, published in the *Art Journal*, 1863

56 Engraving by Pelée after T. Webster's 'Spring',
1855, published in the *Art Journal*, 1866

57 Wood-engraving by Dalziel after
D.G. Rossetti, 'The Maids of Elfen-Mere',
in W. Allingham, *The Music Master, A Love
Story, and Two Series of Day and Night Songs*, 1855

58 J.E. Millais, 'Spring', 1856–9;
oil, $43\frac{1}{2} \times 68$ (110.5 × 172.7);
The Rt Hon. The Viscount Leverhulme

59 H. Wallis, 'The Stonebreaker', 1857–8;
oil, 25¾ × 31 (65.4 × 78.7);
Birmingham Museum and Art Gallery

60 W.L. Windus, 'Too Late', 1857–8;
oil, 37½ × 30 (95.3 × 76.2); *Tate Gallery*

[135]

61 J. McN. Whistler, 'The White Girl', 1861–2;
oil, 84½ × 42½ (214.7 × 108); *National Gallery of Art, Washington*

words, 'he wished to paint a picture full of beauty and without subject', the word 'subject' here, as in general in the context of Victorian art, meaning narrative content. Millais had used symbolism before but always in the service of narrative. The leaves in 'Mariana' signify death as they do in 'Autumn Leaves' but they are there to point up a particular aspect of Mariana's particular plight. The work remains a subject-picture. In 'Autumn Leaves' symbolism is an end in itself, in the sense that the whole scene is intended as a symbolic representation of a universal truth.

As well as avoiding subject, Effie says, Millais was seeking beauty. He was anxious that this side to 'Autumn Leaves' should be appreciated and told Effie during the R.A. exhibition that even though his work was being 'picked to pieces' because it was 'out of the scale of received conventionalities', she would notice that 'no criticism or reports go to say that *any* of the faces in the pictures are ugly, and hundreds are daily exclaiming about the extreme beauty of the heads of the children'.[13] While working on 'Autumn Leaves' he wrote an uncharacteristically theoretical letter on the subject of beauty to his friend Charles Collins:

> Aspect is the great secret. *The prospect of the aspect.* I have never seen any beauty yet but what looked at times altogether without it. The *only* head you could paint to be considered beautiful by *everybody* would be the face of a little girl about eight years old, before humanity is subject to such change. With years, features become so much more decided, expressive, through the development of character that they admit of more or less appreciation – hence the difference of opinion about beauty. A child represents beauty more in the abstract, and when a peculiar expression shows itself in the face, then comes the occasion of difference between people as to whether it increases or injures the beauty. Now this is evidently the game the Greeks played in Art, they avoided *all* expression, feeling that it was detrimental to beauty according to the capacity of understanding in the mass. I believe that perfect beauty and *tender* expression *alone* are compatible and there is undoubtedly the greatest achievement if successful. In that case hundreds would say '*but she looks so pained and unhappy*' but I think there would be less dissension than in any other treatment. That very lovely expression in little Alice's eyes which you know, would be the very point which thousands would object to. They would say 'there is such an odd miserable look about her, I don't like that for a child, etc. etc.' You will think with all this that I have been offered the place of lecturer on painting at the RA. The fact is I have been going

through a kind of cross examination within myself lately as to a manner of producing beauty, when I desire it to be the chief impression.[14]

In other words, the features most likely to be appreciated as beautiful are those that are impassive or gently wistful, qualities found in children's faces before they acquire marks of character. We need hardly point out how 'Autumn Leaves' shows Millais putting his idea into practice. Consciously or unconsciously, he seems to have been influenced by a passage in the Fifth Discourse of Sir Joshua Reynolds: 'If you mean to preserve the most perfect beauty *in its most perfect state*, you cannot express the passions, all of which produce distortion and deformity, more or less, in the most beautiful faces.' Reynolds is talking about the expression of emotion rather than character but the principle is the same: the more marked the expression the less conducive to beauty.

It follows from that principle that, having decided to aim for beauty as the 'chief impression' in a picture, the artist should choose a subject that does not depend on the suggestion of strong feelings or character through physiognomy, a subject that, in the Victorian sense, was little or no subject at all. This is the aesthetic reasoning that lay behind 'Autumn Leaves'. It is full of beauty and *therefore* without subject. The symbolic representation of a theme, mortality, in terms of seasonal imagery, with figures used not as actors in a drama but as personifications, of youth and beauty itself, was a perfect solution to the problem of making a picture full of beauty, without subject, yet not without meaning. And the fact that the figures are children had the advantage Millais describes in his letter to Charles Collins, that a child 'represents beauty more in the abstract', his or her face naturally bearing only the mildest, tenderly wistful expression. This idea stayed with Millais and informs the many child pictures, often deliberately Reynoldsian, that he painted through the rest of his career – though later with neither the natural observation nor the symbolism of 'Autumn Leaves' to save them from sentimentality.

It is a shock to find Millais echoing the thoughts of a man regarded as a villain of artifice and empty painterliness by the P.R.B. and dubbed by them 'Sir Sloshua'. This is a measure of the changes that had come over his attitudes since the Brotherhood's early years. Pre-Raphaelitism was based on the idea that if you take care of truth, beauty will take care of itself. Setting out to produce beauty as the 'chief impression' in a picture represents a reversion to the classical theory against which Pre-Raphaelitism was a reaction. (And the reference to Greek sculpture as

beautiful because expressionless in the letter to Collins looks forward to the way antique art was reinterpreted in the classical revival that was part of the Aesthetic Movement of the 1860s and '70s – the general importance of 'Autumn Leaves' to which we shall discuss later.) We might wonder whether the change would have occurred had Millais not become separated from his Pre-Raphaelite mentors, Holman Hunt and Ruskin. Hunt went off to the Holy Land early in 1854 and was away for two years, and Ruskin and Millais were permanently estranged because of Effie's bitterness towards her former husband. Looking elsewhere for the kind of stimulus Hunt and Ruskin had provided, perhaps Millais sharpened his new sense of aesthetic direction partly through contact with Tennyson. At Farringford the two men had 'talks as to the limits of realism in painting' and the poet criticised 'A Huguenot' of 1851–2 (TG 1984, No.41) for its, to his mind, excessively realistic style.[15] This and other such discussions may have helped prepare Millais theoretically for 'Autumn Leaves' as much as the Tennysonian concept of autumn prepared him iconographically.

Not that 'Autumn Leaves' represents a complete *volte-face*. It is Pre-Raphaelitism softened rather than rejected. The principle of preserving the actual, individual looks of the chosen models is still there – the key Pre-Raphaelite concept of portraiture as against idealisation – only the models were carefully chosen for their beauty. The setting is an actual place, but painted from memory and imagination as well as observation. This was the practical outcome of the decision to show a particular season and time of day: autumn sunsets are simply too few and too short-lived to paint entirely from nature in the way Millais had painted a summer background set at no very definite time of day, such as the river bank in 'Ophelia' (TG 1984, No.40). As he explains in the letter to Stephens, pictures such as 'Autumn Leaves' 'are really more difficult to paint than any other, as they are not to be achieved by faithful attention to Nature, such effects are so transient and occur so rarely that the rendering becomes a matter of feeling and recollection'.

'Autumn Leaves' is by no means 'sloshy' in Pre-Raphaelite terms but because it depicts twilight it is less tightly detailed than the works of Millais's period of high Pre-Raphaelitism. Painting twilight held a practical advantage for an artist growing bored and impatient, as Millais was, with the meticulousness that was necessary to represent a scene in broad daylight in a manner consistent with Pre-Raphaelite principles. In 1853, after finishing the background to 'The Proscribed Royalist' (TG 1984, No.46), he had written to Hunt: 'Upon my word it is quite ridiculous. I have been four months about a wretched little strip of uninteresting green

stuff.'[16] Effie says that with 'Autumn Leaves' he was 'much delighted with the rapidity of his execution'. So, probably, was she. There was every reason for Millais to increase his output now that he had a wife to support and the imminent prospect of children. But there is more to the choice of a dusk setting and the relative lack of definition in 'Autumn Leaves' than mere practicalities. It stands in a tradition of twilight painting stemming from the Venetian Renaissance, in which vagueness of form enhances an air of reticence and mystery about the content, and suggests an image from the memory, the imagination or a dream, rather than a scene directly perceived.

Millais followed 'Autumn Leaves' with further pictures in the same non-narrative vein and on the same theme. The most obviously related is 'Spring' (pl.58; TG 1984, No.96), in which a scythe suggests the presence of the 'Grim Reaper'. This was shown at the 1859 Royal Academy exhibition with a yet doomier pendant in the shape of 'The Vale of Rest' (ibid., No.100). Millais's difficulty selling these two works highlights the failure of collectors and dealers to respond to 'Autumn Leaves' and its progeny. Having priced them at £1000 each (they are over twice the size of 'Autumn Leaves'), he was cold-shouldered, received not so much as a hint of an offer for a fortnight after the exhibition opened, became desperate, was grateful to accept £700 for 'The Vale of Rest' and only sold 'Spring' after it had been on the market for a whole year – and for a price that was lower still. Unlike 'Autumn Leaves', the later pictures were not spoken for in advance of completion and Millais's letters of around the time he first put them before the public show apprehension, turning to disappointment, turning to panic. In the early 1850s he had become so accustomed to popularity that it was humiliating to have to struggle to sell his new work. And he was constantly urged to go back to the type of easily legible subject-picture that so readily won him that popularity. 'Whatever I do, no matter how successful, it will always be the same story', he wrote to Effie on 17 May 1859, '"Why don't you give us the Huguenot again?"'[17] He did give them 'The Huguenot' again in 1860 with 'The Black Brunswicker' (TG 1984, No.108), earning himself £1000 for a smaller, easier picture than either 'Spring' or 'The Vale of Rest', and never painted anything as serious, symbolic, difficult and 'out of the scale of received conventionalities' as 'Autumn Leaves' again. Some of the ideas from which it was created can be traced in the child pictures of his later career, studies of impassive or wistful girls such as his R.A. Diploma Picture, 'A Souvenir of Velasquez', and in bleak, autumnal Scottish landscapes such as 'Chill October' (TG 1984, No.140) and 'Lingering Autumn' (Lady Lever Art Gallery, Port Sunlight).

But this is a kind of half-life. In the separating out of figural and landscape elements, neither retained the powerful meaning they had when played off against each other.

Though in private collections, 'Autumn Leaves' was to a fair degree publicly accessible during the later 1850s and early 1860s. A wood-engraving was published in the *Illustrated London News* on 30 August 1856 and the original was exhibited in Manchester in 1857, Edinburgh and Liverpool in 1858, and London in 1862. Not surprisingly, it was greatly admired by artists and several important pictures of the period show its influence. Henry Wallis's 'The Stonebreaker' (pl.59; TG 1984, No.92) is more explicitly tragic and includes an element of social criticism, but the colours and the painting of the sunset over distant blue hills are unmistakably Millaisian. The Liverpool artist William Lindsay Windus was closely associated with John Miller, whose collection included not only 'Autumn Leaves' but also 'The Blind Girl' (ibid., No.69). Features from both are visible in Windus's 'Too Late' (pl.60; ibid., No.97), which Miller also owned and may even have commissioned. Windus picks up the theme of mortality in 'Autumn Leaves' and the tension between figures and setting – although he reverses the arrangement, making his landscape green and redolent of life, with his figures united in thoughts of an impending death. But 'Too Late' differs from the Millais in one essential respect: it depends on exactly the kind of narrative set-up, telling expressions and gestures that 'Autumn Leaves' deliberately lacks. Indeed, it provides a good illustration of what 'subject' really means in the phrase we have discussed from Effie's journal. Another sunset picture indebted to 'Autumn Leaves' is William Dyce's 'Pegwell Bay' (TG 1984, No.106), where fossil-embedded cliffs and a comet in the sky act as *vanitas* symbols, suggesting vastnesses of time and space against which mere human lives, figures on the beach gathering sea-shells, appear brief and insignificant.

The effect of 'Autumn Leaves' on Whistler's 'The White Girl' (pl.61), a work we know Millais himself admired with enthusiasm, is typical of its general importance in the history of British art. Like an older sister of Sophie and Alice Gray, with the dead leaves replaced by fallen flowers and a growling bear's head, 'The White Girl' suggests the theme of the Fall in sexual terms – which is arguably an elaboration of one strain of meaning in 'Autumn Leaves'. On the other hand, Whistler insisted that we should not look for meaning in 'The White Girl' but for pure visual delight. Whether or not we completely accept this, it is clear that 'The White Girl' is a key picture for that post-Pre-Raphaelite trend in British art towards placing beauty above all other considerations, normally called the

Aesthetic Movement. It is characteristic of countless paintings full of beauty and with little or no narrative content produced from around 1860 by Whistler, Albert Moore, Rossetti, Burne-Jones and many others, works born out of a dissatisfaction with storytelling as a basis for art and a preference (to borrow terms used by Ruskin) for 'fair pictures' above the 'stern facts' of high Pre-Raphaelitism. 'Autumn Leaves' marks the beginning of the shift. It arose from a desire to create beauty, and a theory of how that might be achieved; it set an example for the use of symbolism as an alternative to 'subject' and introduced the impassively beautiful female face that became the chief icon of aestheticism.

The Price of 'Work':
the background to its first exhibition, 1865

MARY BENNETT

Ford Madox Brown's letters to his patron George Rae of Birkenhead have recently reappeared and besides the material drawn on extensively by Ford Madox Hueffer in his biography of the artist, contain some revealing additional background to the artist's negotiations over the final payment for 'Work' (pl.62) and its presentation before the public.[1]

The artist opened his one-man exhibition of one hundred pictures and drawings at 191 Piccadilly in March 1865 with a catalogue written by himself which was a considered statement of his ideas, complementing his diary of the 1850s (pl.63).[2] While embracing work of his whole career, the exhibition was fundamentally designed to show off his latest picture, which had been in hand for over a decade and was the most extensively worked out, most highly finished and intellectually significant of his pictures to date. Exhibitions of single pictures in the later 1850s were on the increase and their greatest populariser was Ernest Gambart the international dealer.[3] Acceptance at the Royal Academy could be uncertain, hanging in a good position dependent on the whim of the hanging committee, and no financial reward was forthcoming if the picture was already sold. In Madox Brown's mind was undoubtedly the tremendously successful exhibition of Holman Hunt's large 'Finding of the Saviour in the Temple' (TG 1984, No.85) in 1860 in Bond Street and its sale to Gambart for an exceptional price which included exhibition and engraving rights. Like 'Work' it had taken many years of toil to finish and at its exhibition the opportunity had been taken not merely to provide a detailed description but to publish a complete outline of the artist's career (written by F.G. Stephens under Hunt's eye), and to reprint the extensive critical reviews.

'Work' (TG 1984, No.88) had been designed initially in 1852 at the height of Pre-Raphaelite influence on Madox Brown, but had had to wait for a patron until 1856 when Rossetti introduced T.E. Plint of Leeds, who was to be the first of a small group of new patrons for the whole circle.[4] Madox Brown considered himself launched at last.[5] The price was to be

400 gns paid in instalments over two years and Plint hoped to see the completed picture at the R.A. of 1858.[6] The elaboration of its treatment made this impossible and in 1860 the artist negotiated a new agreement, in spite of Plint's initial annoyance, whereby he was to receive a further £400 while going on with it and subsequently to paint another, then unspecified, picture for the money.[7] In the meantime he financed himself from 1859 chiefly through a replica to be painted concurrently for James Leathart of Newcastle, priced at 300 gns.[8] In April 1860 he got it noticed in the *Athenaeum* (probably by F.G. Stephens, the new art critic), in the same column mentioning Hunt's picture: 'Mr. F.M. Brown is engaged on a picture of large size, entitled "Work" – the subject illustrating the different conditions of intellectual and physical labour . . . The painting and design of this work display singular power and brilliancy, and as a whole it is likely to attract a large share of public attention when exhibited, which will be, we believe, in the course of the present year.'[9]

However, the picture was by no means finished when Plint's untimely death in July 1861 left a tangled estate with pictures as the only assets for his large family and many of these, by several different artists, paid for but not completed. Gambart was appointed by the executors to establish order. Before negotiations could commence Madox Brown, still financially straightened, applied to Leathart for advances against collateral in order to be able to proceed with it. The 'English Autumn Afternoon' and 'Wilhelmus Conquistator' were lent in turn against £100 in 1861–2 (Leathart afterwards bought the latter);[10] and 'Manfred' and 'Parisina', or 'Stages of Cruelty', were lent early in 1863.[11] Already in September 1861 Madox Brown thought Gambart had an eye on 'Work' for himself,[12] and at the time of its completion and delivery to Gambart (as trustee), in August 1863, he was able to announce to Leathart the conclusion of very favourable financial terms involving a sum of £900: '. . . the net price for the picture – copyright & right of Exhibition is 1320£ – 420£ originally paid by Plint – 400£ subsequently paid for an other work (not to be painted now) & 500£ to be paid on delivery of the picture. So that considering that I am not Mr. Frith, the bargain has not turned out such a very bad one'.[13] Gambart apparently at this time commented to Leathart, at Newcastle, that 'he expected the engraving would be a success".[14] John Miller, an earlier patron at Liverpool, had advised Madox Brown in the early stages of the negotiations, and its inclusion in the auction of the Plint pictures in 1862 had been avoided. It was now to be exhibited in 1864 as a 'just finished work'[15] and the artist tried to stress to Gambart that he did not want a prior sale by the executors which might dampen its first

appearance. The cachet of its exhibition by Gambart and subsequent engraving would both attract new patrons and confirm those he already had: a chance similar to Holman Hunt's appeared to be opening before him.

He did not, however, consider the contrasting subject matter and selling power of the two pictures. Hunt's 'Finding of the Saviour in the Temple' popularised religion and brought the Bible to life, his painting was social comment without recourse to sentimentality, and by 1863/4 in a style which was already passing (Rossetti had already stressed the different roles of the two pictures back in 1858).[16]

The astute Gambart prevaricated and in April 1864 the artist took action, which he described to George Rae. Rae, who like Leathart, developed as a sympathetic admirer and friend, had first appeared in the autumn of 1861, to buy the 'English Autumn Afternoon' (TG 1984, No.51), repudiated by the Plint executors and by then back from loan to Leathart; with other patrons he had strongly advised the artist to bring his pictures before the public at the International Exhibition of 1862.[17] Perhaps for these reasons, as well no doubt to keep up his own value with his patron, Madox Brown wrote at length on 29 April:[18]

. . . I called on Gambart yesterday, being impatient at hearing nothing of the Exhibition of "Work." I now find that the Executors & he have had a shindy about the possession of Hunt's large picture which he Gambart would not have done with by the time contracted for. They have forced him to buy it back for the price they gave him £3,000 & have given him the sack. He considers them guilty of the basest ingratitude & has thrown all the remaining pictures on their hands. The upshot of it for me is, that he had got the Exhibition of "Work" all arranged & cut out, even the spaces for placards taken at the Railway stations, & now it is all stopped again & the picture in [a] warehouse somewhere in London.

I have written to the Executors proposing to carry the matter through for them myself, or to keep it till next year & then exhibit it with a selection of my other pictures. I now wait their answer.

There is no faith to be put in the prince of picture dealers I see. However in the present instance, he could not help himself, & this untoward falling out, was quite unforeseen.

If I can only get the picture for next year it will be all the better for me.

62 F.M. Brown, 'Work', 1852, 1856–63;
oil, $53\frac{15}{16} \times 77\frac{11}{16}$ (137 × 197.3);
City of Manchester Art Galleries

opposite
63 Title-page of Brown's catalogue
for his exhibition at 191 Piccadilly, 1865

Arthur Rossetti
with Grandpapa's love Sep 23/91

THE EXHIBITION

,OF

WORK, and other Paintings,

BY

FORD MADOX BROWN,

AT THE GALLERY,

191, PICCADILLY

(OPPOSITE SACKVILLE STREET).

A.D. MDCCCLXV.

" Lo que empieza el hombre para si mismo
Dios le acaba para los otros." *Victor Hugo (corrected).*

LONDON:

Printed by M'Corquodale & Co., 18, Cardington Street, N.W.

PRICE SIXPENCE.

[147]

64–5 Two pages of a letter from Brown to George Rae about 'Work', 1864
(letter No.29: see p.150); *Lady Lever Art Gallery, Port Sunlight*

is now upon having a
first-rate collection.

Of course to me it would
be a great thing to know the
picture in the hands of a reasonable
being — for now in their utter
recklessness, God knows what
they "the executors" may do with the picture,
& Gambart now, will not
help them, quite the reverse,
for he is furious —

Meanwhile whether to the accident
of this quarrel as G. declares, or
to some more subtle cause before
this quarrel, I owe it that the work
of my life, I may say, is shut up
in a cupboard!

He elaborated on this, to him crucial subject, a little later:[19]

> I fancy you will be glad to hear these few particulars about the
> "Work" picture, & also the account of the shindy which has taken
> place between Gambart & the Executors of the late Plint, as I had it
> from Gambart himself a few days since; begging you however not to
> mention it again particularly to artists except in very general terms.
>
> It seems Butler the Leeds lawyer a short time since found a signed
> paper of Gambart's agreeing to deliver the "Finding of Our Saviour"
> picture by a certain date this year & Gambart finding that he could not
> do it without injury to the immense stake he has in the engraving,
> they by gentle pressure forced him to buy back the picture of the estate
> *for 3000£* & gave him (in polite words) the *sack* – he showed me their
> letter – He had shortly before made all arrangements for the exhibition
> etc of my "Work" Picture & he showed me a letter from them
> authorising him to proceed with it forthwith. I dont know what he has
> been aiming at all this time but it is most singular that after giving me
> the large sum I received for the right of Exhin of the picture (*out of their
> funds it seems*) he has on one pretence or another kept the picture out
> of sight ever since. He is extremely civil to me & has recently bought
> pictures of me,[20] so perhaps I ought not to reflect on him, but I can't
> help fancying that it is as though he had wished to get the picture out
> of my hands, & then prevent its interfering with the engraving of the
> *Finding of the Saviour* which is his great stake, & with which he
> proposes winding up his publishing business, having feathered his
> nest. This may be but a vain imagination of mine but certain is, the
> affair of my "Work" is now less forward than ever, Gambart & the
> executors quarrelled for good, & the picture now again on their hands
> & warehoused somewhere in London.
>
> I have now written to them proposing to exhibit it next year with a
> selection of my other works. They cannot answer me yet & seem quite
> at a loss what to do, professing to be open to any offer. If you cared to
> possess my *magnum opus*, you might possibly secure it cheap at this
> juncture – I thought I might as well let you know at any rate –, as you
> are so near upon having a first-rate collection.
>
> Of course to me it would be a great thing to know the picture in the
> hands of a reasonable being, for now in their utter helplessness God
> knows what they, the executors, may do with the picture, & Gambart
> now, will not help them, quite the reverse, for he is furious.
>
> Meanwhile either to the accident of this quarrel as G. declares, or to

some more subtle cause before the quarrel, I owe it that the work of
my life, I may say, is shut up in a cupboard!

Further scraps of gossip followed and Madox Brown continued to suggest
that Rae should attempt to buy it cheap from the executors, and
formulated fantastic plans of paying him back for copyright and right of
exhibition by means of bills and other pictures;[21] but Rae, who may have
dallied with the idea, did not rise. Already the artist was making requests
for loans of various pictures and in October came to an agreement with the
executors to have 'Work', free of charge, to exhibit the following season,
subject to a bond with two guarantors against its non-return or loss. He
hoped, he told Rae, subject to Rae's help, to 'be in a position to defray the
expenses of the Exhibition estimated at 200£ even should the returns from
it be next to nominal'. He asked Rae to pay in advance for his new
commission of 'Jacob and Joseph's Coat', 'without too minutely comparing
the amount of work done in proportion'; and he asked him to be a co-surety
(the other was to be William Morris).[22] Details he added in a later letter
with a certain evident satisfaction: 'the value they put on the picture is
1,400£ and the Bond puts the penalty at 2,000£, a tremendous looking
figure certainly'.[23] Rae complied with all this but was not to see the
exhibition himself, being sent off by his doctor to Egypt and Italy. He sent a
series of post-dated cheques and Madox Brown wrote on their receipt on
5 January 1865, '. . . and when I say that but for your kindness in this
matter, I do not think I should have been able to get up my Exhibition this
year you may be sure I feel obliged to you. I can only hope that the Jacob
picture will turn out one of my best for your sake . . . I shall require of you
not only the "Autumn Afternoon" & "Sir Tristram" but the little Irish Girl
also – if you will be so good – I mean to get together *all* I can. What you
suggest as to a sort [of] handbook, has been in my mind for some time. I
think I shall have a catalogue raisonné or annotated of my own with
something of theirs besides [?], but this must be one of the many matters I
have to decide. I should of course spread it about before the opening'.[24]

Holman Hunt did not think much of the idea,[25] was sure he would make
a loss and advised him to advertise in good time. Madox Brown had
apparently been displeased at Hunt's exhibition, with Martineau, at the
Hanover Gallery during 1864 which he saw as a plagiarism of his idea.[26]
Like Hunt, he advertised in the *Reader* shortly before the opening, which
took place on 10 March in pouring rain.[27] Hunt's forecast proved correct.
While the press coverage was satisfactory enough, attendance was thin
and it cost the artist over £300.[28] The exhibition had neither the

fashionable Gambart's showmanship nor was there any announcement of an engraving of 'Work'. Just before it closed Madox Brown wrote to Rae on 12 June 1865, 'I am off this afternoon to have a look at the place & see who are interested enough to take a farewell look at it. For the last month the numbers have fallen off much all who care about such matters appearing to have satisfied themselves before, & the general public I never much hoped wd take the thing up. As an immediate pecuniary matter it has certainly been a loss rather than a gain . . . But on the whole I cannot for an instance doubt it has been a great help to me, as I shall find no doubt in the future . . . Apropos of "Work" I suppose you have seen that it is to be put up at Christie's on Saturday 17 inst. so tomorrow eve by six it has to be there – I am told it is a bad year for picture sales, but I must hope for the best, it seems Gambart made them an offer but they thought it their proper course to put it up for auction'.[29] It was bought in at 510 gns.[30]

He was still fruitlessly planning ways and means to get it back a year later[31] and Rossetti best summed it up at that time in the letter quoted by Hueffer: 'An unfavourable sale would not only be injurious but very disheartening, and on the other hand, if you thought it necessary to replace the £500 at once you would be able without difficulty to tempt some one by so evident a bargain and the sacrifice would have the great advantage of being private instead of public. Whereas, if the picture can be kept, it would eventually be certain to fetch a better price, even if not yet a true one, either before or after your death. Were its subject a less purely realistic one, I should have no fear for its fate even now but the epoch of preraphaelitism was a short one which is quite over and will never be renewed, and its products will be exceptionally valuable one day but not yet.'[32]

The Pre-Raphaelites and Mediaeval Illuminated Manuscripts

JULIAN TREUHERZ

Pre-Raphaelite paintings reminded some contemporary observers of mediaeval illuminated manuscripts. To Coventry Patmore the Oxford Union murals appeared 'so brilliant as to make the walls look like the margin of an illuminated manuscript' and Ruskin wrote that 'Rossetti's colour was based on the former art of illumination'. Later writers have continued to make the analogy. Richard Muther described Ford Madox Brown's figures as 'stiff and party coloured like card kings' with 'a bright joy of colour and the half-barbaric motleyness of old miniatures'. More recently Millais's 'Mariana' has been said to possess a 'lapidary richness of the surface, reminiscent of a bejewelled medieval manuscript'.[1]

Such loose comparisons, usually applied to pictures with mediaeval subjects, are given greater support by the references scattered through Pre-Raphaelite letters and diaries to visits to the British Museum or the Bodleian Library to look at illuminated manuscripts. But whether these had any appreciable effect on the Pre-Raphaelite style is a question which has never been explored. The sources of Pre-Raphaelite painting are many, confused and difficult to analyse: early Italian art, van Eyck, Dürer, Holbein, the Nazarenes. The interest in manuscript illumination is no exception. Its effects were non-existent or slight on some artists and strong on others. It affected the details of a number of paintings and the essence of a few. The interest of the Pre-Raphaelites in early Italian and Flemish art links them with a general shift in taste towards what was previously dismissed as primitive. Their looking at mediaeval miniature painting is part of this movement and reflects contemporary changes in the appreciation of mediaeval illumination.

Mediaeval miniature painting was much admired in the early Victorian period by a group of collectors, scholars and connoisseurs,[2] but when an artist came into contact with an illumination it was likely to be as source material for an authentic costume in a historical subject, and it was probably through an engraved illustration in a history book that the contact was made. Miniature painting was not well known to artists until

the later eighteenth century, when Joseph Strutt published a series of books on the dress, sports, pastimes, arms and antiquities of England. These contained numerous engravings copied from illuminated manuscripts mainly in the British Museum and the Bodleian Library, and were used as source material for the historical paintings of artists such as West, Bonington and Stothard. In the 1830s and 1840s Strutt's pioneer work was amplified by other publications such as the costume histories of Planché and Fairholt, and the series of cheap illustrated books of popular history published by Charles Knight. In all these the sections on the middle ages were illustrated with engravings of details from illuminated manuscripts and other mediaeval artefacts. But all of them were books about history not art, and the illustrations were in black and white.[3]

In this way Ford Madox Brown made indirect use of manuscript illumination when working on his epic 'Chaucer at the Court of Edward III' (Art Gallery of New South Wales, Sydney; see TG 1984, No.7). In October 1847 he 'went out to see after stuffs & a pourtrait of Chaucer published by C. Knight'.[4] This was probably the engraving after the Hoccleve manuscript in the British Museum which Knight published in 1845 in *Cabinet pictures of English Life* by J. Saunders. Another of Knight's publications, *The Pictorial History of England* with text by George Craik and James MacFarlane, 1837, seems to have provided Brown with costumes for this painting, taken mostly from manuscripts, though sometimes from other sources such as tomb effigies. These costumes include the headdress of Philippa the Picard, the lady on the left turning her head back, the plate-like hat of the Cardinal on the right and the distinctive dress of the lady seated by the fountain in the lower foreground. Brown's use of *The Pictorial History* as his source is confirmed by his adoption of the term 'sideless gown', a name coined for this garment by Craik and MacFarlane. Sometimes the artist had costumes made up from these illustrations (hence the 'stuffs' he mentioned in October 1847) and worn by models or lay figures. *The Pictorial History* also includes a miniature of a crossbowman shooting a bird, adapted by Brown for the design on the fountain in the Tate Gallery version of the painting. In the landscape backgrounds to both versions are a ploughman and a sower: both unmistakably derive from the figures common in manuscript borders and calendars illustrating agricultural occupations. Similar, though not exactly corresponding examples are shown in *The Pictorial History*.[5]

Not only the details, but the whole painting may have been inspired by a manuscript illumination. In his diary Brown claimed he had the idea for the Chaucer picture after reading a passage in Sir James Mackintosh's

History of England referring in very general terms to the genius of Geoffrey Chaucer. Brown continued, 'This at once fixed me, I immediately saw visions of Chaucer reading his poems to knights & ladyes fair, to the king & court amid air & sun shine'.[6] This recalls very directly the frontispiece to the fifteenth-century manuscript of 'Troilus and Cressida' at Corpus Christi College, Cambridge. It shows the poet reciting in the open air to a colourfully attired assembly of courtiers (pl.66).[7] The landscape setting, the piled up composition, the upturned faces and back views of some of the listeners, the seated figures in the foreground, one of them resting his face on his arm like Brown's Black Prince, even the presence of a lady in a 'sideless dress', all these suggest that the frontispiece was known to Brown.

However, this attractive theory cannot be proved. Though known to scholars, the Corpus Christi manuscript was difficult of access and there is no record of Brown having examined it.[8] If he had, he would surely have mentioned it, as he did with other sources. No engraving of it is known. The subject of Chaucer reading at court does not occur in the standard lives of the poet consulted by Brown but similar subjects were painted by others in the 1840s. In 1847 Samuel West exhibited a 'Chaucer at the Court of Edward III' at Westminster Hall. This would have been seen by Brown and, like Brown's picture, included the King, Queen Philippa, the Black Prince, John of Gaunt and others gathered on a dais, but it is known only from a written description.[9] Thus there is the possibility that the Troilus frontispiece was known to other artists, and that Brown's painting, perhaps based on such an intermediary, contains an indirect reminiscence of the fifteenth-century miniature.

In any case, the period of the emergence of Pre-Raphaelitism coincided with the widespread publication of facsimiles of mediaeval miniatures. In the 1830s and particularly the 1840s they were reproduced for their own sake and in colour, in contrast to the black and white engravings in the costume and history books.[10]

In 1833 there appeared *Illuminated Ornaments selected from the Manuscripts of the Middle Ages*, a book of large colour plates drawn and engraved by Henry Shaw with commentaries by Sir Frederick Madden, then Assistant Keeper of Manuscripts at the British Museum. Madden's text showed a definite preference for the naturalism of late mediaeval and Renaissance miniatures. The plates employed hand colouring and gold inks. Similar books followed, particularly in the 1840s with the development of chromolithography, which was exploited by Henry Noel Humphreys. In collaboration with Owen Jones, Humphreys published *Illuminated Books of the Middle Ages*, 1844–9, with sumptuous colour

plates. Humphreys also published a number of facsimiles of individual manuscripts and was involved in the fashion for producing pastiche illuminated books printed with texts in black letter or Gothic script, decorated initials and elaborate borders. The full page chromolithographic illustrations of these volumes were sometimes reproductions of actual manuscripts, but more often not at all mediaeval in style. In addition there appeared a great many 'how to do it' manuals and even a short-lived journal, *The Amateur Illuminator's Magazine*, 1861–2.

Members of the Pre-Raphaelite Brotherhood were aware of the revived interest in 'missal painting' as it was often called. Millais must have known the work of Henry Noel Humphreys for Humphreys's son Noel was the model for the young Jesus in 'Christ in the House of his Parents' of 1850 (TG 1984, No.26).[11] On 21 May 1849, according to the P.R.B. Journal, 'Millais called in the evening to take Gabriel with him [to] Mr Bateman's the Illuminator; they also picked up Woolner on the way'. They examined Bateman's 'missal letters' and on 10 October Woolner and William Michael Rossetti visited Bateman again and saw 'the designs of ivy borders etc. he has made for Woolner's poem on "Friendship", and looked over the illuminated letters etc. he has copied from old manuscripts'.[12] Edward La Trobe Bateman was the lithographer for three illustrated books designed by Owen Jones for poems by M.A. Bacon, *Flowers and their kindred Thoughts*, 1848, *Fruits from the Garden and Field*, 1850 and *Winged Thoughts*, 1851. The texts were ornamented with imitation penwork decoration carefully based on mediaeval work. Early in 1852 Bateman shared a cottage with Rossetti and in July he emigrated with Woolner to Australia.

The first reference to 'missal painting' in the early work of the P.R.B. occurs in the work of Charles Allston Collins. Two of his paintings include representations of illuminated manuscripts. In 'Berengaria's Alarm . . .', 1850 (TG 1984, No.27) among the objects on the floor is a book open at a highly coloured and elaborately painted full page miniature (pl.68). This is taken from the first page of the Gospel of St John from the Arnstein Bible, a twelfth-century bible in the British Museum (pl.67).[13] The page is a decorative treatment of the words 'In principio' using coloured interlace, the figure of God the Father, and the eagle inspiring St John to write his gospel. It was reproduced in colour in *Illuminated Books of the Middle Ages* by Humphreys and Jones and it is likely that it was this which drew it to Collins's attention, though he could of course have seen the real thing at the British Museum. His copy is not quite correct, for the page, faithfully reproduced by Humphreys and Jones, includes a quarter page of text below the illumination. Collins enlarged the illumination to fill the page of his

book and placed the continuation of the text on the facing page in script which was larger and more legible, though not historical in style.

Collins included in his painting a scroll and a tapestry, both alluding to the story of Joseph and the coat of many colours. Like Richard Coeur de Lion, Joseph was presumed dead on the discovery of his clothing. Collins was much interested in Tractarianism and its preoccupation with religious symbolism and iconography; he attended the services at St Andrew's, Wells Street, a church with strong Tractarian connections. The choice of the St John page may have been made because St John was a harbinger of Christ in the same way that the pedlar was a harbinger of the King.

The symbolism of Collins's second representation of an illuminated manuscript is clearer. In 'Convent Thoughts', 1850 (TG 1984, No.33) a nun stands 'with a missal in her hand studying the significance of the passion flower'.[14] The manuscript is open at a miniature of the Crucifixion, an obvious reference, like the passion flower, to the Passion of Christ. The nun's index finger marks another page with a miniature of the Annunciation which, with the white lilies and the inscription 'Sicut lilium' on the frame, signifies the purity of the nun (pl.69).

'Convent Thoughts' was a topical picture in Tractarian circles. In the six years before 1851, when it was exhibited, six communities of nuns had been founded within the Church of England, the first since the Reformation. The earliest was a Puseyite sisterhood which opened in 1845 at 17 Park Village West, across Regent's Park from Hanover Terrace where Collins lived. In 1848 the sisters moved to Albany Street and worshipped at Christ Church, Albany Street, also attended by the Rossetti family. The subject of well-bred young ladies taking the veil was sufficiently in the news to be mocked in the pages of *Punch* in 1850 in a cartoon of fashionably crinolined ladies donning nuns' veils to enter a convent where 'their leisure will be employed in illuminating books of devotion'. This was not mere jest: though these sisterhoods were practical organisations engaged in bringing charity to the poor, at least one of them had an order devoted to the contemplative life. This community, not necessarily known to Collins, was the Devonport Society of Sisters of Mercy. The habit of its contemplative order was of white serge with a white veil (Collins is said to have borrowed the nun's habit in his picture from Holman Hunt) and the nuns spent their time in prayer, reading, needlework and illumination.[15]

The manuscript held by the nun is based on a late fifteenth-century Italian book of Hours in the Soane Museum bearing the arms of the Ardinghelli and Segni families of Florence. It is not known why Collins

chose this obscure book, which is not of outstanding quality, but he may have gone to examine it after seeing a quite different leaf of it reproduced by Henry Noel Humphreys in his *The Art of Illumination and Missal Painting: a guide to modern illuminators*, 1849.[16]

As with the Arnstein Bible, Collins has taken certain liberties with his original. The Crucifixion page has been copied fairly accurately but the border has been thinned out a little. Collins has moved the Crucifixion from the left hand page of the book of Hours to the right hand page in the painting; and though an Annunciation appears in the original manuscript, it is quite a different one. Collins has excluded the angel Gabriel and has depicted the Virgin Annunciate kneeling at a prie-dieu in front of a baldacchino, an unusual iconographic scheme for an illuminated manuscript and perhaps copied from a painting.

The literal approach of the early phase of Pre-Raphaelitism is exemplified in the use made by Brown and Collins of manuscript illumination to copy the externals of the middle ages. Similar direct quotations occur in the work of Rossetti. For example, in his 'Fra Pace' of 1856 (private collection; Surtees No.80)[†] the phials of colour attached to the monk's desk are copied from an initial in a manuscript from the British Museum (pl.70). Another initial also from a volume in the same collection (pl.71) was the source for the bell chimes suspended from a slanting pole seen in 'The Wedding of St George and the Princess Sabra' (TG 1984, No.221), one of Rossetti's 'Froissartian' watercolours of 1857, all on themes of chivalry and courtly love. It is likely that Rossetti did not know the originals of these two details, but took them from Henry Shaw's *Dresses and Decorations of the Middle Ages* where they are reproduced on the same page; Rossetti is known to have used this book on other occasions as a source for costume.[17]

But there is more to Rossetti's interest in manuscript illumination than mere quotation of detail. Particularly in his 'Froissartian' subjects, he developed an imaginative and inventive vision of the middle ages in which manuscripts are assimilated rather than copied. Paradoxically, this vision was based on a closer acquaintance with things mediaeval than that of Brown or Collins.

During the 1850s the middle ages became a deep preoccupation for Rossetti, one which was strengthened by the entry into the Pre-Raphaelite circle of Morris and Burne-Jones in 1856. All three had at an early age been imaginatively drawn to the middle ages. As a young student at Cary's

† Pl.94 in Mrs Surtees's catalogue. Permission to reproduce the work in the present book has been withheld. Ed.

66 Frontispiece to Chaucer's *Troilus and Cressida*; English, early fifteenth century;
Corpus Christi MS 61; *Master and Fellows of Corpus Christi College, Cambridge*

67 Arnstein Bible, opening of St John's Gospel;
German, twelfth century; Harley MS 2799 f. 185v;
By permission of the British Library

68 C.A. Collins, detail from 'Berengaria's
Alarm for the Safety of her Husband . . .', 1850;
City of Manchester Art Galleries

69 C.A. Collins, detail from
'Convent Thoughts', 1850–1;
Ashmolean Museum, Oxford

71 Initial 'O' with Musicians; French,
fourteenth century; Burney MS 275 f. 395v:
By permission of the British Library

70 St Jude; French, late fourteenth
century; Harley MS 2897 f. 86v;
By permission of the British Library

72 'Roman de la Rose', Venus and her
Doves; Flemish, late fifteenth century;
Harley MS 4425 f. 138v;
By permission of the British Library

73 'Roman de la Rose', Courtly Company in
a Garden'; Flemish, late fifteenth century;
Harley MS 4425 f. 12v;
By permission of the British Library

Drawing Academy, Rossetti became known for drawing chivalric subjects, and in 1849 spent time at the British Museum 'reading old romaunts to find stunning words for poetry'.[18] At the age of seventeen Burne-Jones was sufficiently immersed in the middle ages to write letters in mock mediaeval English (from 'Your faithful, right-trustie and liege servante Edouard Cardinal de Byrmingham'), and four years later he described his famous vision at Godstowe Priory of a 'long procession of the faithful, banners of the cross, copes and crosiers, gay knights and ladies by the river bank, hawking parties and all the pageantry of the golden age'. At Oxford, he and Morris steeped themselves in the middle ages, reading chronicles and looking at illuminated manuscripts in the Bodleian.[19]

By the time they had come of age artistically, this deep and compulsive fascination had given them a familiarity with things mediaeval which became a kind of second nature to them. They had developed the ability to express themselves freely each in their own personal kind of mediaeval idiom. Morris and Burne-Jones were more scholarly, Rossetti more imaginative and inventive in transforming his sources. The result was quite different from Ford Madox Brown's painstaking recreation of picturesque and instructive late mediaeval costume.

Rossetti, Burne-Jones and Morris were more widely read in mediaeval history and literature than Brown; they had also more opportunity for direct contact with illuminated manuscripts. Brown in his diary once mentions visiting the British Museum to see a French Bible, but says nothing else about it. Rossetti was friendly with two important collectors of illuminated manuscripts. One of these was William Burges, whose scholarly interest in the middle ages led him to form a collection of notable examples. But more important by far was John Ruskin.[20]

Ruskin was an enthusiastic collector of 'missals'. He took up in turn Millais, Rossetti and Burne-Jones and tried to involve his protégés in his enthusiasm. In 1850 or 1851 he bought his first example, 'a little fourteenth century Hours of the Virgin not of refined work, but extremely rich, grotesque and full of pure colour. The new worlds which every leaf of this book opened to me, and the joy I had, counting their letters, and unravelling their arabesques as if they had all been of beaten gold, cannot be told'.[21] This book of Hours is now in the Victoria and Albert Museum. By 1853–4, the period when he first discovered Rossetti, the study and collection of manuscripts had become his constant pursuit. He spent hours in the British Museum, sometimes accompanied by Millais, and boasted that he had 'examined without missing a volume, every illuminated manuscript in the British Museum'.[22] He wrote notes on them, praised

their qualities in his books and cut up pages of them to send to friends or show to students.

Those close to him could not escape his new craze. In 1853, writing to his father of his guilt at being a 'mere collector', he admitted 'I do idolise my Turners and missals' and to Rossetti in 1855 he wrote that he had been 'launching out in a very heedless way buying missals and Albert Durers'.[23] His most important acquisitions of this period were the Psalter and Hours of Isabelle of France of 1260–70, which he called the St Louis Psalter, the Beaupré Antiphoner of 1290, King Haakon's Bible, illuminated in France in the late thirteenth century, and the Cambrai Hours of the early fourteenth century.[24]

It was not so much the particular items in Ruskin's collection but Ruskin's ideas on the subject which were influential on Rossetti. For Ruskin one of the most important qualities of manuscript illumination was the grotesque. He devoted a chapter of *Modern Painters* to explaining it. By the grotesque Ruskin meant the free play of imagination and fantasy which gave life to allegory and symbolism in the middle ages. He felt illumination was particularly suited to such fantasy which was a quality he felt lacking in much modern art. Nevertheless, he wrote, 'in many of the works of Watts and Rossetti is already visible, as I trust, the dawn of a new era of art, in a true unison of the grotesque with the realistic power'.[25] At this time, Ruskin was commissioning from Rossetti watercolours such as 'Dante's Vision of Matilda Gathering Flowers' (unlocated, but the composition known from a drawing in the Ashmolean) and 'Dante's Vision of Rachel and Leah' (TG 1984, No.214). Both use realistic figures to embody ideas, here the active and contemplative life, and thus combine allegory with realism. In this way, Ruskin was encouraging Rossetti to learn from mediaeval art.

But allegory and fantasy were more to Rossetti's taste than the 'realistic power' of modern art, and it was Ruskin's praise of the stylisation of mediaeval miniatures which bore fruit in Rossetti's work. Ruskin was the first nineteenth-century writer to value illumination of the period 1250 to 1350 as the greatest achievement of the art. Though he loved nature, he abhorred too much naturalism in the pages of a book. What appealed to him was the decorative element, 'the peculiar modification of natural forms for decorative purposes . . . in all its perfection, with all its beauty and all its necessary shortcomings'.[26] Of 'the illuminations of an old missal' he wrote, 'in their bold rejection of all principles of perspective, light and shade, and drawing, they are infinitely more ornamental to the page, owing to the vivid opposition of their bright colours and quaint lines, than

if they had been drawn by Da Vinci himself'.[27]

Rossetti increasingly rejected conventional perspective and drawing in the 1850s, and developed a stylised manner, placing his figures on shallow confined stages, breaking up space-defining planes with flickering surface patterns and drawing his figures in awkward postures. This cultivation of the quaint may have been unconsciously inculcated by contact with Ruskin's ideas on illuminated manuscripts. It certainly uses general ideas taken from illumination. In a drawing of a lady with a fan of c.1855 (Birmingham City Art Gallery) the figure is set against a diapered background of lozenges of a kind frequent in miniature painting; such patterned grounds are common in Rossetti's work. The use of a patterned gold ground is seen in 'The Roman de la Rose', 1864 (Tate Gallery). The chunky furniture and box-like spaces of such subjects as 'The Tune of Seven Towers' (TG 1984, No.220) seem to derive from the primitive perspective of the furniture and stage-like constructions in which mediaeval illuminators placed their figures (pl.70).

Yet mediaeval miniatures never looked quite like this. Rossetti's 'Froissartian' watercolours seem designed to recall the idea of illuminated manuscripts rather than to resemble them closely. In scale, technique, space and colour they are highly personal and lack the fineness of manuscript pages. Rossetti was once bullied by William Burges into drawing on vellum but the result was not a success.[28] Rossetti's colour can convey a glowing quality which, as Ruskin observed, was 'based on the principles of manuscript illumination' and 'permits his design to rival the most beautiful qualities of painted glass'.[29] But the variety of colour harmonies and the heavily worked textures of the 'Froissartian' watercolours do not follow the restricted colours and creamy texture of manuscript pages.

For Rossetti was no scholar and had no patience with literal copying or with the revival of mediaeval technique. His love of inventive fantasy was too strong, his ideas too wilful. He transforms diapered backgrounds into tiled floors and walls, and musical instruments take on impossibly fantastic forms, as in 'The Blue Closet' (TG 1984, No.219). The patterns and decorative devices, used in heraldic profusion, are Rossetti's own. Above all, his themes reject the subjects of mediaeval iconography. His figures have expressive faces and gestures, carrying a powerful emotional charge. Rossetti's 'Froissartian' watercolours are an evocation of the middle ages, 'like a golden, dim dream' as Smetham put it.[30] Like a dream, they incorporate elements of the dreamer's own emotional preoccupations.

Formally, there is a parallel with architecture here. The early architects

of the Gothic Revival aimed at correctness, following historical precedent. They were succeeded by the practitioners of 'Modern Gothic' who used historical motifs but adapted and recombined them in a modern and personal way, often creating powerful emotional effects with space and colour. Rossetti's mediaeval subjects are a kind of equivalent in painting to the 'Modern Gothic' architecture.

Rossetti's most direct tribute to manuscript illumination is his watercolour of 1855–6, 'Fra Pace' (see p.158), which has already been mentioned in connection with a manuscript source for the desk. A monk kneels at a desk copying a dead mouse into an illuminated manuscript; behind, asleep on his robe, is a cat, which is being tickled by a young acolyte. The details of the room are derived in a very general sense from the interiors of van Eyck and his school: the lattice windows, the round window and the cloth stretched above. The monk himself recalls portraits of kneeling donors. 'Fra Pace' is one of several portraits by Rossetti of artists at work: Giotto, Fra Angelico and Dante. A.C. Benson summed up the essence of the picture: 'The face of the monk, thin and amiable . . . the lips drawn up in the nicety of the work . . . his complete absorption, together with the ordered look of the quiet room, with its signs of peaceful habitation, strike the note of cloistered calm and tranquil happiness.'[31]

'Fra Pace' recalls an idea of Ruskin's, expressed in a lecture on illumination of 1854, when he recommended the revival of the art as a happy life for a person of quiet and studious habits, 'something like the disposition of the old monks who were the illuminators of past times'.[32] Ruskin went on to quote from Longfellow's 'The Scriptorium', part of his verse play *The Golden Legend*. A monk is at work at his illumination.

> 'It is growing dark! Yet one line more,
> And then my work for today is o'er
> . . . There now, is an initial letter!
> King René himself never made better!
> Finished down to the leaf and the snail,
> Down to the eyes on the peacock's tail!'

The name of Longfellow's monk is Friar Pacificus, which probably suggested to Rossetti the title of his watercolour.[33]

The picture seems to embody Ruskin's ideal of the happy mediaeval workman, but when Rossetti sent him a tracing of the picture to tempt him to buy it, Ruskin declined, saying it was 'very ingenious and wonderful, but not my sort of drawing'. This is curious, but Ruskin was beginning to

feel that his protégé was too preoccupied with mediaeval quaintness, whilst his own tastes had moved on to the greater breadth of the Renaissance. He later spoke of Rossetti as 'half lost in mediaevalism' and criticised another mediaeval subject as 'painfully quaint and hard'.[34]

It was appropriate that 'Fra Pace' was the picture Rossetti was painting when Burne-Jones first visited Rossetti's studio, and that the first owner of the picture was William Morris. Both had, as undergraduates, wanted to found a brotherhood dedicated to religious art. Burne-Jones and Morris do not belong to the 'primitive' phase of Pre-Raphaelitism, but their interest in mediaeval miniatures was strong.

In his early drawings, Burne-Jones follows Rossetti's quaint manner but was encouraged by Ruskin to a more harmonious style. But throughout his life he admired manuscript illuminations and filled sketchbooks with copies of details, studying their technique as well as their iconography. He worked successfully on vellum, using gold as well as colours. One of his patrons, R.S. Holford, formed a large collection of illuminated manuscripts which Burne-Jones knew; there is a tradition that he may have restored some of them.

One manuscript was particularly important to Burne-Jones. This was the fifteenth-century 'Roman de la Rose' at the British Museum (Harley 4425). Boyce's diary for 14 April 1860 records how he and some friends met Burne-Jones by appointment at the Museum, 'Jones having promised to show us some of the most beautiful illuminated manuscripts in the collection. First the "Roman de la Rose", which is filled with the most exquisite illuminations, as fine as could well be in colour and gradation, tenderness of tone and manipulation, and purity of colour and light: the landscapes perfectly enchanting, the distances and skies suggesting Turner's best and showing as well in every other part close and long observation of nature'.[35]

Here was a book not too quaint, combining naturalism with a dreamlike other-worldliness which appealed to Burne-Jones. It made a deep impression on him, for he returned to it a number of times in his work. The miniature of Venus and her doves (pl.72) was adapted for the tapestry in 'Laus Veneris', 1873–8 (TG 1984, No.150); the reflection in the well in the Narcissus miniature reappears in the Perseus series (Stuttgart, Staatsgalerie) and the Pygmalion miniature inspired 'The Soul Attains' from his Pygmalion series (Birmingham City Art Gallery).[36]

The gardens in this manuscript (pl.73), with their trellises and little square plots, were admired by Burne-Jones. A similar walled garden appears in 'The Knight's Farewell' (TG 1984, No.224), a drawing of 1858

heavily influenced by Rossetti, with the costume of the page taken from another miniature in the same manuscript. Burne-Jones probably also knew another Harleian manuscript of Christine de Pisan's works, which contains attractive gardens with rose trellises.[37] These were to appear in many of Burne-Jones's works, and also in Rossetti's 'The Roman de la Rose' (Tate Gallery). Such gardens also appealed to William Morris who described one in 'The Story of an unknown Church'.[38] When Morris and Philip Webb came to design the garden at the Red House, it was to the 'Roman de la Rose' miniatures that they looked for inspiration. 'In front of the house it was spaced formally into four little square gardens making a big square together; each of the smaller squares had a wattled fence round it with an opening by which one entered, and all over the fence roses grew quickly. At the back of a house was a well-court, of which two sides were formed by the house and two by a tall rose trellis.'[39]

At this time, the late 1850s, Morris was deeply concerned with manuscript illumination. Rossetti wrote, 'In all illumination and work of that kind, he is quite unrivalled by anything modern that I know – Ruskin says better than anything ancient'. Indeed, Ruskin, recommending Morris to the Keeper of Manuscripts at the British Museum, wrote that his 'gift for illumination is I believe as great as any thirteenth century draughtsman'. Morris was also studying in the Bodleian, as his name occurs in the records of visitors as asking to see the famous 'Romance of Alexander'.[40]

Morris was studying manuscript illumination in order to create his own, modern illuminated books. The first of these was made in the summer of 1856 and at various periods throughout his life he designed and decorated manuscripts with exquisite delicacy, using traditional techniques and employing handwriting based on Renaissance script as well as borders based on Gothic foliage patterns. But he developed these to produce a style recognisably his own, one with something in common with his more famous textile and wallpaper designs. Morris was also a collector of illuminated manuscripts, but his most important examples were not acquired until the latter part of his life.[41]

In Morris's painting of 'Queen Guenevere', 1858 (TG 1984, No.94), an illuminated manuscript lies open on the dressing table. It shows not a full-page miniature, but a modest, more typical page, with lettering and decorated initials, a page chosen not from a facsimile, but from a real manuscript, chosen by someone who understood the illuminator's craft. Morris did not just borrow motifs from mediaeval manuscripts, but seemed to fulfil Ruskin's words in *Modern Painters*, 'I am striving . . . to revive the art of illumination, properly so called; not the art of miniature painting in

books or on vellum, which has ridiculously been confused with it; but of making *writing*, simple writing, beautiful to the eye, by investing it with the great chord of perfect colour, blue, purple, scarlet, white and gold'.[42]

Rossetti and the Oxford Murals, 1857

ROSALIE MANDER

The date that is honoured for the formation of the Pre-Raphaelite Brotherhood is 1848 but a claim can be made (I want to stake one here) that 1857 is of more importance in the history of Victorian art because of what it inspired.

The work of the Brotherhood[1] had little direct influence beyond contemporaries but from the decoration of the bays at the Oxford Union in the summer of 1857 stems the quintessential work of Burne-Jones, the only painter of the time to be recognised on the Continent, 'his reputation swelled abroad upon the tide of the Symbolist Movement',[2] and the Arts and Crafts movement initiated by Morris. Still flourishing, it has had added to it nowadays the principle of Conservation of which his Society for the Preservation of Ancient Buildings ('Anti-Scrape', 1881) was the forerunner.

The link-man of the two movements is Rossetti (pl.75). Prime mover in the Brotherhood in his twenties, he enjoyed a second flowering of leadership nine years later with different followers: the charisma undimmed. It has been said that he had genius but no talent.[3] Certainly his personality was too strong for his character; the poetry and the painting suffered from what he gave out in personal relationships, for charm is a fatal gift for an artist:

> We poets in our youth begin in gladness;
> But thereof comes in the end despondency and madness.

In 1857 Rossetti was invited to Oxford by Benjamin Woodward, the rising young Irish architect ('a good thirteenth century man', declared Rossetti) to see his nearly completed Museum. It was a revolutionary building designed to illustrate at once Ruskin's Gothic ideas and to drag the University, reluctantly, into the new age of Science. The seventeenth-century collection of 'Knicknackery' put together by Elias Ashmole and the Tradescant brothers that ranged from Dodos to precious stones, shells and Red Indian hunting shirts was to be transferred from the Old Ashmolean and studied in the new Museum, scientifically, with the typically Victorian utilitarian aim of causing improvements from Medicine to Manufacture.

Here, appropriately, was to take place in 1860 the famous encounter between Bishop Wilberforce ('Soapy Sam') on behalf of Genesis and Thomas Henry Huxley representing Darwin on the side of the monkeys.

The sculptors Thomas Woolner (a member of the Brotherhood) and Alexander Munro (who just missed being included) had already executed statues of representative men of science but Rossetti was not attracted by the suggestion that he should contribute a mural on the subject of 'Newton gathering pebbles on the shores of the Ocean of Truth' (one of those complicated titles, like that of Hunt's 'Christian Missionary', that he always mocked). But when he went to see Woodward's new Debating Hall for the Union he immediately offered to fill the bays below the roof with frescoes. He would expect no fee beyond expenses and would recruit volunteers for the work. Madox Brown and Holman Hunt and Bell Scott declined but Arthur Hughes and Roddam Spencer Stanhope, both beginning to be recognised, accepted, as did Hungerford Pollen who had successfully decorated the ceiling of Merton Chapel. He lost his Fellowship there on following Newman into the Roman Catholic Church and went to Dublin. The nineteen-year-old Valentine Prinsep, son of the hostess at Little Holland House, who made herself the handmaid of G.F. Watts ('Signor'), was also included. Watts in fact urged him to try the experience as he himself had provided the frescoes for the New Hall at Lincoln's Inn.

Then Rossetti, with some rashness, invited two totally inexperienced undergraduates who had only recently come down: Edward Jones (the 'Burne' was added later) and William Morris (pl. 78). While up at Exeter College they had become enthusiastic mediaevalists: gone for church-crawls in the country around, read Ruskin and enormously admired Rossetti's illustration to Allingham's 'The Maids of Elfen-Mere' (pl. 57) which was shown in the window of Wyatt's print shop in the High Street.[4] It was at the back of these premises that the Union held its debates.

For Morris and Burne-Jones, on a tour of cathedrals in France together, the quay at Le Havre had been their road to Damascus where they vowed to devote themselves to Art, without much idea of how to go about it. Burne-Jones managed to get a glance at his hero, Rossetti, by attending one of his classes at the Working Men's College and, all shyness, had been introduced by Vernon Lushington. When the great man warmly invited him to his studio, Morris came too. 'I was two and twenty and had never met, even seen a painter in my life', Burne-Jones wrote home, but now besides meeting Madox Brown and Arthur Hughes and Thomas Woolner they had even visited Ruskin. 'Just come back from being with our hero for four hours – so happy we've been: he is so kind to us, calls us his dear boys

and makes us feel like such old old friends. To-night he comes down to our rooms to carry off my drawing and shew it to lots of people; to-morrow night he comes again, and every Thursday night the same – isn't that like a dream? think of knowing Ruskin like an equal and being called his dear boys.'[5]

Interest in fresco and mural painting in general was in the air, largely because of the competition for the decoration of the new Houses of Parliament. Rossetti had attended the showing of cartoons for the first of these and written 'It is indeed a splendid sight', and, after the second exhibition, expressed amazement and gratification that 'High Art and high talent are not confined to the Continent'.[6] On a visit to Paris he had also seen work by Delaroche and Flandrin. So it was no wonder that young artists were eager to try their hands at the latest fashion but, unfortunately, enthusiasm was not equalled by knowledge of technique. The murals became frescoes almost inadvertently as the paint, a form of distemper with size, was applied willy-nilly to the brick walls whether the whitewash on them had dried out or not. The stippling with fine brushes to follow the practice in mediaeval manuscripts produced a *pointillist* effect strangely ahead of its time. Scaffolding was put up and a man called Davis employed on the floor to mix paints and pass buckets of it up to the workers who were none too sparing in their use of it.

For subjects the stories of the Arthurian legend were chosen, probably at the instigation of Morris who knew his Malory. These were indeed more suitable than would have been Rossetti's predilection for legends from the Bible or Dante. Morris and Burne-Jones had first discovered Southey's edition of 1817 when they were in Birmingham in 1855, and after the Union adventure Morris presented Rossetti with Thomas Wright's edition of Caxton's text of the *Morte d'Arthur* but popular interest was not general until the publication of Tennyson's complete *Idylls* in 1872. Early in 1857 the *Poems*, including some Idylls, published by Moxon with illustrations by Rossetti, Hunt and Millais, had pleased neither public nor poet.

Hunt considered the Arthurian tales to be coarse: 'It must be owned', he wrote, 'that many of the adventures are of a distinctly barbarous stamp as to refinement and honour (even when the characters presented are knights and ladies of high renown)'.[7] But Burne-Jones's bay showing Merlin beguiled by Nimuë (afterwards Vivien), holding a guitar-like musical instrument in her arms as if it were a baby, is far from barbarous or even beguiling. His conceptions of knights match those of the Laureate. Nothing is there of what it must really have been like as there is in R.S. Hawker's *Quest of the Sangraal*. When it came to the Kelmscott *Chaucer*,

Burne-Jones refused to illustrate *The Miller's Tale* and of others said to his assistant, Thomas Rooke, 'I'd like to pretend Chaucer didn't do them'.[8]

There were ten bays at a kind of clerestory height, each nine feet high and with two six-foil windows most awkwardly placed, from the point of view of pictures, in the middle (pl.74). Rossetti made a sketch for a tympanum over the Frewin Court porch for Munro to sculpt and to colour although no trace of pigment remains (pl.79). In a triangle it ingeniously fits in King Arthur at a round table with his knights. At the base is a swan or peacock to be eaten at the feast, though this can hardly have the same Christian significance as the plate of bread rolls shown on one side of it and the flask of wine on the other.

The visitor entering the Library now will find Rossetti's 'Sir Lancelot Prevented by his Sin from Entering the Chapel of the Sangraal' (cf. pl.81) to his left above the door, and proceeding clockwise will find the other bays as follows:

Valentine Prinsep: 'Sir Pelleas Leaving the Lady Ettarde'.

J. Hungerford Pollen: 'King Arthur Obtaining the Sword Excalibar from the Damsel of the Lake'.

William Riviere: 'King Arthur's First Victory with the Sword'.

William Morris: 'Sir Palomides' Jealousy of Sir Tristram' (cf. pl.80).

E. Burne-Jones: 'Merlin Being Imprisoned beneath a Stone by the Damsel of the Lake'.

R. Spencer Stanhope: 'Sir Gawaine Meeting Three Ladies at a Well'.

Arthur Hughes: 'Arthur Carried Away to Avalon and the Sword Thrown Back into the Lake'.

William Riviere: 'The Education of Arthur by Merlin'.

William Riviere: 'Arthur's Wedding' (with the incident of the White Hart).

William Riviere filled in the three bays left unfinished: two of Rossetti's, and one on which Holman Hunt's name had been pencilled in. In contemporary accounts the titles vary. Coventry Patmore, for instance, gave Arthur Hughes's title as 'Arthur conveyed by weeping Queens to Avalon after his death'. Rossetti in his letter to Charles Eliot Norton of Harvard in July 1858[9] said he intended the series to be viewed as beginning with Pollen and ending with Hughes, an arrangement based on Excalibar that curiously anticipated Tennyson in *The Holy Grail*, 1869:

> Nay, one there is, and at the eastern end,
> Wealthy with wandering lines of mount and mere,
> Where Arthur finds the brand Excalibur.

And also one to the west, and counter to it,
And blank: and who shall blazon it? when and how? –
O there, perchance, when all our wars are done,
The brand Excalibur will be cast away.

His choice of subjects also anticipates Tennyson's obsession throughout the *Idylls* with themes of frustrated love.

The enterprise created much interest in the University; indeed so many visitors came to gaze that Pollen, who was anxious to get back home, complained to his wife of 'the rattle of talk from surrounding worthies'.

We know that Pauline Trevelyan paid frequent visits, often accompanied by her husband, Sir Walter.[10] Both of them had been staunch supporters of Ruskin and Dr (later Sir Henry) Acland in the campaign for the Museum and entertained at Wallington many of the P.R.B. group.

Dr Acland was accused by Swinburne of behaving 'goatishly' in trying to join in the 'orgies and dare-devilries' of the group.[11] This seems very unlikely but Swinburne was prejudiced because he had been persuaded to go to one of Acland's lectures on sanitation and the others had once taken a train to London to avoid one of his dinner parties. If he was a bore to the young people he was also something of a hero when cholera broke out in the Oxford slums as he had foretold would happen if drainage were not installed.

Whether Benjamin Jowett ever looked in is not known but he may well have done so as he liked to be 'with it'. If he came he might have indeed said what has been immortalised in Max Beerbohm's cartoon (pl.82). At the bottom of a ladder he looks up, asking 'And what were they going to do with the Graal when they found it, Mr Rossetti?' Beerbohm seems not to have taken his background from the original but from a copy of it, with differences, painted by Treffry Dunn on a piece of furniture at 'The Pines' (pl.83).[12]

Whatever members of the University or others looking in thought of them, the young artists all enjoyed themselves hugely and called the adventure 'The Jovial Campaign'. An undergraduate of the time, the Revd William Tuckwell, later a distinguished divine, wrote of it: 'A merry rollicking set they were: I was working daily in the Library . . . and heard their laughter, and songs and jokes, and the yolleys of their soda-water corks, for this innutrient fluid was furnished to them without stint at the Society's expense.'[13] More unorthodox but to become an intimate friend was the under-sized, red-haired Swinburne, still up at Balliol. He wrote:

when the Union was just finished – Jones and I had a great talk. Stanhope and Swan attacked, and we defended, our idea of Heaven, viz. a rose-garden full of stunners. Atrocities of an appalling nature were uttered on the other side. We became so fierce that two respectable members of the University – entering to see the pictures – stood mute and looked at us . . . and after listening five minutes to our language, they literally fled from the room![14]

Teasing Morris, called 'Topsy' from his mass of hair, and getting him to read aloud his 'grinds' was a favourite outlet for their high spirits and this was reflected on the ceiling where, on the background of brown, russet and black, little figures of him, squat and tousel-headed, would appear astride the beams. The others once looked down from their painting to see him raging on the floor below unable to get out of the helmet made for him by a local blacksmith (pl. 76). Morris, responsible for the decoration of the roof, intended it to have a natural history design roughly (very roughly) based on the mediaeval Bestiaries that he collected, to which were added Rossetti's favourite wombats. Several helpers came in to give a hand, among them Charles Faulkner, known as 'The Fogger' in the slang of the time. He was a fellow of University College and later to become a partner in the Morris Firm where, as a mathematician, he was hopefully put in charge of the accounts, an office taken over later with more efficiency by George Wardle. Of Faulkner's efforts Burne-Jones wrote, 'Charley comes out tremendously strong on the roof with all kinds of beasts and birds'. A squib of the time described the ceiling:

> Here gleams the dragon in the air;
> There roams along a dancing bear;
> Here crocodiles in scaly coats
> Make love to birds with purple throats;
> And there in vests of brightest green
> Rhinoceroses large are seen;
> While winking with their weather eye,
> Roll round red hippopotami;
> And kindly lent in great variety
> By the Entomological society
> Blue bees, which honeyed words their trade is,
> Pay court to grey opossum ladies,
> Where mammoth beasts with mammoth wants
> Are kindly fed by ring-tailed ants . . .[15]

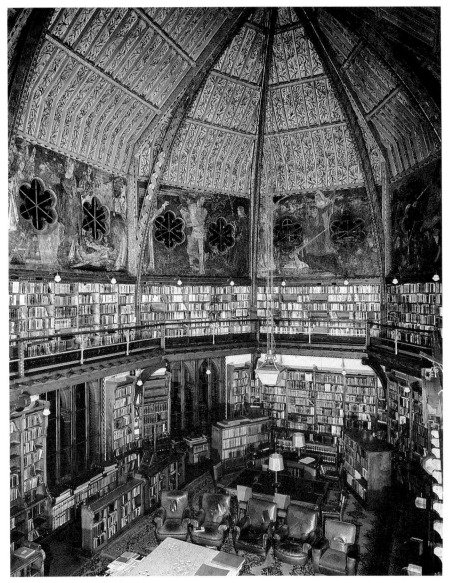

74 Interior of the Library
(formerly the Debating Hall), Oxford Union

75 W. Holman Hunt, Portrait of D.G. Rossetti, 1853; pastel and chalks, $11\frac{1}{4} \times 10\frac{3}{16}$ (28.6 × 25.9); *City of Manchester Art Galleries*

76 Helmet made for William Morris; *William Morris Gallery, Walthamstow*

77 D.G. Rossetti, Portrait of Jane Burden (Mrs William Morris), 1858; pen, 19 × 15 (48.3 × 38.1); *National Gallery of Ireland, Dublin*

78 Photograph of William Morris, 1857; *William Morris Gallery, Walthamstow*

79 A. Munro, 'King Arthur and the Knights
of the Round Table', 1857–8; Oxford Union

80 'Sir Palomides' Jealousy of Sir Tristram': sketch by Morris
of his Union mural or parody of it by one of the other artists;
pen, $4\frac{1}{2} \times 7\frac{1}{4}$ (11.4×18.4); *Birmingham Museum and Art Gallery*

81 D.G. Rossetti (retouched by another hand), Study for 'Sir Lancelot
Prevented by his Sin from Entering the Chapel of the Sangraal', 1857;
watercolour, 27 × 41 (68.6 × 104.1); *Ashmolean Museum, Oxford*

82 Max Beerbohm, 'The sole remark
likely to have been made by Benjamin
Jowett about the mural paintings at the
Oxford Union', 1916; pencil and watercolour,
$17\frac{3}{4} \times 11\frac{3}{4}$ (45.1 × 29.9); *Tate Gallery*

83 Detail from H.T. Dunn's copy of Rossetti's
'Sir Lancelot' mural, painted on a piece
of furniture; *National Trust, Wightwick Manor*

Woodward, who had hoped Rossetti and Millais would paint murals 'full of crocodiles and various vermin' for his Museum, would no doubt have approved but Lady Trevelyan did not care for it: 'in *dark* colors & with that sort of northern grotesque of twining serpents &c – very ugly – unnecessarily ugly I think'[16] (forerunner of Morris's love for sagas from the lands of the midnight sun?). The sunflowers still clearly visible on his mural of 'Palomides and Tristram' illustrate Swinburne's line from *Joyeuse Garde*: 'In a green place where heavy sunflowers blow . . .'. Intended primarily to disguise the problem of fitting the figures round the windows, they may be seen as trailers for his textile patterns to come. 'O tempera, O Morris' does not really apply as a reproach for they remain clearer than most.

Of the bays in general Lady Trevelyan wrote to Bell Scott: 'They will be very fine and striking, *I hope they will last.*' Of Rossetti's she said, 'the color is like flowers or fresh fruit with the bloom on',[17] and Ruskin declared it to be 'the finest piece of colour in the world'.[18] Hughes's rendering of 'Sir Belvedere throwing back Excalibar' he considered 'not decorative enough' and 'that a moonlight & an effect of light was not suitable', but Pauline Trevelyan countered with her opinion that 'the quiet of it seems to me pleasant & reposeful among all the blue skies, red haired ladies, and sunflowers. Several of the mourning ladies are very pathetic', and concluded that the whole thing 'excites and delights one immensely'.

The whole thing was exciting indeed: it glowed, as Coventry Patmore described it, 'with a voluptuous radiance of variegated tints, the colour coming from points instead of masses and positively radiant, at the same time they are wholly the reverse of glaring . . . colouring so brilliant as to make the walls look like the margin of a highly-illuminated manuscript',[19] which, after all, is what they set out to do.

But behind the fun of talking far into the night in their digs and playing practical jokes on each other there or at the Union and the joyful endeavour of working together on the experiment, Life was waiting to imitate Art in a drama where the protagonists were Rossetti and Morris. For one day, we do not know when, nor how many were gathered about Rossetti, nor whether it was in church or at the theatre or at the inn at the corner of Holywell, they saw Jane Burden. She was a daughter of the groom at the stables down Holywell and of astonishing beauty. Her looks were regal and timeless so that people who had seen her declared hers to be a world face: a Helen of Troy or a Cleopatra. In *Mrs Brown*, a *roman-á-clef* of the period by Violet Paget, it could be Janey whose face is described, 'with strange, curling full lips, and masses of wiry, iron-black hair'. She may have come of gypsy stock.[20] Her looks belied her character: she was really

something of a tomboy, not at all stately, and had a keen sense of humour all her life with an abhorence of cant in any form. However it was, Rossetti declared her to be a 'stunner' and the others naturally followed suit and begged her to be a model for them. She is not, however, recognisable in any of the mural pictures, not even in Rossetti's own 'Lancelot and the Graal' which was symbolic of what was to come: Janey, Queen Guinevere; Morris, King Arthur; and Rossetti, Lancelot her lover.[21]

In November Rossetti was called away to attend on Elizabeth Siddal, bored in exile at Matlock for her health and curious as to the goings-on at Oxford: suspicious of them as well. For his two remaining bays, 'Sir Galahad Receiving the Sangraal' and 'Lancelot Found in Guinevere's Chamber', he made only studies.

Rossetti went back to Oxford in 1858 and drew there his most exquisite likeness of Janey (pl. 77), and then in 1859 she was married to Morris. The ceremony was performed at St Michael's church by Canon R.W. Dixon, poet as well as priest, and one of those who had collaborated on the Union ceiling decoration. He married them under the names of William and Mary. Swinburne wrote to Edwin Hatch of Pembroke (an unlikely friend who was to become a well-known Bampton lecturer and has a plaque in St Mary's), 'I hope you will be glad to hear this as I am: to think of Morris having that wonderful and most perfect stunner of his to look at or speak to. This idea of marrying her is insane. To kiss her feet is the utmost one should dream of doing'.[22]

But Guinevere was to be domesticated at Red House in Kent, custom-built for Morris by Philip Webb, a progressive young architect in sympathy with Pre-Raphaelite ideals. It was because they so hated contemporary furnishings that the Morris Firm was founded in reaction against them, back to the mediaeval, and from this follows the Arts and Crafts movement. Burne-Jones designed stained glass and embroideries for the Firm and his illustrations to the Kelmscott *Chaucer*, published in 1896, mark the culmination of the lifelong friendship between him and Morris. And for Rossetti, who had started it all, the meeting with Janey that fine Oxford summer (all Oxford summers are fine in memory) led to her abiding presence in his poems and his best-known later pictures: 'La Pia' and 'Proserpine' (TG 1984, Nos 153, 151) among them, perhaps allegories of the bonds that held them both in frustration.

The bays left empty were filled at the request of the Oxford Union Committee in 1859 by William Riviere who conveniently lived in Oxford. The large white hart running across the chamber in 'Arthur's Wedding Feast' was probably by his son, the *animalier*, Briton, and is one of the best

preserved and most effective features of the whole scheme. Rossetti objected to Riviere's appointment because he was paid a fee, regardless of the fact that the expenses which the original group incurred had come to much more than settled fees would have done. He took no more interest and said that it were better for the whole lot to be white-washed over. Some Committee members proposed covering the murals with Morris's Pomegranate wall-paper.

In 1875 the Union Committee wanted something for the ceiling, more sober 'neutral tints',[23] and asked Morris's advice. The result he proposed is a dull repeating pattern like one of his lining fabrics for curtains. Put in professionally, it has completely obliterated the more entertaining features of 1857.

Since then a book of photographs with an Introduction by Holman Hunt was published in 1905,[24] and in 1935 after an Appeal some restoration of the murals was put in hand under the direction of Professor Tristram. New lights were installed to replace the gas which had had such a disastrous effect on the paintings and an unveiling ceremony was held in 1936.

For the present situation I cannot do better than quote from the booklet by Dr John Renton available at the Union. He has been the moving spirit in reviving interest in the work. He states that he had shared the general belief that the murals had deteriorated beyond recall but one day in 1976 'found an off beam of sunlight illuminating a fragment of colour and felt that something might still be done with them'.

I approached Mr Cyril Band, Head of the Photographic Department of the Clarendon Laboratory, to see if photography could recapture something of the original work . . . he used an ordinary 35mm camera with a flash unit and made some colour studies. The results were most encouraging . . . With advice from the Ashmolean Museum, some of the dirt was removed using a soft brush and cotton wool dipped in distilled water with a little industrial methylated spirits added. This was for the purpose of photography: the murals are still not clearly visible under the present lighting conditions . . . In Hilary term, 1976, work started . . . Considerable experimentation was necessary to determine the most suitable film, but eventually an Agfa film which could be exposed up to 100 seconds, was found to give highly satisfactory results . . . During the cleaning process, it was possible to see the small brush strokes mentioned in the literature, particularly in the faces: the patches which had fallen from the wall and may still be

behind the bookcases have been filled in, often with amorphous areas
of colour . . .

In conclusion; with repairs to the walls, in particular treatment to prevent
further dampness, which is the prime cause of exfoliation due to the build-
up of salts under the paintings, and with more suitable lighting, the murals
could be preserved and the sight of them enjoyed once more. This work is
now (1983) being put in hand.

'A Serious Talk': Ruskin's Place
in Burne-Jones's Artistic Development

JOHN CHRISTIAN

'Just come back from being with our hero for four hours – so happy we've been: he is so kind to us, calls us his dear boys and makes us feel like such old old friends. To-night he comes down to our rooms to carry off my drawing and shew it to lots of people; to-morrow night he comes again, and every Thursday night the same – isn't that like a dream? think of knowing Ruskin like an equal and being called his dear boys. Oh! he is so good and kind – better than his books, which are the best books in the world.'[1] Thus the young Burne-Jones described a visit to Denmark Hill with William Morris in November 1856. The previous May he had settled in London, intent on becoming a painter under the supervision of Rossetti, and this was his first meeting with Ruskin, who had been abroad from May to October. It was the start of the longest, the most mutually rewarding, and in many ways the most fascinating, of all Ruskin's relationships with the Pre-Raphaelites.

In fact, although the friendship was only just beginning, long-cherished hopes and ambitions lay behind it on either side. For Burne-Jones it was indeed a 'dream' come true since he had worshipped Ruskin from afar for several years. His first encounter with his hero's mind may well have been as a boy at King Edward's School, Birmingham. By 1861 the school library contained nearly all Ruskin's books to date, and it is likely that *Modern Painters* I and II (1843 and 1846) were acquired by James Prince Lee, the great headmaster who left King Edward's in 1847, three years after Burne-Jones arrived.[2] Among his many interests Lee had a deep appreciation of art, liking that 'which was true to nature and the inner truth'[3] – an impeccably Ruskinian view.

But it was during his three years at Oxford, from 1853 to 1855, that Burne-Jones's awareness of Ruskin really took wing. His boon companion, William Morris, certainly came up knowing the first volumes of *Modern Painters*, and together they absorbed these and Ruskin's other works, seizing avidly on new ones as they appeared, the last volumes of *The Stones of Venice* in 1853, the Edinburgh Lectures in April 1854. 'Morris would

often read Ruskin aloud. He had a mighty singing voice, and chanted rather than read those weltering oceans of eloquence.'⁴ Both youths had arrived in Oxford full of idealism and intending to be ordained, and they experienced many influences before deciding instead to devote themselves to art. It was Ruskin above all, however, who helped them to make the transition by showing them that art no less than the Church could be the vehicle of moral fervour, since in his view artistic imagination was akin to the gift of prophecy. Burne-Jones had drawn copiously from an early age, and the strong bias towards imaginative expression which his work already revealed made Ruskin's insistence on the supremacy of the imagination all the more attractive. It was the central theme of *Modern Painters*, however, that imaginative truth must be based on a thorough understanding of objective reality; as Ruskin puts it in a famous passage at the end of the first volume, artists 'should go to Nature in all singleness of heart, . . . rejecting nothing, selecting nothing, and scorning nothing; believing all things to be right and good, and rejoicing always in the truth. Then, when their memories are stored, and their imaginations fed, and their hands firm, let them take up the scarlet and the gold, give the reins to their fancy, and show us what their heads are made of'.⁵ Mindful of this advice, Burne-Jones began to prepare for the task that still lay dimly ahead by making painstaking studies of foliage and flowers in Bagley and Wytham Woods.

Ruskin also gave him his first real sense of style, leading him to Turner, whose influence is briefly apparent in his designs for Maclaren's *Fairy Family*, begun in 1854,⁶ and soon to those artists who would play such a crucial part in his early development. Inspired by the Edinburgh Lecture on Pre-Raphaelitism, he visited the Royal Academy in 1854, where Holman Hunt was exhibiting 'The Light of the World' and 'The Awakening Conscience' (TG 1984, Nos 57–8), and the following year he saw Thomas Combe's collection in Oxford, where he encountered his first Rossetti, 'Dante Drawing an Angel' (ibid., No.197); this filled him with the 'greatest wonder and delight' and 'at once' established Rossetti for him as 'the chief figure in the Pre-Raphaelite Brotherhood'.⁷ Ruskin also introduced him to the early Italian masters, through the praises accorded to them in *Modern Painters* II and the woodcuts after Giotto's frescoes in the Arena Chapel at Padua, published by the Arundel Society in 1853, for which he wrote descriptive notes. Burne-Jones's decision to become a painter was finally taken in the Long Vacation of 1855 at the end of a holiday with Morris in northern France which owed its course largely to Ruskin, including not only a tour of the Cathedrals but a thrilling confrontation with Fra

Angelico's 'Coronation of the Virgin' in the Louvre. In January 1856 he had his momentous first meeting with Rossetti and, hardly less important, received his first letter from Ruskin, sent in acknowledgement of a complimentary copy of *The Oxford and Cambridge Magazine*. 'I'm not E.C.B. Jones now', he wrote ecstatically, 'I've dropped my personality – I'm a correspondent with RUSKIN, and my future title is "the man who wrote to Ruskin and got an answer by return"'.[8] Below he drew himself prostrate before a nimbused figure of his hero, thus perfectly expressing the spirit of almost religious dedication in which he was embarking on his new profession, inspired by the image of the artist as a seer or prophet evoked by Ruskin himself.

For Burne-Jones, then, the meeting at Denmark Hill the following November was both the end of a journey and the promise of a new beginning. In a sense, however, this was also true of Ruskin, who seems to have reacted with almost as much enthusiasm as his admirer. To understand this it is necessary to recall his previous relations with the Pre-Raphaelites.

Ruskin's austere evangelical upbringing had instilled in him from an early age a conviction of possessing the truth and a profound sense of duty to convert and correct error. Evident throughout his writing, this cast of mind continued to colour his artistic and moral judgement even when, in the 1850s, the religious faith on which it rested was shaken. Indeed religious doubts made him cling all the more tenaciously to artistic certainties, and he could never resist trying to influence the artists with whom he came into contact. The young American painter W.J. Stillman, who spent a sketching holiday with him in Switzerland in the summer of 1860, spoke for many when he wrote that 'he wanted me to hold the brush while he painted'.[9] During this period Ruskin's aesthetic dogmatism was also encouraged by a deep involvement in art education. In 1854 he was invited to take a class at the newly established Working Men's College. This was enormously popular, and in 1857, seeking a wider audience, he published *The Elements of Drawing*, following it two years later with *The Elements of Perspective*. His methods were further disseminated in lectures and correspondence courses, conducted with such varied seekers of advice as Lady Waterford and her sister, Lady Canning, the Sunderland cork-cutter, Thomas Dixon, and the girls and governesses of Winnington Hall, the school in Cheshire he 'adopted' in the late 1850s. Unfortunately he often failed to realise that it was one thing to deal with schoolgirls and 'working men' and quite another with professional artists.

Ruskin's approach to the Pre-Raphaelites was based on the belief that

they, like all the artists he admired, irrespective of style, had fulfilled the programme enunciated in *Modern Painters* of evoking sublime visions through the action of imagination on profound knowledge of natural phenomena.[10] Time and again he discusses their early achievements in these terms. A key example is the letter he wrote to *The Times* in May 1854 about Holman Hunt's 'Light of the World', interpreting the ivy-choked door and other exquisitely rendered details as symbols which illuminate the divine drama of Christ's call to the human soul.

However, the identity of Pre-Raphaelite practice with his own theoretical ideal gave him, he felt, the right to guide and admonish where he saw room for improvement or standards falling off. His first protégé was Millais, whom he met in the summer of 1851 as a result of his letters to *The Times* defending the P.R.B. pictures at the Royal Academy. There was immediately talk of their going together to Switzerland, where Ruskin's beloved Alpine scenery would have given him the perfect opportunity to expound his favourite theories. This plan fell through, but a similar purpose lay behind the holiday which Millais spent with the Ruskins in the Trossachs in the summer of 1853, when he painted the famous portrait of his patron standing against a waterfall at Glenfinlas (TG 1984, No.56). Ruskin's attitude to Millais at this time is reflected in a highly characteristic comment in a letter to his father of 24 July; the artist, he wrote, 'is a very interesting study, but I don't know how to manage him'.[11]

The Scottish trip was of course to lead to the break-up of Ruskin's marriage, and the severence of relations between him and Millais. Nor could he approve when Holman Hunt left England the following year to paint Biblical scenes in the East, fearing that it would inhibit the free play of his imagination, so brilliantly displayed in 'The Light of the World'. There was still, however, Rossetti, whom Ruskin met in April 1854 and recognised, rightly, as the driving intellectual and imaginative force behind the P.R.B. During the next few years they were in close communication and Rossetti derived much stimulus from Ruskin's friendship. He was also grateful for generous financial support from Ruskin, who bought his pictures on a regular basis, advanced money for the publication of his *Early Italian Poets* (1861), and even settled a pension on Miss Siddal. A dominant personality himself, however, he naturally found it irksome to be told by Ruskin that he was 'a conceited monkey, thinking your pictures right when I tell you positively they are wrong',[12] or to 'take all the pure green out of the flesh in the Nativity I send, and try to get it a little less like worsted-work by Wednesday, when I will send for it'[13] – a typically tactless instruction issued in October 1855. Gradually the two men drifted apart,

Rossetti increasingly resentful of Ruskin's criticism, Ruskin more and more disenchanted with Rossetti's development.

The relationship was only to break down finally in the late 1860s, and when Burne-Jones arrived on the scene his heroes were still close friends. To Ruskin, however, by now well aware of the problems of 'managing' Pre-Raphaelites, this young follower of Rossetti's must have seemed an ideal. First and foremost, he was obviously worthy of interest. With characteristic perception, Ruskin recognised his genius from the beginning, showing his work 'to lots of people' as early as 1856, praising it 'in unqualified terms',[14] and coining the phrase 'Gigantic Jones' that so delighted Tennyson. Yet for all his natural ability the young artist was almost totally untrained. This genuinely concerned Ruskin, who believed that right training from an early age was essential to artistic expression, but for someone with his love of influence it also represented a certain charm, especially as Burne-Jones seemed only too willing to meet him half-way by making a hero of him. This hero-worship, moreover, was doubly gratifying to Ruskin since it clearly included a strong element of affection. This was something for which he was always subconsciously searching, but failed to find in his relations with Rossetti and Miss Siddal, who often seemed to show a selfish disregard for his personal feelings.[15]

Ruskin must have felt all the surer that Burne-Jones was mouldable material in that he had recently provided striking evidence of understanding the principles of *Modern Painters*. In January 1856, resuming the book after an interval of ten years, Ruskin had published the third volume, and Burne-Jones had written a flatteringly eulogistic review in the April issue of *The Oxford and Cambridge Magazine*.[16] Two months later he had followed this up with a spirited reply to a hostile attack on Ruskin and his works which Lady Eastlake, motivated by personal animosity, had contributed to the *Quarterly Review* in March.[17]

Burne-Jones's articles concentrate on the early chapters of Volume III, in which Ruskin first demolishes Reynolds's concept of the Grand Manner and then seeks to establish 'the real nature of greatness of style' in terms of his own criteria. This is essentially a recapitulation of his argument in Volume I that the greatest art is that which embodies 'the greatest number of the greatest ideas' – ideas of Truth, Beauty, or Relation. Again he stresses the crucial importance of 'Invention', or imagination, drawing an analogy with poetry, which he defines as 'the suggestion, by the imagination, of noble grounds for the noble emotions'. He returns to his theme that painters must show a strict regard for 'truth' and 'accept Nature as she is', but he maintains that 'greatness of style' depends equally

on 'Love of Beauty', a tendency to 'seek for and dwell upon the fairest forms, and in all things insist on the beauty that is in them, not on the ugliness'. Under a third heading, 'Sincerity', he argues that artists must include 'the largest possible quantity of Truth in the most perfect possible harmony', and show a 'quality of Grasp' in their work, 'like the power of a great reasoner over his subject, or a great poet over his conception'. The fourth and last requirement is 'Choice of Noble Subject', sacred themes constituting the highest rank, followed by 'the acts or meditations of great men', and so on down the scale.[18]

In further chapters Ruskin gives an indication of how he sees this programme being put into action by painters. He develops the concept of the 'ideal grotesque', already adumbrated in *The Stones of Venice* and now used to cover all allegorical art capable of moral interpretation. Indeed art for Ruskin was essentially a matter of allegory or symbolism, and he claims that 'no element of imagination has a wider range, a more magnificent use, or so colossal a grasp of sacred truth'.[19] Having mentioned examples in the work of Giotto, Dürer, Blake and others, he looks forward to a modern revival, already under way in some of Turner's mythological subjects and the work of Rossetti and G.F. Watts.

Similarly he discusses his hopes for religious painting. In a brilliant chapter on 'The False Religious Ideal' he dismisses Raphael's 'Charge to Peter' as 'a mere mythic absurdity' and describes his own version, at once sternly realistic and replete with meaning. This of course was precisely how he saw Hunt's 'Light of the World', and he now pursues this theme, claiming that religious art as he envisages it has only just begun to exist. Some of the early Italian masters had shown ' a reality of conception . . . which approaches to a true ideal', but it had been left to Turner and the Pre-Raphaelites to 'form the first foundation that has been ever laid for true sacred art'.[20]

Burne-Jones quotes this passage in his review, and in 1857 he produced a design which seemed to justify Ruskin's highest expectations. This was his first stained-glass cartoon for Powells, 'The Good Shepherd' (pl.84). 'Christ is here represented as a real Shepherd', Rossetti wrote of it, 'in such dress as is fit for walking the fields and hills. He carries the lost sheep on His shoulder, and it is chewing some vine leaves which are wound round His hat . . . A loaf and bottle of wine, the Sacred Elements, hang at His girdle'. The design had 'driven Ruskin wild with joy',[21] and the reason is obvious. Religious theme, searching observation, meaningful symbolism – all were present.

But it was not long before Ruskin's 'joy' turned to dismay as Rossetti and

his followers plunged gaily into a type of mediaevalism which seemed to deny everything he had been saying about the Pre-Raphaelites. The origins of this taste were present in Rossetti's work well before the advent of Morris and Burne-Jones,[22] but they, with their passion for everything mediaeval, fully developed by the time they left Oxford, undoubtedly encouraged it. The phase reached a climax in the summer of 1857, when the three of them and other associates painted the famous murals illustrating the *Morte d'Arthur* in the Oxford Union. It also finds vivid expression in Rossetti's 'Froissartian' watercolours of this time, in Burne-Jones's contemporary pen-and-ink drawings, and in Morris's first volume of poetry, *The Defence of Guenevere*, published in March 1858.

The best indication of Ruskin's feelings about the mediaeval style occurs in a letter he wrote in October 1858 to G.F. Watts, who had complained to him about Rossetti's influence on his pupil, Val Prinsep. 'I was very glad to have your letter', he began, 'entirely feeling with you in this matter – and even more culpable than you charge me with being; for I am answerable for a good deal of this fatal mediaevalism in the beginning of it – not indeed for the principle of retrogression – but for the stiffness and quaintness and intensity as opposed to classical grace and tranquility'. After explaining that he was 'sickened of all Gothic by Rossetti's clique, all the more that I've been having a great go with Paul Veronese', and promising 'to get hold of Val this week and have a serious talk with him', Ruskin concluded: 'The worst of it is that all the fun of these fellows goes straight into their work, one can't get them to be quiet at it, or resist a fancy; if it strikes them ever so little a stroke on the bells of their soul, away they go to jingle, jingle, without every caring what o'clock it is.'[23]

As the last sentence implies, Ruskin felt that the style was essentially frivolous. There was a tongue-in-cheek quality about it, summed up by Rossetti's remark that he adopted many of his quaintest effects to 'puzzle fools'.[24] How remote from the earnest search for symbol-laden detail that Ruskin advocated! Indeed there seemed little scope for this in the new subject matter. When Ruskin spoke of the P.R.B. 'laying the first foundation for true sacred art' he was thinking not only of 'The Light of the World' but of Rossetti's religious works of the mid-1850s.[25] No less admirable, in his view, were the painter's Dantesque compositions of the same period; Dante was for Ruskin 'the great prophetic exponent of the heart of the Middle Ages',[26] and these pictures clearly belonged to the second rank of 'noble subjects', those showing 'the acts or meditations of great men'. But there was little or no moral content in Malory. 'Rossetti and the P.R.B. are all gone crazy about the Morte d'Arthur', he complained to Charles Eliot Norton in

1859,[27] and Lady Trevelyan was clearly echoing him when, on buying one of Rossetti's finest religious works on his advice in 1858, she wrote: 'I cannot help feeling very glad he has done that instead of the "Blue Closets" – "Tunes of the 7 Towers" or other subjects which really have no meaning except a vague medievalism . . . not what one wants to see him spending years of life upon.'[28]

Ruskin found the style's formal qualities equally distressing, as he showed by his comments on Rossetti's 'Froissartian' watercolour, 'Before the Battle' (Surtees No.106), begun for Norton in the autumn of 1857. 'Almost the worst thing he has ever done', he declared on seeing it first, and even after making Rossetti retouch it, he found it 'still painfully quaint and hard', its 'mode of colour-treatment . . . too much like that of the Knave of hearts'.[29] Mannered, cerebral and inward-looking, the style seemed to have lost all contact with nature, the bedrock for Ruskin of beauty and truth. Hence his stipulation that he would pay Rossetti to paint a second bay in the Union only on the condition that 'there's no absolute nonsense in it, and the trees are like trees, and the stones like stones'.[30] Nor did he like the passion for quaint and finicky detail, so often resulting in over-busy effects. 'Clever but not right' was his assessment of Morris's design for the Union roof,[31] a riot of birds and animals inspired by mediaeval illumination. Where in all this was the 'quality of Grasp', the 'harmonising' of 'truths' that artists should aim for? Above all, where was that sense of peace and order that Ruskin never ceased to yearn for in nature and art, the quality he had identified in his analysis of Typical Beauty in *Modern Painters* II as 'Repose: the Type of Divine Permanence', writing of it that 'no work of art can be great without it, and . . . all art is great in proportion to the appearance of it'? In a passage which might have been written with the mediaeval style in mind, he continues: 'There is no art . . . whatsoever, but its results may be classed by this test alone, everything of evil is betrayed . . . by it, glitter and confusion, and glare of colour, inconsistency or absence of thought, forced expression, evil choice of subject, . . . pretence, over decoration, over division of parts.'[32] It was 'repose' that he had in mind when he spoke to Watts of 'classical grace and tranquility'. For, not surprisingly, he found it pre-eminently in classical Greek sculpture (the Parthenon 'Theseus' is the example given in *Modern Painters*), as well as in those artists whom he tended to see as heirs to the classical tradition: Giotto and Orcagna, Titian and Tintoretto.

As Ruskin told Watts, his distaste for the painters' eccentricities was enhanced by the 'great go' he had recently had with Veronese. This is a reference to an important event which had occurred a few months before.

Over the years the strict evangelical faith in which he had been brought up had weakened. The hardness of the human condition had made him question the beneficence of God, and the indifference of men to the influence of beauty had left him disillusioned where once he had been full of hope. These feelings reached a climax in Turin in the summer of 1858 when the stark contrast between a dismal service in a Waldensian chapel and the robust beauty of Veronese's 'Solomon and Sheba', glowing in the afternoon sunlight in the gallery, finally completed a process of 'unconversion'. Throwing off his inherited puritanism, he embraced 'a religion of Humanity', based on the principle that 'human work must be done honourably and thoroughly, because we are now Men; – whether we ever expect to be angels, or ever were slugs, being practically no matter'.[33] He was to maintain this humanist standpoint until he regained a measure of Christian faith in 1874.

Ruskin's 'unconversion' profoundly affected his aesthetic values. He now declared that art should express 'a good, stout, self-commanding, magnificent Animality', and that he found this quality above all in sixteenth-century Venetian painting. 'Francia and Angelico, and all the purists, however beautiful', were dismissed as 'poor weak creatures',[34] and the mediaeval style seemed all the more irrelevant. Nor was 'animality' the only thing he missed in Rossetti and his followers by comparison with the Venetians. He had long thought of Veronese as an example of how the great artist should work – unselfconsciously, without 'egotism', creating masterpieces as if he were the agent of a higher power, careless of the need to express his own emotions. The mediaeval style was nothing if not 'egotistic'.

Ruskin had told Watts that he would have 'a serious talk' with Prinsep, but the phrase may be equally applied to his relations with Burne-Jones during the next few years. Indeed it was to him that he looked principally to 'save' the Pre-Raphaelite situation now that Rossetti was becoming so resistent to 'managing'. The crisis in Turin ensured that he brought to the 'talk' all the zeal of a convert, and one moreover who felt he had to atone. In admitting to Watts that he was 'answerable for a good deal of this fatal mediaevalism', he was thinking of his advocacy of Gothic architecture, his emphasis on symbolism and the 'grotesque', his love of Dante and Giotto, above all his readiness to show the painters his large collection of illuminated manuscripts and Dürer engravings. Dürer is particularly interesting in relation to Burne-Jones, whose early pen and ink drawings were much influenced by his prints.[35] This no doubt reflects the importance of Dürer to Ruskin as a master of allegory and a model of that 'distinct

drawing' which he believed essential to the 'harmonious' rendering of 'truth'. Yet Ruskin may well have felt that the painters were using Dürer as little more than a source of 'puzzling' detail, as indeed in many cases they were.

Two contemporary events must have strengthened his resolve to intervene. The first was the appearance of Millais's 'Sir Isumbras' (Lady Lever Art Gallery, Port Sunlight) at the Royal Academy of 1857. The picture had horrified him; 'not merely Fall [but] Catastrophe', a complete 'reversal of principle', he lamented in *Academy Notes*.[36] Then a year later he had failed once again to create the perfect Pre-Raphaelite. During his momentous visit to Turin he had sent for the unfortunate John Brett, who was working on his 'Val d'Aosta' (TG 1984, No.99), and 'lectured' him into a 'completely wretched' state. Predictably, the picture was a disappointment, as Ruskin himself admitted: 'I never saw the mirror so held up to Nature; but it is Mirror's work, not Man's.'[37]

Once of the earliest signs that his 'talk' with Burne-Jones was in progress may be traced in the artist's repeated attempts in 1857 and 1858 to paint blossom direct from nature in his picture 'The Blessed Damozel' (pl.85).[38] This was clearly connected with Ruskin's advice to artists to study the beauty of blossom against a blue spring sky in his *Academy Notes* for 1858[39] – advice which resulted in a crop of pictures showing this effect at the Academy the following year, notably by Millais, J.C. Horsley, and Arthur Hughes. It is doubtless significant that Burne-Jones stayed with Hughes when he made a final attempt to paint blossom at Maidstone in the spring of 1858.

About the same time there is a fascinating glimpse of Burne-Jones and his fiancée, Georgiana Macdonald, visiting Ruskin as he worked on the Turner bequest in the basement of the National Gallery. Lady Burne-Jones recalled how Ruskin, as he sorted the drawings, 'talked, or pointed out any special thing', and how 'he showed us some old pictures lately brought back from Italy by Sir Charles Eastlake, but not yet hung'.[40] These were almost certainly the important group of early Florentine and Sienese works purchased from the Lombardi-Baldi collection in 1857, and both they and the Turners would have given Ruskin ample opportunity to preach his favourite sermon about visual and spiritual truth.

Again, it seems likely that Ruskin had something to do with Burne-Jones's prolonged stay at Little Holland House this summer, although ostensibly this was the result of Mrs Prinsep's motherly concern when he suddenly suffered a nervous and physical collapse. Certainly Ruskin must have approved of his daily contact with the house's resident genius, G.F.

84 E. Burne-Jones, 'The Good Shepherd',
cartoon for stained glass, 1857; pen and
watercolour, $50\frac{3}{4} \times 18\frac{11}{16}$ (129×47.5);
Victoria and Albert Museum

85 E. Burne-Jones, 'The Blessed Damozel',
1857–60; watercolour and bodycolour,
$15\frac{3}{4} \times 8$ (40×20.3);
Fogg Art Museum, Harvard University

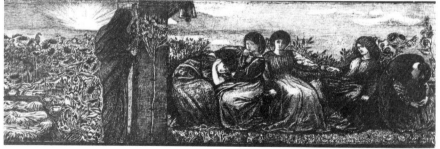

86 E. Burne-Jones, 'Ladies and Death', 1860;
pen, $5\frac{11}{16} \times 17\frac{11}{16}$ (14.4×45); *National Gallery of Victoria, Melbourne*

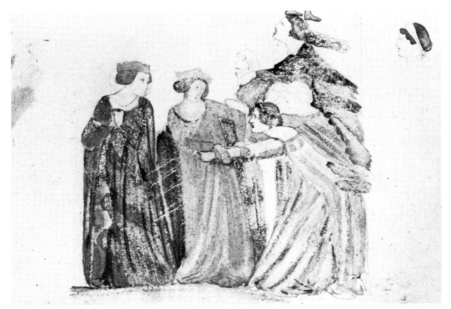

87 E. Burne-Jones, copy of a detail from 'The Last Judgement'
in the Campo Santo, Pisa, 1859; pencil and watercolour,
paper size $11\frac{3}{16} \times 9$ (28.4 × 22.9); *Fitzwilliam Museum, Cambridge*

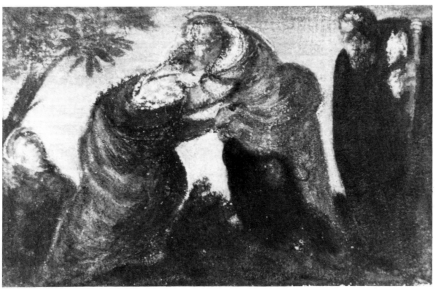

88 E. Burne-Jones, copy after Tintoretto's 'The Visitation'
in the Scuola di S. Rocco, Venice, 1862; watercolour,
$3\frac{9}{16} \times 5\frac{1}{2}$ (9 × 14); *The Ruskin Galleries, Bembridge School, Isle of Wight*

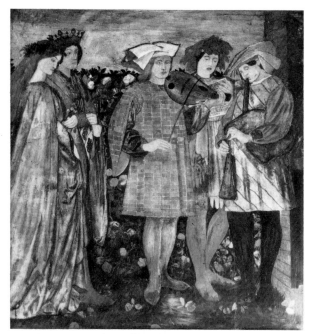

89 E. Burne-Jones, 'The Wedding Procession of
Sir Degrevaunt', 1860; mural painting at Red House

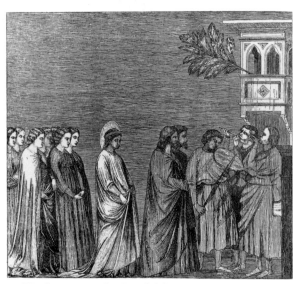

90 Wood-engraving after Giotto's 'The Virgin
Returns to her Home' in the Arena Chapel, Padua,
published by the Arundel Society, 1853

91 E. Burne-Jones,
'Thisbe', cartoon for
needlework, 1863–4;
watercolour, 54 × 27
(137.2 × 68.6);
William Morris Gallery,
Walthamstow

Watts, an artist whose work, he believed, gave evidence of a 'new era' in 'grotesque' imagination, but who shared his misgivings about Rossetti. Like Ruskin, Watts disliked 'egotism'. His pupil Spencer Stanhope wrote that he 'utterly condemns all . . . mannerisms, and says that *nothing* ought to be studied (the Elgin marbles excepted) but nature'.[41] Like Ruskin again he cherished a picture of a golden thread running from Phidias to Giotto to Titian – an image on which his own style was based. There is little doubt that he urged Burne-Jones to adopt a more objective approach. 'It was Watts', Burne-Jones wrote later, 'who compelled me to try and draw better'.[42]

In 1859 Burne-Jones executed a large pen and ink drawing, 'The Wise and Foolish Virgins' (TG 1984, No.227), which suggests that Ruskin had not been 'talking' in vain. Abandoning mediaeval themes for a religious subject, he treated it with a wealth of naturalistic detail and even hinted at a growing awareness of classical sculpture in the frieze-like arrangement and drapery forms of the figures.[43] However, another pen drawing of this year, 'Buondelmonte's Wedding' (Fitzwilliam Museum, Cambridge), was not so happy from Ruskin's point of view. Apparently commissioned by him, a sure sign that he was trying to bring influence to bear, the finished product is an almost ludicrously extravagant essay in the mediaeval style, full of wilful eccentricities which remind one of some of Du Maurier's Pre-Raphaelite parodies, published in *Punch* in 1866.[44] Clearly more positive 'talking' was needed – nothing less than a visit to Italy itself.

Burne-Jones set out on the first of his four visits to Italy in September 1859, accompanied, not surprisingly, by Val Prinsep. They were away six weeks and Burne-Jones made numerous copies at every stage of the journey,[45] which included Genoa, Pisa, Florence, Siena, Verona, Padua and Venice. As these copies show, he was by no means swamped by Ruskin in Italy. He was already looking hard, for instance, at Carpaccio and Botticelli, artists whom Ruskin was not to 'discover' till many years later. But Ruskin was certainly a forceful presence, as Prinsep admitted in recalling how, in Venice, 'Ruskin in hand, we sought out every cornice, design, or monument praised by him. We bowed before Tintoret and scoffed at Sansovino. A broken pediment was a thing of horror'.[46] The majority of Burne-Jones's copies are taken from the early masters who, in Ruskin's opinion, had 'approached to a true ideal' of religious art – Giotto, Masaccio, Ghirlandaio and others. A good example is a sketch of a group of terrified women in 'The Last Judgment', then attributed to Orcagna, in the Campo Santo at Pisa (pl.87). In his Edinburgh Lecture on Pre-Raphaelitism and again in the chapter on the 'False Religious Ideal',

Ruskin had taken this fresco and its companion, 'The Triumph of Death', as supreme examples of imaginative conceptions based on a firm grasp of 'facts'. In the chapter on 'Grotesque Idealism' he had included the 'Triumph' in a list of great allegorical works; and in *The Stones of Venice* he had described Orcagna as an artist who could 'taste the finer characters of Greek art' and would have 'understood the Theseus in an instant'.[47] Thus in every sense these frescoes were models to note.

Burne-Jones's work on his return continued to show the impress of Ruskin's ideas. A pen and ink drawing of 1860, 'Ladies and Death' (pl.86), is clearly inspired by motifs in 'The Triumph of Death', notably the open coffins that Ruskin singles out as a particularly significant example of Orcagna's fearless depiction of 'facts'. A similar relationship exists between another outstanding example of Ruskinian values and one of the murals illustrating the romance of 'Sir Degrevaunt' that Burne-Jones painted for Morris at Red House this summer. The scene of the knight's wedding procession (pl.89) is based on the right-hand part of Giotto's rendering of a comparable theme, the Virgin Mary returning home after her betrothal, among the frescoes in the Arena Chapel at Padua (pl.90); and the reason for this is at once explained if one looks at Ruskin's comments on the fresco in his descriptive notes of 1853. 'Of all the compositions', he writes, this is 'the most characteristic of the noble time in which it was done', exemplifying 'the simplicity and repose which were peculiar to the compositions of the early fourteenth century. In order to judge of it fairly, it ought first to be compared with any classical composition – with a portion, for instance, of the Elgin frieze – which would instantly make manifest in it a strange seriousness and dignity and slowness of motion, resulting chiefly from the excessive simplicity of all its terminal lines'.[48] Here, in short, was the epitome of 'classical grace and tranquility'. There is no evidence that Burne-Jones copied Giotto's fresco in 1859, but he had no need; the Arundel Society woodcut supplied the data he required.

Shortly before he left for Red House Burne-Jones had painted the two well known 'Von Bork' watercolours (TG 1984, Nos 230–1), in which signs may be traced of the more 'Venetian' manner which came to supersede mediaevalism for so many painters in his circle about this time. The origins of this phenomenon are complex. It certainly had much to do with the advent of Rossetti's new model, Fanny Cornforth, with her coarse good looks and rich golden hair. But while Ruskin regretted the effects of this on Rossetti's work, the change reflected his own feeling for the 'animality' of Venetian painting. He spent the winter of 1858–9 'trying to get at the mind of Titian' in the German art galleries;[49] and the results

appeared in the last volume of *Modern Painters* (1860), in which his new humanism found expression in long analyses of pictures by Titian and Veronese.

By now Ruskin might have been expected to feel that Burne-Jones was safely on the right course. Their personal relations had never been closer. 'We loved [Mr Ruskin] profoundly', Lady Burne-Jones wrote of this period, 'and he drew us very near to himself. When he was in England we often saw him, and when abroad he wrote to us, at first as "My dear Edward and Georgie" and afterwards as "My dearest Children," which name was never quite dropped'.[50] But of Burne-Jones the artist Ruskin still had doubts. In November 1860 he complained to Norton that he was 'always doing things which need one to get into a state of Dantesque Visionariness before one can see them . . . it tires me so',[51] and in January 1862 he spoke of him regretfully as the artist who 'promised to be the sweetest of all the P.R.B. designers'.[52] Two months later he told Ellen Heaton that the artist had been ill and was 'much depressed about his work'.[53] How much of this depression, one wonders, was caused by Ruskin himself, like the 'completely wretched' state to which he had reduced John Brett in 1858?

Ruskin in fact was to make one last effort at reform, taking the Burne-Joneses to north Italy with him in the summer of 1862 and making the artist copy Venetian paintings and the work of a new hero, Luini.[54] Many of these copies record works that Ruskin believed were in a state of rapid decay, but characteristically he also chose pictures which he thought would teach some lesson required by the copyist. At one point he became almost Machiavelian, first ordering a copy, then announcing that he no longer 'cared' to have it, but adding that Burne-Jones should finish it 'as is best for your own work'.[55] The picture in question was Tintoretto's 'Marriage at Cana' in the sacristy of S. Maria della Salute. No finished copy is known, only slight pencil sketches,[56] but it is no accident that these show some of the seated female guests, a passage Ruskin greatly admired for its 'grace', writing lyrically of 'fair faces and golden hair' and 'beautiful profiles and bendings of breasts and necks along the whole line'.[57] Time and again Burne-Jones found himself copying pictures which represented Ruskin's favourite aesthetic values – expressions of noble Giottesque form; examples of imagination working on 'facts' to produce profound symbolism or majestic narrative; embodiments of Vital or Typical beauty. One more example must suffice: Tintoretto's 'Visitation' in the Scuola di S. Rocco (pl.88). 'There is no picture [in Venice]', Ruskin had written, 'that I covet so much . . . The gestures are as simple and natural as Giotto's, only expressed in grander lines, such as none but Tintoret ever reached . . . the

outlines of the drapery [are] so severe that the intervals between the figures look like ravines between great rocks, and have all the sublimity of an alpine valley at twilight'.[58]

It was only in the period immediately following this journey that Ruskin at last came to feel that his efforts had been rewarded, thus allowing us to assess their impact on Burne-Jones. Ruskin's ideas were shifting again, away from Venetian 'animality' towards an art of incandescent purity from which every distressing nuance had been purged. As he admitted in 1854, he had 'naturally a great dread of subjects altogether painful';[59] and purity in all its forms – a snow-clad mountain, a flower, a girl – had always moved him deeply. Now these tendencies became obsessions. The development had much to do with Rose La Touche and her surrogates, the girls of Winnington school. Not only did they fill his mind with images of innocence; the anguish Rose caused him seemed to make him incapable of facing any further pain, even in the medium of art.[60] At the same time, his preoccupation with the ills of contemporary society made him bitterly resentful of art which seemed to pander to man's morbid love of sensation – a tendency he associated above all with Gustave Doré.

In opposition to this harmfully 'dramatic' art he evolved the concept of 'constant' art, an art of abiding values which taught moral lessons by the nobility of its subject matter and uplifted through the calm serenity of its forms. 'Constant art', he wrote in 1867, 'represents beautiful things, or creatures, for the sake of their own worthiness only; they are in perfect repose, and are there only to be looked at . . . It is what they are, not what they are doing, which is to interest you'.[61] Closely associated with this idea was his growing interest in Luini and Italian painting generally of the period 1470–1520 – 'simply the Age of the Masters', who 'desire only to make everything dainty, delightful, and perfect', as he described it in a lecture of 1870.[62] Like these 'masters', the modern practitioner of 'constant' art was to paint 'ideal grotesques', especially ones drawn from mythology which, now that his religious faith was shattered, Ruskin regarded as a vital repository of revealed truth. A famous example is given at the very end of *Modern Painters*, where he analyses two of Turner's mythological subjects, seeing them as symbols of nineteenth-century England, darkened by industrialisation and the rush for wealth, and his hopes for her future. He continued to study myths throughout the 1860s, and in his books of the period – *Munera Pulveris*, *The Cestus of Aglaia*, *The Queen of the Air* and others – they are used again and again to illuminate his ideas, often in tortuously allusive trains of thought which stretch them to the very limits of meaning.

The relevance of this programme to Burne-Jones is clear enough. From the beginning he had shown a tendency to think in terms of simple narrative and static, elegant forms which was quite unlike the dramatic, psychological approach of Rossetti. Ruskin himself recognised this, describing him to Miss Bell, the headmistress of Winnington, in 1859 as 'the most wonderful of all the Pre-Raphaelites in redundance of delicate and pathetic fancy – inferior to Rossetti in depth – but beyond him in grace and sweetness'.[63] No doubt it was this 'grace and sweetness' that particularly attracted Ruskin to his work. It may even have coloured his views, just as Rossetti's paintings helped to clarify his ideas on the relation of 'fact' to symbolism in the mid-1850s. Certainly it suggests one more reason why he transferred his attention to Burne-Jones from Rossetti, whose work showed an undeniable coarsening, a loss of innocence, with the coming of Fanny Cornforth, who was already his mistress before his marriage in 1860. At the same time Burne-Jones's instinctive approach can only have been encouraged by Ruskin's talk about 'classical grace', 'repose', and the obligation to 'seek for and dwell upon the fairest forms', slipping imperceptibly into the almost tangible stillness and intense emphasis on beauty which are so characteristic of his developed style.

In the year following the second Italian journey, Burne-Jones produced a series of designs of standing female figures in which he seems both to find himself and to produce images of serenity, grandeur and innocence which reflect his recent study of Luini and Tintoretto and are eminently Ruskinian. One of the most beautiful, 'Fair Rosamond' (TG 1984, No.235), was indeed soon to come into Ruskin's possession, while others were made for a tapestry which Burne-Jones designed for him, intending it to be woven by the girls at Winnington (pl.91).[64] The choice of subject here – the heroines of Chaucer's *Legend of Good Women* – clearly reflects Ruskin's current devotion to Chaucer as a mine of 'grotesque' material full of the most profound moral significance. We cannot be sure that Burne-Jones saw the figures in this light, but his interest in mythological and allegorical themes certainly dates from this period. It was a field ideally suited to his imaginative and formal approach, so that again Ruskin seems to be encouraging a natural taste.

In 1862 Ruskin described Burne-Jones as 'a man . . . whose life is as pure as an archangel's, whose genius is as strange and high as that of Albert Dürer or Hans Memling – who loves me with a love as of a brother – and far more – of a devoted friend'.[65] Three years later he wrote of the 'understanding' that he had 'never been able to get, except from two women . . . and from Edward Jones'.[66] At this intensely difficult period in his private life

he sought the painter's company more than ever, coming to work in his studio, sitting to him for his portrait,[67] confiding in him over Rose. He was also able to help him financially, having inherited a sizeable fortune on his father's death in 1864.

All this continued to give him the opportunity to 'talk', although now it was becoming not so much a lecture as a discussion of shared aims with an artist who was rapidly establishing his reputation.[68] In 1864 Ruskin planned to take Burne-Jones to Italy again, focusing their attention this time on Florence. The journey never took place due to the death of Ruskin's father in March, but about the same time he was urging him not to paint 'melancholy subjects'[69], and to use lighter colours 'so as not to have any nasty black and brown things to make me look at when I come to ask what you've been about'.[70] This is a reference to the colour symbolism that was an important part of the 'constant' programme, dark, murky colours being associated for Ruskin with greed and 'foulness', while light tones symbolised divine, life-giving love.[71] Again the great expression of this idea is contained in the account of Turner's mythological works at the end of *Modern Painters*, but it is also reflected in Burne-Jones, whose colours suddenly lightened in the mid-1860s.

However, the most telling example of Ruskin's intervention at this stage is the commission he gave Burne-Jones in 1863 for a series of figures to illustrate the allegorical passages in *Munera Pulveris*, his controversial papers on political economy which had begun to appear in *Fraser's Magazine* the previous year.[72] In doing this, Ruskin was inviting Burne-Jones to create examples of 'constant' art in the most literal sense, and it is perhaps not surprising that the commission resulted in one of Burne-Jones's most important works of the time, 'The Wine of Circe', completed in 1869 (TG 1984, No.244). Nor is it hard to see how much this owes to Ruskin's ideas. Not only does the design go back to *Munera Pulveris*, in which Ruskin sees the enchantress as a force for good, 'her power [being] that of frank, and full vital pleasure, which, if governed and watched, nourishes men'.[73] Comparison of the early sketches with the finished painting also shows that the conception changed dramatically in accordance with the 'constant' ideal – the forms becoming more 'graceful' and light flooding into the room, which had originally been seen in the sombre terms of the mediaeval and Venetian styles.

It only remained for Ruskin himself to show approval, and this he did with characteristic emphasis in a lecture 'On the Present State of Modern Art' which he delivered at the Royal Institution in June 1867. Having analysed the faults of contemporary British painting, he proceeded to

outline his own programme, illustrating it with examples of Burne-Jones's work. Showing his audience some of the 'Good Women' tapestry cartoons, he explained how they brought out the inner meaning of the subjects and revealed the artist's 'special gift [of] seizing the good, and disdaining evil'. Such designs, he felt, showed entire 'sympathy for the repose of the Constant schools' and 'bid fair to be quite dominant in the English dramatic school'. Indeed, 'already, in those qualities which are most desirable and inimitable, [they] may challenge comparison with the best dramatic design of the great periods', while in their 'purity and seeking for good and virtue as the life of all things and creatures, [they] stand, I think, unrivalled and alone'.[74]

The complete intellectual sympathy represented by the 'Modern Art' lecture could not, in the nature of things, survive. How far it had been eroded only four years later was dramatically revealed when Ruskin launched a savage attack on Michelangelo in a Slade lecture in the summer of 1871, to the dismay of Burne-Jones who was then at the height of his Michelangelesque phase.[75] The rift was never quite healed. Burne-Jones continued to have misgivings about Ruskin's aesthetic opinions,[76] as Ruskin himself realised, observing in 1886 that 'to this very day my love of Turner dims Mr Burne-Jones's pleasure in my praise'.[77] Equally, he deplored Burne-Jones's devotion to drapery and the figure, and could not understand why he refused to make 'a study of fruit with the minuteness of William Hunt'.[78] When Burne-Jones exhibited 'The Depths of the Sea' at the Royal Academy in 1886 he was 'grieved and angered', feeling that the artist had missed a great opportunity to present the world with some profound 'grotesque'.[79]

Yet the broad basis of agreement remained. In 1877 Ruskin was lavish in praise of Burne-Jones's contributions to the first Grosvenor Gallery exhibition ('I *know* that these will be immortal'),[80] and in 1883 he made him the subject of one of his 'Art of England' lectures at Oxford, emphasising his 'deeply interesting function' as a 'modern painter of mythology'.[81] Nor did the friendship fade. In 1878, smothering acute embarrassment, Burne-Jones loyally gave evidence for Ruskin in the famous libel action brought against him by Whistler. In 1883 he carried out two commissions designed to commemorate the now dead Rose La Touche, a drawing of 'The Rape of Proserpine',[82] and the gold hawthorn cross that Ruskin presented annually to the May Queen at Whitelands College.[83] Visits and loving letters between 'Beloved Oldie' and 'Darling Ned' continued until Burne-Jones's death in 1898, two years before that of Ruskin.

There were a number of possible reactions to Ruskin's freely given if not always welcome advice. A weak artist could easily be damaged by it, like the hapless John Brett, or even totally destroyed. This was the fate of W.J. Stillman, who suffered an acute crisis of confidence and even temporary blindness while working with Ruskin in Switzerland in 1860. Having abandoned painting for a diplomatic career, he later wrote: 'Ruskin had dragged me from my old methods, and given me none to replace them. I lost my faith in myself, and in him as a guide to art.'[84] On the other hand a powerful artistic personality like Rossetti was almost bound to quarrel with Ruskin sooner or later if he was not to compromise his independence. Even more extreme was the position of Ford Madox Brown, who regarded Ruskin as a patronising humbug, and would have dismissed with contempt any idea of submitting to his influence.

Burne-Jones's achievement was to preserve his artistic integrity and yet retain Ruskin's respect for him as a painter and his friendship. Just as he had studied Ruskinian models of style in Italy in 1859 while using his eyes for himself to notice artists important for his own development but still outside the range of Ruskin's interests, so he continued to make selective use of Ruskin's advice, taking from it what he needed and tactfully ignoring the rest. His artistic temperament was no less strong than Rossetti's, and there is evidence that he too could find Ruskin trying; he got very tired of making copies in Venice in 1862, feeling he was wasting time and longing to return to his studio. Yet his relationship with Ruskin, unlike Rossetti's, survived, partly due to his natural artistic inclinations, which corresponded much better than Rossetti's with Ruskin's developing views, but even more, perhaps, to his sweetness of character, which enabled him to react to Ruskin with an almost feminine sensitivity and give him the 'understanding' he so longed to receive. Certainly it was at the personal rather than the intellectual level that the relationship ultimately came to exist, and while neither of the friends had forgotten the 'serious talk', both could afford to treat it with a whimsicality based on the knowledge that something far more important had taken its place. 'He is merely what you would have been if you had been born here, and rightly trained from the beginning', Ruskin told Burne-Jones on his 'discovery' of Carpaccio in Venice in 1869.[85] And Burne-Jones, replying to Ruskin's announcement that he was to lecture on him in 1883, asked: 'Shall you say I do all I ought not to do, and won't be guided, and am obstinate and tiresome?'[86]

The Holman Hunt Collection,
A Personal Recollection

DIANA HOLMAN-HUNT

As I lack appropriate qualifications, I hope that scholars may forgive an intimate approach to my subject. However, perhaps even the most learned may find some information of interest.

My grandfather, William Holman Hunt, O.M., 1827–1910, is not generally remembered for his Collection. I have no space here to include more than an occasional reference to miniatures, jewellery, silver, rugs, embroidery, enamels, Persian and de Morgan tiles and Islamic metalwork. I have chosen to concentrate on the fine arts, furniture and ceramics.

Hunt began collecting in 1856 and continued for forty years. Throughout this long period his taste remained consistently eclectic. For example, in 1857, the same year as he designed simple furniture for William Morris in keeping with his friend's idealistic principles, he designed the Egyptian-style chairs, made for him by the craftsmen Messrs J.G. Crace, of mahogany and sycamore inlaid with ivory and ebony.[1] This passion for intricate inlay, decorating oriental or Italian furniture and objects, remained with him always, although surprisingly, neither Boulle nor Dutch marquetry appealed to him.

In 1897 Hunt attended Millais's posthumous sale at Christie's and, as a final addition to his Collection, bought a pair of elaborately carved Chinese nineteenth-century ebony armchairs inlaid with mother-of-pearl, with marble backs and seats, which had once belonged to Dante Gabriel Rossetti (pl.93).[2] It was in the 1860s that Rossetti became interested in exotic furniture. Chang, the Chinese giant, who was 8 ft 2 in tall, was exhibited in London in 1865 and again in 1880. He brought these huge thrones with him and presumably Rossetti acquired them on one of these visits. They do not appear in Rossetti's posthumous sale catalogue, so perhaps he gave or sold them privately to Millais. At the Millais sale Hunt also bought five old Beauvais tapestry panels which had lined the walls of his great friend's studio since 1863.[3]

In 1881, after years of temporary lodgings and travelling to and from the Middle East, Hunt settled down at last at Draycott Lodge, once the

home of Horace Walpole, a beautiful rambling Regency house with a large garden and orchards. This was the first time that Hunt was able to display the Collection to his satisfaction. Photographs of the interior (frontispiece and pls 92, 94) show the Morris papered walls hung with Italian Old Masters, his own self-portraits, framed prints and photographs, lustre plates and majolica. A variety of ornate chests and cabinets, some draped or covered with embroidered Jacobean four-poster bed-hangings, are arranged at random with Victorian, Georgian and Regency furniture.

The assortment of chairs alone emphasises the contrast in his taste. There is one of Hepplewhite style made of solid ivory in India, late eighteenth century, several seventeenth-century carved ebony Javanese thrones rather similar to the Singhalese ones of the same date in the Holbein Room at Strawberry Hill,[4] Morris rush-seated dining-chairs, others in styles as different as mock French and Gothic Renaissance, a crofter's wicker chair, some Chippendale (possibly Morris reproductions), a Queen Anne double-ended window seat, a quaint milking-stool from the Tyrol and the odd contemporary Thonet Bentwood. Venetian chandeliers, pierced brass lanterns from Damascus and Benson copper lamps hang from the insecure-looking ceilings. Every available surface is littered with framed photographs, books and a mass of ceramics and ornaments.

Curiously, the general impression is harmonious, a non-style, created from a confusion of styles, which became fashionable through the influences of the major Pre-Raphaelites and other Victorian artists. This non-style is echoed in the watercolour by H.T. Dunn of Rossetti's living room in Chelsea and the watercolour of Burne-Jones's dining-room by T.M. Rooke. An equally extraordinary conglomeration is evident in the contemporary photographs of Leighton House in the 1890s.

It is hard to detect any influence of Hunt's Collection on his own work, except perhaps the unusual colour combinations and glazed texture of the Limoges enamels, and vast quantity of majolica bought in Italy in the 1860s. The gleam of brass and copper appealed to him. Some of his paintings have a curiously metallic finish and of course his obsession with detail is almost always evident. He was no connoisseur and it was often by happy accident that he acquired a rare and valuable piece or an 'Old Master' which has since proved of real interest. Rossetti, on the other hand, was much influenced by the Botticelli and other Italian paintings that he bought at about the same time.

Perhaps one reason for the apparent neglect of Hunt's Collection is that it has been so widely dispersed since his death through numerous small sales, many anonymous. Although I am his only direct descendant, it is

mainly by luck that I have about half a dozen items, already given to my son. These circumstances may be clarified by the following explanation, which scholars may skip! To the inquisitive, the contents of another's cupboard are often intriguing, even if once unlocked it only reveals a few bones rather than a skeleton.

My grandmother, Hunt's second wife Edith, née Waugh, whom he married in Switzerland in 1875, was many years his junior. Her elder sister Fanny, whom he had married in 1865, had died in Florence the following year after giving birth to a son, Cyril. Edith's first child was a girl, Gladys, who was soon followed by Hilary, my father. Naturally Gladys was jealous of the baby boy and resented the favouritism shown him to the neglect of Cyril. She always remained devoted to her elder half-brother. As they grew older, the two younger children proved a startling contrast to each other. Gladys was extremely appreciative of her father's life and work and greatly interested in the Collection. She had many artistic friends. My father's interests were limited to racing, polo, hunting, gambling and latterly breeding greyhounds.

Edith was indefatigable. In 1905, when Hunt's sight was failing, she greatly assisted him with the first edition of a two-volume, copiously illustrated memoir: *Pre-Raphaelitism and the Pre-Raphaelite Brotherhood*. Only recently they had moved from Draycott Lodge to 18 Melbury Road in Kensington. Because they missed the gardens and orchards in Fulham, Gladys designed a house for them which was built on the river at Sonning. Before rearranging and distributing the Collection between these two houses, Edith engaged an excellent photographer to record what she and Hunt considered to be some of the most important items. She painted over these large photographs very skilfully with watercolour, mounting them all on thick cards measuring 18 × 13 inches. She added her signature to Hunt's as well as both their annotations, adding various letters from eminent scholars. She ordered a handsome solander box, embossed in gold with *W. Holman Hunt, Pictures and Objects*, to hold the thirty odd sheets (I fear that several are missing). The whole was dedicated by Hunt and her to 'Our son Hilary'.

After Hunt's death in 1910, Edith inherited everything. His life, work and the Collection were her pride and joy. She began editing an enlarged second edition of *Pre-Raphaelitism*, often changing the text and adding more illustrations and an index, to the relief of students today.

She had most of Hunt's letters, to and from his contemporaries, and censored with a paint brush and Indian ink any sentence which she felt might prove derogatory to his sacred memory. In 1911–12, she not only

sold the house at Sonning, but three of the most important items of the Collection: a Cranach (pl.96),[5] an early fifteenth-century Florentine 'oak leaf' jar[6] and a Tuscan jug of $c.1475$, for quite ridiculous sums.

To Edith's dismay, over nine years passed after her beloved Hilary's marriage to my mother with no sign of a child. Neither Cyril nor Gladys was married. As soon as the news of my impending arrival reached her from Burma, where my father was an engineer in the Public Works Department, she insisted that her grandchild, already referred to as William, should be born in the bed in which Hunt had died at 18 Melbury Road. The room with its Morris curtains and wallpaper had remained unchanged. She prayed that I might 'benefit from the atmosphere where Hunt's spirit might still linger'.

My mother's parents, the Freemans, were horrified by the arrangement: the domestic staff was inadequate; there was no electric light. Gladys and my father, who were both staying in the house, quarrelled incessantly. Gladys had recently undergone a severe nervous breakdown after a broken engagement. My mother suffered terribly from the many ordeals of this visit and swore never to have another child. After a few months she returned to Burma and left me to be brought up by her parents.

The Freemans dreaded my father's letters from Burma. When I was six, he wrote insisting that now the war was over, during the London Season, which the Freemans spent in their vast corner house, 24A Bryanston Square, I should occasionally visit his mother at Melbury Road for the day. I was duly despatched in the chauffeur-driven Daimler and brought back by bus after tea.

Some impressions of the first occasion remain vivid. Edith, whom I called Grand, almost at once led me to a cabinet made entirely of brass and glass in the drawing-room. She referred to this as my 'Museum'[7] and emphasised the importance and excitement of 'collecting'. The top half was filled with beautiful bowls and goblets. A fifteenth-century Venetian enamelled glass dish attracted my attention. She explained that only the contents of the bottom half, lined in velvet, were for me, and lifted the lid to reveal a jumble of objects. She knew I could read and write and said: 'We must make a catalogue.' I had no idea what this meant. Were these things presents for me? She said yes, collecting was an art, and it was never too early to acquire taste through discrimination.

I put on one side and carefully arranged such odds and ends as appealed to me. I felt confused by her constant references to 'Holman' and 'Hilary', whom I did not identify at once with my grandfather and father. When asked which was my favourite colour, I answered: 'Pink'. She spat with

indignation and said: 'Pink is not a colour.' I knew I had proved a disappointment.

My visits to spend a day with Grand became quite frequent and involved trudging round various museums and galleries and calling on old ladies. I enjoyed travelling on the top of buses even on wet days when we had to hold up umbrellas and unroll the oilcloth aprons from the seat in front to cover our laps. I remember her pointing to the Albert Memorial and saying that apart from the Taj Mahal, it was the greatest memorial in the world. Wishing to judge my taste, she asked me as we travelled home from one of our Sunday pilgrimages to the crypt of St Paul's, if I preferred Wren's Cathedral to George Gilbert Scott's masterpiece. I confessed that I could not appreciate buildings; they were so big, and apart from the contents of my museum and some of the Collection, I really did not know what I liked. This met with frosty disapproval: it was high time that I developed a more mature aesthetic sense. I suspect that she wrote to Papa complaining of my slow progress.

I was eight when another daunting letter arrived from Burma insisting that I was now old enough to be sent to boarding-school and should stay for a week or ten days during the holidays alone with Grand. The Freemans were dismayed but bound to agree. The most expensive school in Eastbourne was selected from various prospectuses.

On my visits to Melbury Road I dreaded weekends. On Fridays, rehearsals would begin for Sundays when a lot of uninvited guests would arrive in the afternoon admitted by two boy scouts in uniform bearing staves. On Saturdays we sallied forth to buy stale Dundee cakes, loaves, margarine, fish-paste and mousetrap cheese to provide 'sustenance' for the party. I was expected to entertain the less distinguished on a guided tour of the Collection. I practised painstaking recitation for hours and was once rewarded by Grand crying: 'My Pat! You've got it all Pet.' More often she would correct me, saying I must get it right by Sunday and remember that almost all the Italian things were bought when Grandpa Holman and Great Aunt Fanny were delayed in Florence on their way to the Middle East as there was an outbreak of cholera in Jerusalem, and not forget that he returned there after Fanny's death to carve her sarcophagus. Also I must stress that the Donatellos and Della Robbias had all been exhibited at the Old Masters Exhibition at Burlington House in 1888. I fear that I passed on much inaccurate information, and when at a loss improvised, or expressed my own opinion.

After tea, at a signal from Grand, I would escort my selection of the guests to the morning-room. She kept the more cultured in the drawing-

room where four or five of her beloved Holman's paintings were hung and the more important furniture and ornaments were displayed. I always began my tour by thumping the Hobman chest: 'This is the only piece in the Collection which Grandpa inherited from his rich Uncle Hobman who kept his furs in it. Then Grandpa used it as a prop-box for the models' clothes. It's still full of them.' I much resented being dressed in these musty garments throughout my visits, rather than being allowed to wear my own clothes. To this day I avoid wearing anything folksy or ethnic. Parrot-like I would add: 'It's been in the family since it was made.' It is in fact an early sixteenth-century Italian bridal chest with scenes elaborately carved, the backgrounds stippled with poker-work and black-painted decoration. There is a similar chest in the Victoria and Albert Museum and two more in the Castle Museum, Norwich. I would confide in the visitors that it was a pity that the lid of the chest was closed and covered with an embroidered cloth and valuable ornaments, because if one lifted the lid the inside was even more beautiful than the front and sides. The ornaments included a Chinese Kangxi baluster jar of c.1670–1700[8] and two small Chinese 'rose petal' bowls of c.1730–50.

It was quite tricky to steer my audience through an obstacle course of small Moorish coffee tables, incense burners, engraved Damascan grain bowls, and large Japanese vases. A clumsy guest might step back the better to see something. I would get the blame for any breakages.

'The picture above the Hobman chest is a late Giovanni Bellini which Grandpa bought in 1867 from an Italian family who had become impoverished when their estate was flooded. Grandpa repainted the hands which were damaged by a candle burning in front of them day and night.' Hunt, Edith and Gladys always insisted that it was a genuine Giovanni Bellini and I have his signed statement that he paid the Italian family the enormous sum of £800 for it. He wrote to F.G. Stephens soon after Fanny's death: 'If I croak, don't let it go for under a thousand.' Presumably in the 1860s, many tourists were fair game for impecunious and unscrupulous Italian aristocrats. However, I have papers proving that this Venetian family had offered the picture to the Uffizi who agreed to exchange it for other less attractive works. It was in fact a good early Cariani and eventually sold as such (pl.95).[9] I have the name of the Florentine family who were not as honest as the Venetians and connived with their friends and relations to cheat the gullible Englishman and his bride into buying various bogus 'Old Masters'. When Hunt was courting Fanny in 1864–5, she accompanied him to many London exhibitions. Perhaps they had seen the twenty-odd della Robbias at the South Kensington Museum, about

which even the *cognoscenti* were not well-informed in those days.

To return to my tour of the morning-room at Melbury Road, I would have to remember the long-winded title of a glazed, multi-coloured terracotta, 'The Madonna adoring the Child with God the Father, Six Cherubs and the Dove', surrounded by a garland of leaves and fruit. Both Hunt and Edith were particularly proud of this because Ruskin had said that 'this Andrea della Robbia is the gem of the whole collection'. I think that he must have seen it before the addition of a plinth which certainly does not belong to the main composition. There was a stormy seascape by Ruskin quite near which served as a reminder.

In a corner of the room was a very dark picture in a tabernacle frame which I thought of as 'the Black Madonna'. She had wicked eyes. This was in fact a small fifteenth-century triptych[10] and one of the only two pre-Raphael paintings owned by Hunt.

Above the fireplace was my favourite sculpture: a white marble tondo in high relief of the Madonna and Child (pl.97). It had the most beautiful wooden carved and gilded frame of fruit and flowers. It too had been bought in Florence in 1867 and had been exhibited at the Royal Academy Winter Exhibition in 1888 as 'artist unknown but by some ascribed to Mino de Fiesole, 1431–1486'. It was the first piece of sculpture that I really loved. For years I have treasured the letters from Dr J.H. Middleton (who was the Director of the Art Museum Division, South Kensington, 1893–6) of 1888 sharing my youthful enthusiasm. One of them referred to the tondo as 'the most wonderful treat' and that it pleased him more than any other exhibit: '. . . there can be no doubt that it is by Andrea della Robbia'. Alfred Higgins (a member of The Burlington Fine Arts Club and a distinguished art collector of the nineteenth century) also wrote at length saying that the moment he saw the lovely marble tondo he was sure that it was 'the only known original marble by Andrea himself except those above the high altar of Santa Maria della Grazie at Arezzo'; the one at the South Kensington Museum was 'obviously just a terracotta model from which he worked the marble version to perfection'. It is interesting to see how scholarship has developed in the intervening century for it is in fact a beautifully executed fake made only about 20 years before Hunt bought it.[11] On the mantelpiece were Chinese vases crammed with dried honesty and peacock feathers, a large Persian bowl, a Persian lustred tile with a fragmentary inscription[12] and also a very pretty seventeenth-century Ming *cloisonné* box,[13] in which Grand kept a mysterious Tibetan charm.

My favourite painting, known as the 'Madonna dei Fiori', was attributed by Hunt to Pier Francesco Fiorentino (pl.98). It was on wood and had a

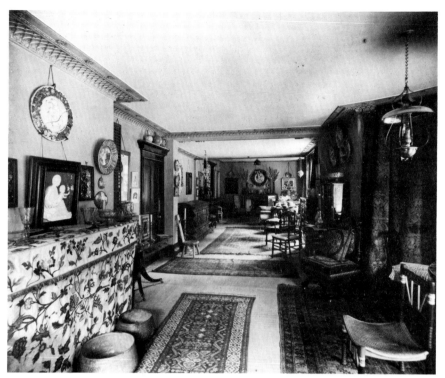

92 Drawing-room, Draycott Lodge,
Fulham, 1893

93 Giant Chang's ebony armchair;
Chinese, nineteenth century; formerly
in W. Holman Hunt's collection;
Ashmolean Museum, Oxford

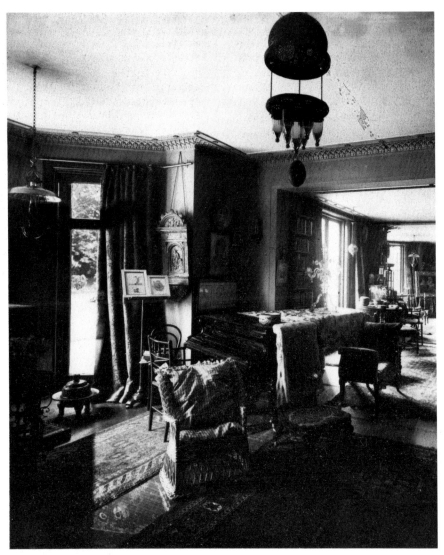

94 Drawing-room, Draycott Lodge, Fulham, 1893

95 Giovanni Cariani, 'Madonna and Child with Saints Jerome and Ambrose'; formerly in W. Holman Hunt's collection

96 Lucas Cranach, 'Portrait of a Man'; formerly in W. Holman Hunt's collection

97 Nineteenth-century copy after Andrea
della Robbia, 'Madonna and Child';
formerly in W. Holman Hunt's collection

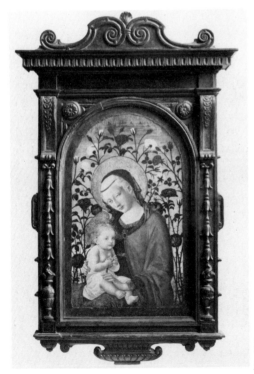

98 Pseudo Pier Francesco Fiorentino,
'Madonna dei Fiori'; formerly
in W. Holman Hunt's collection

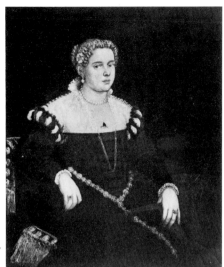

99 Attributed to Titian,
'Portrait of Titian's Daughter,
Lavinia'; formerly in
W. Holman Hunt's collection

100 Southern Indian or Singhalese ivory cabinet,
late seventeenth century; formerly in W. Holman Hunt's collection;
Victoria and Albert Museum

[217]

rounded top but fitted perfectly into a fine tabernacle frame which some learned gentleman said was of sixteenth-century rather than fifteenth-century style. The Christ-child clasped a little bird in his hand and the background was filled with lovely red and white roses.

Still in the morning-room I would announce: 'This is the study by Velasquez for the St Sebastian at Valencia. Most pictures of him are horrible, with blood streaming from wounds caused by masses of arrows.' A letter from Lord Leighton was admiring but distrustful of the attribution.[14]

On top of an elaborately inlaid Jacobean chest of drawers was a small Indian writing-case, also inlaid with ivory. I would tap it and say: 'A present from Swinburne, who knew the sort of thing Grandpa liked.'

I hated Van Dyck's 'Lamentation over the Dead Christ'[15] and thought it badly drawn. I might confide indiscreetly that according to Grand, St Sebastians, Crucifixions and Depositions were very hard to sell.

The Moorish throne came next, inlaid with little bits of mirror. I liked this more than the Italian *prie-dieu* which I had to be sure to remember was used in Grandpa's picture of Great Aunt Fanny called 'Isabella and the Pot of Basil'.

There was more sculpture in the hall along with portraits by Hunt and various drawings. I remember one small marble Madonna and Child in low relief in a handsome tabernacle frame which Grand said Hunt had designed when he bought the sculpture in Florence in 1867. He was convinced that his was an original Donatello and it was exhibited as such at the Royal Academy Winter Exhibition in 1888. It was in fact a nineteenth-century fake based on the design of Desiderio da Settignano's Dudley Madonna in the Victoria and Albert Museum. Another Madonna and Child in coloured stucco was also attributed to Donatello. Actually it was one of many fifteenth-century casts of Desiderio da Settignano's well-known low-relief marble Madonna in Turin. I feel thankful that both Hunt and Edith were dead by the time it was discovered that only a few of their nine 'Renaissance' sculptures were what they believed them to be.[16]

On one pen and ink and red chalk drawing of nudes, someone had written 'Raffaello' in pencil. Naively, Hunt thought that this was the artist's signature.[17] This was particularly surprising since the verso was inscribed 'Michelangelo'. Even then it worried me that it bore the stamp of Sir Joshua Reynolds's collection: he was reputed to be so knowledgeable. I knew that there was an attractive drawing of Adam and Eve, wearing no fig leaves, which Grand said was by Mantegna; this was hidden underneath a very large book and only shown to privileged old gentlemen. It was

in fact by Francesco di Giorgio Martini, the most important Sienese artist of the fifteenth century. I could not help feeling amused on hearing that when relined 'the figure of the Almighty became obscured'.[18]

I really preferred a beautiful black chalk cartoon by Sodoma of 'The Holy Family with the Young St John the Baptist and Angels',[19] and loved the portrait sketch of Emma Brandling which was a present to Hunt from G.F. Watts. She had been the Queen of Beauty at the Eglinton Tournament in 1841. On the same canvas was a study of Hunt for the head of King Alfred in the Lincoln's Inn fresco. Nearby was a head of a bearded man by William Dyce; I thought it must be of Grandpa Holman but in fact the sitter is unknown.

In the dining-room I felt more confident, but when very young was inclined to burst into unseemly giggles when referring to the large Regency sideboard. Grand had said that Queen Victoria had 'thrown it out of Kensington Palace and that it had been rescued by Augustus Egg', a wonderful friend who presented it to Grandpa in 1856. Augustus Egg was such a ridiculous name: Augustus was a chubby lad and even Humpty Dumpty hated to be called an egg. Obviously Queen Victoria had left the Palace years before. Probably Augustus Egg had picked it up very cheaply in a North Kensington junk shop. The legs of this sideboard were inlaid with bone or ivory and I daresay this intricate work influenced Hunt before he designed the Egyptian-style chairs.

I would explain to my audience that sometimes I had to clear the sideboard of a clutter of silver, Venetian candelabra and Persian brass vases in order to stand on it and clean the pair of very dark 'Miracles of San Rocco' by Tintoretto with slices of raw potato and a piece of old silk.[20]

On the other side of the room I would point to Titian's portrait of his daughter Lavinia (pl.99), saying: 'She's rather plain and Grand says that Titian hair is not red as most people think but just fair, like mine.'[21] Below it was a seventeenth-century Goan cabinet – Indo-Portuguese – inlaid with ebony and ivory. I might point out that the front legs were carved Indian goddesses with mermaids' tails.

I would pass on to the Romney portrait of Jack Russell, the hunting parson, as a child, which hung over the lift which, when one tugged at the rope, trundled up horrid macaroni pudding and curried fish sandwiches from the kitchen. It lacked a provenance and when sold at Christie's in 1959, their expert doubted its attribution and the sitter's identity: it was simply catalogued as 'Romney' and fetched ninety guineas.

Because it was the very first item in the Collection, I had to be sure not to forget to draw attention to one particular chair: 'This chair is very old

English. Grand says her beloved Holman carved this decoration with his own hands.' This information was quite incorrect. This Victorian Gothic chair is very similar to one in Pugin's catalogue and was probably carved to Hunt's design by Messrs J.G. Crace. It is now used by the President of the British Academy. 'Ford Madox Brown was so impressed by Grandpa's chair that he designed that Gothic revival table in the window to go with it. You see how the boss here is carved in the same way and the legs are like a curved X.'[22] I felt it was not worth mentioning the twelve traditional Sussex rush-seated armchairs and primitive-looking dining-table designed by Philip Webb for Morris – in comparison with everything else, they looked so ordinary. I think that Hunt probably bought these when he and his sister Emily moved into Tor Villa on Campden Hill in 1857.

Back in the hall, the sixteenth-century Portuguese altar frontal, which Grand had repaired with her own hair, was always popular. At this point I had to decide whether there were too many in my party to risk the first flight of stairs; a notice was tacked to a tread: 'Edith H.–H. painted this staircase in 1905.' Someone might step forward off the carpet the better to peer at the small portraits of ugly old men. To this day I cannot imagine why Hunt bought these except perhaps as status symbols. One portrait was inscribed: 'Portrait of Archbishop Cranmer of Canterbury from The Lord Somerset's gallery'; another, by Sustermans, was said to be of Ferdinand of Denmark and there was another of little interest. Between these un-attractive works, the wall was hung with various dangerous-looking weapons, scimitars and swords. To avoid any damage to the paintwork, I often waved to the first landing and said: 'Up there you can see a terracotta bust by Rysbrack of Henry Cavendish when he was 19. He was a woman hater and if he so much as spotted a housemaid, she was instantly dismissed. He left a *million* pounds!'. I find it strange that I cannot recall a single landscape in the Collection and was surprised to discover re-cently that Hunt lent a Crome 'Heath Scene' to the 1862 International Exhibition.

When I returned to Bryanston Square, my grandmother Freeman would encourage me to recount my spartan experiences which she found hilarious: 'Boy scouts! At least she could have a parlourmaid.' However, the state of my hands after cleaning so much silver, brass and copper horrified her and resulted in another letter to Grand. Of course she quite understood that as the household was understaffed Diana should do some light dusting. Perhaps the boy scouts could be engaged for the more arduous domestic work?

It was a relief to wear my own clothes and sink back against the silk-

covered down cushions on a comfortable sofa in the drawing-room where guests took all the furniture for granted. The central heating, electric light, delicious food, daily hot baths and beloved servants were a welcome contrast. The window seats and settees at Melbury Road were just plain wooden frames covered with scratchy rugs, prayer-mats and saddle-bags stuffed with lumpy kapok. The so-called chesterfield, on which I slept in Grand's room, was of similar construction.

In the early '20s, to everyone's surprise, my Aunt Gladys married an eye-specialist, Michael Joseph. She was over forty and twice his size. On the few occasions she called, I found her very alarming. In 1925 my Uncle Cyril came to stay at Melbury Road during the holidays. He was a tea-planter in Ceylon, rarely came to England and never married. He was even taller than my father, 6 ft 4 in, and a tremendous help with the spring-cleaning. He could reach many pictures, the glazing of which I must polish, as well as the Donatellos and della Robbias. But even he had to climb a rickety pair of steps to lift down lots of dishes and plates, some from high shelves under the cornice. Wearing a *jellaba* to save his only London suit, he would carry up jugs of hot and cold water from the beetle-infested kitchen, while I squatted on a dust-sheet between two *papier mâché* bowls. I grated soap into one and used the other for rinsing. This was a terrifying responsibility: each specimen would be described by Grand as I dried it with a square of old linen. The majolica included notably a plate of *c.*1535, signed by Baldassare Manara of Faenza, showing Romulus and Remus[23] and a pair of large Deruta plates of *c.*1530 of St Francis and St Dominic. There was also an Hispano-Moresque ware bowl of the second half of the fifteenth century, bearing the arms of the Morelli of Florence,[24] and a Venetian glass *tazza* of *c.*1500 decorated with gilt and enamel. The sixth-century B.C. Attic black-figure Hydria[25] had to be treated with linseed oil as did the huge Italian bridal chest, the top of which was painted with the arms of the Bernardino family of Lucca. There is an almost matching piece in the Victoria and Albert Museum.[26] I was already accustomed to polishing all the furniture with a concoction of turpentine and beeswax. Giant Chang's ebony chairs, which had belonged in turn to Rossetti and Millais, were far too heavy for Grand and me to move and most tedious to clean: the mother-of-pearl inlay must not get too wet. Somehow, Uncle Cyril could manoeuvre them and other monsters off the Caucasian and Persian rugs without tearing the Japanese matting which Hunt had bought on Whistler's advice. In some rooms the floor-boards were painted green or black. Cyril told me that ebony would not float: logs dropped to the bottom of the sea. He beat the dust out of the rugs and prayer-mats, having

hung them on a wire attached to the branch of a tree[27] and a hook in the garden wall. These rugs had been wrapped round Hunt's paintings before they were crated and despatched from Jerusalem.

When Grand instructed me to wash the Indian ivory cabinet (pl. 100)[28] with watered milk to preserve the whiteness, Uncle Cyril scoffed: this was an old wives' tale. She looked annoyed but agreed with him that if kept in the dark, ivory became discoloured. The cabinet doors were always kept open to expose the carved interior to the light. According to the first edition of *Pre-Raphaelitism*, this sixteenth-century ivory cabinet was one of Hunt's earliest purchases. It stood on a simple green-stained base, presumably made in the Morris workshop to Hunt's specification. Ian Bennett[29] credits Hunt with the introduction of the green stain which was used on simple country furniture designed for Morris by Webb in 1856. Although Handley-Read wrote that it was Ford Madox Brown in 1860 who introduced this green stain, I am inclined to disagree.

In the evenings after eating a very nasty supper, such as lentil soup and dumplings, off trays, Grand might entertain us by reading aloud long and often boring extracts from *Pre-Raphaelitism*. Sometimes Cyril would escape into the garden to smoke his pipe or say that he would like to take a walk, presumably to the nearest pub. Even then, I was aware that Papa was privileged to smoke gaspers and drink whisky in the drawing-room. With *Pre-Raphaelitism* on her lap, she told me that, even when a very young man, Hunt had decreed that artists should not only be well paid and well dressed but live in comfort surrounded by beautiful things. I could see that he had succeeded in this but what impressed me most was that he had earned his living since the age of twelve. My favourite story was that, when utterly destitute and penniless as a young man, he had found half-a-crown down the side of an armchair which changed his luck and, added to his talent, proved the foundation of his fortune, which included the Collection.

Even at night, after we had said our prayers, with Grand kneeling at her *prie-dieu*, she would ramble on about her beloved. Once, when drooping with sleep on my uncomfortable 'chesterfield', I asked her how and when Hunt conceived such a passion for collecting. I ached all over from cleaning. She explained that although the Great Exhibition was a phenomenal success, it included contemporary English furniture which was considered by the *cognoscenti* as badly designed and hideous. When sharing rooms with Dante Gabriel Rossetti above Peagrim, the upholsterer's shop,[30] they were both disgusted by the vulgarity of the horrors displayed in the window. She conceded that Rossetti had a magpie's eye for attractive *bric-a-brac* which he picked up for a few pence:

chipped bits of china, fragments of brocade, cracked glass etc.

One night she described Hunt's visit to dine at Carlton House Terrace with the Gladstones. He deeply shocked his hostess by an enthusiastic defence of boxing of which she had expressed disapproval. On leaving the party, escorted to the front door by his host, Hunt had been extremely critical and uncomplimentary about Mr Gladstone's collection of Dresden and Sèvres. I protested that I had been taught that it was 'very rude to pass remarks' about people's things, adding that perhaps the Gladstones would think one of Grandpa's drug jars as ugly as I did, and as for the plate with a picture of a woman with a fat tummy and bloated cherub, I thought it awful but quite funny.[31] At home we had lots of beautiful Dresden and Sèvres. Grand was quite angry and cried: '*This* is your home!'. Silence reigned and at last we fell asleep.

The next day, Uncle Cyril pleaded with her that I was overtired and that we had worked very hard all the week. Grand agreed that we deserved a treat and gave us a florin each. I said I particularly wanted to visit the Burmese Pavilion at the Wembley Exhibition.

I thought it very mean when, during the following year, 1927, she presented Hunt's beautiful drawing of Cyril's mother, Fanny, to the Ashmolean Museum, rather than to him. However, I was quite relieved that she gave Giant Chang's chairs to the Museum at the same time.

In 1928 I was astonished to hear that Aunt Gladys, who seemed so old, had adopted a five-year-old girl, Elisabeth – who now likes to be known in the art world as Elisabeth Burt. She and I did not meet for some years because when Papa arrived in England, I insisted on leaving school aged fourteen and spent over two years abroad in Germany and Italy where I fell in love with Filippo Lippi. I returned to Melbury Road in 1931 to suffer a secretarial course because Papa decreed that I must earn my own living. One day, on arriving home, I was surprised when Gladys opened the door. Grand had been run over in Kensington High Street. She was eighty-three.

My father was on leave somewhere in the Far East. I was too frightened of Aunt Gladys to protest when she destroyed labels attached to various things on which Grand had written 'Given to Hilary' or 'Diana's' and almost everyday removed taxi-loads of objects and papers. Alone in the creepy house, apart from two elderly servants, I was terrified of burglars and dared not comment when Gladys removed the silver and, with Grand's keys, opened the bureau in the bedroom and took away all the jewellery.

Like me she was greatly attracted by the 'Madonna dei Fiori'. Before Papa returned from Burma, with the executors' permission, she borrowed the painting, which he had inherited, and engaged Hunt's last pupil,

Stanley Pollitt, to make a copy. Nine-year-old Elisabeth was fascinated to watch Stanley at work: he was paid £3 a week. Gladys knew a cabinet-maker who did his best to copy the tabernacle frame.

My other grandmother was dead. My Freeman grandfather lived on in the country but was crippled and blind. I could not stay at Melbury Road. He decided that it was unsuitable for me to live with either of my parents, who had parted, and soon arranged for me to spend some months with a family in Paris. When at last I returned from France, my father arrived from Burma and rented a two-roomed flat for me in Kensington.

He told me that Susan Lushington,[32] who lived in a large house at Cobham in Surrey, had kindly agreed to store his possessions. We would go down by train and I might choose a few things I needed. Everything, including the Collection, had been left equally between him and Gladys. I gathered they had had terrible rows over the Will. Poor Cyril only inherited an oil portrait of his mother, a diamond and turquoise necklace and a Japanese vase which were entailed on me. However, the last two items were, in his words, 'put up the spout'. Being broke one day, he sold the Japanese vase to Gladys.[33] For years Elisabeth used it as an umbrella stand and was thrilled when it fetched a small fortune at Sotheby's quite recently.

I wondered if Papa had inherited my favourite painting, the 'Madonna dei Fiori' with its background of red and white roses, or the lovely marble tondo with its beautiful carved and gilded frame, and if so, how would they look in my low-ceilinged flat? Could I ask for the fifteenth-century enamelled Venetian *tazza*? Suddenly, Papa said: 'You won't want any pictures or ornaments cluttering up your digs' (I remembered that on one of his visits to Melbury Road he had said: 'The Eyeties art is A.1. but the Guvnor's is better'). I took the hint and chose two Syrian copper trays to hang on the walls,[34] a couple of rugs, the Hobman chest, the Goan cabinet and two Regency mirrors. Soon after this Papa returned to Burma.

Within a year, to Papa's fury, I eloped while still in my teens. He disapproved of the match and refused to speak to me. On his next visit to England in May 1937, without telling me, he sold a number of items anonymously at Christie's.[35] Inevitably these included not only the 'Madonna dei Fiori' and the Cariani (as 'Bellini') but also the two Tintorettos, the Raphael drawing, the 'Cranmer' portrait (as 'Holbein'), the Sustermans, and yet another 'Holbein' and a 'Bronzino'. The 'Black Madonna' followed in March 1938.[36]

Gladys heard of the sale and bid successfully for several works including one of my favourites, the 'Madonna dei Fiori'.[37] According to Elisabeth,

once Gladys had the original painting she gave the Stanley Pollitt copy to her husband Michael Joseph to hang in his consulting-room in Harley Street.

When Gladys died in 1953, Elisabeth was not only left Gladys's share of the Hunt pictures and a half-share of the Collection but various items which Gladys had bought from my father.

However, much to Michael Joseph's annoyance, he was left no money and Elisabeth was only left a pittance. The far larger residue was put in trust for her three children. In consequence, over the past thirty years, she has had to sell an enormous number of her inherited possessions.

After Michael Joseph died, in 1966 his sisters sold what Elisabeth thought was the Pollitt copy of the Pseudo Pier Francesco Fiorentino as coming from the Hunt Collection.[38] It seems that she did not realise that in fact the Misses Joseph had the original. Elisabeth cannot remember what became of the Pollitt copy. It is a curious story . . .

To sum up, the Collection was a mixed bag with some lucky dips. To begin with half-a-crown and end up with a Cranach, a Van Dyck, a Cariani, a Pseudo Pier Francesco Fiorentino, some extremely attractive sculpture, drawings by Francesco di Giorgio and Sodoma, as well as many museum pieces of furniture and a number of very fine ceramics, is a remarkable achievement.

Bearing in mind the many other categories of the Collection not detailed here, I feel that at least Hunt knew and bought what he liked. Today, many collectors never even see what they bid for and consign their investment to the vault of some bank.

I did not know of the existence of Hunt's and Edith's illustrated catalogue dedicated to my father until it came up for sale anonymously at Christie's in 1975. My son was outbid by an American dealer, Harry H. Lunn of Washington, whom I tracked down to the Westbury Hotel. His secretary told me that it would be impossible for me to borrow it even for the night as Mr Lunn was leaving the next morning. To my astonishment and delight, he telephoned and called on his way out to dinner, bringing the solander box with him. He insisted on giving it to me. This exceptionally generous gesture made this essay possible. Blessed are the disinherited as they shall receive the unexpected.

The Pre-Raphaelites: A Personal View

JEREMY MAAS

It all started (for me, that is) when I read *The Pre-Raphaelite Tragedy* by William Gaunt. This was published in 1942, although it was probably not until about 1945 while still at school that I came across it. I can well imagine that this, my first awareness of the Pre-Raphaelites, was an experience common to many of us at that time and for some years afterwards. When young I was a voracious reader, particularly of romantic literature, with perhaps a rather over-developed visual imagination. For me, therefore, Gaunt's book had all the right ingredients, and what a story! Probably before I had seen a single picture painted by their circle, the Pre-Raphaelites were at once admitted to my private world (followed, of course, by other casts of characters from *The Aesthetic Adventure* and *Victorian Olympus*) and have been there ever since. Even the word itself, *Pre-Raphaelite*, appealed with its harmonious concatenation of vowel sounds, and to fall in with anything ending in 'ite' was to be espousing a worthwhile minority cause.

William Gaunt's book went into several editions, but it is now out of print. In 1943 the title was temporarily changed to *The Pre-Raphaelite Dream*. When, years later, I first met the author, I asked him why this had happened and he told me that at that time there was enough suffering about already and that the original title of the book would not appeal to wounded soldiers recovering in hospital (necessarily an important sector of the reading public then). William Gaunt, as I remember him, was a gentle, good-natured man who looked at first sight more like a retired boxer than an author and art critic. Although I can imagine that there are those (not that I have met any) who might dismiss *The Pre-Raphaelite Tragedy* as a journalistic and popularising treatment of history, I would defend the book to this day as by far the best introduction to the Pre-Raphaelites. In the October 1975 issue of *Connoisseur*, its editor, Bevis Hillier, paid a seventy-fifth birthday tribute to Gaunt, and very rightly claimed that 'no other writer so completely got beneath the skin of the Pre-Raphaelites, understood the springs of their mysticism or their true aspirations or helped us to conceive of their inconceivable way of life as Gaunt did'. Hillier further claimed, with full justification, that 'the quality

of Gaunt's prose is something not to be met with in most modern writing on art'. To support this assertion he quoted from Gaunt's description of how Holman Hunt painted 'The Scapegoat' by the shores of the Dead Sea. In his description of the sea itself, Hillier noticed 'the skill with which, by making us visualise swimming in the sea or testing the echo of the caves ourselves, he transports us straight to the scene:

"The swimmer in this leaden element would roll over and over, feet above head, driven by the current against the dead arms of submerged trees: smarting from its salty bite. The caves of Oosdoom (the ancient Sodom) were hung with stalactites of curious form and if you shouted 'Remember Lot's wife' the rumour of sound hurtled round every silent crag and repeated with morbid accuracy 'Remember Lot's wife'."'

One day soon after I had finished writing *Victorian Painters*, I bumped into Gaunt and told him that I had found his books so useful 'for their . . . for their . . .' – somehow, and regrettably, the right word seemed to hang about just out of reach; I could not grasp it. 'For supplying the mood?' he said, with typical modesty. I hope I replied, 'Oh, more than that', but he was not far wrong.

At Oxford I ostensibly read English Literature and Language and, as a second subject, decided to teach myself the history of art. As there was no formal faculty for this, there were no tutors who most assuredly would have taught me to despise Victorian painting, for which I was left free to indulge an early passion. At Oxford this meant the Pre-Raphaelites. Again and again I would stand in front of their pictures, a willing victim to their spell. Here, in the Ashmolean, were Millais's 'Return of the Dove to the Ark' (I was later to acquire a pen and ink sketch for this, now in the National Gallery of Canada), 'Convent Thoughts', C.A. Collins's masterpiece, and 'Home from Sea', a deeply affecting picture by the sweet and gentle Arthur Hughes. Curiously, although I had to attend many tutorials at Keble, I never did see 'The Light of the World' all the time I was there, although I was aware of its presence in the chapel, as I had known the image since childhood.

Visits at this time to the Tate Gallery broadened my horizon and I began to form the conclusion that the best Pre-Raphaelite pictures were charged with passion and compassion, and that they recorded with complete honesty the anguish and joys of life, the beauty of nature at its most exquisite, the yearnings of young love; that in them the tenderest of emotions are caught and depicted, without the slightest hint of sentimentality. Indeed I came to regard traces of sentimentality as symptoms of a

picture's failure to be truly Pre-Raphaelite, even if in other respects it was the painter's aim that it should be so regarded.

The Winter Exhibition of 1951–2 at the Royal Academy, *The First Hundred Years of the Royal Academy 1769–1868*, added further to my education. I have the illustrated souvenir before me as I write, and see now, with some embarrassment, distressingly naïve pencilled marginal notes made at the age of twenty-three. Here for the first time I saw Millais's 'Isabella'; in the exhibition also were 'Mariana' and 'Ferdinand Lured by Ariel' (I was later kindly lent this marvellous picture by its present owner for an exhibition). Here also was 'The Blind Girl', for some time now one of my favourite Pre-Raphaelite pictures. Close by were hanging the large version of Ford Madox Brown's 'The Pretty Baa-Lambs' and Brett's 'The Stonebreaker'. 'Ghastly', I wrote with a line pointing to each. Well, they are still not amongst my favourites, unlike W.S. Burton's 'A Wounded Cavalier', which, together with Wallis's 'Chatterton' at the Tate Gallery, I believed then, as I do now, to be amongst the great masterpieces of this school. Others I saw for the first time were Hunt's 'The Hireling Shepherd', one of my two most favourite pictures by this artist (the other being 'Valentine Rescuing Sylvia from Proteus'). Hunt, I have always thought, was surely knocked completely off course by going to the Holy Land. In my view the pictures by Hunt which one can enjoy without reservation were for the most part painted before 1854, the year of his first visit; and the most powerful, and most famous, picture he painted there, 'The Scapegoat', was painted mainly in that year and the next. This too was at this same exhibition. When the picture was first shown at the Royal Academy in 1856, the public could make neither head nor tail of it, and it was considered by everyone, including Ruskin, to be a failure. So my pencilled comment, 'absolutely astonishing', on first seeing the picture was, perhaps, not inappropriate.

I met my wife while at Oxford. Antonia was at the Ruskin School of Art, but we lost touch for a time and went our separate ways and did not marry until four years later. I mention this merely in order to introduce a subject I find almost inexplicable to this day. In the meantime I had made friends with Helen Dennis and we were companions, off and on, for nearly a year. Unbeknownst to me Antonia had also met Helen's brother, Edward. Neither brother nor sister had thought it worth while mentioning to either of us that they were the great-grandchildren of Ford Madox Brown, and that their grandmother, William Michael Rossetti's daughter, lived at their home with their parents in Woodstock. It was not until several years later that I learned of this relationship and met Mrs Angeli.

My interest in the Pre-Raphaelites began to take a more positive shape when, in December 1960, I opened a commercial picture gallery. Before taking possession of the premises I set about collecting pictures for an exhibition of Pre-Raphaelite works. This was not nearly so easy as one would imagine. First, there had been little recent literature on the subject (it was not until later that I studied the subject systematically) and the only books I had at the time were *Pre-Raphaelite Painters* by Robin Ironside, with a descriptive catalogue by John Gere (1948), an excellent work, with an outstanding introduction by Ironside, and Percy Bate's *The English Pre-Raphaelite Painters* (1899). Other books were rapidly acquired over the months.

My first ports of call were two old-established London galleries, the Leicester, still in Leicester Square, still with its turn-stile and still in the charge of Oliver Brown, who could remember Whistler, Holman Hunt and others. The other was the Walker Gallery of Bond Street, then managed by Jack Naimaster, who later became chairman of the Fine Art Society. Both these galleries had vestiges of old, and what they may have regarded as 'tired', stock, which to me were like pure gold. Only too gratefully they pressed me to take pictures by Simeon Solomon, Burne-Jones, Hunt and others. I shall never forget the almost indecent look of relief which Naimaster betrayed after he had successfully begged me to remove four large and magnificent crayon portraits of the Flower family by Frederick Sandys (while attempting later to hang one of these pictures for the exhibition I slipped a disc, and for its entire duration leant painfully on a stick). One day at Sotheby's I spotted a parcel of beautiful drawings by Lizzie Siddal, with an estimate, I believe, of about £5. To my (and his) astonishment I was outbid for them by an elderly and distinguished-looking gentleman at about £120, thus creating a world record for her work. With sinking heart I asked a porter to slip my card into the parcel. On it I had asked the purchaser to kindly get in touch with me. He, Sir Geoffrey Mander, asked his wife, Lady Mander (Rosalie Glynn Grylls), to seek out the unexpected underbidder to enquire his interest. Most generously they offered to let me buy six of the drawings. One of them, 'The Lady of Shalott', is in the Tate Gallery exhibition of 1984 (No.198). Thus it was that I met the first of the redoubtable band of ladies who were to contribute so much to Pre-Raphaelite studies in the 1960s and '70s. Ernestine Carter, in an article in the *Sunday Times* of 5 October 1969, called this group the Pre-Raphaeladies or, alternatively, the Pre-Raphaelite Sisterhood. Four of them, Lady Mander, Mary Bennett, Diana Holman-Hunt and Mary Lutyens have contributed to this book, and I am still privileged to number

all of them among my friends. To me it seems that the spirit of the original Brotherhood and its fragmentation lingers on in these ladies, who are far too individual in temperament and strong in character to form a group.

It was about this time that I met Diana Holman-Hunt, grand-daughter of the artist; her delightful book *My Grand-mothers and I* had been published in 1960. Always generous, she kindly lent me two oils and four drawings for the exhibition. Friendship with Virginia Surtees dates from this time. A great grand-daughter of Rossetti's model, Ruth Herbert, she was about to embark on the compilation of her scholarly *catalogue raisonné* of Rossetti's paintings and drawings, published in 1971. This was followed by an introduction to Mary Lutyens, daughter of the celebrated architect, then already researching for *Effie in Venice* (1965) and its sequel, the absorbing *Millais and the Ruskins* (1967). (The trilogy was completed in 1972 with the publication of *The Ruskins and the Grays*).

Meetings with descendants of the Pre-Raphaelites quickly followed: few seemed to want to part with anything; most wanted to add to their collections, and many generously offered to lend. The doyenne of descendants was undoubtedly Helen Rossetti Angeli, and the few of us who were interested in those days would make our pilgrimage to the little house in Woodstock, Oxfordshire, where Mrs Angeli lived with her daughter Imogen Dennis – Edward and Helen having gone their separate ways. Mrs Angeli, a frail figure, lying on a sofa which Shelley had bought in Pisa in 1821, the year before he drowned, would recall (in a voice which sounded more like a boy's treble than a soprano) her family, both Madox Brown and Rossetti, as though she had seen them only minutes previously. On one such visit a sprightly hedgehog scuttled in from the tiny garden for a saucer of milk, calling to mind stories of her uncle Gabriel's menagerie in his Chelsea garden. Only a few doors away lived Mrs Evans, a great collector of English pictures and then in her mid-nineties. She spoke with disdain of Ford Madox Brown's 'The Pretty Baa-Lambs', which she had been offered for £5, and had turned down. Another visit on the same day, in Oxford, was to Mrs Chapman, G.F. Watts's ward, who was equally aged. The grand total of years between these three old ladies came to nearly three hundred.

The pictures for the exhibition, which was due to open on 13 November 1961, were nearly all assembled. They came from every imaginable source: one, a pencil drawing by Millais, was rescued from an Oxford junk shop; the proprietor had scribbled 'Wet Paint' on the back and pinned it to his shop door while re-decorating. I suppose the average price for the drawings and watercolours in the exhibition was about £20 to £30, while

the oils were from about £85 to £450, the average price being £120. In today's terms it hardly bears thinking of!

We scarcely need reminding of how low an ebb the reputation of Victorian painting had reached in 1961. The visual arts of that age enjoyed the status equivalent to that of a non-person; they were hardly ever mentioned in polite society, let alone in academic circles; and if they ever were it was usually to the accompaniment of sniggers. True, they had their supporters: among such were Sir David Scott, Sir Colin Anderson, Charles and Lavinia Handley-Read, Evelyn Waugh; and John Bryson, who had formed a fine collection of Pre-Raphaelite drawings in the 1930s. Huge parcels of Burne-Jones drawings were often sold at Christie's for a few pounds, while pictures by Millais, Hunt and Rossetti were all too frequently bought in or sold for derisory sums. I remember reading somewhere a scholarly article by Lavinia Handley-Read in which she yearned for the day when the dismal old fuddy-duddies who derided Victorian art would be wheeled away in their bath-chairs so that we could all get down to the serious business of assessing the period without constraint. Contempt for Victorian painting had created a vicious circle: no-one wanted to sell pictures of that period if they were likely to fetch so little; the museums and galleries kept them locked away in basements; dealers, with the nearly solitary exception of Charlotte Frank, dared not offer Victorian pictures, in the certainty of courting ignominious disaster. So the period was like a page torn from a history book and lost to view.

Pre-Raphaelitism was the only movement which was partly to escape this suffocating blanket of censure. There had been several Pre-Raphaelite exhibitions, with varying degrees of emphasis, at public galleries since the war, culminating in the Arts Council exhibition of drawings and watercolours in 1953, with a catalogue and introduction by John Commander, who afterwards removed his interest to other fields. But the approval which the movement elicited was largely lip-service, if only because of the prestige of certain Pre-Raphaelite masterpieces, which, if perhaps thought to be misguided in their conception, were accorded the status of national treasures. Pre-Raphaelitism only narrowly missed disappearing down the vortex of critical obloquy. And as a subject for the discipline of academic research it was most decidedly beyond the pale. One grievous result of this was that there was no-one to turn to for advice: no-one seemed to know very much about the Pre-Raphaelites, let alone care; in those early days, mistakes were made, as much by me as by others: Rossettis, depressingly, became Henry Treffry Dunns or Howells, Burne-Joneses became Strudwicks, Ruskin's Turneresque drawings became

William Wards, as much this way round as the other; however, it will now doubtless be a relief to be told that these errors, born of ignorance and inexperience, were not as common as they might have been.

My rather recklessly conceived exhibition opened on Monday 13 November 1961, while at Agnew's they were bravely showing a loan exhibition of Victorian pictures with a catalogue introduction by Graham Reynolds, an early enthusiast. Within two days nearly all the 139 exhibits had been sold, to the accompaniment of nearly twenty long reviews in the press; some were guarded but most were enthusiastic. John Russell of the *Sunday Times* was unable to review the exhibition, but, by a piece of great good fortune, his place was taken by Robin Ironside, whose review on 12 November was irradiated by his formidable intelligence and his sympathy with the school. William Gaunt, too, blew a fanfare of trumpets in the *Sunday Telegraph* on 26 November. 'The Pre-Raphaelites', he wrote, 'remain, the more we see of them, at the highest level; the creative force and earnest purpose of the movement and those it inspired are beyond doubt; they continue serenely to inhabit a world of their own'.

To digress, momentarily: the exhibition had a decided influence on my life. One of our earliest visitors was a strikingly beautiful woman, Wenda Parkinson, who, on seeing a drawing by Frederick Sandys entitled 'Love in a Mist', asked to use our telephone. Within half-an-hour, a man, untypically tousled, having risen from his bed with 'flu, stood in front of the drawing and announced, 'Good heavens! that's my mother'. Anthony Crane was Frederick Sandys's grandson and was also descended from Walter Crane. Mrs Parkinson's husband, Norman Parkinson, the photographer, was the next to be summoned. After making further acquaintance with all three, who then lived in Montpelier Row, Twickenham, we followed them to that lovely terraced street and lived there for eighteen years.

On that evening of the 13 November a party was held at the exhibition and I remember well the sense of wonder as descendants of Millais, Rossetti, Burne-Jones and Ford Madox Brown began to arrive. Had I previously read this passage in William Michael Rossetti's *Reminiscences* I might well have had second thoughts as to the wisdom of this re-union. 'It is a sad and indeed a humiliating reflection', he wrote, 'that, after the early days of *camaraderie* and of genuine brotherliness had run their course . . . keen antipathies severed the quondam P.R.B.'s . . . Woolner became hostile to Hunt, Dante Rossetti, and Millais. Hunt became hostile to Woolner and Stephens, and in a minor degree to Dante Rossetti. Stephens became hostile to Hunt. Dante Rossetti became hostile to Woolner, and in a minor

degree to Hunt and Millais. Millais, being an enormously successful man while others were only commonly successful, did not perhaps become strictly hostile to any one; he kept aloof however from Dante Rossetti, and I infer from Woolner.' It was not quite like inviting to a party all the chiefs of staff of the opposing armies in the Second World War, but perhaps I should have known better. In the event, I recall that there was the occasional barely perceptible *frisson* in an atmosphere of otherwise general accord, and a noticeable degree of curiosity about each other. Nor could I have guessed then that I was to employ, years later, a direct descendant of Burne-Jones as a secretary. I see that I was quoted in the *Evening Standard* of 12 December as saying of the party, 'My wife had the experience of introducing a Rossetti to a Millais'. The first baronet's aloofness had been strangely enduring.

It was not until four years later, with the publication of W.E. Fredeman's indispensible *Pre-Raphaelitism: A Bibliocritical Study*, that I discovered that this exhibition was apparently the first commercial one of its kind in history, unless one counts the semi-public exhibition held at No.4 Russell Place, London, by a group of Pre-Raphaelite artists in 1857, which was probably only semi-commercial. It seems scarcely believable, but it was followed by the second, third and fourth commercial Pre-Raphaelite exhibitions – in November 1962, June–July 1964 and May 1965. There were several others in succeeding years.

On one thing there seems to be a general consensus of agreement: that it was in those early years of the 1960s that the Pre-Raphaelites became ripe for a general revival, not merely as a preference of the general public, but as a subject long overdue for and readily susceptible to academic treatment. This new surge of interest occurred some eight or nine years before the revival of interest in Victorian paintings generally. In the same way that the 1860s were an exciting period in social and art history, so also were the 1960s. There is no question that the Hippy movement and its repercussive influence in England owed much of its imagery, its manner, dress and personal appearance to the Pre-Raphaelite ideal. (This was noticed by Ernestine Carter in her article of 1969). It was observed by all of us who were involved with these exhibitions that visitors included increasing numbers of the younger generation, who had begun to resemble the figures in the pictures they had come to see.

Of all the Pre-Raphaelite exhibitions put on by us in my gallery in subsequent years, that which was held in November 1970 was perhaps the most interesting and memorable. The exhibition was particularly strong in pictures of beautiful young women, whose predominant feature

was the suggestion of romantic or sexual yearning, from 'King Pelles's Daughter' and 'Love's Shadow' by Frederick Sandys to Smetham's 'Mandoline Player' and Rossetti's profile portrait head of Annie Miller. The exhibition was so popular that on several occasions we, the entire staff of three, were obliged to decant ourselves into the street to make room for the spectators. Robert Melville, writing in the *New Statesman* on 20 November, summed up the mood:

> The young have discovered premonitions of the psychedelic ex-
> perience in Pre-Raphaelite colour, and associate the introverted
> beauty of the feminine images with pure sexuality. Frederick Sandys's
> profile study of a girl sucking pensively at a sprig of blossom ['Love's
> Shadow'] . . . deserves to be seen as a first-rate P.R. job for the Flower
> People.

By the time of this exhibition the revival of interest in Victorian painting generally was well under way. The Pre-Raphaelites were borne up again on the ground swell of this interest and, in the shifts and eddies of fashion, were lent further momentum by the equally strong revival of interest in the Symbolist Movement in the late '60s and early '70s, the first London exhibition of which had been held a few weeks previously in June and July, at the Piccadilly Gallery. A proliferation of similar exhibitions which followed opened the eyes of the public to the Pre-Raphaelite movement which was recognised, correctly, as one of the strongest influences on the Symbolists; now the recognition of the powerful and pervasive influence of Pre-Raphaelitism in the context of a European movement gave rise to international interest in Pre-Raphaelitism, particularly in France (here greatly assisted by the exhibition *La Peinture Romantique Anglaise et les Préraphaélites* mounted by the British Council in Paris in 1972), in Germany (in 1973–4 there was a superb Pre-Raphaelite exhibition in Baden-Baden) and in Japan, due largely to the energy and enterprise of one man, the entrepreneur M. Koike.

For Pre-Raphaelitism the 1970s was a period of consolidation, one might say. Pre-Raphaelitism now ranks high in international esteem. A wealth of documentation ensures its continued attraction to academic appraisal: scholars of the older generation, once having sipped from the well of Pre-Raphaelitism, rarely leave the charmed waters for long, while the interest of the younger generations is truly established. The list of contributors to this publication is eloquent testimony of the vigour and variety of this interest.

Abbreviations

Allingham 1911 Helen Allingham and E.B. Williams (eds.), *Letters to William Allingham*, 1911

Arts Council 1979 *The Drawings of John Everett Millais*, Arts Council exhibition, 1979. Catalogue by Malcolm Warner

Bennett 1967 Mary Bennett, 'Footnotes to the Millais Exhibition', *Liverpool Bulletin*, XII, 1967, pp.32–59

BL Bodleian Library, Oxford

G. Burne-Jones G[eorgiana] B[urne]-J[ones], *Memorials of Edward Burne-Jones*, 2 vols., 1904

Doughty & Wahl Oswald Doughty and J.R. Wahl (eds.), *Letters of Dante Gabriel Rossetti*, 4 vols., Oxford, 1965–7

FMBP Ford Madox Brown family papers, private collection, Eire

Fredeman William E. Fredeman (ed.), *The P.R.B. Journal, William Michael Rossetti's Diary of the Pre-Raphaelite Brotherhood 1849–1853*, Oxford, 1975

Grieve 1973 A.I. Grieve, *The Art of Dante Gabriel Rossetti: The Pre-Raphaelite Period 1848–50*, Hingham, Norfolk, 1973

Grieve 1976 A.I. Grieve, *The Art of Dante Gabriel Rossetti: 1. Found 2. The Pre-Raphaelite Modern-Life Subject*, Norwich, 1976

Hayward Gallery 1975–6 *Burne-Jones*, exhibition, Hayward Gallery, 1975–6, Southampton Art Gallery and City Museum and Art Gallery, Birmingham, 1976. Catalogue by John Christian

HL Henry E. Huntington Library, San Marino, California

Hueffer Ford Madox Hueffer, *Ford Madox Brown: A Record of His Life and Work*, 1896

Hunt 1886 William Holman Hunt, 'The Pre-Raphaelite Brotherhood: A Fight for Art', *Contemporary Review*, XLIX, 1886, pp.471–88, 737–50, 820–33

Hunt 1887 William Holman Hunt, 'Painting "The Scapegoat"', *Contemporary Review*, LII, 1887, pp.21–38, 206–20

Hunt 1905 William Holman Hunt, *Pre-Raphaelitism and the Pre-Raphaelite Brotherhood*, 2 vols., 1905

JRL John Rylands University Library of Manchester

Lago	Mary Lago (ed.), *Burne-Jones Talking. His conversations 1895–1898 preserved by his studio assistant Thomas Rooke*, 1982
Liverpool 1969	*William Holman Hunt*, exhibition, Walker Art Gallery, Liverpool and Victoria and Albert Museum, 1969. Catalogue by Mary Bennett
Lutyens 1967	Mary Lutyens, *Millais and the Ruskins*, 1967
Maas	Jeremy Maas, *Gambart, Prince of the Victorian Art World*, 1975
J.G. Millais	John Guille Millais, *The Life and Letters of Sir John Everett Millais*, 2 vols., 1899
PML	Pierpont Morgan Library, New York
PUL	Princeton University Library
R.A. 1967	*Millais*, exhibition, Royal Academy and Walker Art Gallery, Liverpool, 1967. Catalogue by Mary Bennett
W.M. Rossetti 1895	William Michael Rossetti (ed.), *Dante Gabriel Rossetti: His Family Letters, with a Memoir*, 2 vols., 1895
W.M. Rossetti 1911	William Michael Rossetti (ed.), *The Works of Dante Gabriel Rossetti*, 1911
Ruskin	E.T. Cook and A.D.O. Wedderburn (eds.), *The Works of John Ruskin: Library Edition*, 39 vols., 1902–12
Scott	William Bell Scott (ed. W. Minto), *Autobiographical Notes of the Life of William Bell Scott*, 2 vols., 1892
Smith	Roger Smith, 'Bonnard's *Costume Historique* – a Pre-Raphaelite Source Book', *Journal of the Costume Society*, VII, 1973
Surtees *or* Surtees 1971	Virginia Surtees, *The Paintings and Drawings of Dante Gabriel Rossetti (1828–1882). A Catalogue Raisonné*, 2 vols., Oxford, 1971. Usually abbreviated here to 'Surtees' followed by her catalogue number
Surtees 1980	Virginia Surtees (ed.), *The Diaries of George Price Boyce*, Norwich, 1980
Surtees 1981	Virginia Surtees (ed.), *The Diary of Ford Madox Brown*, New Haven and London, 1981
TG 1984	*The Pre-Raphaelites*, Tate Gallery exhibition, 1984
UBC/LP	Leathart Papers, Special Collections, University of British Columbia Library
Vaughan	William Vaughan, *German Romanticism and English Art*, New Haven and London, 1979
Woolner	Amy Woolner, *Thomas Woolner, R.A., Sculptor and Poet: His Life in Letters*, 1917

Notes

Style and Content in Pre-Raphaelite Drawings 1848–50
ALASTAIR GRIEVE

Acknowledgements. In preparing this essay I have made frequent use of Mary Bennett's catalogues of the *Millais* (1967) and *Holman Hunt* (1969) exhibitions, Virginia Surtees's *The Paintings and Drawings of Dante Gabriel Rossetti . . . A Catalogue Raisonné* (1971), and Malcolm Warner's catalogue of the exhibition *The Drawings of John Everett Millais* (1979). I have also benefited from information on Hunt's drawings for the Cyclographic Society kindly provided by Judith Bronkhurst and from useful discussion on Millais's drawings with Malcolm Warner. Helpful suggestions were made on the draft by Leslie Parris.

1 W.M. Rossetti 1895, I, p.121.

2 From Rossetti's description on the Cyclographic Society criticism sheet; see Fredeman, facing p.110.

3 See Vaughan, chapter IV.

4 Fredeman, facing p.110

5 See Liverpool 1969, Nos 95–7. Judith Bronkhurst has pointed out that 'The Pilgrim's Return' and 'Hyperion' were incorrectly inscribed '1847' at a much later date.

6 R.A. 1967, Nos 10–15, 210–26.

7 ibid., Nos 210–13.

8 W.M. Rossetti 1895, I, p.141. For Hunt's confused account, see Hunt 1886, p.482.

9 E. Wood, *Dante Gabriel Rossetti . . .*, 1894, p.60. For Rossetti's early admiration for Keats see W.M. Rossetti 1895, I, p.100, W.M. Rossetti 1911, p.260 and S.N. Ray, 'The First Literary Friendship of D.G. Rossetti', *Notes and Queries*, n.s., CCII, 1957, pp.453–4.

10 Birmingham City Art Gallery; R.A. 1967, No.228; repr. Bennett 1967, p.48, fig.28.

11 M. Retzsch, *Romeo and Juliet*, 1836, v, iii, pl.13; repr. Bennett 1967, p.48, fig.29.

12 See Grieve 1973, pp.7, 15, 16 and Smith, pp.28–36.

13 M. Warner (see Arts Council 1979, No.13), following Lindsay Errington, believes the subject to be 'Queen Matilda of Scotland', taken from Agnes Strickland's *Lives of the Queens of England.*

14 A.L. Phillips (translator), *The Chronicle of the Life of St. Elizabeth of Hungary, Duchess of Thuringia . . . written in French by the Count de Montalembert . . . And now translated into English for the greater glory of God . . .*, 1839.

15 C. Kingsley, *The Saint's Tragedy; or, The True Story of Elizabeth of Hungary, Landgravine of Thuringia, Saint of the Romish Calendar*, 1848, p.xxiii.

16 C. Kingsley, *Yeast*, 1908, p.75. This novel first appeared in *Fraser's Magazine*, July–December 1848. For the Pre-Raphaelites' knowledge of it and *The Saint's Tragedy*, see Fredeman, p.50. My attention was drawn to this passage in *Yeast* by Lindsay Errington's Ph.D thesis, 'Social and Religious Themes in English Art 1840–60', London University, 1973, p.23.

17 Fredeman, pp.3, 5.

18 ibid., p.21.

19 ibid., pp.30, 38.

20 See G.B. Tennyson, *Victorian Devotional*

Poetry, The Tractarian Mode, 1981, p.158.

[21] ibid., p.52.

[22] Fredeman, p.60.

[23] ibid., p.71. The dates of Collinson's vacillations are difficult to pin down: see Grieve 1973, pp.26, 27.

[24] Collinson's letter of resignation implies that he had always thought of himself as a 'Catholic', even while a member of the Brotherhood.

[25] Fredeman, p.30.

[26] My attention was drawn to this source for Collinson's drawing by Lindsay Errington.

[27] See Grieve 1973, p.27 and Vaughan, p.42.

[28] I am grateful to John House for this identification.

[29] Fredeman, p.29.

[30] ibid., p.72.

[31] See, for example, R.A. 1967, Nos 244, 246, 264.

[32] See Millais's description of the subject to Mrs Combe: J.G. Millais, I, pp.103–5.

[33] Fredeman, pp.5, 71.

[34] See under Liverpool 1969, No.112.

[35] ibid., No.116, repr. pl.27.

Pre-Raphaelitism and Phrenology

STEPHANIE GRILLI

Acknowledgements. This is an expanded version of a paper delivered at the Frick Fine Arts Museum in April 1980. I would like to thank my former advisor George L. Hersey for the support and the assistance for both my paper and my dissertation from which it was derived. I am grateful to Gwen Raaberg and Gail Davitt for their reading of this essay.

[1] Hunt 1905, I, pp.139–42; William Gaunt, *The Pre-Raphaelite Dream*, New York, 1972, pp.39–40.

[2] No.2, February 1850, p.61.

[3] For the religious aspect of Pre-Raphaelitism, see: Alastair Grieve, 'The Pre-Raphaelite Brotherhood and the Anglican High Church', *Burlington Magazine*, CXI, 1969, pp.294–5; George P. Landow, *William Holman Hunt and Typological Symbolism*, New Haven and London, 1979.

[4] Charles Coulston Gillispie, *Genesis and Geology*, Cambridge, 1951.

[5] Key figures in these developments were such men as W.B. Carpenter and T. Laycock. For a consideration of these issues, see: R.M. Young, *Mind, Brain, and Adaptation in the Nineteenth Century*, Oxford, 1970; R. Smith, *Physiological Psychology and the Philosophy of Nature in Mid-Nineteenth Century Britain*, Doctoral dissertation, Cambridge University, 1970.

[6] An excellent characterisation of the age is Walter E. Houghton's *The Victorian Frame of Mind*, New Haven and London, 1957.

[7] Fredeman, p.27.

[8] Hunt 1905, I, p.51.

[9] *Collected Works*, London, 1890, I, p.405 (originally written in 1850).

[10] L.S. Hearnshaw, *A Short History of British Psychology 1840–1940*, New York, 1964; Angus McLaren, 'Phrenology: Medium and Message', *Journal of Modern History*, XLVI, 1974, pp.86–97; Terry M. Parssinen, 'Popular Science and Society: The Phrenology Movement in Early Victorian Britain', *Journal of Social History*, VIII, 1974, pp.1–20.

[11] Graeme Tytler, *Physiognomy in the European Novel. Faces and Fortunes*, Princeton, 1982, pp.90–3. There is a definite overlap of physiognomy and phrenology, especially in the absorption of Aristotlean notions concerning the relationship of animal and human qualities. The important distinction to keep in mind is physiognomy's sense that the face is 'moulded' in contrast with phrenology's insinuation that the face is an accumulation of aggregrates; in addition, phrenology would allow more variables and would be more extensive in consideration of the cranium, making the head larger than it had been in proportion to the body.

[12] Originally published in 1828; modern facsimile of the 1834 edition with an introduction by Eric T. Carlson MD, New York, 1974, p.2.

[13] Hewett Watson speaking at the Phrenological Association meeting, quoted in the *Newcastle Courant*, 7 September 1838, p.3; cited in Roger James Cooter, *The Cultural Meaning of Popular Science: Phrenology and the Organization of Consent in Nineteenth Century Britain*, Doctoral dissertation, Cambridge University, 1978, p.149. Among the books and pamphlets available during this period are the following: D.G. Goyder, ed., *The Phrenological Almanac; or, Journal of Mental and Moral Science*, Glasgow, 1842; J. Stanley Grimes, *Phreno-Geology: The Progressive Creation of Man*, 1851; *The Handbook of Phrenology*, 1844; J.C. Lyons, *Science of Phrenology*, 1846; Eneas MacKenzie, *Phrenology Explained*, c.1850; *Manual of Phrenology; or an Accompaniment to J. de Ville's Phrenological Bust*, 1841; *McPhun's Catechism of Phrenology*, Glasgow, 1840; Sidney Smith, *The Principles of Phrenology*, Edinburgh, 1843; *Thoughts on Phrenology, or Phrenology Tested by Reason and Revelation*, 1841; John Wilson, *Phrenology Consistent with Reason and Revelation*, Dublin, 1836.

[14] In addition to Cooter's dissertation already cited, see his 'Phrenology and the Provocation of Progress', *History of Science*, XIV, 1976, pp.211–34; also Steven Shapin, 'Homo Phrenologicus: Anthropological Perspectives on an Historical Problem' in Barry Barnes and Steven Shapin (eds.), *Natural Order. Historical Studies of Scientific Culture*, Beverly Hills and London, 1979, pp.73–96.

[15] David de Giustino, *Conquest of the Mind, Phrenology and Victorian Social Thought*, 1975.

[16] David de Giustino, 'Reforming the Commonwealth of Thieves', *Victorian Studies*, XV, 1971–72, pp.439–61.

[17] Cooter, 1978, pp.20–32.

[18] 1855. In 1848 an anonymous writer published *Phrenology: in Relation to the Novel, the Criticism, and the Drama*.

[19] 1 January 1848, p.21.

[20] H.C. Morgan, *History of the Royal Academy Schools*, Doctoral dissertation, York University, 1968. For Hunt's evaluation of this institution, see *Report of the Commissioners appointed to inquire into the Present Position of the Royal Academy in relation to the Fine Arts*, 1863.

[21] Cited in Morgan, p.48.

[22] Cited in Morgan, p.48.

23 Interestingly, C.R. Leslie advised R.A.
students to practice drawing with
portraiture in his series of lectures on
painting: 'Though drawing from the
Antique is first taught by itself in the
Academy, yet as the students have
many opportunities, during the
vacations and while our Exhibition is
open of painting from Nature, I would
strongly recommend to them so to
employ these intervals, – and
particularly in the practice of
portraiture . . .'; *Athenaeum*, No.1060,
19 February 1848, p.191.

24 Fredeman, pp.21–4; see also J.G.
Millais's later, more jaded account in
*The Life and Letters of Sir John Everett
Millais*, 1899.

25 See his *Reply to Sir B. Brodie's Attack on
Phrenology in his 'Psychological
Inquiries', 1857* and *A Handbook of
Phrenology, 1870*; also of interest:
*Discussion on Phrenology; between
Charles Donovan, Esq, and the Rev.
Brewin Grant, BA, December 10, 12,
17, 19, 1849, 1850.*

26 Fredeman, p.4.

27 Hunt 1905, I, p.17.

28 *Discourses on Art*, ed. Robert Wark, San
Marino, California, 1959 (based on the
1797 edition of Reynolds's Works),
p.44.

29 The most famous diatribe is Charles
Dickens's 'Old Lamps for New Ones',
Household Words, No.12, 15 June
1850, p.265; but other critics followed
this line: *The Times*, No.20, 484, 9 May
1850, p.5; 'Pathological Exhibition at
the Royal Academy (Noticed by our
Surgical Advisor)', *Punch*, XVIII,
1850, p.198; *Illustrated London News*,
XVI, 11 May 1850, p.336; *Athenaeum*,
1 June 1850, p.590; *Blackwood's*, July
1850, p.82.

30 Stephanie Grilli, *Pre-Raphaelite
Portraiture, 1848–1854*, Doctoral
dissertation, Yale University, 1980.

31 Hunt 1905, I, p.157.

32 *Pre-Raphaelitism*, 1851.

33 Glasgow, 1845, p.153.

34 Stephanie Grilli, 'Awakening
Consciousness: Pre-Raphaelitism and
Mesmerism', paper presented at the
College Art Association convention,
February 1981.

35 William Vaughan, *German
Romanticism and English Art*, New
Haven and London, 1979.

36 *Athenaeum*, No.1179, 1 June 1850,
p.590.

37 'Pre-Raphaelitism in Art and
Literature', *British Quarterly Review*,
XVI, 1852, pp.197–220.

38 Originally from Lord Byron, quoted in
Hunter, p.97.

39 *Phrenology in Connection with the Study
of Physiognomy*, Boston, 1833,
pp.104–7.

40 Frank Howard, *The Science of Drawing:
Part III – The Human Figure*, 1840,
p.42.

41 Hunt 1905, I, p.314.

42 For a consideration of landscape, see
Allen Staley, *The Pre-Raphaelite
Landscape*, Oxford, 1973.

43 See Liverpool 1969, under No.19.

44 Spurzheim, pp.52–5.

45 *Manual of Phrenology: or an
Accompaniment to J.de Ville's
Phrenological Bust*, 1841, p.14.

46 As I was finishing this essay, I
discovered a book which comes to
similar conclusions but from the
perspective of the psychologist. In *The
Changing Nature of Man. Introduction to
a Historical Psychology*, J.H. Van der
Berg, MD, gives the woman in 'The
Awakening Conscience' prominence
as presenting the 'face' of modern
consciousness. Although he wrongly
interprets the scene as before the 'fall',
Van der Berg's analysis is otherwise
insightful.

47 *The Spectator*, 31 May 1851, p.524.

James Collinson

RONALD PARKINSON

Acknowledgements. I would like to thank those who have helped me in the preparation of this essay: Guy Denison, Brian Gray, Carolyn Harden, Lionel Lambourne, Lady Mander, Elizabeth Murdoch, Richard Riddell, and Stacey Rosenberg.

[1] Violet Hunt, *The Wife of Rossetti*, 1932, p.13, n.1.

[2] Thomas Bodkin, 'James Collinson', *Apollo*, XXXI, 1940, pp.128–33.

[3] S[ydney] R[ace], 'James Collinson of Mansfield', *Nottingham Guardian*, 11 November 1952.

[4] Hunt 1905, I, p.161; Oswald Doughty, *A Victorian Romantic: Dante Gabriel Rossetti*, 1949, p.72.

[5] Hunt 1905, I, p.161. The painting was sold at Christie's, 26 October 1979 (256).

[6] *Athenaeum*, No.1020, 15 May 1847, p.527.

[7] *Literary Gazette*, No.1583, 22 May 1847, p.387.

[8] ibid.

[9] *Athenaeum*, No.2789, 9 April 1881, p.499.

[10] Hunt 1905, I, p.84.

[11] L.M. Packer, *Christina Rossetti*, 1963, p.27; but also see W.M. Rossetti, *Some Reminiscences*, 1906, I, p.72.

[12] Hunt 1905, I, p.128.

[13] Hunt 1905, I, p.129.

[14] *Art Union*, X, 1848, p.167.

[15] Packer, op. cit., p.35.

[16] This portrait is referred to by W.M. Rossetti in a letter to his aunt in May (?) 1849 about the prices of paintings: 'For a small portrait in oil, like the one Collinson did of Christina, £8.8s.'. He notes that the portrait was then in his possession (W.M. Rossetti 1895, II, pp.46–7).

[17] Hunt 1905, I, p.161.

[18] W.M. Rossetti 1895, I, p.131.

[19] Hunt 1905, I, p.161.

[20] There does not seem to be any contemporary evidence that Collinson was called 'the dormouse', and some writers have supposed that Carroll's dormouse was based on Rossetti's pet wombat.

[21] W.M. Rossetti 1895, II, p.41. The painting is not mentioned in the P.R.B. Journal. A later visit to the Isle of Wight is recorded in a letter from W.T. Deverell to F.G. Stephens of 2 September 1856: 'I met little Collinson at Ventnor hard at work on backgrounds – the stock of canvasses he took with him was positively awful!' (BL).

[22] Fredeman, p.8.

[23] ibid., p.13.

[24] ibid., p.37.

[25] Sold Sotheby's, 15 March 1967 (92); repr. Bodkin, op. cit., p.132, fig.v.

[26] Fredeman, p.59.

[27] ibid., p.70.

[28] ibid., p.60. Charles Collins exhibited a similar subject, 'Convent Thoughts', at the R.A. in 1851 (TG 1984, No.33).

[29] 'Controversy, "For modes of faith let graceless zealots fight; His can't be wrong whose life is in the right"', was exhibited at the Liverpool Academy in 1858 (No.407).

[30] Fredeman, p.65.

[31] ibid., p.69.

[32] ibid., p.71: 'Dear Gabriel, I feel that, as a sincere Catholic, I can no longer allow myself to be called a P.R.B. in the brotherhood sense of the term, or to be connected in any way with the magazine. Perhaps this determination to withdraw myself from the Brotherhood is altogether a matter of feeling. I am uneasy about it. I love and reverence God's faith, and I love His holy Saints; and I cannot bear any

longer the self-accusation that, to gratify a little vanity, I am helping to dishonor them, and lower their merits, if not absolutely to bring their sanctity into ridicule. – I cannot blame any one but myself. Whatever may be my thoughts with regard to their works, I am sure that all the P.R.B.s have both written and painted conscientiously; – it was for me to have judged beforehand whether I could conscientiously, as a Catholic, assist in spreading the artistic opinions of those who are not. I reverence – indeed almost idolize – what I have seen of the works of the Pre-Raffaelle painters; [and this] chiefly because [they fill] my heart and mind with that divine faith which could alone animate them to give up their intellect and time and labor so as they did, and all for His glory who, they could never forget, was the Eternal, altho' He had once humbled Himself to the form of man, that man might be clothed with, and know his love, His Divinity. – I have been influenced by no one in this matter; and indeed it is not from any angry or jealous feeling that I wish to be no longer a P.R.B.; and I trust you will [something torn off] . . ., but believe me affectionately your's, James Collinson. – P.S. Please do not attempt to change my mind.'

33 Bodkin, op. cit., p.129.

34 Fredeman, p.72; see also W.M. Rossetti 1895, I, pp.136–7.

35 Fredeman, p.41, but see n.40 below.

36 ibid., p.53.

37 ibid., p.37.

38 Hunt 1905, I, p.193.

39 Fredeman, pp.48–9.

40 George P. Landow, *William Holman Hunt and Typological Symbolism*, 1979, p.141. The letter cited by Landow, from Rossetti to his mother (Doughty & Wahl, I, pp.43–4), does seem to date

from about September 1848. Rossetti's mention of the Cyclographic supports that dating, and there was a play at the Queen's Theatre in August-September 1848 called *The Ship on Fire*, which may well have been the 'profoundly intense drama entitled *Kaeuba the Pirate Vessel*' which Rossetti and Collinson saw and to which Rossetti refers in his letter.

41 ibid., pp.141–7.

42 Alastair Grieve, 'A notice on illustrations to Charles Kingsley's "The Saint's Tragedy" by three Pre-Raphaelite artists', *Burlington Magazine*, CXI, 1969, pp.292–3.

43 Hunt 1905, I, p.252.

44 S[ydney] R[ace], 'James Collinson of Mansfield', *Nottingham Guardian*, 11 November 1952.

45 Fredeman, p.98.

46 Scott, I, p.281.

47 Doughty & Wahl, I, p.253.

48 W.M. Rossetti, *Some Reminiscences*, 1906, I, p.74.

49 Hunt 1905, I, pp.252–3.

50 'Temptation', signed and dated 1855, sold Phillips, 13 December 1982; 'The Writing Lesson', signed and dated 1855, sold Christie's, 24 June 1983.

51 *Art Journal*, June 1855, p.174.

52 Ruskin, XIV, p.24; he found 'the subject not interesting enough to render the picture attractive'.

53 'At the Bazaar', inscribed 'James Collinson 1857', Graves Art Gallery, Sheffield; 'For Sale', Castle Museum, Nottingham; 'To Sell(?)', inscribed on stretcher 'To Sell – Painted by Collinson 1858', private collection; 'The Empty Purse', Tate Gallery; 'For Sale', inscribed 'James Collinson' and (on stretcher) 'For Sale – James Collinson. Chelsea 1857' (quarter size version), sold Christie's, 13 October 1978 (88).

54 'The Landlady', inscribed 'J. Collinson

1856', Graves Art Gallery, Sheffield;
'To Let', Forbes Magazine Collection;
'To Let', private collection.
55 Unpublished M.A. thesis, Courtauld
Institute of Art, 1967, p.31.
56 Exhibition catalogue, *Great Victorian
Pictures*, Arts Council 1978, p.28.
57 *Literary Gazette*, No.2105, 23 May
1857, p.499.
58 Bodkin, op. cit., p.133.
59 W.M. Rossetti 1895, I, p.132.
60 Frederic Boase, *Modern English
Biography*, 1892, reprinted 1965.
61 In *Time Flies: A Reading Diary*; the
'friend' is identified as Collinson by
MacKenzie Bell in *Christina Rossetti*,
1898, p.305.

Walter Howell Deverell
(1827–1854)
MARY LUTYENS

Acknowledgements. This essay is largely
based on an unpublished memoir of
Deverell in the Henry E. Huntington
Library at San Marino, California, by
Frances, wife of Wykeham Deverell, with
a preface and annotations by William
Michael Rossetti (1899), referred to in
the following notes as the Memoir and
William Rossetti as WMR. Passages from
the Memoir and other documents at the
Huntington are published by kind
permission of that Library.

I wish to thank the following for
their help: Mr Robin de Beaumont,
Mr Harold Carlton, Miss Annette Dixon,
Mr John Gere, Mrs Pamela Greenman,
Mrs Hunter-Gray, Miss Rebecca Jeffrey,
Lady Mander, Mr Leslie Parris, Mr John
Physick, Miss Tessa Sidey, Mr and
Mrs Nigel Sitwell, Mr P.D. Stephenson,
Mr Adriaan Viruly and, above all,
Mr and Mrs R.P. Plowden-Wardlaw.

1 In the possession of Mrs Plowden-
Wardlaw, Wykeham Deverell's grand-
daughter. Information supplied
by Mr Plowden-Wardlaw, and the
Stamford Library.
2 Family information. The date and
place of Walter's birth are taken from
the Memoir and his birth date
confirmed by his death certificate. It is
stated in the Memoir that Walter
Ruding was from 1824 Professor of
Classics at the University of Virginia
for five years, but the University has no
record of his ever having been a
member of its faculty. It is hardly
possible that he would have taken his
bride to America without some job
awaiting him. He probably went to
Charlottesville as a private tutor or to a

school coaching boys for the University.

3 Since records of births and deaths do not go back beyond September 1837 it has been impossible to discover the ages of Spencer, Chantry and Margaretta, but as Spencer was the model for Orlando in Deverell's 'As You Like It' in 1852, he must have been adult by then, and as Chantry had probably emigrated to Australia by 1853 he too must have been grown up by that date. Jemima was born in 1832, Wykeham in May 1837 (this is known from their death certificates), Ruding in 1839 and Maria in 1841. Margaretta probably came between Jemima and Wykeham.

4 Stated in the Memoir in which passages from Deverell's journal are quoted. Frances Deverell or some other member of the family destroyed the journal itself except for two pages now at the Huntington Library.

5 That Mr Deverell was Governor of the Perth prison is known from the birth certificate of his daughter Maria, born in July 1841. The birth was registered by the mother from 25 James Street, but the father's occupation was given as Governor of the General Prison, Perth. This has been confirmed by the Scottish Home and Health Department. He was appointed to the office in 1840 at a salary of £400 a year, but 'the appointment was recalled on 18 July 1842, exactly four months after the prison opened, experience proving that Mr Deverell was deficient in certain qualifications deemed essential for such an office' (the true reason for Deverell's dismissal was some financial irregularity). Meanwhile 'considerable additions had been made to adapt' a house 'for the residence of Mr Deverell'. It was no doubt while these additions were being made that the rest of the family remained in London, so they would have had only a year in Perth during which Walter would have been with a tutor. The Scottish Home and Health Department is of the opinion that Mr Deverell need not have had any previous connection with Scotland to have obtained the appointment. His whereabouts between 1829 and 1836 remain a mystery.

6 At the corner of what was then Charlotte Street, now Bloomsbury Street, and Streatham Street. Henry Sass (1788–1844) founded the School. On his retirement in 1842 it was taken over by F.S. Cary (1808–1880) and run by him until 1874, but it was still known as Sass's in Deverell's time.

7 Memoir, pp.80, 137a.

8 G.B. Hill (ed.), *Letters of Dante Gabriel Rossetti to William Allingham*, 1897, p.76.

9 Scott, I, p.285.

10 Hunt 1905, I, pp.197–8.

11 Pen & ink, c.1853, $2\frac{1}{4} \times 1\frac{3}{4}$ in, inscribed 'Deverell' (Coll. Lady Mander), and a slighter drawing, pen and ink, $4\frac{3}{8} \times 4$ in, unsigned and undated (Birmingham City Art Gallery).

12 Oil on canvas, $10\frac{1}{8} \times 8$ in, unsigned and undated. This portrait shows that he had dark brown eyes, like his hair, and full red lips, and was just starting to grow a first moustache. It can therefore be dated c.1847. The background may have been painted later. An undated oil portrait of Deverell by Holman Hunt, reproduced in *The Wife of Rossetti* by Violet Hunt, appears to be of the same period.

13 Surtees 1981, p.64.

14 An unsigned, undated pencil drawing by Deverell, $3 \times 2\frac{1}{2}$ in, said to be of Jemima, is in the Tate Gallery,

presented by Wykeham Deverell in 1912. Since she does not appear to be more than eight, a pretty little girl with ringlets, Deverell must have drawn her in 1840 when he was only thirteen, so it is more likely to have been of Maria who was born in 1841.

[15] Memoir, p.27.

[16] Deverell's paternal uncle. He was of the family of William Hogarth, but as William had had no brothers and no sons, he would have been descended from one of William's two uncles.

[17] From two of the original pages of his journal (HM 12920). The first page, before the entry for June, starts in the middle of a paragraph with a description of some pictures he had seen. These were at the pre-view in May of the sale of Sir Thomas Baring's collection at Christie's in the beginning of June 1848.

[18] Scott, I, p.148, Quentin Bell, *The Schools of Design*, 1963, and information supplied by John Physick.

[19] Both letters quoted in the Memoir, p.29.

[20] Hunt 1905, I, pp.198-9.

[21] Fredeman, p.31. In the Memoir it is stated (p.55) that Deverell discovered Miss Siddal some 'little time before his mother's death in October 1850', to which WMR has added, '& perhaps in 1849'.

[22] *The Germ*, ed. W.M. Rossetti, 1901, Preface, p.25.

[23] Oil on canvas, unsigned and undated, $40\frac{1}{8} \times 52\frac{1}{4}$ in, Forbes Magazine Collection. A pen and ink study for this picture, $8\frac{9}{16} \times 11\frac{5}{16}$ in, is in the Tate Gallery (TG 1984, No.166).

[24] This drawing, and the Claude Duval, pencil, pen and ink with grey wash, $13\frac{3}{4} \times 11\frac{3}{16}$ in, are in Birmingham City Art Gallery. They are partly repr. in *From Hogarth to Keene*, 1938, by H.S. Reitlinger, who calls Deverell's 'story

telling gifts rather remarkable'. Birmingham also own two other drawings by Deverell – 'The Ghost Scene from Hamlet', Act I, Scene i, pencil, pen and ink, $11\frac{5}{8} \times 11\frac{3}{16}$ in, and a sketch of two girls, one kissing the other, 14×10 in, dated 9 May 1853. This was given to F.G. Stephens by Deverell's sisters after his death and is so inscribed. 'Laertes and Ophelia' and 'The Egyptian Ibis' are untraced.

[25] Fredeman, p.72.

[26] Memoir, pp.36-7.

[27] ibid., p.38. Annotation in WMR's writing.

[28] Mrs Plowden-Wardlaw's Collection.

[29] Fredeman, p.85. This picture, oil on wood, $27\frac{3}{4} \times 36\frac{1}{4}$ in, signed Walter H. Deverell, was never exhibited. It is now in the Shipley Art Gallery, Gateshead, near Newcastle.

[30] G.H. Fleming suggests in his *Rossetti and the Pre-Raphaelite Brotherhood*, 1967, p.174, that Rossetti left Red Lion Square in order to withdraw Elizabeth Siddal 'from the constant company of one of the most remarkably handsome young men in London', and quotes in this context a letter of 2 January 1851 from John Tupper to Stephens: 'Happy New Year to you! and P.R.B. to Deverell. I suppose tonight eh? [the night on which Stephens had told Deverell that he was to be elected] You may interpret P.R.B. "Penis rather better" – which to him is important.' Instead of the salacious meaning, this remark may have indicated that Deverell was already suffering from the kidney disease that was to kill him.

[31] Memoir, p.96a in WMR's writing. Previously unpublished.

[32] ibid., p.96a. 'The Pet', oil on canvas, $35\frac{1}{8} \times 22\frac{1}{2}$ in, undated but inscribed 'WH△', is in the Tate Gallery.

[33] Memoir, pp.95-96a.

34 A bold drawing of Spencer's head, pencil on paper, $4\frac{1}{2} \times 4\frac{3}{16}$ in, unsigned and undated, evidently a study for Orlando in 'As You Like It', is in the Tate Gallery, given by Wykeham Deverell in 1912.

35 Memoir, p.18.

36 ibid., pp.109, 113.

37 Rossetti's letters to Deverell, now in the Huntington Library, are all quoted in the Memoir. A sketch was enclosed in this letter showing Rossetti and Deverell sitting at a table drinking while McCracken looks at a picture of Deverell's on an easel. Deverell mentions in his journal that he had received McCracken's letter: Memoir, p.73.

38 Dr Richard Bright (1789–1858) had published in 1827 his discovery of the connection between dropsy and kidney disease. In Rossetti's letter of 23 May a drawing was enclosed, depicting Deverell and Rossetti in top hats looking at their pictures hanging in an imaginary provincial gallery, and in the letter of the 31st were two drawings – one showing McCracken in bed, laid up 'with the sickness of hope deferred, owing to an unfortunate error in packing' ('The Banishment of Hamlet' had arrived instead of 'Twelfth Night'), the other of Rossetti standing beside Deverell at the latter's dressing table and captioned, 'Deverell on receiving a letter from Belfast thinks it as well to put on a mourning band' (on his hat). These four drawings are at the Huntington Library.

39 Oil on canvas, unsigned and undated, $24\frac{15}{16} \times 30\frac{3}{8}$ in, Johannesburg Art Gallery.

40 Both entries quoted in Memoir, pp.97–102.

41 Pen, brown ink with touches of black ink, $5\frac{1}{2} \times 3\frac{1}{8}$ in, National Gallery of Victoria, Melbourne.

42 This full-length picture was later cut in half (family information). One half has disappeared; part of the other, showing only a head, belongs to Mrs Greenman, Wykeham Deverell's grand-daughter in America. There is a note on the back, presumably in Wykeham's writing, saying that the portrait was part of a larger one exhibited at the Royal Academy.

43 This entry from Deverell's journal is the longest quoted in the Memoir, pp.107–13, but is almost entirely about the plays he acted in. It gives an interesting account of the provincial theatre at that time.

44 Undated letter to his mother, Doughty & Wahl, I, pp.224–5.

45 Letter of 30 December 1853 to Mrs Combe, J.G. Millais, I, pp.224–5.

46 Mrs Plowden-Wardlaw's small portrait of Spencer, aged about fifteen, is in the style of the self-portrait (note 12) and probably of the same date, c.1847; and there is a portrait of Wykeham as a child by Deverell at the Ashmolean Museum, oil on board, $7\frac{1}{2} \times 6$ in, as well as a drawing of him at the Tate Gallery, pen and ink on paper, $3\frac{1}{16} \times 5\frac{15}{16}$ in, aged about two or three and therefore executed when Deverell could have been no more than twelve or thirteen. Although Wykeham gave this drawing to the Tate in 1912, just as he gave the drawings of Spencer and Jemima (notes 14 and 34) and presumably identified them himself, this child is more likely to have been Ruding who was born in 1839. Margaretta probably never married, for Rossetti was still writing to her as Miss Deverell in 1866. Maria married a Mr Few and had a child whom she treated so badly that it had to be taken away from her. The two sisters were remembered for their bad tempers and mutual antipathy (family

information). Wykeham was the only member of the family whose descendants are known. He eventually became Secretary of the National Liberal Club and married late in life Frances Wishlade. He died in 1916 and his widow in 1948. They had two daughters, one of whom married and had children, and two sons – John (1880–1965) who became quite a well known actor, and Francis (1882–1942), who married Hilda Strutt and had two daughters, both of whom have issue.

47 Memoir, pp.114–5.
48 Letter to Thomas Woolner, 5 February 1854, Doughty & Wahl, I, p.172.
49 Lutyens 1967, p.98.
50 Hunt 1905, I, p.362, repr. p.361. The drawing, chalks and wash, $13\frac{7}{8} \times 10$ in, signed and dated 'Whh, 1853', was donated by Hunt to Birmingham City Art Gallery in 1907.
51 Memoir, p.137b. The picture was sold to Thomas White, the art dealer, in 1857 for £100 (Lutyens 1974, p.62).
52 Letters to Madox Brown and Christina Rossetti of 2 and 8 November 1853, Doughty & Wahl, I, pp.160–1, 163. John Marshall, F.R.C.S. (1818–1891) became Rossetti's doctor.
53 Letter from Allingham to Deverell of 22 November quoted in the Memoir, pp.90–3.
54 HL, HM 12921. Mr Ruskin reported to his son on 13 November: 'I half broke my heart yesterday by calling on Deverell – a most Gentlemanly young man in the poorest Dwelling's worst Room – a handful of fire on a Black cold day, painting to pass time without purpose or energy'. Lutyens 1967, p.100.
55 Lutyens 1967, p.237.
56 There is a drawing by Deverell in the Tate Gallery of a girl in a cap with a blue ribbon, entitled 'Louisa', pencil and watercolour, $5\frac{1}{2} \times 4\frac{1}{8}$ in, inscribed on the front of the card it is mounted on: 'By WHDeverell (about 1853)' and on the back of the card: 'Portrait of the housekeeper'.
57 J.G. Millais, I, pp.224–5.
58 Letter to Bell Scott of 9 February 1854, Doughty & Wahl, I, p.178.
59 J.G. Millais, I, p.226.
60 Letter to Madox Brown, 3 February 1854, Doughty & Wahl, I, p.171.

Was there Pre-Raphaelite Sculpture?

BENEDICT READ

1 Fredeman, p.96.
2 ibid., p.3.
3 Hunt 1905, I, p.127.
4 see Fredeman, pp.281–2.
5 Doughty & Wahl, I, p.369.
6 J.P. Seddon, 'The Works of the P.R.B. in Llandaff Cathedral', The Public Library Journal: A Quarterly Magazine of the Cardiff and Penarth Free Public Libraries and the Welsh Museum, IV, 1903–4, p.30.
7 Hunt 1905, I, pp.112–3, 128.
8 William Michael Rossetti, Some Reminiscences, 1906, I, p.160.
9 Spectator, XXIV, 2 August 1851, p.740.
10 D. Hudson (ed.), The Diary of Henry Crabb Robinson, 1967, p.265. I am most grateful to Katharine Macdonald for this reference.
11 MS, private collection.
12 Fredeman, p.78.
13 A.G. Temple, Guildhall Memories, 1918, p.43.
14 Woolner, pp.332–3.
15 see Fredeman, p.190.
16 Dictionary of National Biography, XX, p.1371.

'An interesting series of adventures to look back upon': William Holman Hunt's visit to the Dead Sea in November 1854

JUDITH BRONKHURST

Acknowledgements. Manuscript material is published with the kind permission of J.P. Birch, Esq.; The Bodleian Library, Oxford; The British Library; The Henry E. Huntington Library, San Marino; The Humanities Research Center, The University of Texas at Austin; The Pierpont Morgan Library, New York; The John Rylands University Library of Manchester.

Hunt's letters and journal have been transcribed as literally as possible, preserving the original spelling and punctuation. The following editorial signs are employed:

one[?] probable reading

⟨one⟩ deletion in original

⟨? one⟩ uncertain reading of deletion

1 BL, MS Eng. lett. c.296 fol.48v.

2 XLIX, pp.471–88, 737–50, 820–33.

3 Hunt's letter of 12 February 1887 to William Bell Scott (PUL, Troxell Coll.) reveals that he took great exception to William Michael Rossetti's article on 'The Pre-Raphaelite Brotherhood' in the *Magazine of Art*. This claimed that D.G. Rossetti 'was the chief starter of projects, suggester of novel ideas . . . inciter to intellectual enterprise' (IV, 1881, p.435).

4 HL, HM 32338.

5 Christie's, 2 April 1886 (80). Agnew's paid £787 10s for lot 81, the small version of 'The Light of the World' (Manchester City Art Gallery), but Hunt's watercolour 'Jerusalem at Twilight' (private collection), lot 37, was bought in at 50 gns.

6 PML, Millais Papers MA 1485/K405.

7 Hunt to Craik, 9 February 1887, JRL, Craik Papers.

8 *Contemporary Review*, LII, pp.21–38, 206–20. Hereafter Hunt 1887. Agnew's had purchased 'The Scapegoat' at Sir Thomas Fairbairn's sale, Christie's, 7 May 1887 (143), on behalf of Cuthbert Quilter for £1417 10s.

9 See William Beamont, *A Diary of a Journey to the East, in the Autumn of 1854, 1856*, II, pp.40–80.

10 n.d., *c.*11 November 1854, JRL, Eng. MS 1213/31.

11 BL, MS Eng. lett. c.296 fol.48.

12 JRL, English MS 1210.

13 BL, MS Eng. lett. c.296 fols.46–7. The Bodleian manuscript is the middle portion of the journal, which is dated with the days of the week only.

14 JRL, Eng. MS 1210 fol.1v. The visit to the Prussian doctor is omitted in Hunt 1887, but is mentioned in Hunt 1905, I, p.466.

15 Hunt to Millais, 10–12 November 1854, British Library, BM Add. MS 41340 S. fol.157v.

16 BL, MS Eng. lett. c.296 fol.48.

17 ibid., and JRL, Eng. MS 1210 fols.2v, 5–5v, 6v: journal of 16, 22 and 23 November 1854.

18 An account of the unsettled political situation in the area, caused by the lawless activities of 'Abderrahmân el 'Amer, can be found in James Finn, *Stirring Times, or Records from Jerusalem Consular Chronicles of 1853 to 1856*, 1878, I, pp.229–30, 236–7, 248–60; II, pp.34 and 147–9 (Hunt's letter to Finn of 2 December 1854).

19 Hunt 1887, p.27; Hunt 1905, I, p.469. According to the journal of 15–16 November, the conversations with the sheik were on a purely business footing, JRL, Eng. MS 1210 fols. 2v, 3.

[20] BL, MS Eng. lett. c.296 fol.48v.

[21] JRL, Eng. MS 1210 fol.1.

[22] Hunt 1887, p.29.

[23] Hunt did not learn that Soleiman was the sheik's son until 19 November, BL, MS Eng. lett. c.296 fol.47. Presumably the relationship was altered to that of nephew in Hunt 1887, p.34, and Hunt 1905, I, p.484, to avoid confusion over Soleiman's desire to be Hunt's son. The journal reveals that although the artist became fond of Soleiman, he was well aware that the Arab's anxiousness to please was financially motivated, JRL, Eng. MS. 1210 fols.3 – 3v: 16 November 1854.

[24] ibid., fol.4v: 17 November 1854.

[25] Hunt 1887, pp.35 – 6, states that Soleiman alerted Hunt to the approach of seven men, all of whom were armed.

[26] JRL, Eng. MS 1210 fol.5v: (?) 22 November 1854.

[27] ibid., fols.8 – 8v: 28 November 1854; Hunt to Combe, 2 December 1854, BL, MS Eng. lett. c.296 fol.48v.

[28] BL, ibid., fol.48.

[29] JRL, Eng. MS 1210 fol.4v.

[30] BL, MS Eng. lett. c.296 fol.46v. The quotation is from the General Confession in the morning service of the Book of Common Prayer.

[31] See Cosmo Monkhouse, 'Mr. Holman Hunt's Pictures', Academy, XXIX, 20 March 1886, p.209; 'Mr. W. Holman Hunt's Pictures in Bond Street', Athenaeum, 27 March 1886, p.429.

[32] JRL, Eng. MS 1210 fol.2: 15 November 1854.

[33] 1853, I, p.461: de Saulcy identified these as the ruins of Sodom. Hunt to Millais, 10 – 12 November 1854, British Library, BM Add. MS 41340 S., fol.157, expressed his disgust with de Saulcy's 'lies'. Although Beamont, in his diary of 26 October 1854, op. cit., II, p.55, mentions the American expedition to the area, we have no evidence that Hunt had read W.F. Lynch, Narrative of the United States' Expedition to the River Jordan and the Dead Sea, 1849, which suggests (p.310) that Sodom and Gomorrah were buried beneath the Dead Sea at Usdum. Lynch's conclusion was ratified in Melvin Grove Kyle's Explorations at Sodom, the story of ancient Sodom in the light of modern research, [1928].

[34] JRL, Eng. MS 1210 fol.3v.

[35] ibid., fols.4 – 4v.

[36] ibid., fol.5.

[37] BL, MS Eng. lett. c.296 fol.46.

[38] ibid.

[39] ibid., fol.46v.

[40] ibid., fol.47.

[41] JRL, Eng. MS 1210 fol.5.

[42] ibid.

[43] ibid., fol.6.

[44] Hunt first became aware of this problem on Sunday 19 November, BL, MS Eng. lett. c.296 fol.46v.

[45] JRL, Eng. MS 1210 fols.6 – 6v.

[46] Coll. J.P. Birch Esq.

[47] Coll. ibid. Hunt did paint the sky from Sim's house on 19 – 23 March 1855, according to his diary, JRL, Eng. MS 1211 fols.7v – 8. The 1855 account gives one a good idea of the extent to which 'The Scapegoat' was painted in Jerusalem.

[48] JRL, Eng. MS 1210 fol.2v. In Hunt 1887, p.26, and Hunt 1905, I, p.468, the proposed duration of the trip is inflated to five or six weeks.

[49] JRL, Eng. MS 1210 fols.6v – 7.

[50] HL, HH 197. 'The Scapegoat' had been sent to England in June 1855, according to Hunt's letter of that date to Thomas Combe, JRL, Eng. MS 1213/10.

[51] Hunt 1887, p.30.

[52] JRL, Eng. MS 1210 fol.4v.

[53] ibid., fol.7v. Some lines in the manuscript relating to the goat have been crossed out at a later date,

possibly by Edith Holman-Hunt, who on many occasions censored her husband's writings.

[54] Hunt 1887, p.207.

[55] PML, Millais Papers MA 1485/K406.

[56] University of Texas, Humanities Research Center.

[57] The photograph (Coll. J.S. Maas Esq.) is published in A. Meynell and F.W. Farrar, *William Holman Hunt*, The Art Annual, 1893, p.3.

[58] JRL, Eng. MS 1210 fol.2v.

[59] ibid., fol.3.

John Everett Millais's 'Autumn Leaves': 'a picture full of beauty and without subject'

MALCOLM WARNER

[1] 12 May 1856, Millais Papers, PML.

[2] The sum is mentioned in the artist's letter to George Gray, 11 April 1856, Millais Papers, PML.

[3] See letter from Edward Stuart Taylor, *Magazine of Art*, November 1896, p.53.

[4] Eden's sale at Christie's on 30 May 1874 comprised forty-seven works, mostly genre and landscape, including ten pictures by Linnell, eight by Ansdell, five by F.D. Hardy and five by Thomas Webster.

[5] See his *Academy Notes*, issued 9 May 1856 (Ruskin, XIV, pp.66–7).

[6] Stephens Papers, BL.

[7] *The Crayon*, III, November 1856, p.324. I am grateful to Denise McColgan for her help in tracing this article.

[8] Doughty & Wahl, I, pp.43–4.

[9] Hunt 1905, I, p.286.

[10] See J.G. Millais, I, p.127.

[11] Hunt Collection, HL.

[12] Tennyson Research Centre, Central Reference Library, Lincoln.

[13] Pigott Collection, HL.

[14] Bowerswell Papers, PML.

[15] See Hallam Tennyson, *Alfred, Lord Tennyson. A Memoir*, 1897, I, p.380.

[16] Hunt Collection, HL.

[17] J.G. Millais, I, p.348.

The Price of 'Work': the background to its first exhibition, 1865

MARY BENNETT

1 In the Lady Lever Art Gallery, Port Sunlight, together with letters to Rae from Rossetti, Burne-Jones, Morris and Howell. Ford Madox Hueffer in *Ford Madox Brown, A Record of his Life and Work*, 1896, quotes from several but not all of them. In the following notes Ford Madox Brown is abbreviated to 'FMB'.

2 Priced at 6p; there was a second edition (FMB to Rae, Letter No.43, 19 April 1865). 'Chaucer' was the first and 'Work' the last entry. There were fifty-two oils and watercolours, forty-six drawings and one bookcase (Morris & Co.). Most of the text is published by Hueffer. The extended entry on 'Work' has been reprinted in recent years with discussions by Alastair Grieve (1976, pp.38–45) and Julian Treuherz (*Pre-Raphaelite Paintings from the Manchester City Art Gallery*, 1980, pp.53–63).

3 See Jeremy Maas, *Gambart, Prince of the Victorian Art World*, 1975.

4 Surtees 1981, p.192. Plint's background and role as patron are discussed in Julian Lewis, 'Thomas E. Plint – A Patron of Pre-Raphaelite Painters' (unpublished paper, copy at Walker Art Gallery), September 1973.

5 According to Woolner: Allingham 1911, pp.290–1, quoted in Surtees 1981, p.192, n.84.

6 Plint to FMB, 17 November 1856 (FMBP).

7 Plint to FMB, 3 December 1860, and FMB drafts to Plint executors, Butler and Smith of Leeds and J.G. Knight of Leeds and Eastcheap, London, n.d.

1861 and 20 July 1861 (FMBP); and see Hueffer, pp.173–6, quoting FMB to Plint 23 April 1860.

8 Leathart to FMB, 17 November 1859 (FMBP).

9 *Athenaeum*, 28 April 1860, p.588.

10 FMB to Leathart, 18 September 1861 (UBC/LP), partly quoted in Maas, p.149; Leathart to FMB, 20 October and 20 November 1861 (FMBP). Leathart offered at one stage (18 July 1861, etc.) to take over the large picture instead but the price seems to have been too high and the transaction too complicated.

11 FMB to Leathart, 27 February, 5 March and 'March' 1863 (UBC/LP).

12 FMB to Leathart, 24 September 1861 (UBC/LP); quoted in Maas, p.149.

13 FMB to Leathart, 7 August 1863 (UBC/LP), partly quoted in Maas, p.150. This was about ten weeks after the agreement, which is mentioned in letters from the solicitor J. Anderson Rose to FMB, 13 and 20 May 1863 (FMBP). The artist's account book of receipts (FMBP) lists £200 received from Gambart on 18 May and £300 on 26 August 1863, and he had continued to receive periodic payments of £40 from the Plint executors in 1861 and 1862, amounting to £400.

14 Leathart to FMB, 13 August 1863 (FMBP).

15 FMB draft to Gambart, 22 January 1864 (FMBP).

16 Rossetti to Lowes Dickinson (Summer 1858), in Doughty & Wahl, I, p.335, partly quoted in the catalogue.

17 Rae to FMB, 11 and 22 November 1861, 25 January and 22 February 1862 (FMBP).

18 Letter No.28, 29 April 1864.

19 Letter No.29, n.d.

20 'Myosotis' and 'Old Toothless', for which FMB acknowledged the receipt

of £80 on 26 March (draft, FMBP). Gambart, 'not having been able to place the two drawings' (20 October 1864 to FMB, FMBP), subsequently bought a version of 'Elijah', November 1864, and replicas of 'Oure Ladye of Good Children' and 'The Last of England', November and December 1866, at £50 each (FMBP). 'Jacob and Joseph's Coat' (already sold to Rae) was shown at Gambart's *Winter Exhibition*, 1866–7.

21 Letters Nos 32 and 33, 5 and 31 July 1864.

22 Letter No. 36, 17 October 1864. Butler and Smith, Leeds, accepted Morris in a letter of 10 November 1864 (FMBP).

23 Letter No. 37, 23 October 1864.

24 Letter No. 41.

25 Hunt to F.G. Stephens, 18 December 1864 (BL), and see G.H. Fleming, *They ne'er shall meet again*, 1971, p.294, quoting an earlier letter on the subject.

26 Hunt to FMB, 12 March 1865 (FMBP).

27 Letter No. 42, 18 March 1865; in Hueffer, p.211.

28 Letter No. 43, 19 April 1865, in Hueffer, p.212. The artist lists £126 under receipts from the exhibition (FMBP). According to Hueffer (p.211), there was an entrance charge of one shilling and around 3000 visitors.

29 Letter No. 44.

30 Butler and Smith, the Leeds solicitors, wrote on 22 August, despondent over their bad luck in placing the picture, which they had tried with Christie's, Gambart and Agnew; they would prefer a private contract and might try McLean. On 23 September, on the same subject, they noted that Gambart engaged to bid 300 gns at Christie's but not more and they wondered about America. D.T. White appears to have been involved early in 1866. The picture was at that time deposited at Knight and Fosters, 5 Eastcheap,

London, but by 1868 was at the Knight house at Chapeltown, Leeds (FMBP).

31 *Diary*, 1–5 April 1866 (Surtees 1981, pp.214–5).

32 Rossetti to FMB, 3 April 1866, in Hueffer, p.227; Doughty & Wahl, II, p.595.

The Pre-Raphaelites and Mediaeval Illuminated Manuscripts

JULIAN TREUHERZ

1 Patmore, *Saturday Review*, 26 December 1857; Ruskin, XXXVIII, p.269; Muther, *A History of Modern Painting*, 1896, II, p.582; Andrea Rose, *The Pre-Raphaelites*, Oxford, 1981, facing colour pl.8.

2 A.N.L. Munby, *Connoisseurs and Medieval Miniatures 1750–1850*, 1972.

3 Roy Strong, *And when did you last see your father?*, 1978, pp.49–60.

4 Surtees 1981, pp.8–9.

5 Craik and MacFarlane, pp.867–71, 657, 278; Surtees 1981, pp.12, 65.

6 Surtees 1981, p.1.

7 Corpus Christi MS 61. The resemblance was first suggested by Brian and Judy Dobbs, *Dante Gabriel Rossetti*, 1977, p.39. It seems to have been independently noticed by the present writer and by Jenny Elkan, to whom the writer is indebted for assistance.

8 Information from R.L. Page, Librarian, Corpus Christi College, Cambridge.

9 H.G. Clarke, *A critical examination and complete catalogue of the works of art now exhibiting in Westminster Hall*, 1847, No. 37. Mary Bennett kindly

informed me that this subject was painted by West and William Bell Scott.

10 R.M. Burch, *Colour printing and colour printers*, 1910, pp.190–2; C.T. Courtney Lewis, *The Story of Picture Printing in England*, 1928, pp.141–7; Carl Nordenfalk, *Color of the Middle Ages*, University Art Gallery, Pittsburgh, 1976, pp.20–4.

11 J.G. Millais, I, p.78.

12 Fredeman, pp.5, 19.

13 Harley MS 2798–9, II, f.185v. Identified by Jonathan Alexander, to whom grateful thanks are tendered for this and other assistance.

14 Hunt 1905, I, p.294.

15 Peter Anson, *The Call of the Cloister*, 1955, pp.220–67; *Punch*, XIX, 1850, pp.163, 226–7.

16 E.G. Millar, 'Les Manuscrits à peintures des Bibliothèques de Londres', *Bulletin de la Société Française des Reproductions de Manuscrits*, Paris 1914–20, p.35, MS No.6, f.176v.

17 Harley MS 2897 f.86v and Burney MS 275 f.395v, repr. Shaw, I, f. pl.37; John Christian, 'Early German Sources for Pre-Raphaelite Designs', *Art Quarterly*, XXXVI, 1973, p.79.

18 DNB; Doughty & Wahl, I, p.55.

19 G. Burne-Jones, I, pp.60–2, 97, 104.

20 Surtees 1981, p.88; J.M. Crook, *William Burges and the High Victorian Dream*, 1981, pp.97–8, 361; J.S. Dearden, 'John Ruskin the Collector', *The Library*, XXI, 1966, pp.124–54.

21 Ruskin, XXXV, pp.490–1; Dearden No.30.

22 Ruskin, XII, p.lxviii; XXXIII, p.424.

23 Ruskin, XII, p.lxvii.

24 Dearden Nos 16, Fitzwilliam Museum, Cambridge; 21, Walters Art Gallery, Baltimore; 23, Chester Beatty collection; 34, Major T.R. Abbey collection.

25 Ruskin, V, p.137.

26 Ruskin, V, p.262.

27 Ruskin, IX, p.285.

28 Surtees 1980, p.23.

29 Ruskin, XXXIII, p.269.

30 *Letters of James Smetham*, 1892, p.102.

31 *Rossetti*, 1904, pp.187–8.

32 Ruskin, XII, p.485.

33 He referred to it simply as 'Monk' in 1856 (Doughty & Wahl, I, pp.290, 302) and G. Burne-Jones, I, p.129, says it received its title afterwards.

34 Ruskin, XXXVI, pp.228, 331, 404.

35 Surtees 1980, p.30.

36 Narcissus, f.20, cf. 'The Baleful Head'; Pygmalion, f.178v, cf. 'The Soul Attains'.

37 Procession, f.14v, cf. 'The Knight's Farewell'; Christine de Pisan, Harley MS 4431, e.g. f.376.

38 *Works*, I, p.151.

39 G. Burne-Jones, I, p.212.

40 Doughty & Wahl, I, p.312; J. Lindsay, *William Morris*, 1975, p.95; Bodl. MS 264 seen by Morris 27 April 1857. I owe this reference to Bruce Barker-Benfield.

41 J. Dunlap, 'William Morris: Calligrapher', and P. Needham, 'William Morris: Book Collector', *William Morris and the Art of the Book*, New York, Pierpont Morgan Library, 1976.

42 Ruskin, V, p.139.

Rossetti and the Oxford Murals, 1857

ROSALIE MANDER

Acknowledgements. Further particulars are to be found in the text by Mr John Christian accompanying the microfiche published by the University of Chicago Press, available from 19A Paradise Street, Oxford, and in *The Oxford Union Murals* by Dr John Renton, available at the Union premises in Oxford. My thanks are due to Dr Renton for much information and to Mr Cyril Band for the loan of photographs and transparencies for use in lectures on the murals. I am also very grateful to Mr Christian for several references and allowing me to use photographs belonging to him for illustrations, and to Mr Leslie Parris of the Tate Gallery for most helpful editing. I am alone responsible for errors and opinions in the article.

[1] There were seven Brothers who formed the group and who alone should be known by the name: James Collinson, W. Holman Hunt, J.E. Millais, D.G. and W.M. Rossetti, Thomas Woolner, F.G. Stephens. Ford Madox Brown, who was senior to these, thought it *infra dig* to join and other young artists who were Pre-Raphaelite in their aims were left out, mainly because they did not happen to be around.

[2] Duncan Robinson, *William Morris, Edward Burne-Jones and the Kelmscott Chaucer*, 1982, p.7.

[3] Kerrison Preston (ed.), *Letters from Graham Robertson*, 1953, p.74.

[4] James Wyatt, sometime mayor of Oxford, was a patron of Millais as early as 1846, so that when he and Hunt came to Oxford to lick their wounds after the bad notices of their Academy pictures in 1851 Millais had the satisfaction of finding his work hanging in the Gallery beside that of Italian Old Masters and Early English watercolourists. Wyatt was responsible for commissioning Turner to paint the two views of Oxford still most frequently reproduced: the High Street, where they agreed to lower the spire of St Mary's, and the view from Headington.

[5] G. Burne-Jones, I, p.147.

[6] Doughty & Wahl, I, pp.14–16.

[7] W. Holman Hunt, *The Story of the Painting of the Pictures on the Walls and the Decorations on the Ceiling of the Old Debating Hall (now the Library) in the Years 1857–8–9*, Oxford, 1906, p.11.

[8] Lago, p.68.

[9] Doughty & Wahl, I, p.337.

[10] Ed. Virginia Surtees, *Reflections of a Friendship. John Ruskin's Letters to Pauline Trevelyan 1848–1866*, 1979, pp.130, 277–8.

[11] Raleigh Trevelyan, *A Pre-Raphaelite Circle*, 1978, p.137.

[12] He would have seen this when he called to have the meeting with Swinburne described in 'No.2 The Pines' from *And Even Now*, 1920.

[13] The Revd W. Tuckwell, *Reminiscences of Oxford*, 1901, pp.49–50.

[14] Ed. Cecil Y. Lang, *The Swinburne Letters*, I, New Haven, 1959, pp.17–18. Dr Lang in a note to this letter states that Swan is mentioned elsewhere as exceptionally brilliant and sure of a great future but nothing more is known of him, not even his first name!

[15] K.L. Goodwin, 'William Morris' "New and Lighter Design"', *Journal of the William Morris Society*, II, No.3, 1968, p.30.

[16] Ed. Virginia Surtees, *Reflections of a Friendship*, 1979, p.277.

[17] ibid.

[18] G. Burne-Jones, I, p.168.

[19] Coventry Patmore in *Saturday Review*, 26 December 1857.

[20] Stanley Weintraub, *Four Rossettis*, 1978, p.97.

[21] The contrast between the characters of Morris and Rossetti (north and south, nordic and latin) was expressed by Max Beerbohm in his unfinished manuscript of *The Mirror of the Past* (ed.Lawrence Danson from the Collection of Robert H. Taylor, Princeton 1982): 'Morris is a North Wind – no humour – only jocular – high spirits and slang' while Rossetti 'is a South Wind – contrary – at Oxford much stronger'.

[22] Ed. Cecil Y. Lang, *The Swinburne Letters*, I, New Haven, 1959, p.18.

[23] This was the idea of H.H. Asquith, later Prime Minister and created Earl of Oxford and Asquith.

[24] See note 7. Interest in the murals had rapidly extended outside Oxford. *The Times* (6 January 1858) under the heading 'The New Debating Room at Oxford' gave the names of the artists and said: 'The paintings, owing to the beauty and variety of colouring have a most imposing effect'. The *Art Journal* (February 1858) under the heading 'Pre-Raffaelite Art in Oxford' gave names and subjects with special reference to 'Mr Pollen's paintings on the roof of Merton Chapel. It is proposed to adorn the new Museum with similar decorations'.

'A Serious Talk': Ruskin's Place in Burne-Jones's Artistic Development

JOHN CHRISTIAN

[1] G. Burne-Jones, I, p.147. The drawing Ruskin was to show to 'lots of people' was probably 'The Waxen Image', a scene of witchcraft in two compartments executed in pen and ink. Now lost, it was the first work completed by Burne-Jones after meeting Rossetti in January 1856, and was partly inspired by his poem *Sister Helen*.

[2] A library catalogue of 1861 is still in the school archives, and Lee's personality is stamped firmly on the selection.

[3] A.C. Benson, *Life of E.W. Benson*, 1900, I, p.41.

[4] J.W. Mackail, *The Life of William Morris*, Oxford (World's Classics ed.), 1950, I, p.49.

[5] Ruskin, III, p.624.

[6] See John Christian, 'Burne-Jones's Drawings for "The Fairy Family"', *Burlington Magazine*, CXV, 1973, pp.93–100.

[7] G. Burne-Jones, I, p.110.

[8] ibid., I, p.127.

[9] W.J. Stillman, *The Autobiography of a Journalist*, 1901, I, p.264.

[10] It is sometimes assumed that the original ideas of the P.R.B. were influenced by Ruskin. In fact they were evolved largely independently, although Holman Hunt had been deeply impressed by *Modern Painters* when it was lent to him 'for a few hours' in 1847.

[11] Ruskin, XII, p.xxiii

[12] Ruskin, XXXVI, p.272.

[13] Ruskin, XXXVI, p.227.

[14] G. Burne-Jones, I, p.175.

[15] 'What I *do* feel *generally* about you', he

wrote to Rossetti in 1860, 'is that without intending it you are in little things habitually selfish . . . I wish Lizzie and you liked me enough to – say – put on a dressing-gown and run in for a minute rather than not see me; or paint on a picture in an unsightly state, rather than not amuse me when I was ill' (Ruskin, XXXVI, pp.342–3).

16 Although all contributions to the magazine were anonymous, Burne-Jones's authorship of the review seems clear. It is known that he intended to 'introduce' Ruskin, originally in the number for March (G. Burne-Jones, I, p.122), and the writing is very much in his style.

17 The article on 'Ruskin and the Quarterly' in the June issue of the *Oxford and Cambridge Magazine* has been attributed to Morris, but J.W. Mackail believed that it was substantially by Burne-Jones. See Ruskin, V, p.lx, n.2.

18 Ruskin, V, pp.28, 44–69.

19 ibid., p.134.

20 ibid., pp.86–7.

21 Aymer Vallance, 'The Decorative Art of Sir Edward Burne-Jones', *The Art Annual*, Easter 1900, p.2.

22 Notably in two watercolours, 'Arthur's Tomb', 1855 (TG 1984, No.213) and 'Fra Pace', 1856 (Surtees No.80). Significantly, Ruskin described the latter as 'not my sort of drawing' (Ruskin, XXXVI, p.228).

23 Quoted partly in M.S. Watts, *George Frederic Watts*, 1912, I, p.173, partly in R. Chapman, *The Laurel and the Thorn*, 1945, p.153.

24 W. Graham Robertson, *Time Was*, 1931, p.88.

25 Rossetti returned the compliment, observing to Browning of Ruskin's version of the 'Charge to Peter' in the chapter on the 'False Religious Ideal' that 'a glorious picture might be done

from [it]' (Doughty & Wahl, I, p.286).

26 Ruskin, V, p.279.

27 ibid., XXXVI, p.313.

28 Letter in the J.C. Troxell collection, quoted under Surtees No.110. The picture that Lady Trevelyan was buying was 'Mary in the House of St John' (Wilmington), which Ruskin greatly admired. 'The Blue Closet' and 'The Tune of Seven Towers' (TG 1984, Nos 219–20) were among Rossetti's 'Froissartian' watercolours of 1857, both being painted for William Morris.

29 Ruskin, XXXVI, pp.329, 404–5.

30 ibid., p.273.

31 Oswald Doughty, *A Victorian Romantic. Dante Gabriel Rossetti*, 2nd ed., 1960, p.241.

32 Ruskin, IV, pp.117–9.

33 Ruskin, XXIX, pp.88, 90.

34 Ruskin, VII, p.xl.

35 Rossetti in fact described them as 'marvels of finish and imaginative detail, unequalled by anything unless perhaps Albert Dürer's finest works' (Doughty & Wahl, I, p.319). For a fuller account of the influence of Dürer on Rossetti's circle, see John Christian, 'Early German Sources for Pre-Raphaelite Designs', *The Art Quarterly*, XXXVI, 1973, pp.56–83.

36 Ruskin, XIV, p.107.

37 ibid., p.237.

38 See G. Burne-Jones, I, pp.153, 155, 158, 175. The picture also involved painting lilies from specimens found growing in Red Lion Square. See Hayward Gallery 1975–6, No.23.

39 Ruskin, XIV, p.154.

40 G. Burne-Jones, I, p.175.

41 A.M.W. Stirling, *A Painter of Dreams*, 1916, p.302.

42 F. De Lisle, *Burne-Jones*, 1904, p.45.

43 Although Rossetti had discouraged him from studying the antique, evidence that he was doing so by the late 1850s may be found in his

sketchbooks. Throughout this period he was living in Bloomsbury, within easy reach of the British Museum.

[44] This may well be why Ruskin never owned the drawing, although it seems to be the 'subject from Florentine history' which, according to G.P. Boyce, Burne-Jones started to work on for him in January 1859. See John Christian, 'Burne-Jones's Illustrations to the Story of Buondelmonte', *Master Drawings*, XI, 3, 1973, pp.279–288.

[45] Fitzwilliam Museum, Cambridge. See Hayward Gallery 1975–6, No.333.

[46] 'An Artist's Life in Italy in 1860' (sic), *Magazine of Art*, 1904, p.417.

[47] Ruskin, IX, p.188.

[48] Ruskin, XXIV, p.65.

[49] Ruskin, VII, p.6.

[50] G. Burne-Jones, I, p.232.

[51] Ruskin, XXXVI, p.347.

[52] ibid., p.405.

[53] ibid., p.406.

[54] See John Christian, 'Burne-Jones's Second Italian Journey', *Apollo*, CII, 1975, pp.334–7.

[55] G. Burne-Jones, I, p.247.

[56] Fitzwilliam Museum, Cambridge (1084).

[57] Ruskin, XI, p.430.

[58] ibid., p.410.

[59] ibid., XXXVI, p.168.

[60] Ruskin met Rose in 1858 when she was nine years old. He fell in love with her, or his image of her, but her response to his suit was equivocal, while her intense religiosity made her question the state of his soul. He eventually proposed to her in February 1866, but she insisted he should wait three years before she answered.

[61] Ruskin, XIX, p.203.

[62] ibid., pp.443–4.

[63] *The Winnington Letters* (of John Ruskin), ed. Van Akin Burd, 1969, p.150.

[64] See Hayward Gallery 1975–6, Nos 82–3, and G. Burne-Jones, I, pp.266–9, 276. For other examples of these standing figure compositions among Burne-Jones's paintings, see Hayward Gallery 1975–6, Nos 37, 38 and 40.

[65] *Winnington Letters*, p.370.

[66] Ruskin, XXXVI, p.493.

[67] Commissioned by Charles Eliot Norton in 1866 but not completed; drawings were made but do not seem to have survived. See Ruskin, XXXVI, pp.497, 500–1, 511, 521.

[68] Burne-Jones was elected to the Old Water-Colour Society in 1864 and his pictures, though savagely attacked by the critics, soon attracted both patrons and followers. By the late 1860s he was widely regarded as the leader of a new school.

[69] G. Burne-Jones, I, p.274.

[70] Ruskin, XXXVI, p.468.

[71] See, for example, the passage in *The Cestus of Aglaia* (1865) – a book in which he seeks to define 'laws which are binding on Art practice and judgment' – where he writes that it should be 'the aim of the best painters to paint the noblest things they can see by sunlight', the contrary tendency being 'to paint the foulest things . . . by rushlight' (Ruskin, XIX, p.109).

[72] G. Burne-Jones, I, p.271.

[73] Ruskin, XVII, p.213.

[74] Ruskin, XIX, pp.206–7.

[75] Ruskin's outburst evoked widespread criticism and both Poynter and William Blake Richmond gave lectures putting the contrary view. For Burne-Jones's reaction, see G. Burne-Jones, II, p.18.

[76] In his later years he described him as 'a naturalist with a sense of beauty', and even as 'constantly wrong' in his criticism. See Lago, pp.30, 124, and for a confirming comment, W. Graham Robertson, *Time Was*, 1931, p.79.

[77] Ruskin, XIV, p.495.

[78] G. Burne-Jones, II, p.18.

[79] Letter in PML, quoted in Joan Abse, *John Ruskin: The Passionate Moralist*, 1980, p.304. The painting was exh. Hayward Gallery 1975–6, No.155.

[80] Ruskin, XXIX, p.159.

[81] Ruskin, XXXIII, p.296.

[82] Hayward Gallery 1975–6, No.323. Prosperpine was one of Ruskin's pet names for Rose.

[83] The cross itself has recently been rediscovered. See Charlotte Gere and Geoffrey Munn, 'A Rediscovered Symbol of Romantic Love', *Collectors Guide*, May 1983, pp.42–4.

[84] W.J. Stillman, *The Autobiography of a Journalist*, 1901, I, p.270.

[85] Ruskin, IV, p.356, note 3.

[86] G. Burne-Jones, II, p.130.

The Holman Hunt Collection, A Personal Recollection

DIANA HOLMAN-HUNT

Acknowledgements. I am extremely grateful for the interest shown and assistance rendered by the following: Birmingham Museum and Art Gallery (Emmeline Leary); The British Museum; Castle Museum, Norwich (Michael Day); Christie's, London (Noël Annesley); Christie's, New York (Ian G. Kennedy); The Friends of the Ashmolean Museum; Royal Ontario Museum (K. Corey Keeble); Sotheby's (Janet Green); Victoria and Albert Museum (Sir Roy Strong, John Mallet, Robert Skelton, Clive Wainright); Walker Art Gallery (Mary Bennett). I am also indebted to the following: Judith Bronkhurst, Elisabeth Burt, Theodore Crombie, Simon Edsor, Richard Herner, Ian Lowe, S.R. Patch, Godfrey Pilkington, Richard Shone, Virginia Surtees, Sir Ellis Waterhouse, John Wright. Last, but not least, I would like to thank Charles Beddington for his valuable help over research.

[1] Birmingham Museum and Art Gallery, Acc. No.M9–53 ANB, given by Gladys Joseph 1953. See Richard Ormond, 'Holman Hunt's Egyptian Chairs', *Apollo*, LXXXII, 1965, pp.55–8, repr. Exhibited: *The Inspiration of Egypt*, Brighton and Manchester, 1983, No.208.

[2] Given by Edith Holman-Hunt to the Ashmolean Museum, Oxford in 1927.

[3] Edith Holman-Hunt annotated the catalogue 'Tapestries for Hilary [her son], to be put in his attic'; Millais had depicted them in his oil 'The Minuet' of 1866.

[4] These Singhalese chairs from Strawberry Hill were sold by a

Knightsbridge antique shop for £2 each in the 1950s.

5 'Portrait of a Man', oil on panel, 48.4 × 36.4 cm, c.1510–12, collection Heinz Kisters, Kreuzlingen, Switzerland; Friedländer and Rosenberg, *The Paintings of Lucas Cranach*, 1978, No.58, repr.; considered by Hunt to be by an anonymous German master and exhibited as such in the R.A. Winter Exhibition 1912, No.32.

6 Workshop of Giunta di Tugio; now in Naples, Museo di Capodimonte (De Ciccio Gift); see Galeazzo Cora, *Storia della Maiolica di Firenze e del Contado, Secolo XIV e XV*, Florence 1973, plates 89a and c.

7 See Diana Holman-Hunt, *My Grandmothers and I*, 1960, pp.29–30.

8 Described by Hunt as 'Best period of enamel porcelain 1580 Ming'; in fact all the pieces of Chinese porcelain were later than Hunt thought and were standard works made for export.

9 Christie's, 20 March 1959 (111), sold for 700 gns to the Leger Galleries who sold it to the Italian art trade in 1960; see Professor Sir Ellis Waterhouse, 'Holman Hunt's "Giovanni Bellini" and the Pre-Raphaelites' own early Italian pictures', *Burlington Magazine*, CXXIII, 1981, pp.473–7, repr.

10 Madonna and Child with two Saints, Central Italian, probably Umbrian, c.1450–70.

11 Sold at Christie's, 23 March 1959 (118) for £294 to Rosselli.

12 Exhibited *Persian and Arab Art*, Burlington Fine Arts Club, 1885, No.144.

13 More interesting than any of Hunt's Chinese porcelain and one of his successes, although he labelled it 'Japanese 1523–36'.

14 This arrowless St Sebastian was sold at Christie's, 20 March 1959 (146) as

Circle of Ribera; it was bought by the Piccadilly Gallery for 90 gns.

15 Oil on paper laid down on canvas, 23 × 18 cm, 1626–30; Erik Larsen, *L'Opera Completa di Van Dyck 1626–41*, 1980, No.487, repr.; then the property of Spencer A. Samuels & Co. Ltd, New York.

16 For instance, the Desiderio stucco fetched only £48 6s at Christie's, 10 March 1955 (17, catalogued for some reason as Antonio Rossellino). Doubt was already expressed by Allan Marquand when, using second-hand information, he listed three Hunt collection Della Robbias in his Princeton catalogues; these are *Luca della Robbia*, 1914, No.83 (incorrectly described – it is in fact of the type of Andrea della Robbia No.87) and No.115, and *Andrea della Robbia and his Atelier*, 1922, No.125 (17).

17 Christie's, 24 May 1964 (143, as Sixteenth-Century Italian School), bought Callmann, £718.

18 Signed statement by Hunt in the author's possession; this also reveals that he purchased the drawing from a family in Assisi in 1869 and not in Florence in 1867 as is always stated. This now well-known drawing was purchased in 1964 by Baron Hatvany and on his death passed to the collection of Christ Church, Oxford. It has been frequently illustrated, for instance in Christie's *Review of the Year 1964–5*, p.49, and in Christie's *Review of the Season*, 1979, p.16.

19 Sotheby's, 27 March 1969 (17, repr.).

20 These were bought by Hunt in Florence in 1867; they were small copies of Tintoretto's 'San Rocco Healing the Plague-Stricken' and 'San Rocco in Prison visited by an Angel' in the Church of San Rocco in Venice, and were sold as such at Christie's, 25 February 1955 for £685; one

might infer that Hunt thought they were of much greater interest from the record of his visit to the Church of San Rocco in 1869 in the company of Ruskin (Hunt 1905, II, p.259).

21 Bought by P. de Boer at Christie's, 7 May 1937 (25) as 'Tintoretto's Portrait of his daughter Lavinia' and subsequently exhibited by him as such; Tintoretto had no daughter called Lavinia and the style is Titian's; for other proposed portraits of Lavinia see Hadeln in *Pantheon*, 1931, pp.82ff.

22 Collection of the Trustees of the Stirling Foundation.

23 Sold by Edith Holman-Hunt to the Royal Ontario Museum, Toronto. She was a friend of Charles Trick Currelly, Director of the Museum's Art & Archaeology Division. St Francis plate: acc. No.915.131.

24 Very similar to Victoria and Albert Museum C.2047-1910.

25 Showing scenes from the myth of Hercules; Hunt also possessed a Greek marble head but both pieces remain untraced.

26 Cat. No.278-1869.

27 Edith Holman-Hunt had attached a notice to its trunk which read: 'W.M. Thackeray and his children played around this tree'.

28 Southern Indian or Singhalese, late seventeenth century; now in the Victoria and Albert Museum: I.S.70-1959.

29 Ian Bennett, *World Furniture. The Rebirth of Design: Arts & Crafts & Art Nouveau*, 1976, p.244.

30 See Diana Holman-Hunt, *My Grandfather: His Wives and Loves*, 1969, p.44.

31 This was mid-sixteenth century, Duchy of Urbino or Venice, and depicted Venus and Cupid.

32 Youngest daughter of Vernon Lushington.

33 This Kakiemon jar, which Hunt had purchased at W.M. Thackeray's sale in 1875, is the only Japanese piece recorded in the Collection.

34 Exhibited *Persian and Arab Art*, Burlington Fine Arts Club, 1885, Nos 261* and 312.

35 Christie's, 7 May 1937 (18–26).

36 Christie's, 7 March 1938 (96).

37 Christie's, 7 May 1937 (18–19, 23, 26) and 7 March 1938 (96).

38 Sotheby's, 30 November 1966 (77, repr.), bought by L. Herner; offered for sale again, after removal of much nineteenth-century overpaint, Christie's, New York, 9 January 1981 (55, repr. in colour); Private Collection, New York, 1983.

Index

The longer personal name entries are divided into paragraphs corresponding to some or all of the following subentries:

1 biographical events
2 general aspects
3 WORKS, i.e. artistic works
4 LITERARY WORKS

The order of subheadings is alphabetical except in the biographical paragraphs, where it is chronological.

Abbreviations: PR, Pre-Raphaelite; PRB, Pre-Raphaelite Brotherhood; PRS, Pre-Raphaelites.

L.P.